Dressing with Purpose

Dressing with Purpose

Belonging and Resistance in Scandinavia

Edited by Carrie Hertz

Indiana University Press

This book is a publication of

Indiana University Press
Office of Scholarly Publishing
Herman B Wells Library 350
1320 East 10th Street
Bloomington, Indiana 47405 USA

iupress.org

Printed in China

Cataloging information is available from the Library of Congress.

ISBN 978-0-253-05857-7 (hardback)
ISBN 978-0-253-05858-4 (ebook)

First printing 2021

Contents

In memory of Barbro Klein (1938–2018),
a force of empathy and infectious enthusiasm, a brilliant scholar and mentor.

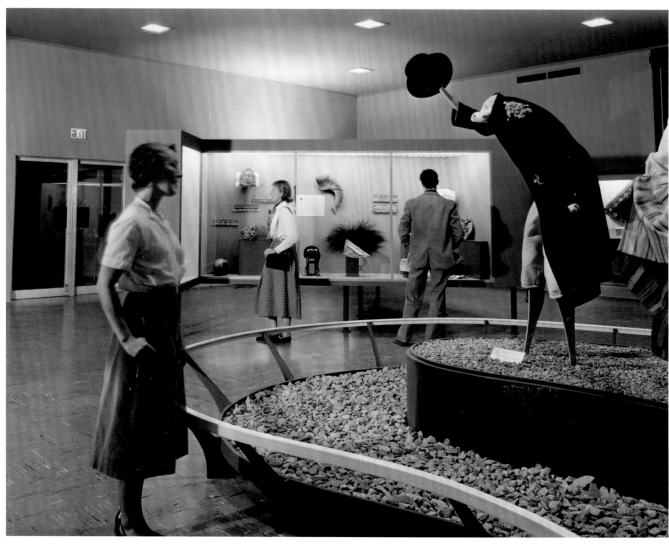

Costumes of the World on Parade, the first exhibition at the Museum of International Folk Art in 1953, included Swedish and Norwegian outfits collected by museum founder Florence Dibell Bartlett. *Bartlett Library and Archives Collection, Museum of International Folk Art.*

Foreword

Khristaan Villela

Executive Director of the Museum of International Folk Art

With the exhibition and publication *Dressing with Purpose: Belonging and Resistance in Scandinavia*, the Museum of International Folk Art continues a history of interest in the traditional arts and cultures of the Nordic countries that extends back to the museum's beginning. The museum's founder, Chicago philanthropist Florence Dibell Bartlett (1881–1954), traveled the world, collecting folk and traditional arts, including clothing and jewelry, everywhere she went. She visited Sweden twice in the early 1930s and acquired a sizeable collection of Scandinavian folk art, including clothing and household decorative items, such as *bonader*, paintings on paper or linen that were hung on the walls of rural homes. Bartlett donated her forty-two bonader to the Art Institute of Chicago in 1931, and they were exhibited in 1939. While in Sweden, Bartlett also purchased an eighteenth-century cottage from a farm in Solleron, Dalarna, complete with all of its contents. Some of the furnishings were exhibited at the Art Institute in 1934 during the *Century of Progress* exhibition, and the idea was to reassemble the house on the museum campus. When the Museum of International Folk Art opened in Santa Fe in September 1953, the first exhibition prominently featured traditional Swedish clothing in a path-breaking display of global dress. At about the same time, Bartlett's Swedish house was shipped from Chicago to Santa Fe, part of an envisioned outdoor museum of vernacular architecture and craft workshops that was probably modeled on the display of traditional Swedish buildings at Stockholm's Skansen. Unfortunately, the house was damaged

soon after its arrival in New Mexico, and no outdoor museum was ever constructed at the Museum of International Folk Art.

Since those early years, the museum has organized or hosted nine exhibitions of Scandinavian or Sámi traditional arts, including *Swedish Christmas* (1954), *Daily Life in Sweden* (1955), *Swedish Interior* (1956), *Norwegian Tapestries* (1960), *Swedish Handicrafts* (1960), *Folk Art of Lapland* (1962), *Bonader from the Bartlett Collection* (1963), *The Reindeer Followers: Folk Artists of Lapland* (1966–1967), and a large traveling exhibition of Swedish folk art organized by the Smithsonian Institution in 1964. The museum's last great foray into Scandinavian traditional arts was the exhibition *Swedish Folk Art: All Tradition Is Change*, an international traveling survey in 1994–1996. A memorable educational project from that exhibition was the recreation of a traditional Swedish country home where children (and adults) could milk a cow and carry firewood indoors. After the show concluded in Santa Fe, the house model was donated to Chicago's Swedish American Museum, where it can still be appreciated.

Dressing with Purpose examines how people in Sweden, Norway, and Sápmi use clothing to show others, both outsiders and those in their own cultural group, who they are. Clothing is one of the main ways that we communicate with one another. The book and exhibition are landmarks in scholarship that bring the traditional arts of Sweden, Norway, and the Sámi people to a wider audience.

Acknowledgments

As a scholar and curator of dress, I spend a lot of time in other people's closets. There is a reason the closet stands as a common metaphor for stashing skeletons and secret selves. Like any collection, the contents of closets include artifacts representing many times and places, treasured memories, lost connections, forgotten obligations, former life chapters, and hidden things waiting to be rediscovered and live again. They comingle, anachronistically accessible all at once. Private wardrobes are not so different from museum storage vaults, a body dressed for public view is not so different from an exhibition, and the keepers of vernacular family collections are no less expert than professional curators. That people are willing to open up their closets honors me, humbles me, and instills in me a profound sense of responsibility. With every project, I take my lead from the caretakers of traditions, the makers and practitioners that give traditions life by sharing them willingly with others.

For this gift, I owe my deepest gratitude to the many individuals who welcomed me into their homes and generously shared their wardrobes, memories, and informed judgments. This book would not have been possible without all the names that fill it. So many people extended their warm hospitality, nourishing me with food as well as ideas. I am endlessly grateful for their time in conversation, commenting on drafts of writing, and collaborating on ethnographic videos for exhibition. My hope is that the voices of my collaborators stand out here and through my work at the Museum of International Folk Art (MOIFA).

With respect to hospitality, I must give special thanks to the Jobs-Björklöf family and friends in Leksand, Sweden, who housed, fed, educated, and entertained me during every trip to Scandinavia, who even clothed me when my luggage was once temporarily lost in transit, who welcomed me into family celebrations, who helped secure donations and commissions for my museum, and who treated me with a kindness that I can never hope to repay. You have my undying respect and loyalty: Kersti Jobs-Björklöf, Erik and Ulla Gärdsback Björklöf, Knis Anna Ersdotter Björklöf and Jerk Gummuns Jones, Britta Jobs and Sven Roos, Tobias Gärdsback Rylander, Kerstin Sinha, and Ingrid Samuelsson.

This book was created as a companion to *Dressing with Purpose: Belonging and Resistance in Scandinavia*, an exhibition at MOIFA in Santa Fe, New Mexico. I was inspired by the seminal scholarship of folklorist Barbro Klein and the internationally collaborative exhibit *Swedish Folk Art: All Tradition Is Change* that she worked on and that opened at MOIFA in 1994, but I was also motivated by my long-standing interest in the intersections of dress, identity, politics, and tradition. I am deeply grateful for Dr. Klein's support, enthusiasm, and guidance early in this project, before her passing in 2018. I am heartbroken she will not see the fruits of her mentorship. I like to believe she would have been proud.

I am fortunate for the participation of many scholars and experts whose work I admire, most notably the contributing authors in this book. I am beholden to their knowledge, passion, and fellowship throughout this project. I am also profoundly indebted to Pravina Shukla and Thomas A. DuBois, who served as advisors from an early stage and who generously shared personal contacts, professional counsel, ideas, encouragement, and later feedback on written drafts. Tim Frandy has been an extraordinary source of support, inspiration, expertise, and advice on language and other crucial matters. I am immensely thankful to those who accompanied me to specific interviews or events in Scandinavia, often assisting with translation but also, and even more importantly, engaging in intellectually rich conversations that have informed and challenged my thinking, including Ingrid Samuelsson, Kersti Jobs-Björklöf, Kerstin Sinha, Ellen Marie Jensen, Laila Durán, Gerlinde Thiessen, Thomas A. DuBois, and Krister Stoor. In this regard, Camilla Rossing deserves special recognition for driving with me and my colleague Chloe Accardi across central Norway, making introductions to artists and experts, and patiently stopping at every stave church along the way.

I offer my deepest respect and appreciation to the many dedicated museum colleagues across Sweden, Norway, Sápmi, Canada, and the United States who kindly made time for me, welcomed me into collections and archives, and shared their resources, expertise, and personal insights. I'm forever ready to return the favor. I give my thanks to Kari-Anne Pedersen, Anne Kristin Moe, Mari Karlstad, Marit Anne Hauan, Ivar Bjørklund, Dikka Storm, Brita Jordal, Marit Bleie Mannsåker, Randi Bårtvedt, Agnete Sivertsen, Randi Myrum, Anna Stella Karlsdottir, Larissa Acharya, Berit Eldvik, Eva Sundström and staff of Skansens klädkammare, Erik Thorell, Anna-Karin Jobs Arnberg, Ole Aastad Bråten, Kajsa Kuoljok, Anni Guttorm, Jean McElvain, Fred Poyner IV, Inga Theissen, Suzanne Pedersen, Nishi Bassi, Veronica L. S. Robinson, Dawn Scher Thomae, and Jennifer Kovarik. Special thanks are due to Laurann Gilbertson at the Vesterheim Norwegian-American Museum, who has repeatedly gone above and beyond and who has been a treasured collaborator ready to dive into every detail.

I also owe a debt of thanks to many others who generously facilitated my efforts, offered advice and encouragement, or provided resources at key moments during the research and writing process, including Jason Baird Jackson, Jenni Laiti, Håkon Brattespe, Vigdis Nielsen, Geir Netland, Lena Sinha, Annemor Sunbø, Grete Fossen, Sallie Anna Steiner, Bodil Myklebust, Moa Sandström, Mathilde Frances Lind, Rachel Valentina González-Martín, Felicia Katz-Harris, Caroline Dechert, Brian Graney, B. Marcus Cederström, Hilary-Joy Virtanen, Coppèlie Cocq, Cunera Buijs, Laura Ricketts, Erika Nordvall Falck, Gerlinde Thiessen, Britt Kramvig, Jody Grage, Helga Utgård, Inger Homme, Marsha MacDowell, C. Kurt Dewhurst, Lynne Swanson, Jon Kay, Lijun Zhang, Wuerxiya, Micah Ling, Nathan D. Gibson, Benjamin Rogers, Peter Fleming and Debbie Adams, Meredith Davidson Schweitzer, Martin Schultz, Rachel Preston Prinz, Marlene Wisuri, Willamarie Moore, Suzanne Seriff, Emily Socolov, and Henry Glassie.

Research and exhibition projects of this scale are expensive and logistically challenging. I am very grateful for funding from the Barbro Osher Pro Suecia Foundation, Swedish Council of America, the National Endowment for the Arts, and Gudrun Sjödén. The Scandinavian Club of Santa Fe and the Scandinavian Club of Albuquerque have been magnanimous in their patronage and enthusiasm. Special thanks to Elisabeth Alley, Christine Pederson, Robert Borson, Lena Mann, Karen Beall, Marlene Lind, and Hal Nilsson. I particularly extend my heartfelt gratitude to Laurel Seth and the International Folk Art Foundation for their generous support with funding for this publication, special acquisitions, and field research through a Florence Dibell Bartlett Memorial Scholarship. I am blessed with superb colleagues at MOIFA, the Museum of New Mexico Foundation, and the Exhibit Services Division through the Department of Cultural Affairs, whose cooperation, creativity, and vital input make everything possible. I owe a huge debt to the spirited Marsha C. Bol, who was MOIFA's director when this project began, for believing in me, hiring me, and remaining a cherished friend and mentor. She is joined by other essential advocates who have helped foster my work, including Charlene Cerny (who was MOIFA's director during *All Tradition Is Change*), Khristaan Villela, Aurelia Gomez, Jamie Clements, Caroline Crupi, and Edelma and David Huntley. Special recognition is due to the critical assistance of Magdalena Wantschik, Barbara Forslund, Edwina Lieb, Cheryl Roth, Louise Spencer, and Martha Manier. The main exhibition designers for *Dressing with Purpose*, Trilby Nelson and Monica Meehan, brought clarity of vision, attentiveness, and warm collaborative spirits. Conservators Larry Humetewa and Maureen Russell worked magic to bring renewed life to brittle leather and tarnished silver. I prize the many enjoyable hours I spent dressing mannequins for photography with the main conservator for the project, textile conservator Angela Duckwall. Addison Doty created the beautiful images of collection objects and ensembles for this book. At MOIFA, my closest collaborator on this project has been folklorist and documentarian Chloe Accardi, who has fiercely believed in my vision and who traveled with me to Scandinavia in 2018, tirelessly assisted with interview transcripts, and helped create

multimedia from many hours of audio and video recordings. Some of her beautiful field photographs also appear in this book.

My gratitude extends to the talented staff of Indiana University Press, especially Gary Dunham, Janice Frisch, and Darja Malcolm-Clarke, as well as the anonymous peer reviewers who offered invaluable insights. Richelle Wilson at the University of Wisconsin–Madison is responsible for copyediting early drafts of the manuscript, and her recommendations were very helpful. I am also grateful for the final, careful copyediting of Leigh McLennon.

Finally, I am blessed with the love and support of my family: Bill, Carol, Kate, Kelli, Langston, Malon, Myron, and Molly (Rest in Power). No one deserves more credit for nurturing my achievements than my husband and fellow folklorist, Thomas Grant Richardson, who not only tolerates my obsessions but stokes them. He accompanied me in 2017, directed filming, and contributed to interviews. He drove us safely through the icy dark and cared for me when I had food poisoning. Throughout this process, he has engaged in countless kitchen-table conversations about art, tradition, and justice. He is my greatest love and collaborator, my best friend. His support, encouragement, and generosity bring endless joy to my life. Forever thank you.

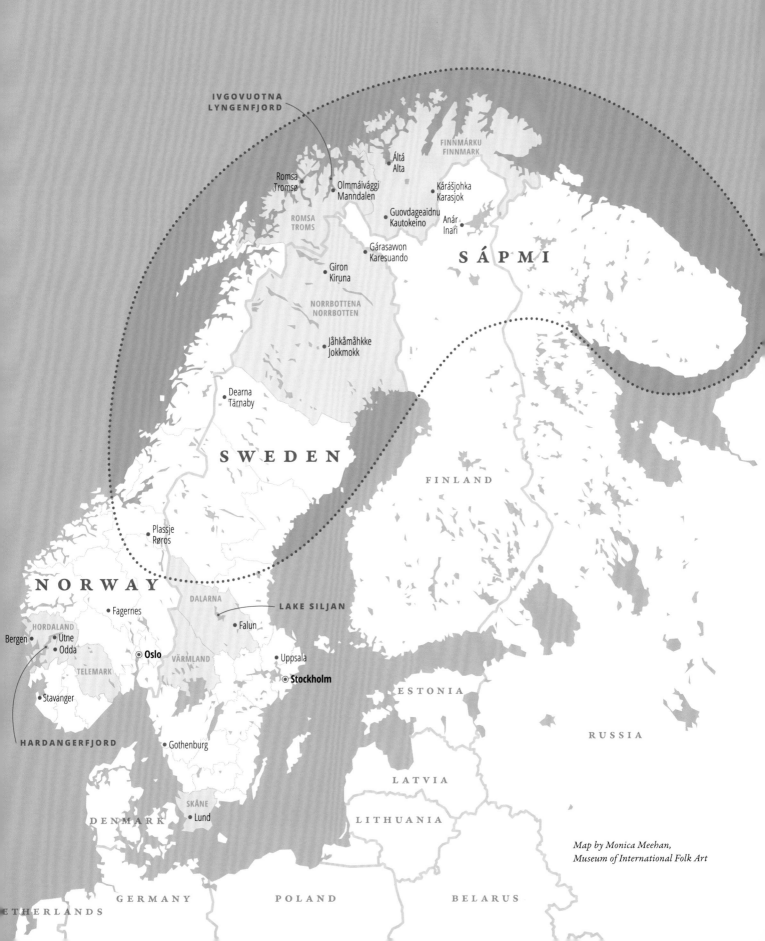

Fennoscandinavian Peninsula

IVGOVUOTNA
LYNGENFJORD

FINNMÁRKU
FINNMARK

Áltá
Alta

Romsa
Tromsø

Olmmáivággi
Manndalen

Kárášjohka
Karasjok

Guovdageaidnu
Kautokeino

Anár
Inari

ROMSA
TROMS

Gárasavvon
Karesuando

SÁPMI

Giron
Kiruna

NORRBOTTENA
NORRBOTTEN

Jåhkåmåhkke
Jokkmokk

Dearna
Tärnaby

SWEDEN

FINLAND

Plassje
Røros

NORWAY

DALARNA

Fagernes

LAKE SILJAN

HORDALAND

Falun

Bergen

Utne

Odda

Oslo

VÄRMLAND

Uppsala

TELEMARK

Stockholm

Stavanger

ESTONIA

HARDANGERFJORD

Gothenburg

RUSSIA

LATVIA

SKÅNE

Lund

LITHUANIA

DENMARK

*Map by Monica Meehan,
Museum of International Folk Art*

GERMANY POLAND BELARUS

ETHERLANDS

A Note on Terms and Place Names

In Europe's period of romantic nationalism, a single shared language became a defining feature of emerging nation-states, justifying the delineation of borders and, for some minority groups, the denial of citizenship. Increasingly, international law and intergovernmental organizations recognize the use of one's native language as a human and civil right. The content of this book spans two continents, at least four nations, and numerous languages and regional dialects. The contributing authors, themselves multilingual, have endeavored to honor this diversity while also producing a work of scholarship accessible in English. This has necessitated strategic choices, outlined here.

When possible, we have maintained proper names and key terminology in their source languages, honoring standard pluralization and the unique spellings of regional dialects, especially for textile terms and dress categories. Similar garments or styles, therefore, may appear variably in the text: a decorative bodice insert is a *bringklut* in the Norwegian district of Hardanger and a *bringeduk* in Valdres. When appropriate, we also follow conventions for naming localized styles of dress, as in Malungsdräkten (the Malung Costume) or Oslobunaden (the Oslo Bunad).

For the endonym *Sámi*, variously rendered (Sámi, Sami, Saami), we follow the accented spelling preferred in North Sámi. Of the nine living Sámi languages, North Sámi represents the vast majority of speakers, so unless specified, we rely on the vocabulary and orthography of the North Sámi dictionary provided by the Universitetet i Tromsø (University of Tromsø). The North Sámi term *gákti* therefore serves as our basic label for traditional Sámi dress in general discussion,

though other variations may be applied (e.g., *gapta* in South Sámi or *gábdde* in Lule Sámi). *Gákti* could be translated as "tunic, dress, or kirtle" but also refers in the vernacular to a typical ensemble fashioned around this main garment.

With geographically identified styles of dress, place names are an integral part of discussion as well as a potential source of controversy for territories forged within histories of shifting empires, colonization, forced displacement, and contested land rights. For locations in Sápmi (ancestral Sámi lands extending across the Fennoscandinavian and Kola peninsulas), we include both Indigenous and state-official place names in the first instance, prioritizing Sámi language (as in the example, Guovdageaidnu/Kautokeino). Readers may consult the map presented in the front of this book. It has been designed to help locate these places as well as small regions of traditional dress mentioned throughout the text that may fall between officially recognized geopolitical boundaries.

Finally, as much as possible, we follow the lead of our interlocuters, who should be the primary authorities on how their identities, clothes, and communities are named and described. Many of the interviews on which much of this work is based were conducted in a combination of languages and dialects; multilingual people often slip between idioms in conversation. Aware that power asymmetries and assumptions become embedded in both academic and vernacular vocabularies, we know that individuals may have important rhetorical and ideological reasons for choosing specific terminology at specific moments. For both ethical and empirical reasons, quotations honor the words actually uttered, except when specified as author translations.

Dressing with Purpose

Introduction

Can We Talk about Traditional Dress?

Carrie Hertz

In 2009, a protest erupted in Greenland (Kalaallit Nunaat) when Danish designer Peter Jensen sent high-heeled versions of Greenlandic boots down the runway of London Fashion Week. This style of kamik—white sealskin boots with thigh-high liners trimmed in crochet lace and heavily embellished with colorful silk embroidery and skin inlays (*avittat*)—is a beautiful example of Indigenous design that imaginatively reworked European floral motifs, techniques, and trade goods into a long tradition for making and innovating sealskin footwear across the Arctic region. The style became emblematic of local cultural persistence, adaptation, and strength in the face of Danish colonization during the lead-up to Greenland Home Rule in 1979.[1] Wearing *kamisat* (or *kamiit*) could simultaneously signal a positive sense of community belonging and resistance to hegemony. The English-language press covering the controversy, however, painted Greenland as an isolated and underdeveloped backwater and its people, the vast majority of whom are Inuit (Kalaallit, Tunumiit, and Inughuit), as unmodern. In the fashion blog *The Cut* for *New York Magazine*, Amy Odell wrote, "Though [Peter Jensen] showed at London Fashion Week, which ended *weeks* ago, Greenlanders only staged an official protest yesterday. So it either takes a very long time for news to get all the way up there or for Greenlanders to feel the heat of their anger (and possibly their fingers)."[2]

News stories rarely, if ever, quoted individual Greenlanders or detailed their actual perspectives (for or against); provided historical background on the boots, other than describing them as folksy and identifying them as part of the "national costume" (both descriptions meant to suggest inauthentic invention or stylistic inertia); or acknowledged that Jensen could be competing unfairly with Indigenous artists who might be earning a living now from making and innovating boots like these.[3] In fact, reference to Inuit origins was never mentioned at all. Instead, the stories repeatedly stressed Jensen's hurt feelings. Rachel Holmes at the *Guardian* reported, "Jensen thinks the protesters may be particularly sensitive because he is Danish, and Greenland was a colony of Denmark until 1979. In an interview with Vogue.com he said, 'I am shocked that our loving tribute to Kamik boots and beadwork capes could be construed as in any way exploitative . . . we hoped to bring the world's attention to the beauty of the Greenlandic national costume. We hoped that the people of Greenland would embrace the attention their heritage has received.'"[4] Whether or not we may consider Jensen's use exploitative—some Greenlanders have stressed they do not—one must conclude that his stated ambition to raise awareness and respect for Greenland culture was a partial failure.[5] In the Western fashion world's rush to his defense, commentators

echoed pernicious stereotypes about anonymous, stubborn, traditional people who are stuck in the past and who must rely on others to discover the full artistic and commercial potential of their cultures, especially their supposedly static traditional dress.

Ironically, 2009 was an especially notable year for the country of Greenland. While non-Inuit fashion designers were asserting their rights to its cultural resources, Greenland was successfully negotiating a new agreement of "self-rule" with Denmark, which included turning over the administrative control of land and natural resources to Greenland's jurisdiction.[6] Greenland's ongoing struggles with Danish oversight and the enduring asymmetries of power over local decision-making, however, received little recognition from fashion critics.

Inuit activist Veronica Dewar has argued that "Indigenous people have the right to own and control their cultural heritage and utilize their environmental resources in a holistic and sustainable manner." In her estimation, the entitlement expressed by the Western fashion industry has perpetuated ongoing colonial relationships by relating to Inuit culture as something to be collected, harvested, and mined like exotic curios, minerals, or oil. "We are no longer willing to be treated like artefacts in museums," she writes, "and that includes our living culture which is embodied in our clothing."[7]

Over the last decade, elite, profit-driven borrowings of traditional dress are increasingly labeled misappropriations, but they have long been defended as clever modernizations when, for example, in the hands of (often male) high fashion designers as opposed to unnamed Indigenous (often female) artists. There is still too often a presumption that fashionable change and values trickle down, underscoring painful histories of unidirectional imposition and acquisition. Examinations of historical encounters are replete with illustrations, like this one, suggesting that elite postures for what is fashionable, what is innovative, what is free for use will prevail over localized perceptions in public discourse.[8] In other words, those at the top, whether landed aristocracy or trendsetting designers of global high fashion, get inspired, while the common folk mostly imitate.

The legacies of European nation-building and colonialism continue to inform our understanding of dress, but more importantly, they also influence the way we think about ourselves and others. Through these historical processes, "European norms surrounding gender, class, race, and sexuality were superimposed onto societies around the world," and these social and intellectual frameworks, though dynamic, still impact contemporary "identity formation and cultural memory."[9] Though this book focuses on a small region of the world in Scandinavia, its findings have far-reaching implications. As the opening case with Greenland suggests, in the broader Nordic region and across the globe, people today

endeavor to defend, adapt, decenter, or unravel the effects of Western cultural imperialism. Dress presents one crucial medium through which these battles are waged, one that offers individuals and groups the chance to assert personal agency and assign meaning to their own acts of self-representation.

This book is about tradition and dress. It is also about "traditional dress," a cultural phenomenon often described as disappearing in contemporary life. In the popular imagination, commonly recognized and problematic categories of traditional dress—folk, national, and ethnic costumes—have been exiled to the past, displaced by modern fashion. But is this intellectual framework either useful or respectful when considering the clothes, and by extension the identities, of individuals who choose to wear them? What *is* traditional dress?

Dress as Creative Social Performance

Getting dressed is always a creative act. How we dress—all the ways we modify, adorn, and transform the human body—conveys who we are, our tastes and social identities.[10] In our self-presentation, choices are governed by personal desire, material opportunity, and social responsibility. Through dress, we all seek balance within freedom and constraint, self and society. Through dress, we all create ourselves.

As a folklorist, I study dress as a form of daily artistic communication that is realized in moments of social performance. Clothing and bodily ornament, as some of the most intimate artifacts of material culture, can be analyzed as "creativity in context," attending to the situated ways that individuals intentionally and artfully fashion who they are and want to be from the resources found in their physical and cultural environments.[11] Folklore, as the study of expressive culture or "creativity in everyday life," recognizes tradition as one of the most important resources that groups of people share, bringing the power of social and historical consequence to the things humans do and make.[12] This approach is called performance theory. It has been developed by Dell Hymes in *Foundations of Sociolinguistics* and applied to the study of oral literature by Richard Bauman in *Story, Performance, and Event*. It has been adapted for the study of material culture by Henry Glassie, notably with studies of vernacular architecture in *Folk Housing in Middle Virginia* and creator-centric ethnographies of potters and weavers in *Turkish Traditional Art Today* and a Nigerian painter in *Prince Twins Seven-Seven*. Most directly impactful to my work, Pravina Shukla has advanced and expanded the application of performance theory through studies of daily dress and adornment in India with *The Grace of Four Moons* and dress for special occasions in Brazil, Sweden, and the United States in *Costume*.

Built on the scholarly foundations of folklore studies and performance theory, this book is a study of individuals and the dress traditions they invigorate, bringing attention, vitality,

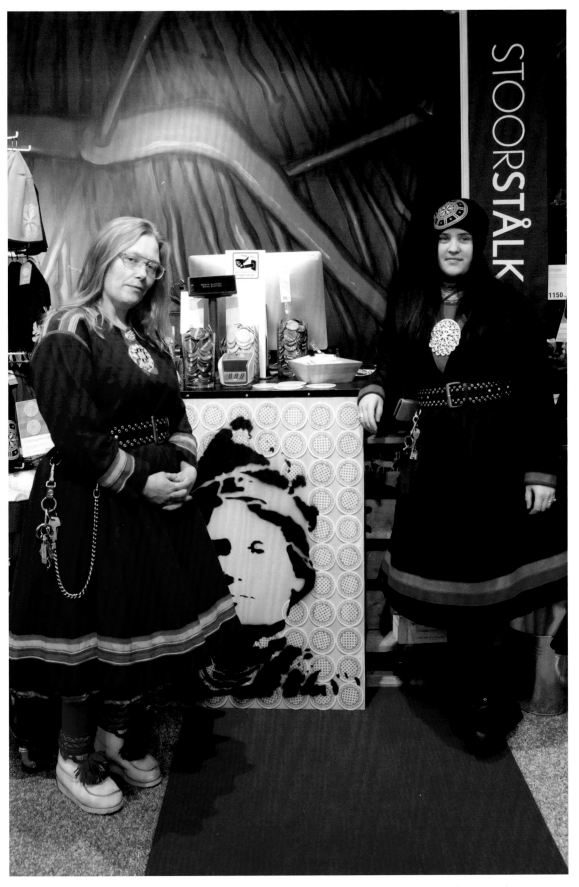

Ida-Maria Kuhmunen and Ann-Therese Rannerud at Stoorstålka in Jåhkåmåhkke posing with Anders Sunna's portrait of activist Elsa Laula Renberg (1877–1930), organizer of the first national Sámi conference in 1917. This photo was taken on the one hundredth anniversary of the conference, now celebrated annually as Sámi National Day. *Photo by Carrie Hertz, 2017.*

and personal creativity to styles with social, historical, and ideological significance in contemporary Scandinavia. I am joined in this consideration of tradition and dress by international scholars representing a variety of disciplinary backgrounds as folklorists, historians, curators, ethnologists, anthropologists, and visual artists. In this introduction, I outline our approach to the topic and present the historical foundations and major themes that inform discussions throughout the book.

Dress and Tradition

Henry Glassie defines tradition as the dynamic "creation of the future out of the past" in which multiple actors, each with their vision of a desirable future, engage with each other in cooperation or conflict in "a process of cultural construction."[13] As the volitional transmission of cultural knowledge from one generation to another, from teacher to student, from peer to peer, tradition patterns new creation. But tradition is also subject to constant evaluation and reinterpretation as people assign meaning and purpose to present actions in terms of past precedent. In everyday speech, we may identify traditions as shared wisdom, values, customary behaviors, skills, performances, cultural institutions, or recognizable forms of musical, verbal, and material artistry. Traditions of all kinds are created, shaped, renewed, and abandoned through a negotiation of wills.

The dressed body is likewise the outcome of individual action and will, relying on learned behavior as well as personal judgment and imagination, with the hope of making self-expression legible to others.[14] Tradition and the individual, therefore, are mutually constituted, inseparable, dependent on each other for meaningful existence.[15] Tradition makes significant social action possible. We need tradition not simply to pursue personal fulfillment within social belonging but also to challenge existing ideas, social structures, and interpretations of the past and present through our subjective and selective reworkings. Individuals design social selves using dress, but their sartorial choices can also alter the social and conceptual spaces they inhabit. Through dress, we attempt to influence the world around us—aligning with or distancing ourselves from others, proclaiming allegiance or opposition to particular cultural norms, and persuading allies to our vision of a better future.

All modes of dressing are traditional, being guided by shared conventions for form and function, even when those expectations are flouted for effect and regardless the rate of fashionable change. All traditions are subject to fashions; traditional styles of dress are no more timeless or fixed than any other product of expressive culture. Charting their changing forms and philosophies by grouping them into sequences of popular periods is one way to construct cultural histories and remains a major contribution of costume and fashion studies.

Change, however, is only one possible organizing principle for analysis. Intentional preservation and cycles of revival are also integral, ever-present parts of contemporary cultural life and are equally revealing.[16] As folklorist Dorothy Noyes writes in her treatment of theories of tradition in postmodernism, "whereas earlier scholarship assumed continuity and tried to explain change, today flux is assumed and it is stability for which we must account."[17] Regardless of one's analytical angle, the forces of stability, progress, and revival intermingle in all times and places, with each dynamic stressed at different moments by different actors in service of different rhetorical positions.[18] Elements of replication and novelty coexist in all cultural forms of dress, but wearers and beholders may prioritize and value one over the other.

Glassie challenges simplistic juxtapositions of fashion and tradition, arguing that "if tradition is a people's creation out of their own past, its character is not stasis but continuity; its opposite is not change but oppression, the intrusion of a power that thwarts the course of development."[19] Many oppressive factors may lead people to feel they have lost a meaningful connection to their own past, the most obvious being the violent injustice of colonial conquest and the coerced adoption of alien traditions through processes of domination. Any group, however, that conceptualizes itself as disempowered by external forces will likely experience some feelings of alienation from continuity. Sometimes the perceived source of marginalization is located in others whose unwanted influence is deemed persecuting or polluting, or it may be systemic forces beyond the reach of individual challengers, such as structural racism, cultural imperialism, and globalization. The perceived loss of tradition is rarely experienced as freedom; instead, it is more likely experienced as the loss of future security, as an inability to adequately define oneself.

Tidy divisions that ignore the dual forces of continuity and change and that flatten the potential for multifaceted interpretations of choices made in context lead to glaring absences in scholarship. Because "traditional dress" has been treated as timeless, anonymous, or destined for replacement by "world fashion," it is often excluded from serious consideration by fashion studies. And if established styles of dress are deemed too divergent from idealized forms—say, made following the same patterns of construction but fabricated from factory-woven polyester cloth—they may become of little interest to those searching for "authentic" expressions of cultural distinction.[20] A preoccupation with newness can undervalue how much actually stays the same over time; an overemphasis on consistency can miss the subtle and responsive dynamics of creative, purposeful revision within repetition.

For a long time, world chronologies of dress (written by Western scholars) were presented as a linear and universal progression, situated in European history, that initiated an

Dressed alike for Søttende mai in Oslo, Norway. *Photo by Carrie Hertz, 2018.*

evolutionary transformation from costume to fashion—traditional to modern, provincial to cosmopolitan, domestic to commercial, peripheral to central, and local to global.[21] Theories of cultural change and human social development proposed during the nineteenth century supported this approach. Judgments about the successful adoption of Western-style modernity, including what people wore (or did not wear, as the case may be), placed individuals, social groups, even whole nations, cultures, or races on a spectrum of evolution. People and their societies were savage or civilized, traditional or modern. And this polarity extended to their clothes: traditional people wore traditional costumes; modern people wore fashion. Following these intellectual strands leads to a deeply interwoven though perpetually contested dichotomy that pits local tradition against cosmopolitan modernity as incompatible states of being, the rise of the latter foretelling the demise of the former.[22]

Fashion in nearly every other domain of human creation—from architecture to literature to intellectual theories—designates the prevailing or most desirable styles of a given time and place, a definition that should raise procedural questions about the boundaries for analysis (e.g., "the prevailing or most

desirable" for whom, when, and where exactly?). In discourses specific to dress, in contrast, *fashion* can also denote the products of "a distinctive system for the provision of clothes" that endeavors to dictate the most desirable styles of the moment, a system of rapid induced change dependent on the technologies and the social, economic, and political structures that developed in Europe, and thus exemplifying the characteristics of "Western modernity."[23] Because fashion has been linked to key features of Western modernization (namely, scientific secularism, democracy, and industrial market capitalism), scholars have debated the exact point in time for the "birth of fashion" in various parts of the world, a dilemma without parallel for understanding fashionable change in vernacular house forms, storytelling, or philosophy.[24] The conflation of these two understandings—fashion as temporally bound popular practice and fashion as elite discourses about patterns of production and consumption under consumer capitalism—complicates the examination of more socially and culturally intersectional contexts. Taken to its logical extreme, in this intellectual scheme, to be fashionably dressed is to be modern, and to be modern is to adopt mass-produced garments endowed with commercial meanings constructed through

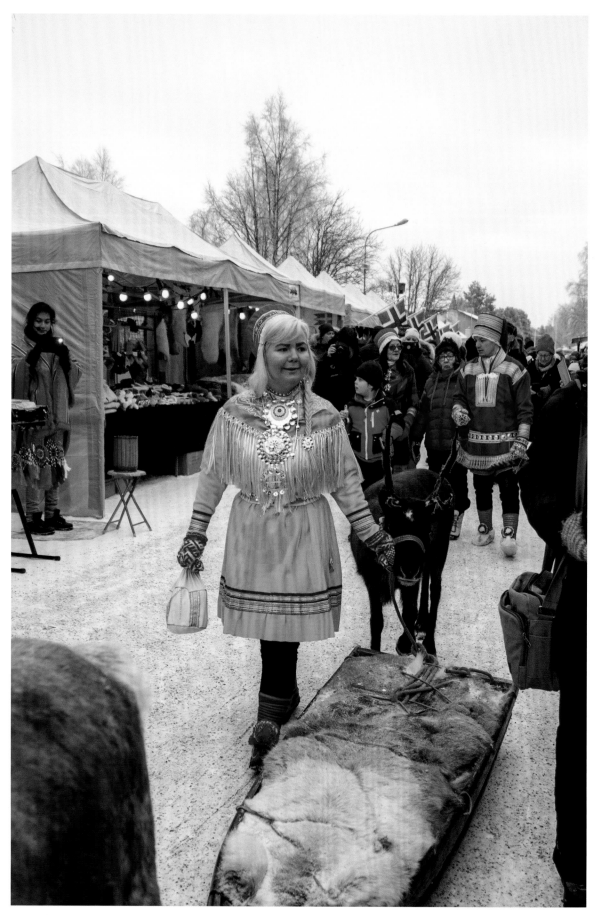

Dressed fashionably for the Winter Market in Jåhkåmåhkke, Sweden. *Photo by Carrie Hertz, 2017.*

capitalist branding and advertising. In this scheme, fashion is a tool of Western imperialism.

Dress scholars, especially over the last decade, have begun dismantling this master narrative.[25] As M. Angela Jansen and Jennifer Craik have argued in the introduction to their edited volume with the cheeky title *Modern Fashion Traditions*, dislodging universalizing Eurocentric perspectives on dress requires an earnest reevaluation of accepted terms and definitions, common debates, and normalized historical narratives.[26] Change will be hard won, in part, because the dichotomous understandings of tradition and modernity that often inform analyses of dress radiate through many other beliefs about cultural difference, including aspects of appearance and biology that cannot be easily altered with a change of clothes, such as skin color.[27] European historical models for classifying dress, after all, supported and justified Western colonial expansion, and they continue to capitalize on the constructed notion of Europe as "the original home of the modern."[28] As anthropologist Sandra Niessen laments in her conclusion to the same volume, in our current era, perhaps no amount of contradictory evidence can unseat the assumption of fashion's origins in Western modernity, because the fallacy supports the hegemonic and economic dominance of a few fashion holding companies that now own unprecedented levels of control over the production, distribution, and marketing of clothing worn around the world.[29] Corporate interests profit from cultivating constant desire for something new and insecurity about being viewed as old-fashioned and inferior. Garments may be rapidly discarded, not for failing structurally but because they no longer communicate modernity.[30] A fixation on modernity helps make a lot of money for a few, regardless of the consequences for the planet and the majority of its inhabitants.

Motivations for change in dress, of course, can exist apart from the demands of corporate profit or personal ego. Fashion histories have long showcased innovations spurred by idealistic hopes for collective social change, from the oft-cited examples of women's bifurcated bloomers introduced by suffragists in the 1850s to men's zoot suits worn by racial minorities in 1940s America.[31] When interpreting dress, however, a narrow emphasis on popular change too often ignores the politics, power, and potential pleasures of purposeful continuity. Ways of dressing that have been socially constituted as traditional rather than primarily fashionable can better serve those moments when wearers wish to feel securely rooted in place—spatially, socially, ritually, historically. At particular times, we want to consciously foreground certain aspects of our identities, to align with others who are bound together by descent or consent, or to reconnect with those separated by distance, whether geographic (diasporas) or temporal (ancestors). At times, we prefer stability and community over disruptive innovation or personal interest.

When tradition and fashion are treated as discrete phenomena rather than discursive frameworks, scholars overlook individual agency to harness the nebulous concepts of continuity and change to construct social identities and influence their worlds. As Coppélie Cocq has argued, viewing tradition as "an analytical concept stresses its power and what it can achieve in terms of defining a culture, categorizing communities, or establishing common grounds and boundaries."[32] The human need to craft narratives about who we are and where we come from creates, mediates, and sustains our experiences of reality. Recognizing the ability that individuals possess to support and reproduce or to question and dismantle prevailing ideas, to bend them toward their own desires, however small the results, reminds us that cultural change is not only possible in all times and places but inevitable. It simply requires collective will.

Traditional Dress

The categories of dress that wearers most often describe as *traditional* are those that reflect one's biological or cultural lineage, ritual or ceremonial role, place of birth, place of residence, ancestral homeland, religious affiliation, or elected group associations. While the types of garments discussed in this book have been known by many terms in many languages and local dialects, they have been primarily classified by English-speaking scholars as *folk*, *regional*, *national*, *ethnic*, *native*, or *indigenous* costumes. Each descriptor suggests clothes that belong to particular social groups defined by a circumscribed ancestry or territory, a nexus of features (clothing-identity-place) often linked in Western conceptualizations of traditional dress.[33] These subcategories of clothes are regularly presented in othering or oppositional terms that reproduce a modernist presumption that "the folk belong to place," but "the rest of us live in time."[34] For example, Linda Welters writes that "folk dress" has historically been defined as "the traditional dress worn by people outside urban areas" and is often described as "non-Western" (even when describing practices originating in Europe), because "it develops outside the realm of the Western European fashion system."[35] James Snowden pinpoints the defining feature of folk dress as being "non-fashionable," even though it likely reflects the most popular modes of dressing for a particular people in a particular time and place.[36] Joanne B. Eicher and Barbara Sumberg prefer the term *ethnic dress* but have similarly characterized it as "the opposite of world fashion," a system that overwhelmingly assumes (not coincidentally) traditional Western forms.[37] *Costume*, too, can be an alienating category by implying inauthenticity, exoticism, or nonmodernity. The term has historically been used in scholarship to delineate the dress of distant times, places, or peoples. In everyday speech, *costume* more commonly designates the dress of role play and theater,

worn by children on Halloween and actors on stage. Understandably, many people reject the notion that some of the most valued garments in their wardrobe, worn to express crucial aspects of their identity and externalize deeply felt emotions, are "costumes."

Shukla, in her ethnographic examination of costume, concludes that all dress helps us project identity. The meaning ascribed to dress, however, much like the social construction of identity itself, is positional and contingent on messages sent and received in context. Defining *costume* as "special dress that enables the expression of extraordinary identity in exceptional circumstances," her theoretical and empirical approach rejects a singular characterization based on a subjective evaluation of formal properties, such as how fashionable a garment may be according to social elites or the relative urbanity of its wearer.[38] Instead, she prioritizes the creative ambitions of wearers who carefully choose clothes that will effectively communicate "a self-conscious definition of the self" in strategic moments.[39] Within this framework, the same garments may be interpreted and categorized differently based on the specific contexts in which they are worn and encountered. Rather than rely on questionably "objective" criteria for classifying artistic traditions defined by subjective outsiders who theorize from a distance, I choose to privilege emic taxonomies and vernacular judgments made on the ground by those performing those traditions.

From the perspective of wearers, the clothes most often ascribed and explicitly valued for their traditionality are those considered essential to an understanding (and often public expression) of who the wearers are in relation to others at significant moments. Daily dress reflects elements of tradition too, but in the act of dressing, decisions can be overshadowed by considerations of practicality, comfort, and cost. In contrast, "traditional" garments will commonly be reserved for particular occasions, accentuating the value, intended messages, and aesthetic splendor of the highlighted identity, objects, and event.

We have few examples of cultures that do not differentiate clothes by their intended functions. Throughout the modern period, even the poorest people in Europe, the peasantry or the working classes, maintained functional wardrobes that distinguished work from best dress, even when faced with extreme scarcity.[40] For example, Norwegian dress scholar Aagot Noss documented the girlhood memories of a rural woman born in 1868 who recalled "wearing her skirt right side out on Sundays and inside out on other days" to separate holidays from everyday life.[41] Throughout the world, even in communities for which the appearance of clothing is little differentiated by occasion, new garments may serve the same function for distinction, worn first for festivals and ceremonies and then, as they age, for plowing the fields, cooking, and cleaning.

The clothes associated with moments of great significance, such as gowns for baptisms or weddings, cleave more toward conservative aesthetics, lending them a sense of durability and depth, something shared across space and time, perhaps shared literally as family heirlooms. The clothing most often understood as traditional is also aspirational, a conduit for realizing idealized values. The importance of such dress derives partly from its perceived connection to a timeless truth, a perfect marriage between form and function. As such, it is worth preserving. The artifacts that compose the "costume collections" of museums are far more likely to be the fancy dress of special occasion than the work and leisurewear of everyday. Their conservation promises continued access to models of excellence from the past for future inspiration.

The white wedding dress, common to private and public collections alike, provides a familiar illustration. Many women in the United States have chosen to wed in formal white dresses since at least the early twentieth century, when the introduction of mainstream bridal shops and mass production made impractical, single-purpose gowns both accessible and affordable to the masses. Brides call their white dresses traditional, signaling solemnity and aligning their personal commitment with that of brides they imagine from previous generations, while also following current bridal fashions for hem lengths, necklines, embellishments, styling, and accessories. By strategically evoking historical markers of high status, such as corsets, trains, glossy fabrics, and shades of white, American brides channel images of princesses or movie stars walking red carpets. Their choices may also echo those of their mothers and grandmothers. White, as a defining feature of "traditional" bridal wear, may communicate desires for class mobility, once-in-a-lifetime rarity, and lavish expense or notions of ritual purity and new beginnings. It could also be understood as less about personal expression than about acquiescence to conservative femininity or commercial persuasion. Popular representations of perfect American brides—thin, white, heterosexual, Christian, and rich—may also expose prevailing biases about beauty, race, gender, sexuality, religion, and class present in cultural discourse. Interpretation is contingent on the nuanced interplay between the intentions of wearers and the likely appraisals of audiences within a particular time and place.[42]

As anyone who has felt the weight of customary expectations knows, traditions can be selected and instrumentalized to empower or disempower particular people and ideas. Calls to "honor tradition" carry with them notions of authority and consensus. Historically, the calculated use of dress has played a crucial role in diverse attempts to define, demarcate, facilitate, and mobilize group identification and moral behavior.[43] By consciously highlighting the traditional aspects of dress in cultural performance—whether life-cycle celebrations, state

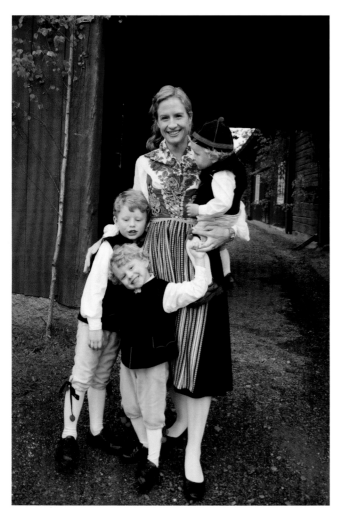

Sara Ramsay and her sons dressed in Leksandsdräkt for Midsummer celebrations in the village of Tibble, Dalarna county, Sweden. *Photo by Carrie Hertz, 2015.*

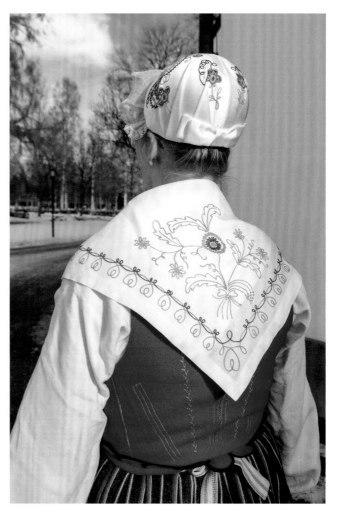

Detail of Sylvia Andersson's embroidered *bindmössa* (frame cap) and shawl from Småland, Sweden. *Photo by Carrie Hertz, 2017.*

pageantry, or public protests—one can affirm, foreground, and amplify the idea of stable identities or unwavering core values.

Individuals often turn to the idea of tradition as a way to honor fundamental principles, realize ideals, and ease the uncertainty of personal transitions. Similarly, popular movements for revaluing certain dress traditions often spring up during times of conflict or rapid transformation, clothing the resistance to dominant narratives, economic systems, or political forces. In the case of Scandinavia, as in many parts of Europe, traditional dress—in the semantic guise of folk, national, and ethnic costume—became a key concept during the modern period, and it continues to circulate as a recurring symbol of local stability in contemporary debates over the disruptions of globalization and environmental degradation, the erosion of the social compact and rising inequality, or the revitalization of marginalized cultures in decolonization movements.

In this book, we examine three traditions in depth— Swedish *folkdräkt*, Norwegian *bunad*, and Sámi *gákti* (plural: *folkdräkter*, *bunader*, and *gávttit*)—exploring their contemporary uses, aesthetics, and meanings in light of their histories, knowing that all histories are constructed, multisided, overlapping, and continuously rediscovered and rewritten.[44] By not prioritizing the most common English translations for these examples—folk, national, and ethnic costume, respectively— we ask an English-speaking readership to question their assumptions of these categories. In defining these examples of dress as traditional, we are less concerned with the authentications of scholars than with the assertions of actors who characterize their own practices and creations as traditional. In doing so, they are signaling a desire to instill their choices with deeper purpose. These choices not only serve present needs but also reframe the past according to personal beliefs and hopes for the future. The customary, localized ways that people dress have commonly received such attentions, establishing recognizable styles emotionally imbued with a longing for personal, familial, and community continuity and cohesion against the fragmentation of time.

The present work is not intended to establish the definitive criteria for a conceptual understanding of "traditional dress"—an impossible task—but rather to contemplate some of its rhetorical uses and aesthetic potentials within everyday lived experience. Few places in Europe today show the same levels of sustained popular enthusiasm and support for certain types of traditional dress, not only in the form of institutional and governmental infrastructure and financing but also in individual and community investment. The authors of this book offer only a tiny sample of dress traditions found in Scandinavia and the Nordic region, each chosen to add specificity to broad, interrelated, and often stereotyped dress categories.

These common terms—*folk*, *national*, and *ethnic dress*—come with complex histories, or what folklorist Roger Abrahams has described as "semantic drag."[45] We use old words to mean new things, but like phantoms, former connotations still linger. Even when the popular theories that animate language fall apart, their outdated vocabularies may survive, layering contradictory associations on top of each other.[46] Many of the ideas that still define these categories of dress today took root in the period of Europe's romantic nationalism.

Dress in the Period of Romantic Nationalism

In the early modern period, the majority of the population in most regions of Europe, especially in the Nordic countries, lived in the rural countryside and engaged in agriculture, animal husbandry, fishing, forestry, mining, handicrafts, or one of the emerging national industries, such as tar and charcoal production.[47] Unlike other parts of the continent, primarily peopled by tenants working elite-owned manors, free-holding peasants made up the majority in Sweden, Norway, and Finland.[48]

The peasantry, as with other estates in the rigid social hierarchy (including the nobility, clergy, and urban merchants or burghers), could be easily identified by their dress. The basic types of rural garments were fairly consistent throughout northern Europe.[49] A typical woman's outfit consisted of a laced bodice layered over a chemise, a full gathered skirt worn with an apron and stockings, and a head covering. Sometimes, the bodice and skirt would be attached to create a dress. Men wore long-sleeved shirts with waistcoats, long or short jackets, and knee-breeches with stockings or long trousers. Specific modes of dressing, combinations of accessories, decorative elements, construction techniques, and details of fit, styling, and design, however, developed more locally than in urban areas, being dependent by necessity on home production, seasonal markets, and networks of itinerant craftspeople and peddlers who tailored their offerings to the resident tastes, mores, and meanings prioritized by customers.

Sumptuary laws legislated a clear visual vocabulary for social stratification, restricting the use of certain styles, fabrics, embellishments, or colors to particular groups of people.

Commercial ordinances further protected the economic interests of professional craft guilds, trade merchants, and national industries.[50] In many places, permanent commercial shops were forbidden from operating in rural areas until the mid-nineteenth century.[51] Despite these imposed limitations, rural dress styles were neither secluded nor static. Individuals consistently assembled outfits that blended home-woven garments of woolen and linen cloth with bought fabrics, urban finery, and professional readymade goods, such as the embroidered gloves and frame caps peddled widely. Outfits might also combine elements associated with different periods and generations, perhaps pairing new fashionable styles with inherited garments.[52]

Many of the stable sartorial differences that arose—allying wearers with specific regions, valleys, villages, or even farms—were not, in fact, the natural accidents of isolation and topography, nor even the inevitability of poverty; they were consciously created and guarded to distinguish one place from another, one people from others. Some communities even formalized local dress codes, usually instigated by religious authorities and affluent farmers endorsing moral agendas. One of the most famous examples of regional dress in Sweden today, the *Vingåkersdräkt*, owes the consistency of its appearance to a parish meeting held in Vingåker in 1674. Those in attendance feared the increasing (and perhaps immodest and hierarchically disruptive) purchasing power of local farmers who might be tempted by fashionable luxuries coming from nearby Stockholm, so they elected to standardize and forbid significant changes to the clothes worn to church. Attending Sunday services during this period was mandatory, and parish clergy doubled as state officials. Parishioners had little choice but to dress accordingly or else face fines and public humiliation.[53] Parish protocols, written across Scandinavia between the seventeenth and nineteenth centuries, reveal widespread anxiety and debate about the potential loss of local distinction and social order in the face of growing wealth, interconnectivity, and a flood of commercial products.[54]

The long history of Sámi dress, too, is marked by variety, innovation, and regulation. In Sápmi (Sámi ancestral lands that transverse the modern borders of Norway, Sweden, Finland, and Russia), Sámi dress traditions had similarly incorporated widely circulated, cosmopolitan products—such as woolen, calico, ribbons, and lace—into a diverse array of regional styles, including garments made of fur and skin and adorned with embroidery or appliqué. South Sámi scholar Maja Dunfjeld, for example, has documented archeological evidence that dates the presence of a continuous but continually changing tradition for spinning and embroidering with tin or pewter thread (*datneárpu*) back to at least the Iron Age.[55] Typical ensembles consisted of a belted tunic worn with leggings or trousers and boots wrapped with woven bands. The

cut and length of the tunic, combinations of colors, and the use of distinctive headwear, outerwear, accessories, and decorative elements communicated gender, personal taste, wealth, social status, kinship, and territory.

Like the legislated clothes of rural peasants, Sámi dress traditions could also be subject to external attempts to control them. In many places, Sámi styles of dress became stigmatized and suppressed. Christian missionaries and church leaders were likely to discourage or prohibit Sámi dress as signs of paganism or primitivism. The widely used *ládjogahpir* is an important example detailed in chapter 7 by Eeva-Kristiina Harlin and Outi Pieski. This style of woman's curved "horn cap," with documented regional variants across Finland and Norway, was eventually abandoned, and many were destroyed, after Christian authorities declared "the devil had his abode in the horn."[56] Later, Sámi dress would be either banned (to encourage cultural assimilation) or required (to inflict social segregation) in compulsory boarding schools.

This briefly sketches the sartorial landscape leading up to the period of romantic nationalism in Scandinavia at the end of the nineteenth century. If we pull back for a moment, we can take a broader historical view to better understand the technological, political, and economic landscape of the era. The revolutionary reorganization of Europe from feudal monarchies into democratic nation-states that started in the late eighteenth century has been characterized as a succession of ruptures in social and political thought. Violent upheavals redrew the European map. Scientific knowledge threatened to supplant church authority. Market-driven, transnational industrial capitalism, supported by colonialism and global trade, disrupted local economies, hastened urbanization and migration, and intensified the unfolding "consumer revolution." Emergent state institutions and technologies remodeled communication, conventional knowledge, and historical consciousness with the development of mass media, a free press, universal public education, archives, and museums. Improvements in transportation encouraged travel and tourism. Old social systems eroded, such as the rigid class structures that once gave shape to social life and the sumptuary laws that helped materialize them through dress. Provincial modes for custom-made clothing increasingly gave way to the products and prescriptions of an expanding cosmopolitan fashion industry. In the standard temporal parsing of Western culture, Europe became "modern."

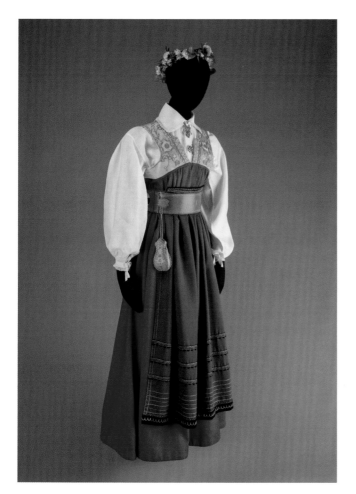 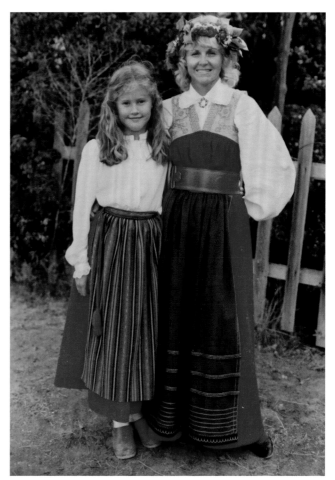

Vingåkersdräkt made by Elisabeth Werner Alley, pictured with her daughter Kristina, who is wearing an outfit inspired by "folk costume" for Midsummer festivities in New Mexico, 1983. *Photos by Addison Doty, courtesy of Elisabeth Werner Alley.*

The process of modernization in western Europe, with its distinct social, cultural, and political institutions, nurtured new aspirations and disappointments. Romanticism and nationalism were two prevailing and overlapping developments that arose concurrently in what was clearly a tumultuous and transformational era. Both movements responded to the potential disruptions of accelerated cultural change, and both assumed the eventual obsolescence of "traditional" dress in modern life.

The romantic movement, informing popular arts and philosophies in Europe during the revolutionary period, looked to an idealized past and primed an existential search for essential truths about humanity. The romantic thinkers of the eighteenth and nineteenth centuries, primarily found among the growing middle classes, believed that the spectacular progress of modernity was also perpetually destabilizing, sowing uncertainty and agitation. In a moral rejection of both high culture and the burgeoning industrialized working classes, this romantic search for a presumed authenticity, folklorist Regina Bendix explains, "implied a critical stance against urban manners, artifice in language, behavior, and art, and against aristocratic excesses; it promised the restoration of a pure, unaffected state of being."[57] Agrarian and pastoral peoples, the common "folk," were seen as direct inheritors of vanishing traditions, carrying them faithfully but fleetingly into the modern era. They held the key to an original and soon-forgotten human past.

Growing popular and scientific interest in the vernacular lifeways and arts of "premodern" peoples, both far away and close to home, motivated city dwellers to experience "unspoiled" places through travel and inspired new literary and artistic styles that attempted to capture the exuberant unpretentiousness ascribed to folk expression. It also steered the formation of new disciplinary fields of study—namely, anthropology, folklore, ethnology, and museology. Collecting remnants of expressive traditions such as oral poetry, provincial dialects, epics and tales, song, and material culture became a priority for scholars across Europe and North America, made urgent by the perceived debasement and homogenization of creeping modernization.

The beautiful handmade clothes of rural peoples were a particular focus for art, collecting, and study. Artists and antiquarian scholars, guided by modernist theories and romantic tastes, helped formulate the constellation of features used to characterize what they named "folk costume," the preindustrial, "premodern" repertoire of dress worn mostly by farming communities in the rural countryside. Artists and scientists alike looked over the plain and patched work clothes of everyday toward the more fanciful churchgoing, ceremonial, or festive versions, often stripped of commonplace "fashionable"

or industrial elements. Many also overemphasized women's clothing over men's and children's, a pattern that continues to inform contemporary traditional dress practices and new studies about them (including this one).

There were pragmatic, empirical, and aesthetic benefits to targeting women's dress for collecting and representation; there was simply more of it available. Women maintained larger, more elaborate and diverse wardrobes and continued wearing local styles even after men traded theirs for more cosmopolitan garb. Men were rarely held to the same moral standards for following sartorial rules as women, whose dress clearly defined social positions left ambiguous in most men's dress, such as marital status. Often being the primary makers (as well as repairers, cleaners, and keepers) of traditional dress, women were more likely to be invested in its continued use and expressive potentials, which also positioned women as logical allies for researchers and preservationists.

At the same time, the representations produced by male outsiders could veer toward the objectifying, even erotic. Take, for instance, Anders Zorn's voyeuristic images of peasant maidens undressing in dark farmhouse interiors or raising their skirts to wade into pastoral rivers. The bodies of peasant women were commonly associated with the regenerative cycles and sensual pleasures of nature, juxtaposed against fecund fields and verdant landscapes. Elite men often saw these exotically dressed figures as canvases on which to project their desires. As we will see, elite women, too, could be complicit in this "domestication of exotic peripheries" by upholding the social and colonial hierarchies they had managed to leverage for their own empowerment.[58]

During the nineteenth and twentieth centuries, a general pattern for describing "traditional dress" emerged, shifting in concert along with its contrasts. If urban dress was industrial, commercial, and propelled by technological invention, folk costume was handmade entirely at home using natural materials and ancient techniques. If modern clothes and patterns of consumption had become wasteful and cheap, folk costume was frugal, conservative, and invaluable. If elite dress was obsessed with social standing and self-aggrandizement, folk costume was equalizing and communal. If sartorial competition was bringing bourgeois pretenders to financial ruin, humble folk costume secured modesty and social order. If fashion was fickle, flashy, and foreign, if it was sparked by the artistic innovations of famed designers, folk costume was static, simple, and localized, the spontaneous materialization of collective authorship nearly frozen in time.[59]

Much of the scholarly and amateur attention paid to folk culture and folk dress reflected the moral, aesthetic, aspirational, and ideological leanings of their enthusiasts. For the romantics, their efforts often held patriotic appeal by seeking

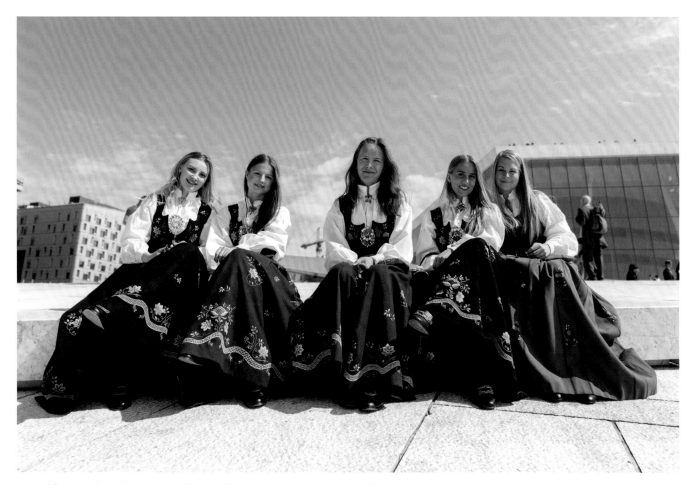

Dressed for Søttende mai in embroidered bunader from Hedmark county. *Photo by Chloe Accardi, 2018.*

a primeval national spirit that could serve as a solid cultural foundation to carry them into an uncertain future. Even in the absence of overt political intent, the romantic favor for the folk vernacular over the cosmopolitan elite helped articulate novel political ideas during Europe's revolutionary era. The poetics of romanticism fueled the ideological doctrine of nationalism, infusing nationalist arguments with emotional and aesthetic power.[60] With the rise of nationalism in Scandinavia, these idealizations of peasant culture became repackaged as the representations of distinctive national cultures.

Through the lens of romantic nationalism, the ideal territorial boundaries for nation-states were conceptualized as natural borders enclosing a population unified by a shared culture, language, and history. The assertion of national homogeneity, built on the foundations of an original, colorful, and ancient past, legitimized geopolitical boundaries with moral authority. A people, it was reasoned, united in traditional practice and appearance, deserved the benefits of self-rule: a state for every nation and a nation for every people. Despite the ever-shifting boundaries of Nordic empires, the borders of their emerging nation-states were projected onto the past and

sharpened by promoting distinctive examples of folklore, especially regionally unique folk costumes, as handsome proof.[61]

The festive dress of rural folk, sentimentalized by romantic enthusiasts, became the inspiration for clothes worn as idealized emblems of authentic statehood, now more likely called "national costumes," during the revolutions, struggles for independence, and nation-building that marked the rise of modern nationalism, not only in Scandinavia but throughout the Western world. Revolutionaries across Europe and North America proclaimed the pure virtues of their provincial clothes—the durable homespun, made domestically without foreign embellishment or vice.[62] The embodied experience of dressing up like peasants, for both men and women, helped rally individual awareness and pride in newly forming nationalized identities.

In the case of Norway, revolutionaries hoped to reconnect directly with a proud Viking past, separating Norwegian culture from five hundred years of Danish influence and intervention.[63] Once released from Denmark's absolute monarchy after the Napoleonic wars, Norway was transferred as compensation to the Swedish kingdom for its loss of Finland to

Russia. Norwegian patriots rebelled, ratifying a democratic constitution on May 17, 1814. After a brief war, Norway agreed to an unequal union with Sweden. By the turn of the twentieth century, Norwegians agitating for full independence were parading the streets in simplified versions of outfits typical for the Hardangerfjord region, now increasingly referred to as *Nasjonaldrakten* (the National Costume).

Bunad, an archaic word for "clothes" in a dialect of Old Norse (and therefore presumably uncorrupted by Danish language), was first introduced in 1901 by the political activist and suffragist Hulda Garborg as an alternative to Nasjonaldrakt, a costume based on a single district's dress traditions. Bunader, in contrast, could comprise an ever-expanding catalog of options with updated, abstractly representative versions of regional female folk dress, now symbolic of "true Norwegianness" in modern times. Made exclusively with Norwegian-sourced wool and linen in a loose silhouette, these progressive outfits drew on tradition and revolutionary sympathies but were equally inspired by popular women's dress reform movements meant to free women's bodies and minds from the discomforts and presumed subservience encoded in feminine fashion. The standardized one-piece design made them easy to sew with limited skill, and bunader could function as comfortable performance costumes for new folkdance troupes made popular by romantic nationalism.

The dress of peasant women, as we see throughout this work, commonly became a source of inspiration for middle- and upper-class female dress reformers who idealized it as simpler and more versatile for a wider variety of physical and public activities. Garborg believed such modernizations were necessary for making folk costume relevant and desirable to urban women. Alterations must be made, she wrote, in order to "retain the best of the old."[64] As one of Garborg's supporters explained, "We want to dress modern European cultural thought in Norwegian folk costume."[65] An expanded public role for women in a nascent but patriarchal democracy was part of their agenda.

The rhetorical arguments of nationalism, though constructed by revolutionary leaders in order to empower resistance against aristocratic, monarchic, or imperial regimes, also disempowered and disenfranchised others.[66] National identity was imagined in terms that were both engendered and racialized. Women from all social positions, for one, were mostly barred from direct participation in the new public and political spheres of masculine citizenship. In some cases, they even lost previously held rights.[67]

National dress schemes in Europe overwhelmingly clothed women, perhaps as compensation for their otherwise limited public influence. Their dressed bodies served as national symbols and allegories of state power, but women were rarely empowered as full citizens. Ruth Roach Pierson has argued

that women's exclusion from the male domain of political decision-making could render them depersonalized archetypes "fit to represent the high cause of the nation for which men were willing to kill and be killed."[68] In Nordic countries, as elsewhere, women from the ethnic majority were celebrated as "mothers" of the nation, bearing its children and instructing them in the national language and cultural norms.[69] Their feminine biology, however, was simultaneously considered inferior. Women, judged as less evolved from a natural state and therefore less modern, were appropriate for nurturing continuity with the traditional past, while brave men forged progressive futures.[70] Women, nonetheless, were pivotal actors in many romantic nationalist projects, especially in defining, preserving, and popularizing cultural traditions as heritage, though they have often been given less credit for their efforts.[71]

The rise of a romantic brand of nationalism across Europe was an ideological and philosophical response to the presumed failures of modern life, one marked by feelings of loss, dislocation, and inauthenticity. Abrahams has argued that romantic nationalist regimes especially esteem expressive cultural traditions, such as folk costume, because they help framers rhetorically draw on utopian fantasies of homogenous, tight-knit, stable communities that must have "existed before the advent of civilization, cosmopolitanism, and the development of technological sophistication under early capitalistic conditions."[72] Modernization eroded localism and with it the sense of security in collective responsibility. Folk groups and their colorful dress epitomized a lost or disappearing "good life" of communal love and loyalty, of deeper spiritual connection to each other and to the land. It can be a short jump, however, from romantic longing to utopian visions of transcending divisions by denying cultural difference and rejecting outside disturbance. Such visions can boost fascism, totalitarianism, and cultural hegemony.

Ethnic, religious, or linguistic minorities living in developing nation-states, such as Sámi people, were typically backgrounded in depictions of national belonging or endangered with cultural erasure through displacement and dispossession. As Norwegian historian Iver B. Neumann reminds us, the newborn notion of democracy during the period of European nation formation was centered on majority rule, rarely of a numerical nature (considering the limitations placed on direct political participation) but more often of an imagined singular and unified ethnicity, a polity of "the people" (*folkeleg* in Norwegian; *folket* in Swedish).[73] As Swedish and Danish empires, the Nordic region represented multiethnic societies with strong regional cultures, but as a collection of separate nations, interior minority groups highlighted identities in contest with the national ideal. "If minorities are not specifically recognized," Neumann reasoned, "then equality for them must mean assimilation."[74] While regional variety

Dressing with Purpose

could be folded into notions of ethnonationalism, the scientific emphasis around the turn of the twentieth century on human hierarchies defined by race biology and social evolution rendered pathways for ethnic and racial equality wholly improbable.

The subjugation of Sámi people into Scandinavian nation-states was defended as an organic process, its presumed inevitability serving as self-fulfilling prophecy. Sven Nilsson, a Swedish archeologist and a former director of Naturhistoriska Riksmuseet (the Royal Museum of Natural History), argued in an 1868 essay, "The Primitive Inhabitants of Scandinavia," that it was "a universal law of nature" that physically and intellectually superior humans should "pursue and extirpate" their inferiors, a haunting conclusion that foreshadows the future participation of Swedish actors in eugenics and the Nazi party.[75]

Nordic histories, constructed in the modern period and informed by race theories, colonial beliefs about historical change, and ethnonationalism, "ethnically cleansed" Sámi people from authoritative narratives of Scandinavian prehistory and national development. Despite centuries of interaction between Sámi and non-Sámi, cohabitating the same landmass, "Sámi people became a foreign group to be discovered and ethnographically described, replacing former relations and forgetting past shared events."[76] Though Sámi individuals became Swedish, Norwegian, Finnish, and Russian citizens, they were not Swedish or Norwegian or Finnish or Russian ancestors. They were not sacred keepers of national traditions. While peasants held the key to a forgotten cultural origin, contemporary Sámi culture offered only an evolutionary parallel, "a mirror in which progressivist Swedes could observe how far they themselves had traveled along a road from nature to culture while romanticists could bewail what had been lost along the way."[77]

Both Indigenous and peasant folk culture attracted romantic attention. But it was only peasant folk costume that rebels held up and transformed into national symbols to legitimate "land-based patriotism" during declarations of independence in Norway, Finland, and Iceland.[78] For the purposes of dressing their "imagined communities," nationalists reframed peasant folk culture as the nation's unique, collective inheritance.[79] Even today, Sámi histories that account for Indigenous perspectives are rarely folded into school curriculums. Even today, Sámi Indigenous or "ethnic dress," which, like folk and national costume, reflects clear territorial origins, is inconsistently incorporated into encyclopedias, costume books, and museum exhibitions of Scandinavian, Nordic, or European traditional dress.[80] Not unlike the way European peasant dress can be understood as "non-Western," Sámi people have often been regarded as "non-European Europeans."[81] Arguably, Sámi dress represents one of the more vibrant and varied examples of traditional dress practice in twenty-first-century Europe. In comparison to folkdräkt or bunad, Sámi dress is worn for a much wider variety of occasions in far more flexible styles and combinations. This vibrancy is owed, in part, to the gákti's oppositional potential to resist the invisibility and historicization imposed on Sámi people.

Sámi resistance to intrusive, sometimes violent attempts to define and regulate Sámi culture is articulated in oral history and demonstrated in recorded events of activism and rebellion that stretch back to early contact. Even before the radical ethnopolitical movements of the 1960s that advocated for Indigenous rights and decolonization, Sámi have sought to redress persisting legacies of cultural dominion imposed by Nordic nation-states, including seizing ancestral lands, adjudicating the criteria for legally determining Indigenous status, instituting structural injustices, and writing Indigenous groups out of national origin stories.[82] As one of the most visible means of raising political consciousness, Sámi dress traditions have been strengthened—in both practice and discourse—with the emergence of a global Indigenous rights network. Both indigeneity and romantic nationalism, as organizing principles for identity, draw some of their power and emotional appeal from arguments about the natural entitlement to or the unjust theft of land. In conflicts between decolonialism and nationalism, we are currently seeing these two competing paradigms playing out on a global scale.

Traditional dress has often become entangled in elite projects to define national identities and marginalize exoticized groups. Peasants and Sámi, however, were not merely imagined and stage-managed by outsiders. They collaborated, challenged, thwarted, and acted according to their own individual desires, circumstances, and perceptions. Both groups were politically active throughout the modern period, agitating for expanded recognition and rights. Throughout the nineteenth and twentieth centuries, many also became deeply involved in organizations and enterprises that sprang up in tandem with romantic and national efforts, such as local dress research committees and study circles, craft schools, folk music and dance groups, living exhibitions, tourist ventures, popular movements focused on local history and handicraft, and the establishment of museums and archives. The boundaries between insider and outsider, elite and vernacular, expert and amateur, urban and rural, and center and periphery are not always clear and are never constant. These clothes, moreover, have never carried a single, settled symbolic meaning. A very important point repeated throughout this book is that politically motivated sartorial schemes do not necessarily replace or supersede the manifold functions and localized meanings associated with dress, nor do they prevent the ongoing transformation of such schemes into multifaceted traditions through living practice.

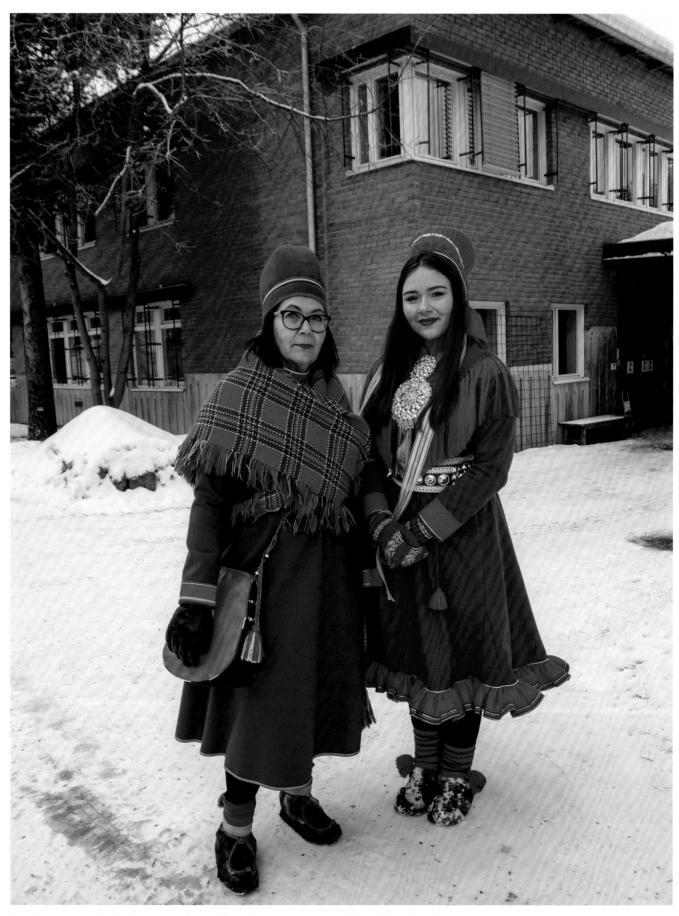

Eva Aira and Inga Lajla Aira Balto dressed for the Winter Market in gávttit from Jåhkåmåhkke and Kárášjohka. *Photo by Carrie Hertz, 2017.*

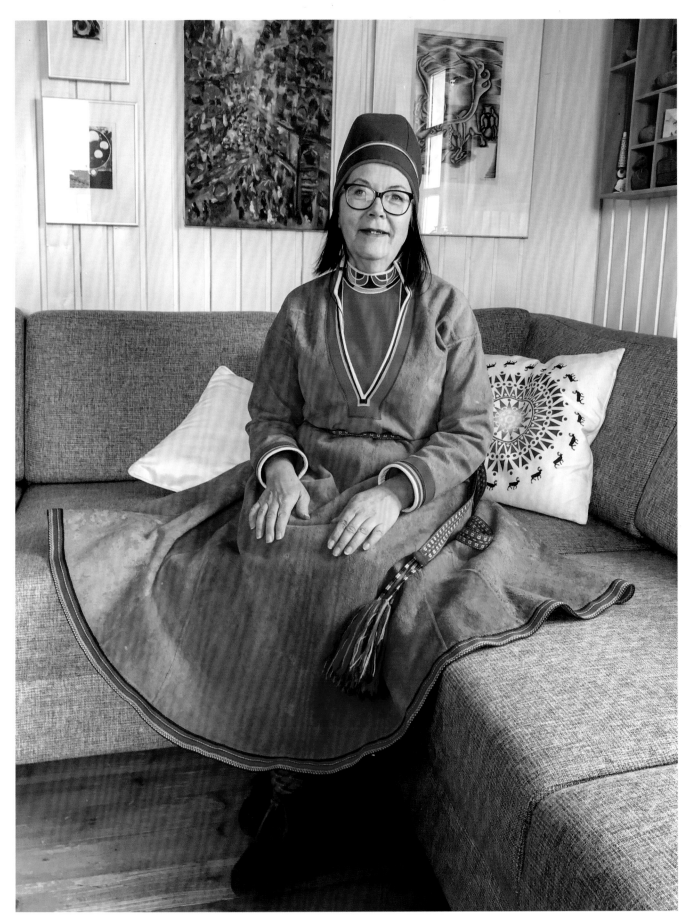

Eva Aira in a *sváltjá* (reindeer skin gákti) worn with her mother's *sliehppá* (decorative collar). *Photo by Carrie Hertz, 2018.*

Too often, scholars have prioritized the intentions of assorted aesthetic and political reformers over those of other motivated actors, including those raised with dress practices who may primarily understand their ongoing engagement as family tradition. In their everyday lives, furthermore, people regularly acknowledge dress's potential for multiple effects. A bunad worn to parade the streets of Oslo on the Seventeenth of May can also be worn to celebrate a nephew's baptism, as well as to protest the Norwegian state's attempts to nationalize provincial waterways. Is it then a national, folk, or ethnic costume? Is it "traditional," or is it, as some scholars contend, "invented" too recently, too narrowly, or too self-consciously to represent genuine continuity with the past? Who gets to say what is authentic?[83] In these moments of performance, meaning is created in the space between wearers and beholders, and these negotiations, whether they play out face-to-face or in virtual spaces, engage with larger patterns of access and power.[84]

We know that dress codes and their meanings are policed, but they will also be challenged. Like identity itself, forms of folkdräkt, bunad, and gákti have been historically racialized through monocultural imaginaries, classed through socio-economic disparities, and gendered through binary divisions between men and women or notions of masculinity and femininity. Their use can also be interwoven with spiritual beliefs and religious practices that map issues of moral worthiness and ethical imperatives onto individual choices. Personal identity and the dress we use to express it are always embedded in a constellation of social identifications, temporalities, and spaces that intersect, overlap, and sometimes contradict each

other.[85] Through negotiations around dress, individuals pull at the many threads binding their existence.

In recent years, younger generations, especially, have initiated conversations around the potential for queering traditional dress alongside contemporary advocacy for social acceptance of nonconforming sexualities and gendered expressions.[86] Projects like Queering Sápmi have focused public attention on the struggle for gay and transgender rights in Sámi communities and the larger society. Led by a small group of Sámi and Norwegian activists and supported by a network of international organizations and individual participants, Queering Sápmi produced a book of photographs and personal life stories as well as a traveling exhibition still in circulation, formed the support group Queersámit, and arranged the first Sápmi Pride event in 2014.[87] Portraits generated by and around activities associated with the project illustrate a creative search for new vocabularies of traditional dress that can communicate intersectional identities beyond existing norms for gender, sexuality, and Sámi ethnicity, as with outfits assembled from both men's and women's garments and traditional accessories newly embellished with rainbow pride flags.

Dress, in its many semantic and semiotic guises, has been harnessed as a metaphor for both progress and stability, the exotic and the utopian, oppression and freedom, belonging and resistance. It has been enthralled at one time or another to every imaginable ideology. By considering contemporary dress traditions, we have the opportunity to add much-needed nuance to the construction of future historical narratives and cultural concepts of dress by attending to the voices of talented, thoughtful people who go about their lives and, through the act of dressing, creatively project their own definition of self, their own assessments of the past, their own contributions to fashioning the future.

We begin where most people start. "Traditional dress," for most people, is introduced by relatives and may be worn first as a reflection of belonging to one's family.

Family Traditions

Across Scandinavia, many families, over many generations, have participated in and contributed to dynamic, local traditions for dressing. A brief visit with the Aira-Balto family introduces some of the themes found throughout this book and serves as a reminder that dress traditions can be understood in diverse ways.

I met Eva Aira and her then-sixteen-year-old daughter, Inga Lajla Aira Balto, at the 2017 Winter Market held in Jåhkåmåhkke/Dálvvadis/Jokkmokk, Sweden.[88] The pair was strikingly dressed for the event in gávttit representing two different areas in Sápmi—Eva in a Jåhkåmåhkke style from her home region and Inga Lajla in a Kárášjohka/Karasjok style from where she was born and where the family now lives in

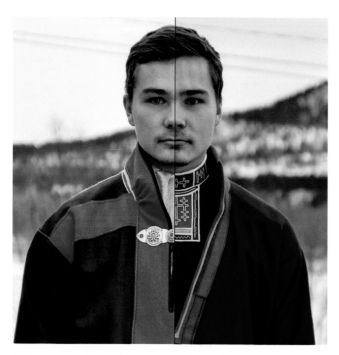

Per Thomas Aira Balto in gávttit from Kárášjohka (*left*) and Jåhkåmåhkke (*right*). © *Per Thomas Aira Balto.*

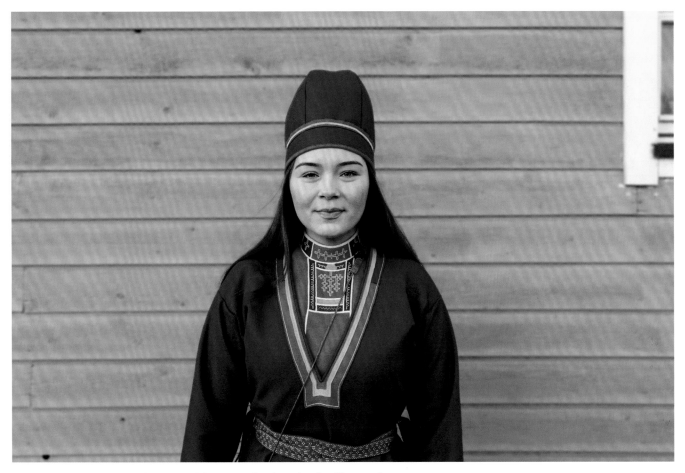

Inga Lajla Aira Balto wearing a sliehppá made by her grandmother. *Photo by Chloe Accardi, 2018.*

Norway. In describing her outfit that day, Inga Lajla told me, "When I wear it, I feel most like myself." At their invitation, I visited their home in Kárášjohka the next week and again in 2018.[89]

Inside the family's two-story yellow timber house, the living room showcases some of Eva's abstract graphic artworks.[90] Between 2012 and 2019, she served as the principal of Kárášjohka Kunstskolen, an art school associated with the Sámi Dáiddaguovddáš (Sámi Center for Contemporary Art). Eva's mother, Elsa Aira, was also a well-respected figure in Sámi art and education, having been one of the founding teachers of *duodji* (Sámi art, craft, and design) at Samernas Utbildningscentrum (the Sámi Education Center) in Jåhkåmåhkke and a cowriter of an important book on Lule Sámi dress.[91] She was responsible for teaching not only Eva how to sew but also generations of students. Eva, in turn, is now teaching Inga Lajla.

Sitting around the kitchen table, drinking coffee and eating slices of reindeer sausage, cheese, and bread with cloudberry jam, we talked about the significance of gávttit to family history and identity. Following in her late mother's footsteps, Eva makes most of the family's clothes worn for special occasions,

such as holidays, church confirmations, weddings, graduations, parties, concerts, club meetings, and political gatherings. Eva's twenty-two-year-old son, Per Thomas, also likes to wear his older gávttit for both warmth and style while driving his snowmobile, and for the past two years, her younger son, John Daniel, has been dressing in cotton or polyester gávttit for his summer job as a Sámi interpreter for tourists at the Sápmi Culture Park in Kárášjohka. Each family member possesses a sizeable wardrobe of garments and accessories in both Kárášjohka and Jåhkåmåhkke styles, appropriate for a variety of occasions, from formal to informal. They are stored collectively in a walk-in closet at the top of the stairs. Together, the clothes serve as a living record of the family's interwoven past, present, and future.

Church-related events, such as weddings and funerals, demand the most conservative styles, while "party gávttit," worn to more casual gatherings, can better reflect the latest fashions. According to Inga Lajla, the most fashionable thing among her age group now is "a lot of glitter," achieved through tinsel ribbons and synthetic fabrics, and wearing "a lot of silver" jewelry, but she is also noticing a countertrend for "vintage" styles from the mid-twentieth century. Eva agreed, saying that

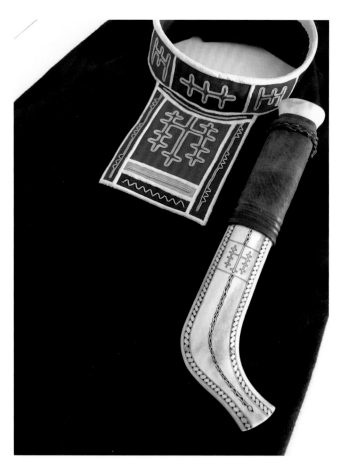

Matching motifs: sliehppá by Elsa Aira and knife with sheath by Per Thomas Aira Balto. *Photo by Carrie Hertz, 2018.*

"the young people have tried *everything*" and are going "back to basics." "Now, they've seen it's prettier to have a darker dress," she explained. "Not so much silver. Not so much color. Just plain." Despite these constant, cycling trends for particular colors, materials, and embellishments, the basic silhouettes and construction patterns remain fairly stable. Offering the Jåhkåmåhkke woman's gákti (*gábdde* or *gáppte* in Lule Sámi) as an example, the dress has gotten shorter and longer over time, the hat has gotten flatter and taller, but the overall look has remained easily recognizable. Eva values a certain amount of aesthetic conservatism, she said, because it makes it easier to send and receive messages through dress.

Eva and Inga Lajla agree that gávttit is a general sign of Sámi ethnic and Indigenous cultural identity, but its communicative potential is far more nuanced than that, at least among women, who are greatly respected as keepers of this specialized knowledge. As Inga Lajla told me, wearing gávttit is most important "when Sámis are gathered together." Eva added, "It's an unspoken language." For those embedded in Sámi communities who understand the subtleties of its signs, Sámi dress can offer a complex index of information about the wearer's connections to specific territories, social roles, and families. In

Jåhkåmåhkke tradition, for instance, wearing three-color leg bands in yellow, red, and green or blue indicates that someone has been confirmed in the Lutheran church. Or, specific to the Aira-Balto family, each member has a thick leather belt studded in silver ornaments following a unique design, similar to a family crest, that the family created together in collaboration with a local silversmith. When outsiders, those without enough knowledge to communicate effectively, choose to wear gávttit (perhaps because they think the clothes are pretty), they are in essence lying about themselves, unaware of the signals they are sending or the histories they may be evoking. "That kind of people," Eva concludes, "don't know where they belong. They don't have any heritage at all. And it's a pity."

Eva and Inga Lajla's sentiments are echoed by a general belief among many Sámi that individuals who lack belonging in a collective are "at risk of disruptive feelings, such as sadness, insecurity, low self-worth, depression and boredom."[92] Eva believes that non-Sámi wish to dress up as "ethnic" Others because they have lost an important sense of shared responsibility and connection to their own past, a criticism that may be levied against many of the middle-class romantics who once dressed up as peasants. A desire to protect the integrity of local traditions comes from a sincere fear that a "global culture" will be built from the repackaged and commodified forms of local folk and Indigenous traditions, now starved of collective meaning and divorced from any notion of communal accountability.[93] Traditional dress, worn by those who understand neither it nor the people who created it, becomes just another passing fashion. For those who are deeply invested, however, traditional dress is one way to give material substance to emotional connections designed to transcend the passage of time.

Before her passing, Elsa made complete ensembles in Jåhkåmåhkke style for each of her grandchildren's confirmations, but she did not live to see any of them worn. An expert in traditional pewter embroidery (*daddnim*), Elsa created singular designs for each child's *sliehppá* (a type of decorative collar). For her confirmation three years ago, Inga Lajla dressed in her grandmother's custom-made ensemble for the first time. "I was so young when she died," she told me. "There's still a foggy memory of her, but with this, I can remember more [clearly] when I wear it." Per Thomas is now attending the duodji school in Jåhkåmåhkke where his grandmother once taught. While learning to make knives, Per Thomas scrimshawed the embroidered design from his sliehppá into an antler sheath. By translating the design, he adopted it as a personal motif, a representation of his identity, an identity formed, in part, through the creative energies of his grandmother.

One common way to understand tradition has been external control or repression, as in traditions of law and religion, but another is reciprocity, as in apprenticeship, as in family inheritance. In the act of sharing, "the receiver must respect, but the

giver must let go."[94] Wearing "traditional" dress, at its heart, is a celebration of identity—not simply that of an individual but that of a person enmeshed in a web of valued relationships, geographies, and histories. Different types of clothes help us understand and display different aspects of ourselves.[95] By emphasizing and reshaping the traditional aspects of dress, we can situate that self within a place of intimacy, making purposeful connections to the past, communing with ancestors, and demonstrating accountability for shared memory. In these moments, traditional dress promises to be a vernacular force against social alienation, assisting individuals in their motivations to connect with others through affecting and persuasive modes of creativity and, in the process, fashioning meaningful futures together.

The Contents of This Book

When dress is understood as traditional and therefore mutually shared, the act of dressing is consciously recognized as representing something greater than individual choice. The precise boundaries for participation, the limits of innovation, and the possibilities for interpretation, however, are perpetually negotiated through living practice. Learning and engaging with these social expectations is part of the initiation of belonging into consensual communities.[96] While traditional styles of dress may fall out of use, traditional dress as a category of human creativity is not disappearing, because "tradition is a factor, rather than a foil, of modernity."[97]

The authors of this book hope to further the growing scholarship on dress as contextually bound artistic communication, simultaneously traditional and fashionable, through a series of case studies that reflect a diversity of themes, dress styles, communities, and perspectives within a tightly focused region. The book is organized into three parts, one for each of our featured dress traditions, in order to ground the experiences, perspectives, and creative acts of contemporary people within broader discussions of histories, politics, ethics, and aesthetics. In the chapters that follow, you are introduced to individuals who, through dress, contemplate enduring questions about belonging and resistance, continuity and progress. Despite an emphasis on dress traditions rooted in the past, they are not reenactors. The clothes they wear are not historical replicas. Like those before them, these individuals foreground particular aspects of the past and background others in an interpretive, selective process tailored for contemporary life. Rather than attempting to stop time or escape into a simulated past, their choices are future-oriented. We might call it a "critical nostalgia," a cultural process of analyzing and actively shaping the present through comparisons with positively evaluated aspects of the past, both to remember and to reconsider.[98] Rather than "passively float with the tides of change," people judge which changes can be tolerated or embraced and

which must be resisted.[99] By dressing with purpose, individuals intentionally seek a sense of belonging, articulate personal values, and combine the best of the past and the present in the hope of influencing the world around them.

Notes

1 This style of kamik is commonly worn as part of an ensemble of traditional festive dress that emerged in the twentieth century as a conscious symbol of national and ethnic pride. To read more about its historical development and contemporary use, see Buijs and Petersen, "Festive Clothing and National Costumes"; Thuesen, "Dressing Up in Greenland"; Kleinschmidt, "Formal Clothing." To read about other controversies surrounding its appropriation by Danish Greenlanders, see Sørensen, "Contested Culture." For more on the history of Inuit footwear traditions, see J. Oakes and Riewe, *Our Boots*.

2 Odell, "Greenland Deeply Offended" (emphasis in the original).

3 See, for example, Long, "Peter Jensen"; Bumpus, "A Controversial Fashion."

4 Holmes, "Designer Death Threats."

5 For an example of a positive opinion, see Nordal, "Danish Designer's Boots Causing a Stir."

6 In her study of Greenland's Self Government Act, Rauna Kuokkanen cites the "right to mineral resources as the most undeniably significant aspect" of the act to interviewees ("To See What State We Are In," 187–189).

7 Dewar, "Our Clothing, Our Culture, Our Identity," 25. See also Bertram, "Power Patterns."

8 Chapman, "Freezing the Frame," 25. See also Jackson, "On Cultural Appropriation," for a thorough theoretical and historiographic examination of cultural appropriation, framing it as a "metacultural discourse" intended to redress such painful histories and asymmetrical relationships.

9 Reeploeg, "Women in the Arctic," 183.

10 The most commonly accepted definition of *dress* comes from Mary Ellen Roach-Higgins and Joanne B. Eicher's "Dress and Identity," in which the authors define it cross-culturally as "modifications of the body and/or supplements to the body" (7). In their formulation, the human body becomes the clay and canvas for fashioning identity.

11 I am guided in my understanding of material culture by the theories and methodologies of Henry Glassie as outlined most explicitly in *Material Culture*.

12 There have been many definitions offered for *folklore*, one of the most influential being Dan Ben-Amos's "artistic communication in small groups," introduced in "Toward a Definition of Folklore in Context." The definition I have adopted for this treatment comes from Shukla, *The Grace of Four Moons*, 3.

13 Glassie, "Tradition," 176–179.

14 Shukla, *The Grace of Four Moons*, 383; Entwistle, *The Fashioned Body*, 57–65.

15 My perspectives on the relationship between individuals and tradition owes credit to the insights in Cashman, Mould, and Shukla, *The Individual and Tradition*.

16 There are many possible theoretical models available for contemplating this, or what Jackson ("On Cultural Appropriation," 79–80) identifies as "continuity-mindedness," including for instance, traditionalization, heritagization, folklorization,

revitalization, and revivalism—terms meant to evoke active, agentive cultural processes similar to the folkloristic model of "tradition" as outlined by Glassie ("Tradition").

17 Noyes, *Humble Theory*, 101. My discussion of tradition is further indebted to Noyes's arguments laid out on pages 101–106.

18 Glassie, "Tradition," 188–189. Since at least the late twentieth century, the idea of tradition in folkloristics has been conceptualized as a selective, interpretive, and argumentative process rhetorically linking the past and the present. See Bauman, "Folklore," 31–32; and a more recent discussion by Finnish folklorist Pertti J. Anttonen, *Tradition through Modernity*, 36.

19 Glassie, "Tradition," 177.

20 Unfortunately, the history of folklore scholarship demonstrates this tendency. Thomas A. DuBois has challenged folklorists to turn more ethnographic attention to contemporary uses of traditional dress—including the romantic category of "folk costume" that we helped produce. See "Costuming the European Social Body." This book answers his call and joins other folklorists, such as Pravina Shukla and contributing author Lizette Gradén, who have been leading this charge.

21 For a literature review of works in this vein of discourse, see Jansen and Craik, *Modern Fashion Traditions*, 1–15. For a fairly recent illustration that equates fashion with Western civilization and characterizes it as a universalizing "turning point in the history of human societies," see Belfanti, "The Civilization of Fashion."

22 For a thorough historiography of the concepts of "tradition" and "modernity," see Anttonen, *Tradition through Modernity*.

23 Entwistle, *The Fashioned Body*, 43–44.

24 For a representative overview of "birth of fashion" debates, see Heller, "The Birth of Fashion." In her assessment, "partial or limited knowledge of earlier cultures may often contribute to perceiving a birth of fashion. . . . There is a noteworthy tendency to discover a birth of fashion in whatever period a scholar studies" (26). Her conclusions suggest that the absence of "fashion" in non-Western or "premodern" cultures relies more on unqualified assumptions than evidence.

25 For influential theoretical discussions along these lines, see Baizerman, Eicher, and Cerny, "Eurocentrism in the Study of Ethnic Dress"; Eicher, Lillethun, and Welters, "(Re)Defining Fashion in Dress"; and most recently, Welters and Lillethun, *Fashion History*.

26 Jansen and Craik, *Modern Fashion Traditions*, 8–9.

27 We see this interdependence of appearance, politics, identity, and oppression play out in a wide variety of ways throughout history. For a relevant example, see Frykman, "Becoming the Perfect Swede"; in this examination of body politics in Sweden's pursuit for a modern national identity, he argues that the body—its looks, fitness, genetics, and performative habits—"became an important battleground" for defining and even engineering "the typical Swede."

28 Chakrabarty, *Provincializing Europe*, xiv.

29 Niessen, "Afterword: Fashion's Fallacy."

30 For a discussion of fashion industry rhetoric around rapid disposal, as well as an examination of individual creative resistance to this rhetoric, see Hertz, "Costuming Potential."

31 See, for example, the entry for "Fashion" in Misiroglu, *American Countercultures*, 248–251.

32 Cocq, "Traditionalisation for Revitalisation," 82.

33 Take, for instance, the use of regional dress to visually map culturally distinct peoples and places in early European cartography and "costume books." See Moseley-Christian, "Confluence of

Costume"; Olian, "Sixteenth-Century Costume Books"; Ilg, "The Cultural Significance of Costume Books."

34 Noyes, *Humble Theory*, 410.

35 Welters, *Folk Dress in Europe and Anatolia*, 3. Welters and Lillethun explicitly complicate this reading of European "folk dress" in *Fashion History* (163–168).

36 Snowden, *The Folk Dress of Europe*, 7.

37 Eicher and Sumberg, "World Fashion, Ethnic and National Dress," 300–301.

38 Shukla, *Costume*, 14.

39 Ibid, 4.

40 For a review of scholarship on the dress of lower classes, see Worth, "Developing a Method," 71. For more on functional distinctions and perceptions determined by occasion, see the classic functional and communicative analysis in Bogatyrev, *The Functions of Folk Costume in Moravian Slovakia*, and for a more contemporary example, see Horton and Jordan-Smith, "Deciphering Folk Costume."

41 Noss, "Rural Norwegian Dress and Its Symbolic Functions," 155.

42 Hertz, "White Wedding Dress in the Midwest."

43 For a literature review of scholarship on the intersections of dress and social control, see Hertz, "The Uniform." For uses of dress to serve nationalistic public discourse, see Bendix and Noyes, "In Modern Dress."

44 Chakrabarty, *Provincializing Europe*.

45 Abrahams, "Phantoms of Romantic Nationalism," 22.

46 Bendix, *In Search of Authenticity*, 15.

47 Winton, "Commercial Interests and Politics in Scandinavia," 213.

48 Reformers and scholars have regularly championed a free (male) peasant mythos in Scandinavian history. For more nuanced discussions of peasant inequality in Scandinavia, see Östman, "Land and Agrarian Masculinity."

49 See A. Oakes and Hill, *Rural Costume*; Anawalt, *The Worldwide History of Dress*, 101, 117.

50 For discussions of sumptuary laws and commercial ordinances in Scandinavia during the early modern period, see Engelhardt Mathiassen et al., *Fashionable Encounters*; Winton, "Commercial Interests and Politics in Scandinavia." For examples of "sartorial disobedience" (that is, defying sumptuary laws), see Maxwell, *Patriots against Fashion*, especially 46–57.

51 I. Bergman, *Folk Costumes in Sweden*, 4.

52 Noss, "Festive Folk Costumes of Norway."

53 Nylén, *Folkligt Dräktskick i Västra Vingåker och Österåker*.

54 Anderssen, "Foreign Seductions," 27; Granlund, "Sweden," 23.

55 Dunfjeld's research, published in Norwegian as *Tjaalehtjimmie*, is discussed in English in Guttorm, "Duodji—árbediehtu ja oapmi." See also Ojala, "East and West, North and South in Sápmi," for a look at the contested boundaries of Sápmi as a geographic and political concept and the role of archeology in defining prehistory in such a way as to impact the contemporary recognition of particular identities and rights.

56 Gjessing, "Hornluen," 53. Various research and art projects over the last decade have used the ládjogahpir as a focus for social critique or to encourage its revitalization in contemporary practice. See Harlin, "Recording Sami Heritage in European Museums," 78; as well as Harlin and Pieski's contribution to this book (chapter 7).

57 Bendix, *In Search of Authenticity*, 16.

58 Reeploeg, "Women in the Arctic," 183.

59 For a historiography of "folk costume" as a conceptual category, see Yoder, "Folk Costume." See also Noyes and Bendix, "Introduction," 109–111, for a discussion of the construction of costume as a foil to fashion.

60 Leerssen, "Notes Towards a Definition of Romantic Nationalism," 10. For an examination of theoretical arguments characteristic of romantic nationalist political movements and why folklore forms played prominently in their philosophies, see Wilson, "Herder, Folklore and Romantic Nationalism."

61 Orvar Löfgren ("Materializing the Nation") has identified nationalized folk costumes as one important building block within a more comprehensive nation-building "tool-kit" of unifying symbols that included other common elements such as folkdance, objectified landscapes, popular myths and legends, national anthems, and flags.

62 For examples, see Haulman, *The Politics of Fashion in Eighteenth-Century America*, 81–116; Maxwell, *Patriots against Fashion*, especially 153–179.

63 Falnes, *National Romanticism in Norway*, 70.

64 Ylvisåker, "Folk Costume as a National Symbol."

65 Quoted in translation in Neumann, "State and Nation," 250. For more on the cultural discourse surrounding contemporary dress reform movements, see Anthony, *Feminism in Germany and Scandinavia*, 53–82.

66 Abrahams, "Phantoms of Romantic Nationalism," 5. As Patricia Williams ("Festival, Folk Dress, Government and Tradition") illustrates, it was not just new democracies; communist and totalitarian regimes, too, have historically promoted idealizations of folk culture as a form of state-directed propaganda to "provide a distraction from political realities," "to glorify the state," and to "exploit the emotionalism attached to traditional elements" (44). In her examples, regional folk costume became a special feature in authoritarian celebrations for Nazi parties and communist regimes in central and eastern Europe.

67 For discussions of women's political participation in Scandinavian nationalist movements, see Sennefelt, "The Shifting Boundaries of Political Participation"; Sandvik, "Gender and Politics Before and After the Norwegian Constitution of 1814." Finland offers a rare counterexample with its implementation of simultaneous universal suffrage in 1906.

68 Pierson, "Nations," 44.

69 Blom, "Gender and Nation in International Comparison," 8–9.

70 Ibid, 13. Löfgren ("Materializing the Nation") argues that nationalism can also adopt "a rhetoric of femininity" but that "female metaphors" for the nation tend to focus on caregiving and home, while male metaphors serve the "potency and pride" often called for during revolutionary times (191).

71 For representative examples, see Klein, "Women and the Formation of Swedish Folklife Research." Kuokkanen ("Myths and Realities of Sami Women") argues that one can see a similar minimization in past scholarship of Sámi women's contributions to artistic, political, and heritage movements.

72 Abrahams, "Phantoms of Romantic Nationalism," 20.

73 At any time in modern Scandinavian history, we can see contested imaginings for national belonging, sometimes including or excluding any number of groups, such as immigrants, refugees, Roma, Muslims, Jews, Catholics, Finnish-speaking Norwegians, and Swedish-speaking Finns. For more thorough historical and theoretical discussions, see Tägil, *Ethnicity and Nation Building in the Nordic World*; Klein, "Foreigners, Foreignness, and the Swedish Folklife Sphere."

74 Neumann, "State and Nation," 248.

75 S. Nilsson, *The Primitive Inhabitants of Scandinavia*, 1; this quotation is cited and discussed in relation to Nilsson's contemporaries in Fur, "Colonial Fantasies," 19–22.

76 Svalastog, "Mapping Sami Life and Culture," 23.

77 Fur, "But in Itself, the Law Is Only White," 37. As a possible counterpoint, Anna Lydia Svalastog ("Mapping Sami Life and Culture," 36) outlines studies based on social Darwinist theories that hypothesized adopted traces of ancient Norse traditions in contemporary Sámi practice.

78 Abrahams, "Phantoms of Romantic Nationalism," 5, 27.

79 For the classic treatment of the nation as an extended "community," see Anderson, *Imagined Communities*.

80 See Grini, "Sámi (Re)presentation in a Differentiating Museumscape," for a recent discussion of the way Sámi history, aesthetics, artists, and material culture continue to be excluded from national imaginaries in Oslo's major museums.

81 See Nordin and Ojala, "Collecting, Connecting, Constructing," 61. As Nordin and Ojala outline, there is a long tradition of non-Sámi scholars trying to prove that the Sámi, in fact, migrated into Europe from somewhere else. Similarly, European scientists and physical anthropologists measured countless bones and living bodies in their attempt to prove that Sámi were not white like other Europeans; see Painter, *The History of White People*, 44, 78–80, 116, 220–221.

82 Lehtola, "Sámi Histories, Colonialism, and Finland"; Fur, "Colonial Fantasies."

83 "Invented traditions," an oft-repeated theoretical concept, was first introduced by Hobsbawm and Ranger in *The Invention of Tradition*. Charles L. Briggs, in his article "The Politics of Discursive Authority," argues that overlooked inequities of power and authority are needed to declare some people's valued traditions as "real" and other's "invented" and, by implication, fake or inauthentic. Now, it is more generally accepted in cultural studies that authenticity, like tradition, is determined through a dynamic process of social negotiation. See Hofer, "The Perception of Tradition in European Ethnology," 135–136.

84 This argument is at the heart of performance theory in folklore studies, as laid out most clearly for contexts of face-to-face artistic communication in Paredes and Bauman, *Toward New Perspectives in Folklore*, and refined for the medium of dress by Shukla in *Grace of Four Moons*. For a pertinent example of the application of performance theory to analyze participation in the virtual spaces of social media, see Cocq, "Indigenous Voices on the Web."

85 Hurtado and Cantú, *MeXicana Fashions*, 3–14.

86 Based on a series of interviews and workshops conducted by researchers at the University of Lapland, the study "Human Rights and Multiple Discrimination of Minorities within Minorities" provides an overview of the types of discrimination experienced by LGBTQIA Sámi. See Olsén, Heinämäki, and Harkoma.

87 For the publication, see Elfrida Bergman and Lindquist, *Queering Sápmi*. For an interview with one of the organizers for the 2014 Sápmi Pride, see Blåhed, "Sweden's Indigenous Sami People Held Their First-Ever Pride Event."

88 For this location, I privilege the place name in Lule Sámi, the most widely spoken Sámi language in the area.

89 Quotations come from filmed interviews made with Eva and Inga Lajla on February 4 and 9, 2017, and May 7 and 8, 2018. I also met with Per Thomas at his school in Jåhkåmåhkke on May 9, 2018. I am indebted to my colleagues Thomas Grant Richardson and Chloe Accardi, who assisted me with filming and interviewing during these visits in 2017 and 2018, respectively. Virtual correspondence has continued with members of Aira-Balto family. Eva, with the help of relatives, completed a woman's Jåhkåmåhkke gákti for MOIFA's permanent collection.

90 Eva's artwork is briefly profiled in Kent, *The Sámi Peoples of the North*, 174.

91 See Aira, Tuolja, and Sandberg, *Julevsáme Gárvo / LuleSámiska Dräkter*.

92 Gustafsson, "Beauty as a Capacity," 193.

93 For relevant discussions of recent misappropriations, exotifications, and commercial exploitations of gákti, see Kramvig and Flemmen, "What Alters when the Traditional Sámi Costume Travels?"; Kramvig, "Orientalism or Cultural Encounters?"

94 Noyes, *Humble Theory*, 111.

95 Shukla, *Costume*, 14.

96 See Guttorm, "Duodji: A New Step," especially 185–186.

97 Bronner, *Explaining Traditions*, 7.

98 Cashman, "Critical Nostalgia and Material Culture in Northern Ireland." I am grateful to my colleague Mathilde Frances Lind for bringing this citation to my attention.

99 Ibid., 146.

Part One:

Folkdräkt in Sweden

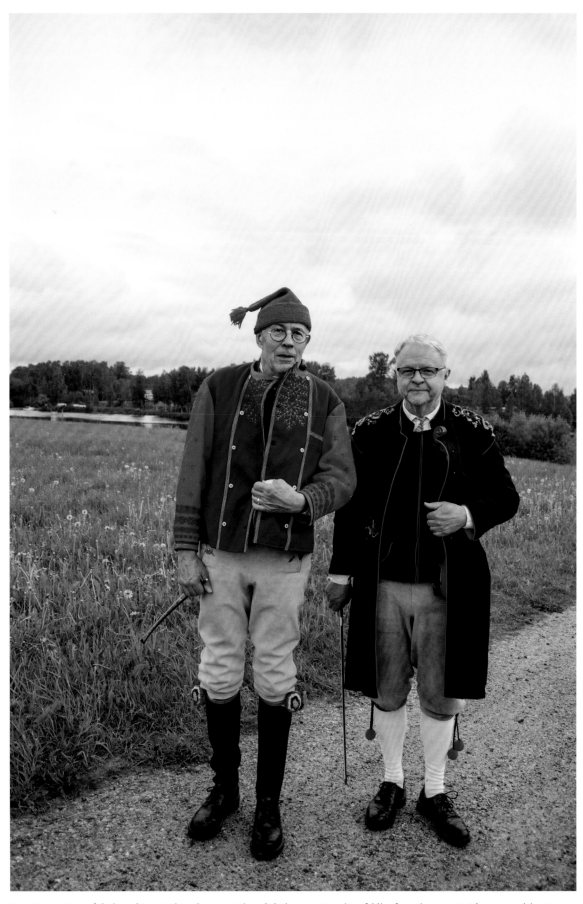

Sven Roos in Gagnefsdräkt and Lars-Erik Backman in Leksandsdräkt protecting their fiddles from the rain at Midsummer celebrations in Dalarna county. *Photo by Carrie Hertz, 2015.*

1

Swedish Folkdräkt

Carrie Hertz

Throughout the Swedish countryside, some communities developed distinctive styles of dress to reflect local identity. These conventions for dressing were guided by local customs, beholden to sumptuary laws, and often arbitrated in parish assemblies. By the nineteenth century, many intellectuals of the period assumed that modernity would surely strike a "death blow" to such examples of "folk costume" and set out to systematically collect and record its forms in images and written descriptions.[1] It was primarily women's fine ceremonial clothes—worn for life-cycle rituals, for feast days, and to church—that ended up in Sweden's museums, in beautifully illustrated books on provincial dress, and in the famous depictions of folk life by Swedish artists such as Anders Zorn, Carl Larsson, Jakob Kulle, and others. These attempts to understand, describe, and ultimately "rescue" traditional dress in Sweden were guided principally by influential male figures who have since become thought of as "fathers" to the nation.[2] Their outsized legacies live on as a sort of enshrined mythology of national origins in which regional dress traditions played an important role in their attempts to define what is and should be considered "Swedish." Contemporary practitioners and audiences can often feel compelled to support or critique the

meanings and histories these figures ascribed to traditional dress, finding it nearly impossible to ignore the power they still exert on public imagination. As folklorist Pertti J. Antonnen argues, "present definitions of the past are always influenced by past definitions of the past."[3]

In this chapter, we complicate the perspectives of the budding nation's romantic nationalists who set the stage for modern Sweden by establishing new institutions devoted to heritage. By examining their choices and the interpretations they advanced, we can better recognize a multilayered historical record crowded with other actors attempting to embrace, contradict, or adapt the master narratives of folkdräkt that preceded them. Up through the present day, people have found the idea of folk costume to be a useful device for imagining good lives and healthy societies, though their perceptions of what threatens or promotes community well-being may greatly diverge. The meaning of *folkdräkter* is continually under negotiation, reinterpreted through numerous cultural, historical, and positional lenses. As Swedish scholars Jonas Frykman and Orvar Löfgren argue, "cultural forms can be carried through history," but their meanings are neither uniformly understood nor stable.[4]

Mandated Uniformity and Elective Diversity, or Elective Uniformity and Mandated Diversity

An interest in salvaging and displaying examples of provincial dress helped propel the development of new public museums in Sweden.[5] Most famously, Artur Hazelius, founder of Nordiska museet (the Nordic Museum) and one of the earliest open-air museums, Skansen, began building his ethnographic collections of peasant folk life in 1872 with items of women's dress collected during a trip to the central province of Dalarna (also known by its Latin name, Dalecarlia). He used his growing collections—examples of rural furniture, tools, utensils, tableware, painted wall hangings, textiles, and clothes—to stage domestic scenes of furnished home interiors populated by plaster and wax figures dressed in folk costume for internationally traveling public displays, shown in Vienna, Philadelphia, Chicago, and Paris.[6] These later served as the founding collections for Nordiska museet in 1880. By 1891, Hazelius, with a land grant from King Oscar II, established Skansen on Djurgården, an island in central Stockholm, with a layout of peasant farmsteads from different regions, each comprising restored buildings and ethnographic artifacts. Plans also incorporated a zoological park to represent the ecological diversity of the country. Like a "Sweden in miniature," the arrangement of the park mirrored the country's cultural geography with a Sámi reindeer camp at the most northern end and a family farmstead from Skåne in the south.[7] The curated grounds were enlivened with costumed interpreters, many recruited from the countryside, who demonstrated traditional crafts, baked *tunnbröd* (flatbread), spun wool, tended animals and crops, played regional fiddle tunes, and performed ring dances. From the beginning, elaborate festivals, such as Midsummer maypole raisings and royal Memorial Days, welcomed visitors in celebration.[8]

Skansen answered the romantic impulses of the period, especially for the growing middle and educated classes living in Sweden's capital. It served as a model for similar open-air museums around the world, exhibiting more democratically conceived national cultures and histories. Perhaps most impactful for Swedish museology, Skansen directly inspired the influential *hembygdsförening* (local heritage societies) movement that established provincial research and exhibition centers—"Skansen in miniature"—in communities across Sweden.[9] *Hembygd*, meaning "home district or area" (or more evocatively, "homeland"), has come to imply an intentional style of small-community planning "built on the foundations of the past" by uniting "the best of the old and the best of the new" into contemporary life.[10] From a more practical standpoint, this approach usually involves preserving vernacular architecture, promoting appreciation for local landscapes and agricultural traditions, and supporting the continuation of provincial festivals, crafts, and dress traditions.

The romantic novelist Karl-Erik Forsslund, one of the leading figures in the hembygd movement, understood the Swedish countryside (and especially the disappearing lifeways of its former peasant society) as the embodiment of everything natural, healthy, and spiritually redemptive, now being lost in the restless striving of modern urban life. In his well-received novel *Storgården*, published in 1900, Forsslund wrote about a young man in Stockholm who "is inspired, upon visiting Skansen to forsake the spiritual desolation of the big city and return to his family farm in Dalarna."[11] Around the turn of the twentieth century, many educated urbanites found themselves drawn to (or, as with Forsslund, drawn back to) the countryside. Skansen, in contrast, brought the countryside, a nostalgic and idealized version of it, into the heart of the national capital.

Hazelius's efforts, resulting in national collections and institutions, were certainly nationalistic in intent. He, like many others during the nineteenth century, hoped to articulate a celebratory (and competitive) national identity on an expanding international stage, but his design for Skansen also proposed that "maintaining difference was simultaneously an act of unification."[12] Hazelius's work further served ideological purposes beyond the strictly geopolitical. His collecting of Dalecarlian material culture was, in fact, spurred by his admiration of it and his fear for its demise. He was especially fond of witnessing beautifully dressed congregants on their way to Sunday service in parishes such as Leksand, Rättvik, and Stora Tuna and expressed deep disappointment at what he saw as evidence of rapid aesthetic and moral decline in the province—that is, the adoption of "modern" clothes.[13] For him and like-minded intellectuals, "Dalarna was the last preserve not only of traditional modes of production but also a traditional morality" in Sweden.[14]

Hazelius's interest in visualizing a more utopian way of life, filled with exceptional examples of handcrafted beauty, is evident in his conceptualization for Skansen. Unlike some of its later institutional imitators (for example, Colonial Williamsburg and Plimoth Plantation in the United States), the experience of visiting Skansen has never been framed as a trip "back in time," achieved through first-person interpretation in which costumed hosts roleplay people from the past.[15] Rather than presenting the grand progressive narratives of the nation's founders or formation, Skansen is more focused on celebrating a "mythic space" with the family sphere, rural lifeways, and craft skills seen as the moral foundation of Swedish culture.[16] In this way, harmonious communities, agricultural knowledge, and folk art were popularized as crucial parts of the country's valued inheritance. The timing of Hazelius's endeavor

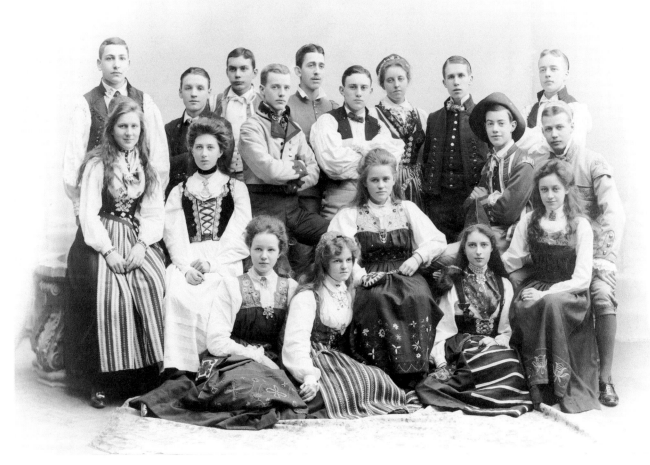

Swedish youth in folkdräkter, ca. 1905. *Courtesy of Nordiska museet (NMA.0054456).*

responded to broadly shared feelings that such cornerstones of Swedish identity would be lost or corrupted during the fitful modernizations of the nineteenth century.

Swedish folklorists Mats Hellspong and Barbro Klein point to the eighteenth century, when Sweden's "Age of Greatness" came to a close, as the beginning of a renewed interest in folk culture that would last more than two centuries. By the mid-nineteenth century, the creative lives of peasants were increasingly seen as a "preserve in a changeable world" and a wellspring of inspiration that could serve as an antidote to the "tastelessness and general decline" in quality being wrought by industrialization. Many rural people were leaving the countryside, moving to cities for new factory jobs, and contributing to a growing urban working class. After a host of misfortunes—crop failures, famine, land reform, rising unemployment, religious and political persecution, and social inequality—hundreds of thousands of Swedes escaped poverty by emigrating abroad, most to the United States and its

promise of new opportunity and freedoms. For those who remained, modernizations were rapidly transforming life and landscapes. With the loss of Norway in 1905, "Sweden's last illusions of greatness vanished," and new symbols of national pride were sorely needed.[17] National leaders were increasingly called upon in this period to provide "a sense of psychological rootedness to alienated individuals."[18] While Hazelius's motto for his collection was "*Känn dig själf*" ("Know yourself"), early visitors to his Nordiska museet, in contrast, were greeted (then, as they still are today) by a giant sculpture of the sixteenth-century king Gustav Vasa demanding, "*Warer Svenske!*" ("Be ye Swedish!").[19]

Within this frame of mind, romantic nationalists raised folkdräkter up as symbols of a wholesome and idealized continuity for a bruised national identity. The love of regional folk costume was equated with love of country. A growing swath of enthusiasts, primarily among the middle classes and student radicals, embraced rural regional clothes as a new fashion,

Heidi Mattsson in a Sverigedräkt she made with IKEA shopping bags and other recycled materials in 2015. *Courtesy of Heidi Mattsson.*

especially worn as party outfits or to pose in studio portraits. These urban posers often mixed garments without concern for territorial specificity, regional integrity, or historical accuracy.[20] Bernhard Salin, the director of Nordiska museet at the time, wrote in a foreword to the 1907 *Svenska folkdräkter*, by Per Gustaf Wistrand, that he hoped the young people at universities who were then taking up folk costume would do so as "an expression of the deep and warm feelings for our heritage, which is the soil from which true patriotism springs."[21] It was urban elites who tended to understand rural dress as primarily "national," conceptualizing it like Skansen's collection as a sign of unity-in-diversity, or as David Kaminsky describes it, a sort of "additive nationalism."[22] Looking at studio portraits from the turn of the twentieth century, one is struck by the motley tableaux of dance troupes and student groups, each member dressed in a different regional costume, like a living exhibit of the most common typologies.

Around the same time, in 1902, Märta Jörgensen offered an alternative approach. After founding the Svenska kvinnliga nationaldräktsföreningen (Swedish Women's National Costume Association) with others interested in feminist *reformdräkt* (reform dress), she introduced a single *Sverigedräkten*, the Swedish National Costume, as a blouse, dress, and apron inspired by clothes she saw in Dalarna after moving to Falun from Stockholm.[23] In the blue and yellow colors of the Swedish flag and embellished with embroidered oxeye daisies, the outfit was explicitly designed to evoke feelings of national patriotism without reproducing any particular regional models. A second option with a red bodice and trim was created in honor of the union with Norway, but not surprisingly, it gained little popularity and was completely abandoned by 1905 when the union was peacefully dissolved. Jörgensen's designs, combining cosmopolitan art nouveau stylistic flair with provincial features, provided a new option for women without rural affiliations. It did not, however, garner much of a following until it was revived near the end of the century.

Since Sweden's first official *Sveriges nationaldag* (National Day), held in 1983, women of the royal family have worn the Sverigedräkt to represent the nation as a whole during public festivities held at Skansen every June 6. The outfit, often sold readymade or as easy-to-assemble kits, has also become popular among urban women, beauty pageant contestants, and immigrants who wish to show their pride of place, happily announcing themselves as Swedes. Recently, an immigrant from Holland, Heidi Mattsson, made national news after she posted an image of herself on Facebook wearing a creative reinterpretation of the standard Sverigedräkt for nationaldag celebrations held in Gothenburg.[24] Heidi, wishing to avoid expensive materials, made her version out of IKEA shopping bags (*Frakta*). She used felt appliqués for the embroidered daisies, soda-can tabs for the silver brooch, and a cereal box covered

with part of an old sheet for the headdress. Heidi hoped the reference to IKEA, as one of the most internationally recognizable symbols of Sweden today, helped make her outfit "extra Swedish."[25] Heidi's conscious blending of "modern" and "traditional" elements for contemporary use is well in keeping with Jörgensen's intentions.

Wholesale inventions like the Sverigedräkt have been rare in Sweden and elsewhere.[26] The popular adoption of a one-size-fits-all national uniform is even rarer.[27] Most of the people swept up in Sweden's nationalized folk costume movements have preferred regionally specific varieties with clear connections to provincial and personal histories. In many cases, however, communities either did not possess a distinctive living dress tradition to revive or never had one.

Throughout the twentieth century, Swedes across the country introduced local dress revivals and reconstructions for their own areas, often developed collaboratively within organized community groups. For these grassroots endeavors, the nineteenth-century museum collections proved instrumental, providing extant models, images, and written accounts on which to base new patterns and designs. The published materials held at Nordiska museet, especially, served as a sort of "folk costume canon" with now-iconic versions imbued with notions of scientific authority and ethnographic authenticity.[28] Some of these, such as the Östervallskogsdräkt for women and the *mansdräkt* from Norra Ny, were reintroduced into practice as faithful copies of the ones illustrated by Emelie von Walterstorff and featured in early publications. Both of these outfits from the province of Värmland, however, were unusual. The woman's example was already an artistic reconstruction created in the 1870s solely for display in Nordiska museet's first public exhibition. When an adequate folkdräkt could not be acquired to represent the area, the museum commissioned this one based on old garments and written descriptions from Holmedal parish. In the illustration for the man's outfit, it featured a finely embroidered wedding shirt, a relatively rare garment that now in revival became a standard component of the outfit.[29] The strategic choices made and publicized by collectors introduced "improvements" that later became seen as prescriptive.[30]

Early efforts often looked to the national museums in Stockholm for guidance, but as with the hembygd movement, new organizations soon sprang up across the country, attending to ever-more-localized desires, circumstances, and collections. Local collectives initiated new strategies for adapting traditional dress for contemporary purposes through activities focused on formal and informal arts education, as well as improving economic opportunities (for women, especially) that resulted in design schools, folk high schools (*folkhögskolor*), training programs, arts and preservation associations, study circles, and handicraft shops.[31] One of the most

Pl. XXIX.

SOMMARDRÄKT.
Östervallskogs socken, Nordmarks härad, Värmland.

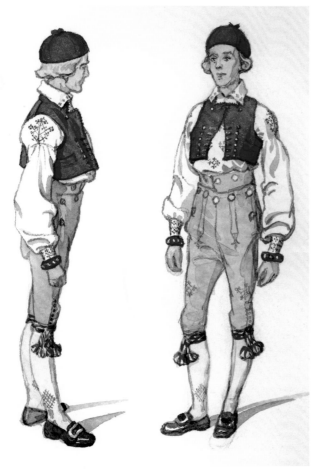

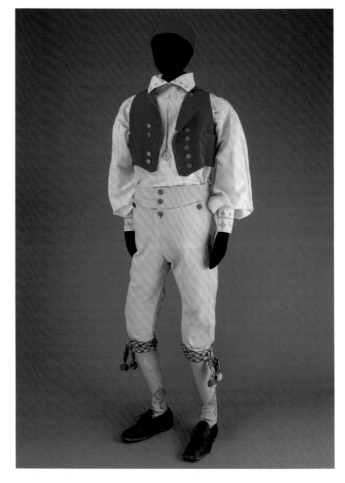

important strategies for sustaining rural dress techniques and traditions was the *hemslöjd* movement (literally "homecraft" but more commonly translated as "handicraft"). Textile artist Lilli Zickerman founded Föreningen för Svensk Hemslöjd (the Swedish Handicraft Association) in 1899 with a "pedagogical center" including a textile studio, a furniture workshop, and a retail store in Stockholm.[32] Zickerman promoted an appreciation for "the local character of handicrafts," and soon, similar associations and *hemslöjdsbutiker* (handicraft shops) began popping up across the countryside to cater to regional specializations.[33] Many of these shops served as community resources, offering training and patterns, sharing research, representing local artisans, and selling supplies and finished goods. For folk costume enthusiasts without family members to teach them, the local hemslöjdsbutik became (and in many places has remained) an invaluable resource.

Between the two world wars, more than seven hundred local societies and study circles dedicated to researching, preserving, and revitalizing regional folk culture were established in Sweden, perhaps responding to the shock of widespread violence and destruction in Europe with a vision of peaceful village life.[34] Many of these groups created a more-or-less official folk costume for their area, typically with a single standardized choice for men and women. These simplifications served broad desires for clear symbols of spatial belonging and became centerpieces for folkdance troupes, musical concerts, public festivals, and formal events. Rather than being known as "national costumes," they were increasingly described collectively as *bygdedräkter* (variously translated as "rural," "regional," or "local dress").[35] This spirit of localized and elective uniformity was also consonant with the political tenor of the period, when Social Democrats were pushing sweeping egalitarian reforms and describing the nation as a family united by a shared "folk home" (*folkhem*) that required "dissolving all social and economic differences that now divide citizens into privileged and disadvantaged, dominating and dependent, rich and poor, haves and have-nots, plunderers and plundered."[36] Belonging—to family, community, and nation—was framed as an act of intentional cooperation and cohesion as well as an "imagined sameness," and many people chose to materialize this concept more intimately by dressing like their closest neighbors.[37] Through this expanding pattern of creation, numerous communities presented themselves as distinctive and valuable units within a more encompassing framework for belonging. There are now more than four hundred regional folkdräkter recognized in Sweden, with additional varieties found in diaspora.[38]

Today, a nationwide infrastructure for institutional and grassroots support still helps sustain the production of folkdräkter, handicrafts, and other folk arts, often by loosely coordinating or consolidating many independent, localized, or privatized efforts. Enthusiasm for folkdräkter, however, has proved cyclical, swelling for periods, then waning again, but never fully disappearing. These surges in popularity typically accompany national, international, and community-level reform movements related to countercultural currents against social alienation, economic marginalization, centralization, globalization, or environmental degradation. Both the 1920s and the 1970s, for example, saw spikes in participation running parallel with international folk revivals and back-to-the-land environmental movements.[39]

Today, wearing distinctive local styles of dress in Sweden does not enjoy the same widespread popularity as it does in neighboring Norway. In the first decades of the twenty-first century, scholars have pointed to a "fatigue with traditional folk art" in general.[40] National museums have started replacing or revising the old, dusty displays of regional folkdräkter with "fashion," and folkdräkt scholarship may be mocked as "pompom research" for its former concern over seemingly trivial details, such as the hyperlocal distinction between the number of pompoms dangling from men's knee-breeches.[41] Men's pompoms and knee-tassels, now considered by many to be ridiculously effeminate, are a particular source of scorn, not only in academic circles but also in social scenes devoted to folk music and dance.[42] In my experience traveling around Sweden, people in urban and suburban areas routinely describe folk costume as, at best, "nerdy" or "snobby," and at worst, "racist."

On the world stage, the Swedish state consciously promotes itself as a progressive, inclusive, pluralistic nation with large immigrant and refugee populations whose presence complicates and implicates the nostalgic valorization of the country's "folklife sphere."[43] Klein writes, "If emigration away from Sweden characterized the 1870s and 1880s, immigration into it characterized the 1970s and 1980s."[44] Of all the Scandinavian countries today, Sweden has accepted the largest share of immigrants, particularly refugees, both in actual numbers and in proportion to population size, now representing roughly 15 percent.[45] After Hazelius's time of nation-building, Scandinavian nationalism had been constructed around "a hegemonic ideal of egalitarianism," one manifested through a celebration of elective conformity.[46] By the 1990s, however, Swedish intellectuals had declared the emergence of a new "multicultural Sweden" preconditioned not only by immigration but also by rapid increases in tourism, travel, technological advancements,

Facing, Reconstructed folkdräkter from Värmland based on illustrations from Nordiska museet's collection. *Left,* watercolors of a woman's Östervallskogsdräkt and mansdräkt from Norra Ny parish by Emelie von Walterstorff (NMA.0068251 and NMA.0027740). *Photos by Mats Landin, courtesy of Nordiska museet. Right,* Museum of International Folk Art, gifts of Florence Dibell Bartlett (V.2019.11.1–9 and V.2019.30.1–7). *Photos by Addison Doty.*

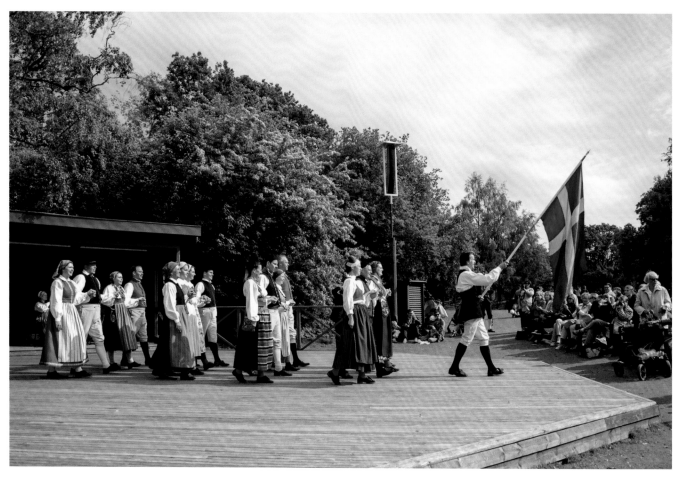

Folk dancers performing at Skansen in Stockholm. *Photo by Carrie Hertz, 2015.*

and the globalization of media and commerce.[47] Within this contemporary ethos of interconnectivity and progress, Swedish folk costumes can be seen negatively as intentionally exclusionary and parochial.

Many scholars have cited Sweden's ambiguous relationship with explicit displays of patriotism today, describing Swedish nationalism as rather "banal" or "un-Swedish," or likening it to an "unwaved flag."[48] As Orvar Löfgren has pointed out, even the national flag is sometimes accused by Swedish citizens of being a racist or chauvinistic symbol.[49] Critics remain suspicious of lingering legacies—the mono-ethnicization of Swedish national identity during romantic nationalism and its exploitation by eugenicists in the early twentieth century through the Nazi era.[50] Interpreted within these spheres of influence, the constructed symbolism of regional folk costume can be especially fraught in light of growing ethnonationalist movements in Sweden today.

While the initial, nationwide interest in folkdräkter at the end of the nineteenth century was for many "a protest against the effects of industrialism" and the loss of national power for Sweden, both seen as furthering poor quality in material culture, moral decline, and social alienation, new interest

among far-right groups situates the wearing of folk costume as a protest against contemporary globalization and multiculturalism.[51] Since the 1980s, a period marked by rising inequality and the political dismantling of the welfare state, far-right agitators and anti-immigration politicians, such as the Sweden Democrats, have regularly attempted to exploit folkdräkter by "invoking nostalgia, ironically, for the golden years of left-wing Social Democratic rule," a sort of mythic past of prosperity and equality seen as dependent on racial homogeneity and moral uniformity rather than elective cooperation.[52] As one critic told a reporter in Stockholm, "They have an obscene dream that 100 years ago everyone had blond hair and blue eyes and was very happy." The Sweden Democrats paint contemporary Sweden as a country in a state of rapid social, moral, and aesthetic decline, and they blame immigrants (especially people of color and minority faiths) for this poor turn of events. One of the major problems with this depiction, the critic continued, is that it too often goes unchallenged: "When nobody else has a contribution to make, people find it easy to believe the Sweden Democrats' version of events."[53] Kaminsky agrees, arguing that the popular rejection of previously beloved national symbols as silly, shameful, or embarrassing has also left them

vulnerable to these right-wing platforms eager to pick them up.[54] Such disavowals can further feed into some citizens' fears that by welcoming "strange foreigners," who may integrate but not assimilate, the fabric of Swedish culture (as they have come to expect it) will disappear, like the now-maligned folk costumes hidden away in closets and museums' permanent storage vaults.

The normalized impression of Swedish cultural history that these groups draw on, however, is often the one manifested at the turn of the twentieth century by romantic nationalist institutions engaged in paternalistic forms of salvage collecting. Stefan Bohman, when he was head of the Research and Education Department at Nordiska museet, wrote about the patronage of neo-Nazi groups with regret: "Hazelius is regarded as the defender of what is considered genuinely Swedish and his name is used in their rhetoric of racial supremacy and preservation of national values. Skansen, founded by Hazelius, is depicted as a sanctuary of Swedish culture on the verge of extinction. For that reason, many skinheads dedicate themselves to the activities of Skansen." Bohman considered this one of the unintended and negative consequences of cultural heritage-making in Sweden, providing "an example of values nourished by the public" when great emphasis is placed on the construction of narrowly defined national identities.[55]

Many Swedes deny that chauvinist beliefs like these motivate their appreciation of common forms now recognized as cultural heritage. Folk Musicians against Xenophobia (*Folkmusiker mot främlingsfientlighet* / FMR)—a grassroots organization that celebrates regional music repertoires, dances, and folk costumes—explicitly rejects, in name and deed, ethnonationalistic interpretations for these targeted traditions. In an interview with Export Music Sweden, one of the organizers, Anna Gustavsson, explained, "We do not want Swedish folk culture to be appropriated by racist and nationalist movements, causing all practitioners and lovers of Swedish folk culture to be perceived as supporting nationalist and xenophobic cultural views."[56]

The ethnonationalist exploitations and manipulations of folkdräkter can be especially disturbing for those raised in places with long histories of practice. For some, such abuses have sparked renewed interest in protecting and projecting alternative meanings through intentional use. Karin Eksvärd of Vuollerim, a small community in the north of Sweden, told me in 2018 that she had recently pulled her folkdräkt, made by her mother for her church confirmation, out of the back of her closet.[57] She had grown up wearing it in Dalarna but stopped after moving away from the province. She started wearing it again in direct protest of what she sees as a perversion of the warm communal feelings of interdependence that folkdräkt should express between people committed to one another's well-being. To Karin, the political misappropriation of folkdräkt to pit groups against each other, declaring only one "the real Swedes," is against the very ethos of elective togetherness embodied in her understanding of the folkdräkt tradition, one that welcomes a multiplicity of forms that no one is obligated to wear. In her mind, folkdräkt today should be less emblematic of identities of descent (bestowed through accidents of birth) than about mutual consent (chosen to demonstrate loyalty to each other).[58] Karin's understanding of mutual consent acknowledges room for the peaceful coexistence of diverse patterns of thinking and cultural practices. For some far-right groups, the ideals of mutual consent may also hold appeal, but of a different sort: not for an elective multiculturalism but for an obedience to a set of conservative standards for beliefs and behaviors associated with a normative version of the past. In the twenty-first century, these unresolved tensions between the "perception and practice" of a Swedish national history, culture, and character "can turn an ideology of community into a weapon" of exclusion.[59]

While some may still understand rural dress traditions within a grand scheme for Swedish national identity, others emphasize them as proof of palpable difference. With rising inequality and loss of opportunity, an increasing number of rural Swedes conceive of themselves and their provincial homes not as complementary parts of the national whole but as people and places in competition with state interests.[60] Centralization policies have exacerbated these sentiments by eroding local autonomy. During the second half of the twentieth century, the central government orchestrated significant reductions in local representation, merging 2,500 independent municipalities in 1950 down to 279 by 1980. This amalgamation potentially reduced overall spending and improved efficiency by consolidating schools, governmental offices, and social services, but it also diluted access and self-determination for smaller administrative units.

In response, running in tandem with these mergers, some rural communities began emphasizing their separate distinctiveness, both from the nation and from their newly merged neighbors, with waves of rekindled enthusiasm for more finely localized history associations, cultural festivals, and dress revivals in the 1970s.[61] Swedish ethnologist Kjell Hansen argues that when these communities wear local dress today, "they do so in order to foreground and represent concrete places that otherwise have been integrated, even dissolved, into wider territorial, social, and cultural fields for a long time," often to the perceived detriment of locals whose interests become subsumed under larger metropolitan areas.[62]

These many localized, sometimes contradictory adaptations and redefinitions too often get left out of broad histories of traditional dress in Sweden. While the histories of elite borrowings become the most commonplace explanations, local actions, assertions, counternarratives, and metacommentaries

concerning the origins, significance, and persistence of valorized traditions go unnoted in most scholarly accounts.[63]

In the sections that follow, we pivot from the national to the provincial, focusing on the ways that making and wearing folkdräkter can help individuals formulate personal and shared ideologies and demonstrate loyalty to their notions of family and community. Then, in the next chapter, Lizette Gradén refines our focus even further by attending to issues of preserving and interpreting private family dress collections. She deepens the discussion of museology introduced here by comparing the curatorial methodologies of father figures of Swedish heritage with female caretakers who often work within more domestic spaces, exploring tensions between institutional and vernacular practice.

Whether we are discussing practice within the context of making, wearing, or keeping, as Gradén states, traditional dress can be viewed as "stylized performances of who we are" and wish to be. These contextually bound activities are embedded within broader pursuits, defining one's ethical and aesthetic desires for fashioning a life. As Gradén's contribution shows, too often, folkdräkt has been viewed primarily through the lens of national museum history and heritage-making, underplaying individual agency and intergenerational cooperation in more private settings. Naturally, like all centers and peripheries, these spheres are intertwined. We offer a more intimate look at the sartorial practices, aesthetic assessments, and philosophies of individuals living in one province of Sweden, one of the most celebrated for its continuous use of localized forms of dress over a matter of centuries. We now turn to Dalarna.

Dalarna

For those interested in Swedish folkdräkt, Dalarna has been considered, even before the time of Hazelius, a place of pilgrimage.[64] In this area, the small villages nestled around Lake Siljan developed and consciously preserved highly localized styles of dress, each designed to clearly reflect gender, age, marital status, season, religious calendars, and parish affiliations. Even villages a few kilometers apart might display striking distinctions, despite sharing many other regional similarities.[65] For centuries, emerging from the Middle Ages, these distinctive yet dynamic dress practices had attracted outside admiration, regularly appearing as costumes worn by courtiers to masquerade balls as early as the seventeenth century.[66]

Dalarna had a number of features that made it unique among Sweden's provinces and thus of great interest to the romantically minded at the end of the nineteenth century. While the lower area around Falun counted as one of the more developed places in Sweden with robust mining, forestry, and manufacturing industries, the upper part of the province was dominated by free-holding farmers.[67] Considered north of the "shieling line" (fäbodgränsen) in standard typologies of Swedish regional landscapes, upper Dalarna was characterized by a pastoral system of small-scale agricultural life wherein the use of outlying summer farms, or fäbodar, maximized the output of the area's poor soil, dense forests, and hilly terrain. During summer months, livestock were moved from outbuildings in the village to forest grazing pastures, historically tended by the youngest or oldest women of the family, who filled their days making cheese and butter for winter. Small crop yields were further subsidized by seasonal migrant labor as painters, builders, and factory workers or by making crafts for sale, resulting in village- or parish-level specializations.[68] Many of these parish specialties now stand as national symbols for Sweden, most notably the red-painted wooden Dala horses (Dalahästar) carved primarily in Mora.[69]

The economic necessity of peddling regional handicrafts as traveling salespeople or specialized trade skills as migrant laborers may have contributed to the cultivation of stable, localized dress traditions. Recognizable dress contributed to economic success. Because Dalecarlians enjoyed a reputation for industrious talent, individuals who made their origins clear were more likely to be hired in city factories or trusted as vendors. Women from Våmhus in Mora parish, for example, were famous across Europe for making popular styles of jewelry using a readily available material—human hair. Queen Victoria in London was counted among their satisfied customers.[70] When hårkullor (hair workers) traveled—going as far as England, Russia, and Jerusalem—the women's recognizable Moradräkt served as a savvy advertisement for their hairworking skills and wares.[71] Not only were Dalecarlians regarded as honest and hardworking, but their honed skills became shorthand for dependable quality. By the twentieth century, new commercial products capitalized on this image of exotically dressed Dalecarlian "maids" (Dalkullor) as especially clever, wholesome, beautiful, and unambiguously "Swedish," using their likeness to sell everything from sewing machines to chocolate, margarine, bananas, coffee, and cigars.[72]

There was another peculiarity about Dalarna that made it attractive to those swept up in popular movements centered on local history, heritage, and folk culture. For centuries, free-holding peasants had followed a system for

Facing, Distinctive dress around Lake Siljan. Museum of International Folk Art. *Photos by Addison Doty:*
Top, Women's festive ensembles from the parishes of Rättvik (with block-print, or *kattum,* apron) and Dala-Floda. *Gift of Florence Dibell Bartlett (V.2019.14.1–9 and V.2019.4.1-7).*
Bottom left, Crocheted cap from Nås made by Birgitta Larsson, ca. 1990s. *IFAF collection (FA.2019.21.2).*
Bottom right, Liduväska (bag) from Rättvik. *Gift of Florence Dibell Bartlett (A.1955.1.502).*

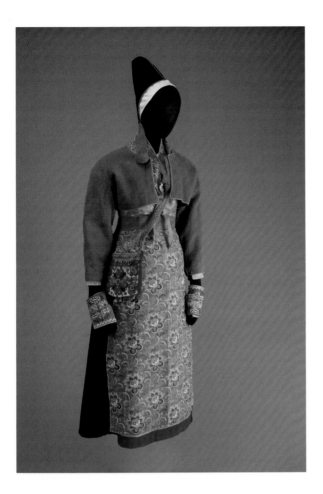

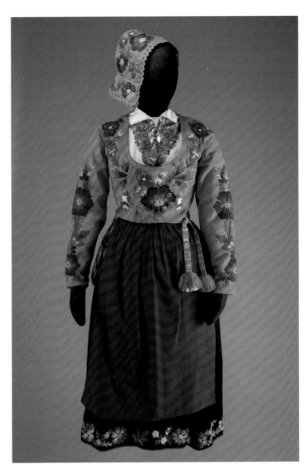

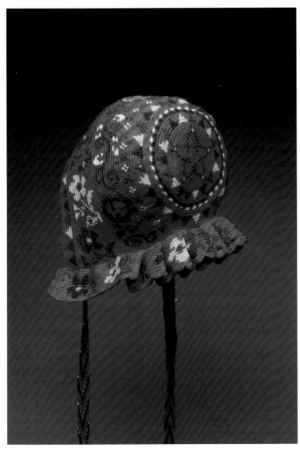

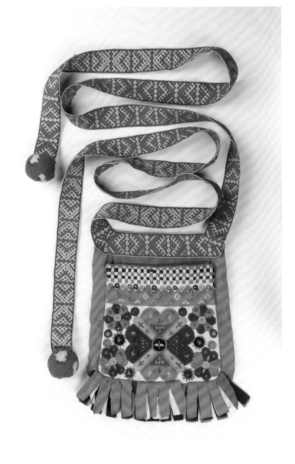

Ullvi village overlooking the Österdal River, Dalarna province. *Photo by Carrie Hertz, 2015.*

partible inheritance known as *sämjodelning* that divided assets between siblings, brothers and sisters alike, though not always evenly. Farms and fields were repeatedly split into tiny lots, resulting in a patchwork of individually owned parcels. While a succession of forced land reforms to increase agricultural productivity had consolidated landholdings into more isolated farmsteads throughout much of Europe, the complex pattern of ownership in Dalarna resisted easy redistribution or enclosure.[73] Many settlements in Dalarna remained organized into numerous densely packed villages with homes and farm buildings all jumbled together and surrounded by tilled fields and rolling meadows. The clusters of timber structures, all treated with the same protective rust-red paint (made with a by-product from the nearby Falun copper mine), contributed to the visual cohesion of intimate settings.

Since the majority of residents were landowners, women included, the majority of people were also guaranteed a voice in local decision-making. As ethnologist Göran Rosander concludes, these customs and settlement patterns promoted a relatively egalitarian, tight-knit, stable social structure in a cozy agrarian landscape that later proved especially enticing to tourists and romantics from the more aristocratic and class-divided south.[74] For those wishing to escape the loneliness or powerlessness they felt as wage earners in urban contexts, Dalarna seemed to offer the model for cooperation, equality, and communal belonging that, as geographer Ulf Sporrang points out, "did not produce social dropouts."[75]

The cultural milieu of Dalarna, with its close geography of specialized crafts and dress, made it especially appealing for the unity-in-diversity ethos of Skansen and the hembygd movement developing at the time. The province illustrated a "sense of culture bound to environment—rejecting universalism" and offered a scaled-down "model of regional belonging, based around the idea of localized regional cultures."[76] Throughout the nineteenth century, a steady stream of artists, researchers, and pleasure-seekers came to Dalarna. Many of Sweden's best-known painters kept summer homes or moved permanently to the region, most famously Gustaf Ankarcrona in Leksand, Carl Larsson in Sundborn, and Anders Zorn in Mora. No fewer than forty-five nationally recognized artists, photographers, composers, and poets settled in the villages of Leksand alone.[77] In addition to celebrating provincial life in their artwork, many of these figures founded artist colonies, museums, and associations dedicated to local culture, crafts, and history.

Working with locals, they revived or expanded community celebrations, such as events for Midsummer, folk music festivals, fiddle competitions, and dances.

Not surprisingly, artists showered great attention on the preservation and perpetuation of local dress. Children's book illustrator Ottilia Adelborg moved to Gagnef and worked with elders to organize a school for teaching regional varieties of bobbin lace.[78] Ankarcrona, in 1904, founded a local handicraft society in Leksand, the first of its kind in Sweden. Dedicated in part to teaching and championing the techniques needed to maintain the *Leksandsdräkt*, the society opened the Leksands Hemslöjd, the first parish-level craft shop following Lilli Zickerman's model, later copied throughout Sweden.[79]

Often wearing the local dress themselves, many Dalarna transplants, like Ankarcrona, became outspoken proponents for folkdräkter's popularization, directly contributing to its local revitalization and innovation. Zorn, for example, designed a distinctive pin for Mora, comprising a cascade of silver arrow-shaped pendants still worn today with the Moradräkt and celebrated as *Zornbroschen* (the Zorn brooch).[80] In 1903, Carl and Karin Larsson designed a new ensemble for Sundborn with a green laced bodice, striped skirt, and red apron. The dress was immortalized in Carl Larsson's Arts and Crafts–inspired watercolors depicting his cheerful, sun-drenched daughters wearing it.

While outside enthusiasts who enjoyed international audiences for their efforts have received deserved acclaim for their contributions to the historical, cultural, and aesthetic development of Dalarna, they should be considered "powerful helpers" and collaborators working alongside "native-born Dalecarlians" who also served as pioneers.[81] As Pravina Shukla explains, "Revivals of folk traditions are generally credited to outsiders and their formal institutions, but it is the insiders, the local creators and leaders, who populate these institutions—the museums, schools, and stores—who accept the responsibility of local action and actually make things happen."[82] Rosander goes further, arguing that the outsiders who were most successful at mobilizing renewed energies in Dalarna were those that demonstrated a genuine sense of shared responsibility by adopting local dress codes, learning local crafts and dialects, and modeling their homes according to local house types. These individuals not only consciously

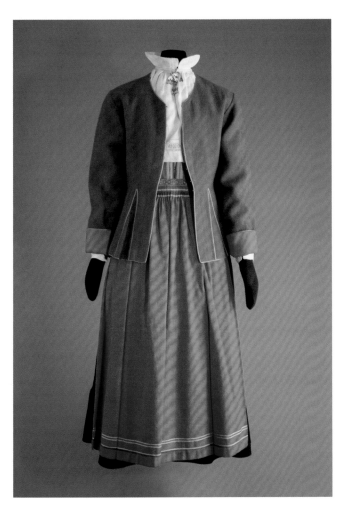

Woman's Moradräkt with Zorn brooch. Museum of International Folk Art, gift of Florence Dibell Bartlett (V.2019.3.1–7). *Photo by Addison Doty.*

Gustaf Ankarcrona's grave in the Leksand churchyard.
Photo by Carrie Hertz, 2017.

chose to praise, support, reform, and exploit the products of local life, but they also showed a certain willingness to adapt to local social norms, thereby demonstrating a wish to belong to the communities they championed.[83] They stood in stark contrast to the swarms of boorish tourists that had started arriving to Dalarna by railroad in the late nineteenth century and who regularly violated customary decorum and private spaces.[84]

The quality of life and aesthetic splendor represented by the diverse and vibrant traditions of Dalarna, not least the beautiful handcrafted clothes, increasingly served as a mythic model for people across Sweden. By the 1930s, Dalarna had been cemented as the "Swedish Ideal" in public consciousness.[85] Swedish cultural historian Gustaf Näsström, summarizing the romanticization of the region, wrote in 1937, "While industrialized civilization rolled victoriously forward over other parts of the country, bringing feelings of unease and loss in its wake, Dalecarlia shone like an Arcadian refuge for tired city souls and all kinds of longing for firm roots and a country idyll in a picturesque old background."[86] As Näsström suggests, like the artists who preceded them, some of the people traveling to Dalarna wanted more than to satisfy their curiosity as tourists—they wanted to experience what they imagined life in Dalarna had to offer. With the passage of laws guaranteeing generous vacations in the 1930s, this prospect became increasingly possible for the middle classes, who bought up summer homes. Descendants of those who had left Dalarna for industrial work also began returning to reclaim the slivers of land they still owned through customary inheritance.[87] Adopting provincial dress was another way of immersing oneself more fully in the local environment.

Though some rural regions of Sweden, like Dalarna, became symbols of "the good life," massive depopulation continued throughout the twentieth century and has accelerated in the twenty-first. Former population statistics have reversed. In the late nineteenth century and for centuries preceding it, nearly 90 percent of Swedes resided permanently in rural areas and engaged in agriculture. Now, roughly 85 percent of Sweden's population lives in urban and suburban settings, exacerbating the centralization of institutions and resources.[88]

With shrinking tax bases, rural municipalities cannot offer the same services and incentives as cities, leading not only to disparities in quality of life but also to growing animosity between rural and urban populations, as rural residents feel that urbanites view the countryside as primarily a place of recreation, leisure, and escape rather than as permanent communities in need of sustaining infrastructure and economic opportunity.[89] Charlotta Mellander, an economics professor at Jönköping International Business School, was recently quoted in the *Local* (an English-language Swedish news source) as saying, "Why shouldn't we have a policeman here [in rural areas] when we pay more tax per capita than people living in Stockholm? Why shouldn't we have a road, a bus, a school within reasonable distance? You should have the right to equal service wherever you live. Right now, that is not the case."[90] Increasingly, younger generations are leaving the countryside, expressing distrust in the stability of local opportunities.[91] Only a small fraction of Swedes, perhaps 2 percent, still make their living in agriculture.[92]

As we have seen, people have long been attracted to Dalarna for its tight-knit agrarian communities and well-developed craft traditions. A number of people living there today, whether recent transplants or from multigenerational families, still wish to make their livings as agriculturalists and artisans. The history of external celebration, as well as cycles of external exploitation, can still be felt in local demonstrations of pride and protection. For some, wearing local styles of dress can declare one's commitment to particular lifestyles, values, families, and lands. In the following sections, we travel to two parishes in upper Dalarna—Leksand and Malung—to meet individuals who consider local dress a foundational element in the type of lives they wish to create for themselves.

Leksand

In Dalarna, many traditional styles of dress grew out of religious practice in the Lutheran State Church, visually allying those who worshipped together at the same parish church. *Sockendräkt* (parish costume), as an alternative term for folkdräkt, highlights this historical background.[93] Dress codes for church attendance that corresponded with the liturgical calendar were common in Dalarna and laid out in parish rules. Leksand parish (*Leksands socken*), therefore, was not alone in developing a parish dress code, but few other places still follow the practice today.[94] To understand why, I turned to people living in the contemporary municipality of Leksand who are widely recognized for their dedication to wearing the Leksandsdräkt and promoting its continued use. That is how I came to visit the Jobs-Björklöf family in the village of Tibble.

I first met members of the Jobs-Björklöf family in the summer of 2015 through the introduction of Pravina Shukla, who has written about Leksandsdräkt with detailed profiles of the family's matriarch, Kersti Jobs-Björklöf.[95] Kersti was already well known at the Museum of International Folk Art, having been integral to the planning process for the 1990s traveling exhibition *Swedish Folk Art: All Tradition Is Change*. The interior of the family's clothing loft (*klädkammare*), located on the upper level of a dedicated building for storing generations' worth of traditional garments, was recreated for exhibition and appeared in the catalog.[96] Kersti has also helped me acquire most of the garments composing the contemporary repertoire of local dress for the museum's permanent collection.[97] Lizette Gradén, who was part of the original research team for *All Tradition Is Change*, has continued working

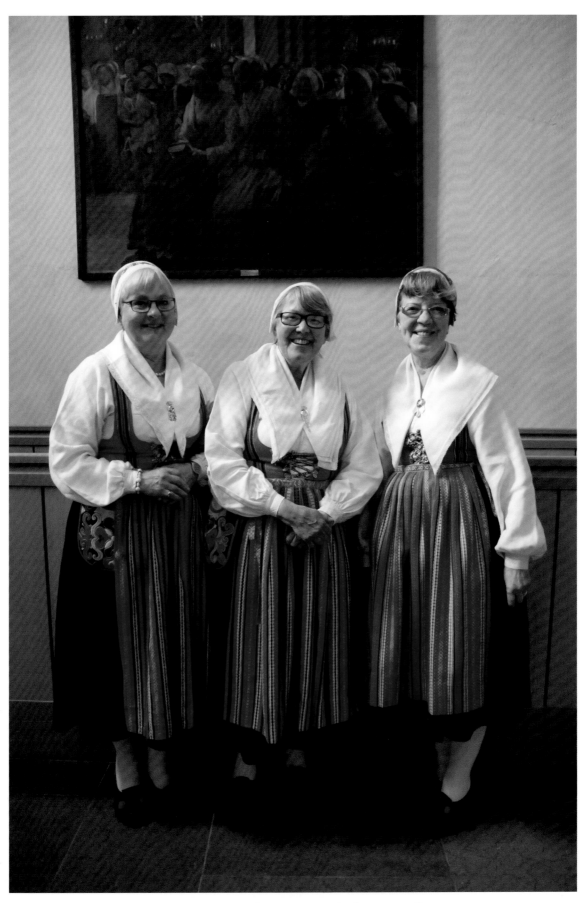

Kersti Jobs-Björklöf (*center*) posing with fellow church wardens Birgitta Fröstad and Kerstin Laurell after Sunday service at the Leksand Church. *Photo by Carrie Hertz, 2015.*

The village of Tibble in Leksand parish. *Photo by Carrie Hertz, 2017.*

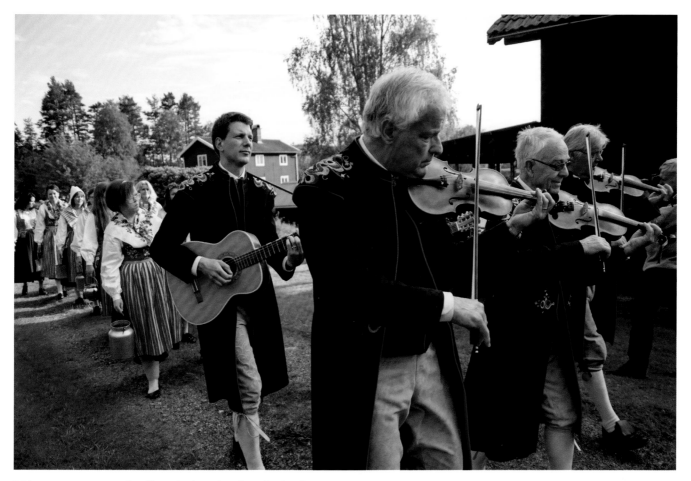

Midsummer procession in the village of Rälta, Leksand parish. *Photo by Carrie Hertz, 2015.*

with Kersti since the 1990s, and in the following chapter, she centers her discussion of vernacular curatorship on Kersti as the material and intellectual caretaker of the family's dress collection.

Since 2015, I have made three visits to Tibble, sleeping in a little two-room *parstuga*, nestled between Kersti's residence and the main farmhouse, which is occupied by her son Erik Björklöf and his wife, Ulla. The lawn connecting the houses was kept neat and trim by a little robotic lawn mower that traveled back and forth throughout summer days before plugging itself in to recharge at night. Generations of the Jobs-Björklöf family have lived on this farmstead, known as Knisgården, stretching back to the sixteenth century. The cluster of homes and agricultural buildings that constitute Knis farm sit within a cozy grouping of similar red timber buildings with only narrow dirt pathways separating neighbors, a blessing when walking home on cold snowy nights.

Tibble, meaning "tight village," is one of several small, dispersed communities that fall within Leksand parish. Village life once was (and for some still is) organized around church attendance, compelling regular trips to the parish center. The

Leksand Church, situated on a hill overlooking Lake Siljan, is located a short distance away in the municipal seat—a quick drive or a pleasant walk along the Österdalälven (Österdal River). Parishioners from dispersed villages used to arrive for Sunday service by boat in a scene captured in countless artistic depictions of the area. The Danish artist Wilhelm Marstrand's 1853 painting, descriptively titled *Church-Goers Arriving by Boat at the Parish Church of Leksand on Lake Siljan, Sweden*, shows men, women, and children dressed in their matching church clothes crowded together on the little beach as people disembark. The painting is held at the National Gallery of Denmark (Statens Museum for Kunst) in Copenhagen, but a full-scale copy made by David Tägström in 1936 hangs proudly in the entrance to the Leksand Church. Congregants, though far fewer dressed in Leksandsdräkt today, pass by it every Sunday.

The basic mansdräkt includes chamois-leather or moleskin knee-breeches (*skinnbrackor/mollskinnsbrackor*) worn with white stockings, a white shirt, and a long, military-style coat and vest in dark wool with red piping.[98] The coat is made in two varieties, a navy-blue one with colorful silk embroideries

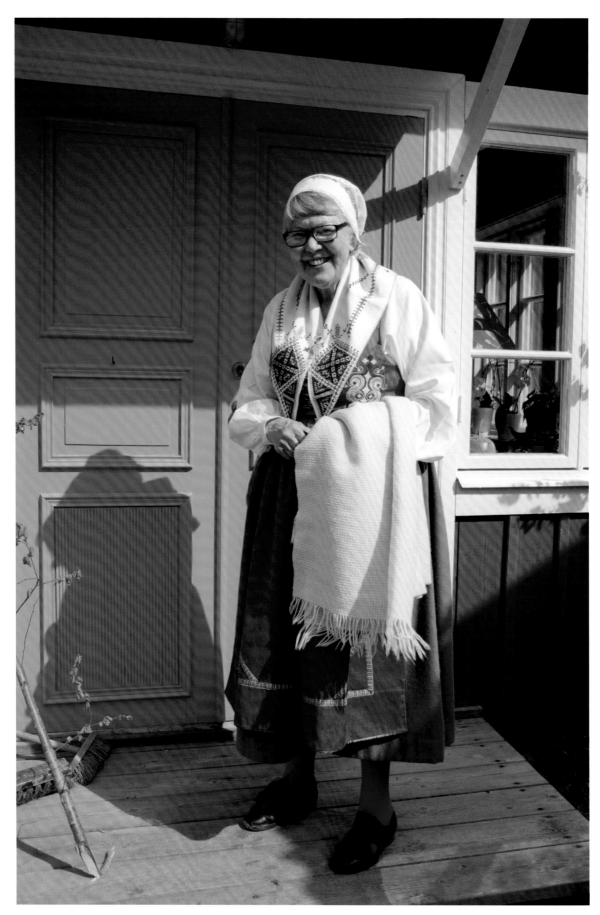

Kersti Jobs-Björklöf dressed to attend church on Midsummer. *Photo by Carrie Hertz, 2015.*

positioned at the center front and on the shoulders like epaulettes (*blåtröjan*) and a black one without embroideries used for funerals and other somber occasions (*kyrkrocken*, or "church coat"). Other than this choice of coats, there are few established "rules" for conventional use. A brimmed hat may also be worn embellished with a thin ribbon woven in black-and-white silk and completed with pompoms (*karlhattband*). The knee-breeches are typically bound with leather garters ornamented with red pompoms (*knätofs*).

The wardrobe for women incorporates far more garments, assembled into coded combinations corresponding with seasonal and liturgical calendars as well as personal rites of passage and community events. The most commonly worn combination consists of a red-striped wool bodice over a white blouse paired with a full black skirt, a red-striped wool apron, white stockings, and a pocket (*kjolsäck*) tied around the waist. A decorative shawl is also worn pinned with a silver brooch at the neck. Depending on whether a woman is married, she may have different choices for headwear and accessories. This "basic red" ensemble (*bas i rött*), appropriate for many celebrations, can be reconfigured by swapping key elements, most importantly the bodice, shawl, or apron. Other outfits fall within the "black field" (*bas i svart*), more appropriate for solemn occasions.

Individual garments are further ranked in importance based on their color and material, preserving connotations associated with the historical rarity or expense of particular dyestuffs, imported cloth, or finished goods made by professionals. The selection of garments—their color, material, decoration, and ranking—signals the general mood and purpose of the occasion. During the most important church high holidays, such as weddings, Midsummer, or Christmas, a woman might wear a red bodice in silk damask embroidered in colorful silk thread. The white blouse would be made of fine imported cambric with the cuffs and collar embellished in geometric whitework designs rendered in satin stitch. Instead of the basic black skirt, a woman could wear the more recently revived green skirt paired with red stockings instead of the usual white. The highest-ranking apron is used, a blue one (*blå raskmajd*) traditionally made with expensive imported materials—woven ribbon trim and fine glazed and calendared wool called *rask* dyed with indigo or woad. Festive accessories, such as leather belts studded with pewter ornaments and silk-embroidered chamois half-gloves, can also be added. The specialness of this combination is further emphasized by including the black silk embroidered shawl for which Leksand is famous, the *tupphalskläde* in local dialect (also commonly referred to in published sources as the *svartstickkläde*).[99] To funerals, in contrast, a woman typically wears a similarly embroidered bodice, but in black damask, over a plain blouse and shawl with a black skirt and yellow-and-black-striped apron of homespun,

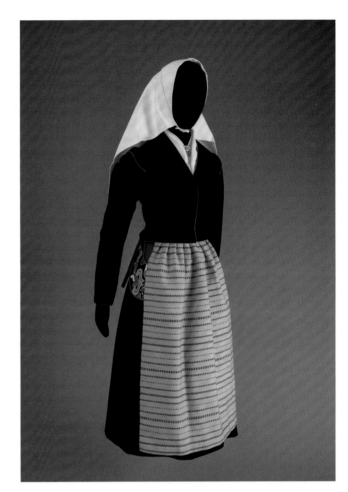

Woman's Leksandsdräkt in the combination worn for funerals, ca. 1970s. Museum of International Folk Art, IFAF collection, with gifts from Kersti Jobs-Björklöf and Lis-Mia Dahl (V.2019.19.1–7). *Photo by Addison Doty.*

home-woven wool. As the easiest and cheapest color to produce (usually from boiling birch leaves), yellow is considered an everyday color, used not only for times of mourning when one should be dressed simply but also for economy, as with dresses that little girls will quickly outgrow.[100]

Some of the economic and social conditions that contributed to the internal logic of the dress code no longer apply, and in fact, some dress elements may now be valued in reverse. Many people prefer the homespun, home-dyed, home-sewn garments made with local materials, as these are increasingly harder to come by today. Newly made garments are more commonly created with factory-woven materials and commercial patterns, often sourced through the Leksands Hemslöjd. Being made according to the Hemslöjd's standardized designs or preassembled kits, these garments tend to be more uniform in material and appearance.

Handcrafted and customized clothes, however, are still available. Some pieces can be purchased new from artisans at high prices, particularly those items traditionally made by specialists, such as tupphalskläder, sheepskin coats, and other

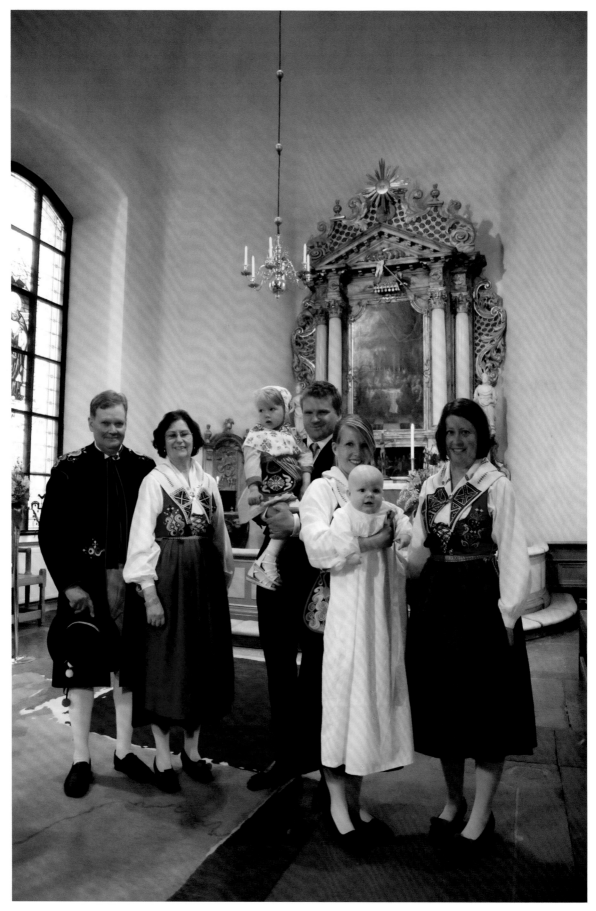

The Skalk family dressed for the baptism of baby Eivin at the Leksand Church. *Photo by Carrie Hertz, 2015.*

Hand-colored drawings created for the 1978 *Almanacka för Leksandsdräkten. Photo by Carrie Hertz, 2017.*

leather goods, all of which can cost hundreds if not thousands of dollars each. Customers can visit one of the dozens of artist studios and workshops scattered throughout the county to arrange for custom orders. Kerstin Lissel at Leksands Skinnateljé, for example, specializes in the fancy style of men's chamois knee-breeches with characteristic embroidery (*laskning*) on the thighs. Unlike the colorful embroidery of men's coats, this type is done in thread matching the leather with only tiny, subtle stitches showing on the fabric face. When the "lashed" or "laced" threads are pulled taut across the back, they create a beautiful, raised appearance as if the leather surface has been embossed. A custom-made pair will cost around 11,500 SEK (US$1,200). Similarly, Helena Karlsson of Skotjänst makes Dalarna styles of traditional birch-bark-bottom footwear cobbled to customers' precise measurements. A pair of women's black leather shoes for Leksand with little red pompoms cost around 4,000 SEK (more than US$400). In addition to bespoke offerings, specialists like Kerstin and Helena provide another service, perhaps of equal importance.

They can repair old clothing and accessories, restoring family heirlooms and secondhand finds for continued use. An active secondhand market remains strong in the area, granting those without access to family collections a chance to wear highly valued vintage versions of local dress.[101]

Even with these varied options for acquiring new and vintage dress, the Leksand dress code for women, organized around a hierarchy of red and black tones, has been carefully preserved in costume almanacs, and for those who choose to follow it, its logic can feel deeply ingrained.

As a church warden, Kersti attends services most Sundays wearing the proper combination of garments. She describes the code as complex, but "in the old days, they knew exactly what they should have and use for going to church." At that time, not only did the majority of people attend church regularly, but they also wore local styles of dress daily. Kersti remembers women wearing Leksandsdräkter, or parts of it, while performing mundane activities, such as mowing the lawn or sitting in hospital waiting rooms, well into the 1980s. Generally, though,

local dress was already becoming reserved for special occasions by the early twentieth century, a period that, despite booming tourism, represented an economic downturn for the area. As fewer people participated in the dress code, memory of it weakened. "You needed some sort of a handbook," she explained, "because the tradition was almost forgotten."[102]

At the urging of Gustaf Ankarcrona, a lawyer named Albert Alm compiled the first costume almanac in 1923 outlining the various combinations for every Sunday of the church year. *Dräktalmanacka för Leksands socken* (*Costume Almanac for Leksand Parish*) was based on interviews with community members, making it precious to descendants, but it lacked illustrations. Copies today are extremely rare.

In 1978, Leksands Hemslöjdsförening (the Leksand Handicraft Society) commissioned a new book, this time with hand-colored illustrations. The society asked Kersti and her mother, Karin Jobs, to write it. By this time, Karin had already prompted a renaissance for wearing the green skirt during weddings and Midsummer, a practice that had disappeared in the 1860s but returned in 1950s through her encouragement.[103] When this new volume, *Almanacka för Leksandsdräkten*, also

went out of print, a committee of church women was formed, and Charlotte Lautmann was selected to be the editor with Kersti, Elisabeth Näs, and Kristina Kvarnbäck serving as key contributors.

Charlotte, the wife of the vicar and a photojournalist for the parish paper, suggested that the new almanac feature only contemporary photographs taken in living contexts. "I didn't want those fake . . . staged photos," she told me in 2015, referencing the valorizing but ultimately exoticizing studio portraits, touristic carte-de-visite scenes, and simulated images of antiquated folk customs that proliferated around the turn of the twentieth century.[104] Charlotte, having grown up outside of Dalarna, values the way local dress practices feel organically interwoven with other details of daily life. While holidays bring out large numbers of people in Leksandsdräkter, one might also see someone dressed to attend a concert or a baptism on an otherwise average day. People in Leksand, she said, "just dress naturally. You are not dressed for theater or for being looked at. It's a natural way of being." She contrasted the way locals wear folkdräkter to their counterparts at Skansen, dressed in standardized costumes that may not belong to them

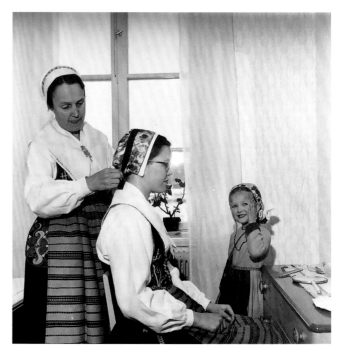

Generations: Kersti Jobs-Björklöf (*seated center*) with her mother, Knis Karin Aronsdotter Jobs, and her sister, Britta. *Photo by Verner Jobs, courtesy of Kersti Jobs-Björklöf.*

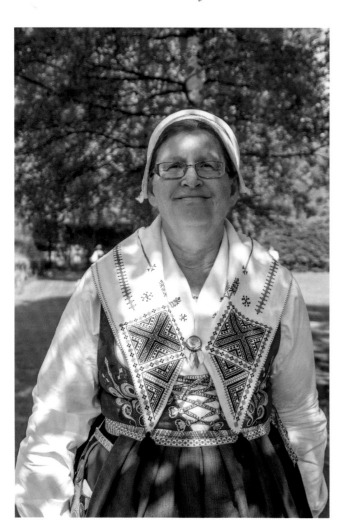

Charlotte Lautmann. *Photo by Carrie Hertz, 2015.*

so they may perform choreographed dances for tourists. For Charlotte, the celebration and standardization of folkdräkter spurred by romantic nationalism should not overshadow the centuries-long, living practice found in Leksand, though of course, these histories can be understood as mutually constituting.

While romantic images and national displays were produced for the gaze of outsiders by relying on widely legible symbolism, insiders primarily dress for each other, communicating personal information using subtle and shifting local conventions. Charlotte wanted to capture a sense of these subtleties in the new almanac, *Leksandsklädd* (*Leksand Dress*). When it was completed in 2013, the book was consciously populated with familiar faces from the community, each pictured in their own clothes at different Sundays, holiday gatherings, and personal celebrations. In group scenes, the internal diversity driven by personal taste and circumstance is easily discerned, a fact often missed when a single version appears at Skansen or in illustrated typologies of regional dress in Sweden. Charlotte, like many people in Leksand, stresses that the local dress is not an unchanging uniform.[105]

While an almanac, codifying variations within an encompassing framework, may suggest inflexibility or stasis, the Leksand dress code is actually the product of ongoing communal consensus, reflecting alterations in community practice with each new edition. When work began for *Leksandsklädd*, the committee observed changes to church liturgy. Until recently, the last Sunday before Advent had been considered a solemn day of reflection, requiring an apron from the black tone. New liturgical texts, however, emphasize more joyful themes of resurrection, suggesting a celebratory option from the red tone. With this new interpretation in mind, the committee considered a slight modification to present practice. Kersti explained, "We had a meeting with the church wardens and [other] Leksand people interested in this. We said we want to change [the apron for] this Sunday. It should be green instead of black-and-white. We were hesitating, because we didn't feel as if it was okay. It was deep in us, not only me, but also the others. In the end, we said okay. In this book, it was said you should have the green one." Despite the committee's attempts to poll parishioners, after the new almanac was published, some were resistant. A neighbor contacted Kersti and told her, "I can't go to church [that day] with a green apron." When the Sunday in question arrived, very few people followed the almanac. Instead, they followed the previously published code, also held in their memory and experienced intuitively through years of repetition. Kersti concluded, "I think you can't order what to do, because the tradition is strong. You can't just decide that from now on, we shall be dressed like that, or say you should change. That's hopeless! I think that this central decision, it's not easy, because people want to do as they *feel* is right." In

this way, the almanac was never intended as an inviolable rule book. While it might serve as a general agreement, a resource, and possibly an arbiter during disputes, the true negotiation of coded practice still plays out in the shifting context of daily life. For many like Kersti, who was raised in a family that paid close attention to the annual cycle of ensembles, the code is held primarily in the mind. Others, like Charlotte, who moved to Leksand but wishes to take part, lack such memory or intuition. Local advocates, fearing that the complexity of the code deters novices from participating, hoped the almanac would encourage them by offering a pathway to cultural competence.

Certainly, as the incident with the green apron suggests, not everyone follows the published code to the letter for a variety of reasons. Multigenerational families, such as the Jobs-Björklöfs, often collectively possess hundreds of garments accumulated over many years and lifetimes that can now be circulated among relatives as needed. Individuals without similar family collections may not be able to afford the extensive wardrobes required. They may not have the interest or inclination. If people do not attend Sunday services regularly, a number of the dress combinations are unnecessary. A woman

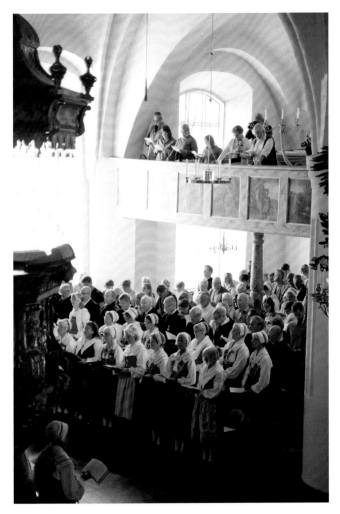

The Leksand Church choir. *Photo by Carrie Hertz, 2015.*

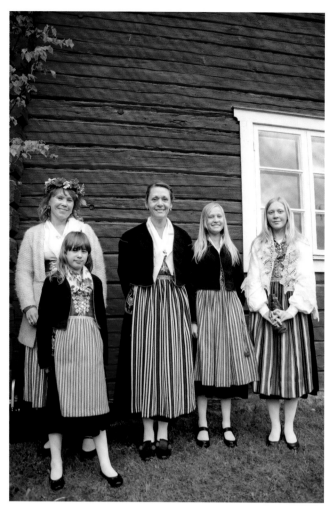

Personal variations of the Leksandsdräkt worn for Midsummer in Tibble.
Photo by Carrie Hertz, 2015.

Some community members are deeply invested not only in following the dress code but also in adhering to nuanced details unpublished anywhere. One woman told me with visible frustration that her daughter had been openly criticized for not ironing her blouse "correctly" so that crisp lines ran down the outside of the arms. Another woman relayed that she had no interest in wearing local dress, thereby avoiding comments like, "Your pocket is on the wrong side." "You don't do that with any other clothes," she said, "telling strangers, 'Your cut of jeans is wrong!'" Several people also shared the same story, perhaps a local legend: a woman arrived at the church entrance one Sunday, only to discover she was wearing the wrong apron. Rather than face the shame of being incorrectly dressed, she turned around and went home.[106] These anecdotes reveal the social pressure delivered by cultural gatekeepers who clearly define and monitor the boundaries of acceptable engagement with tradition. This class of participant exists for all of the dress traditions featured in this book, usually referred to as "police," as in this case, the *dräktpolis* (costume police).[107]

In Leksand, we see that policing takes many forms, from criticism to self-regulation. Most often, however, knowledgeable individuals will guide unwitting novices into "correct" behavior, if deemed necessary, through compassionate intervention. The committee that created the most recent almanac saw their efforts as a way to curtail anxiety. "It's not easy to know about all these things," Kersti explained, "so this should be a help for people." She believes that the vibrancy of local tradition benefits from encouraging people who clearly wish to become integrated into the community. "I'm not fond of the dräktpolis," she admitted. "You shall be happy if people want to use the costume and say thank you. If you like it and you like being here, why shouldn't you wear it?"

The social weight placed on individuals' choices, whether through embarrassment or through praise, intends to preserve local control over the meanings and uses of garments long admired, studied, and exploited by outsiders. The ways in which the Leksandsdräkt has become entangled in the history of Sweden's romantic nationalism, tourism, right-wing politics, and commercial advertising can be especially frustrating for those who believe the state is now abandoning its former mission to support and celebrate its regional diversity through centralization. Within this context, the proper use of Leksandsdräkt demonstrates a will to belong, not as an admiring pleasure-seeker wishing for a fleeting taste of "the good life," nor as an opportunistic ideologue, but as someone accountable to neighbors in a shared project to preserve local character. As Karin Eksvärd advocated, such a demonstration is often less dependent on matters of descent than on those of consent.

Transplants and part-time summer residents can find a sense of local acceptance. For example, Margaretha Johannes,

can often borrow the required garments if she plans to dress for an occasional baptism or funeral. While members of the choir, the church wardens, and a few others dress faithfully in Leksandsdräkter, most parishioners wear cosmopolitan dresses or button-down shirts and slacks. Many locals dress only once a year for Midsummer festivities. During these community events, individuals may feel freer to prioritize their preferences. While attending maypole raisings in Tibble, Rälta, or the municipal seat, one is most likely to see the "basic red" outfit, often paired with a rose-printed or checkered cotton scarf considered inappropriate for church, but less common garments may also surface. For a drizzly Midsummer in 2015, Ulla, for example, wore a goatskin bodice (*skinnsnörliv*), beautifully embroidered in an embossed style similar to men's breeches, though this now rarely seen garment is more often considered winter or workwear. As a more casual celebration, a Midsummer pole-raising presents opportunities to show more individual flair or connoisseurship with vintage clothes.

a woman who married a Leksand man and began summering there, felt initially too intimidated to wear Leksandsdräkt.[108] With encouragement, however, she took courses every summer at the Leksands Hemslöjd over several years, eventually making most of the main repertoire of garments for herself. She acquired additional pieces from her husband's relatives. Decades later, she describes the process as a sort of enculturation into responsibility that echoes the sentiments of Charlotte Lautmann. To wear Leksandsdräkter, she said, "you should have a connection with this area of some kind, if you were born here or if you live here. It should not be as a theater. It's not to show off: look at this beautiful dress. You should have something inside instead [tapping her heart]. I have been here for many years, but when I started [wearing the Leksandsdräkt], then I thought, *now* I belong to this area." Slipping into a blouse, bodice, and skirt is only one aspect of joining local practice. As Margaretha suggests, one should also feel obliged to acquire deeper knowledge and cultivate deeper emotional bonds. The right to wear the dress comes hand in hand with assuming reciprocal responsibility for the community's well-being.

In Leksand, individuals can easily point to numerous innovations in the local dress, especially those related to fluctuating hemlines, the availability of materials, and modifications to the dress code, as well as newly introduced or revived items, such as the green skirt. In conversation, however, such changes are not given the same rhetorical significance as stable features. Intentional continuity within consensual dress codes is weighed far more heavily than alterations driven by fashion or necessity. Continuity and visual cohesion are active choices, ones that have long been valued in Leksand. A historical example that Kersti shared with me can serve as a clear illustration.

In the nineteenth century, new trade routes emerged between Dalarna and Røros in Norway. When men from Dalarna started transporting local goods by horse-drawn sleighs and wagons, they picked up colorful knit caps in Røros to bring back as souvenirs. Known locally as *spelmansmössor* (fiddler's caps), they became popular accessories, especially among musicians who wore them while playing at festive gatherings. They remain popular today, now more likely made by local knitters and sold at area craft shops than sourced from Norway.[109] Spelmansmössor were made in a variety of similar patterns, but according to Kersti, traders from different parishes, when presented with choices at markets in Røros, elected to purchase the same designs as other buyers from their own parish. Though many parishes around Lake Siljan adopted spelmansmössor, the specific pattern can announce the wearer as someone from Leksand, Rättvik, Ore, or Mora. These men from neighboring parishes all followed the same fashion but wished to highlight their particular local affiliations,

Spelmansmössa (fiddler's cap) for Leksand knit by Britta Solen, ca. 2018. Museum of International Folk Art, IFAF collection (FA.2019.21.1). *Photo by Addison Doty.*

maintaining parish distinctions within the unified diversity of Dalarna. For people in Leksand, then and now, the Leksandsdräkt helps locals conceptualize their home as a specific and distinctive place, as well as materialize their personal connection to it.

Kersti told me that she believes people in Leksand have been "raised in pride," knowing through observation and instruction that the local dress is admired by both insiders and outsiders. The Leksandsdräkt, alongside the picturesque landscapes and other folk-art traditions, still attracts tourists. In the municipal seat, dress designs decorate the downtown. A bank features a glass entrance frosted with the embroidery patterns taken from the shoulders of men's coats. Ribbon patterns encircle trash cans. One of the grocery stores boasts a wall mural depicting Midsummer celebrations with boxes of small charcoal grills stacked in front of it every summer. Many of the shops carry commercial products inspired by Leksandsdräkter,

including pillows and blankets patterned like striped aprons and baseball caps with characteristic embroidery motifs.

When I visited Tibble in the winter of 2017, an informal public debate was underway concerning recent merchandise introduced at the Leksands Hemslöjd. Much of this discourse centered on packages of paper napkins printed with a detail from a typical tupphalskläde. As we learned, the tupphalskläde is the highest-ranking shawl, often embroidered in black silk with the wearer's initials and the year of its manufacture. Each one represents many hours of skilled labor, and a newly made one can cost over US$1,000. This shawl, perhaps more than any other item of women's dress, is the most likely to be treasured as a family heirloom, passed down for generations. In fact, Linn Sund, the Hemslöjd's manager at that time, said she based the design for the napkins on her own grandmother's shawl. Developing new commercial products based on "folk" designs has always been part of the hemslöjd movement, but locals expressed mixed feelings when the napkins appeared for sale in the shop.

While I was staying at Knis farm that February, Kersti hosted a small lunch for women interested in local dress, setting each place with the new napkins. Around me, I watched as one by one, the women set their napkins carefully aside or turned them inside out to hide the pattern. When I commented on this, one person blurted out, "I can't wipe my mouth on the shawl!" They had been raised to treat the tupphalskläde as a precious part of their inheritance, brought out on only the most special of occasions, and this reaction is indicative of their shared interpretation of the garment's cultural, historical, and aesthetic significance. While other inspired products may seem fun or inconsequential, for some locals, mass-produced, disposable napkins of the tupphalskläde cross the line into disrespectful misapplication. Disposable napkins can further alienate those who associate the Leksandsdräkt with a history of agricultural subsistence carefully attuned, by great necessity, to the potential yields and limitations of the local environment.

In addition to communicating a sense of shared responsibility, some individuals from younger generations in Dalarna increasingly consider their use of local dress as a reflection of shifting priorities—specifically, a renewed investment in leading less consumer-driven, more environmentally conscientious lives based on agricultural continuity. When I visited the Dalarnas Museum in Falun, I asked curator Anna-Karin Jobs Arnberg why locals in the province were still interested in folkdräkt.[110] Anna-Karin, a talented embroider in a style known as *påsöm* that is unique to her natal home in Dala-Floda parish, related local popularity to growing concerns about anticonsumerism, localism, and ecological sustainability in food production: "If you look at food today, you want to have food that's organic and local and do-it-yourself. You want to know

what you put in your mouth. I think it's also with the costumes and techniques. I think the time when you're just shopping for everything and everyone looks alike, you want to have something unique that you can wear your whole life. Something out of wool and linen. Some people want to buy sheep so they can produce their own wool. It's something happening today. They want back to tradition. Something that's *worth* something." In this way, local clothing and food production are both valued for remaining small-scale and within personal control, resisting fashionable obsolescence, highlighting natural components and annual cycles, utilizing shared traditional knowledge, and relying on acquired technical skills that promote a sense of individual sustenance and satisfaction within communal cooperation.

Since the 2000s, critics of "fast fashion" have advocated for a "slow fashion" movement centered on moderation, localization, ethical supply chains, and ecological sustainability modeled on the principles of the "slow food" movement.[111] In more recent years, those promoting the revitalization of traditional craft techniques and local styles of dress have also begun adopting the term, expanding its meaning to include issues of heritage, pluralism, and *cultural* sustainability.[112] From this vantage point, folk costume can be imagined as the original slow fashion.

In this calling toward more intentional and responsible living, folklorist Thomas A. DuBois sees the development of a sort of contemporary "secular spirituality" that wishes to reenchant daily life by "restoring the sense of the artisanal, the personal, and the inventive in a world increasingly sustained and performed online, one in which producers and consumers are often completely unknown to each other, while life proceeds at a frenetic and relentless pace."[113] Even in a more secular era, old "church dress" can be imbued with this recontextualized aura of sacred meaning. The intersections between slow movements for food and dress and the longing for a deeper connection to land and lineage became clear to me during another visit to Tibble.

One cold, dark Sunday in February 2017, Erik and Ulla invited me to join them for dinner at the main farmhouse at Knisgården, just a few steps from the parstuga where I was staying. Sitting around a big table, cozy in their large kitchen, I was treated to a masterful, multicourse meal made almost exclusively from foods sourced from the farm and surrounding environs, including freshly caught fish and game meat. Near the end of the meal, their daughter, Knis Anna Ersdotter Björklöf, and her partner, Jerk Gummuns Jones (pronounced Yearrick), dropped by to deliver wheels of homemade cheese— their first attempts at cheese making, just ready to eat after months of ripening.

Erik swelled with pride when he explained that Anna, his only daughter, would continue the agricultural traditions of

the family, inheriting Knis farm. Anna and Jerk, currently on break from attending an agricultural school, were spending the winter at Knis farm to raise hogs as part of a class project. For the next summer, they planned to continue their hands-on education working with cows and sheep on Jerk's family farm in neighboring Rättvik. After dinner, we braved the winter air to visit the sheep huddled up in the barn next to the farmhouse.

The next day, I sat down with Anna and Jerk in the spare little house they were using on the Knis property.[114] Right next to it, their hogs were wallowing happily in a muddy pen. Inside the sparsely furnished living room, a few heavy-metal music posters tacked to the walls and a string of Christmas lights enlivened their temporary home.

Anna and Jerk, then both twenty years old, share similar family backgrounds, having grown up learning to manage farms and wearing the local styles of dress of their respective parishes. They both expressed appreciation for the sense of confident grounding that this familial education has afforded them. Anna described how it feels to wear the Leksandsdräkt: "I'm proud, because when people see me in it, they know where *exactly* I come from. People see: this is a person who has strong roots and is proud to show it. I think that's rare today." Jerk

agreed, adding that wearing the clothes was a way of "honoring your ancestors" and taking part in the flow of local history. There is comfort in imagining that their lives, while uniquely of their own era, will not be wholly different from those of previous generations. Anna referenced her own wardrobe as illustration. Like many others living in old Dalarna families, Anna can put together ensembles of local dress, as needed, from the communal collections kept at Knis farm. Many of these garments are not only exquisitely handmade; they are also tangible links to family stories and lost loved ones. She can combine these treasured garments with new ones that she has made or acquired for herself. She said, "I value old pieces much more, but [I value] also new pieces made just for me, because I know this is something people [in the future] will see like I see the old pieces now, in maybe a hundred years. So even though I think it looks new and machine-made, in a hundred years, someone will think this was made just for her. *This* is her." Anna has faith that her life story will be folded in with the generations of other stories contained in the family's collective wardrobe. Future generations will face different challenges, opportunities, and circumstances, but hopefully they will continue wearing Leksandsdräkter and take responsibility for remembering family traditions. Maybe they will wear her

Knis Anna Ersdotter Björklöf. *Photo by Chloe Accardi, 2018.*

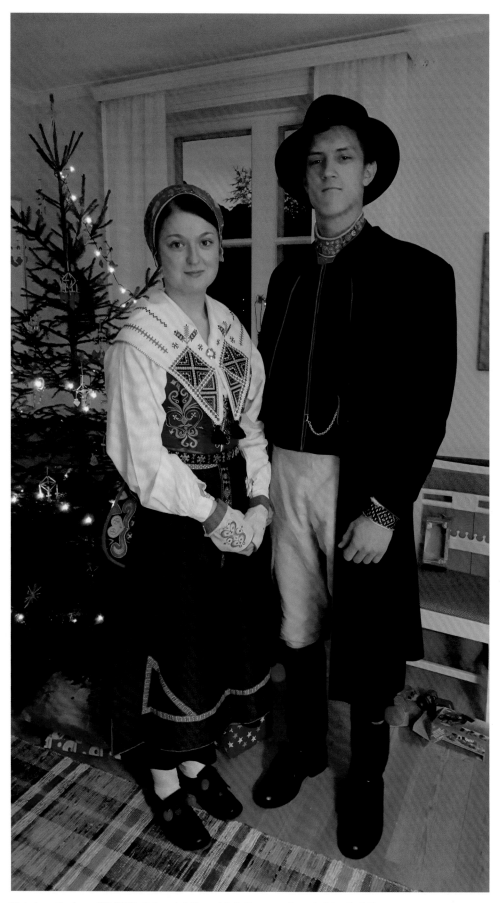

Knis Anna Ersdotter Björklöf in Leksandsdräkt and Jerk Gummuns Jones in Rättviksdräkt
for Christmas Day. © *Ulla Björklöf, 2016.*

clothes, perhaps a shawl embroidered with her initials and the date, and remember her and think about what life in Leksand was like during her time.

I asked Anna and Jerk if their pride in wearing local dress extended to a pride in being Swedish. They agreed that it did not. Anna explained that she valued Leksandsdräkten for showing that she is "not just typical Swedish." The styles of dress in the province, she countered, are "more village to village." Collectively, they reflect the regional identity of Dalarna but more importantly one's place within that shared space. Jerk explained that the distinctions between clothes from different historical parishes, even when objectively minor, are still considered very important and worth preserving. Kids from different areas often cultivate a friendly rivalry about whose local dress is more beautiful, even when there is little difference between them. Jerk offered the men's festive coats worn in Rättvik and Leksand as an example. The two models, as long navy-blue coats with red piping, are nearly identical in cut, color, and detail. The version in Leksand, however, features the much-celebrated embroidered designs on the shoulders. The general consensus about this small dissimilarity among Jerk's friends in Rättvik: "We call it seagull shit." Anna, of course, believes they are simply jealous. No one in Rättvik, however, has been known to adopt it. Integral to the consensual ethos of the contemporary folkdräkt practice in Dalarna is an appreciation for the specific features associated with the place where one lives.

Choosing to wear local dress (and wearing it according to local tradition) is a demonstration of loyalty and contentment. As Jerk described it, "When you have it on, and it's a group of people and everyone has it, it's a special bond." The sense of equality that such a scene suggests, they argue, is at the heart of feeling satisfied with one's own life.

For Anna and Jerk, their choice to continue local dress practices is intertwined with their desire for a continuity embodied in identities as young farmers from old farming families who wish to cultivate the same land tilled by generations stretching back four hundred years. The realizations of these desires, though beholden to the past, are thoroughly embedded in contemporary life and contemporary concerns. Anna's Instagram feed, for example, is populated with idyllic pictures of cows, sheep, and tractors, industrial cheese vats, farm-to-table meals, Midsummer maypoles taken from artful angles, and selfies with friends and family dressed in overalls, streetwear, and folkdräkter.

She also perceives a shift in the way people her age think about the dress and its connection to personal goals. Though rural areas in Sweden have experienced continuous out-migration to cities for decades, she and some of her friends want to stay put. They see such moves as contributing to restlessness and dissatisfaction with only superficial payoff. Continuity

with tradition, on the other hand, suggests security, unbroken familial connections, and fulfillment. She explained, "We're raised in such a way that folk costume is so important. We're raised in old houses. We know who our ancestors are. We know all of them. Our biggest goal is to come home and start growing the fields that our ancestors have. Many of our friends, too, want their *own* farms, but on their own lands. It's a generational thing. Our parents, they wanted to have big careers and to do this-and-that. We're searching for home. We want to have our roots *where we have them*. Career and material things aren't so important to us, I think." Jerk nodded and added as summation, "Yeah, a stable life."

Malung

The parish of Malung in northwestern Dalarna was the site of early specialization in fur and leatherworking reaching back to the seventeenth century. Until the mid-twentieth century, the majority of households were involved in a cottage industry, raising sheep, goats, and cows as part of the regional fäbod system in the summers and maintaining fur and leather workshops on private farmsteads during the winter.[115] As itinerant tanners and tailors, men from Malung, known as *Malungsskinnare*, regularly traveled from village to village throughout the Swedish countryside, preparing skins and fashioning a variety of parish-specific styles of leather knee-breeches, work aprons, vests, bodices, winter skirts, gloves, and shearling coats for individual families while lodging at their farmsteads.[116]

Malung was also situated along trade routes between Värmland and Norway, serving as a rural hub within the flow of goods and raw materials, especially unprocessed sheepskins and goatskins.[117] Developing on this foundation of craft and trade skills, hundreds of commercial tanneries, skin merchants, and leather manufacturers set up operations during the first half of the twentieth century, contributing to Malung's reputation as the leather capital of Sweden.[118] Between 1951 and 2009, a School of Design and Leather Fashion (Malungs riksskinnskola) brought students from across Sweden, Germany, Denmark, Finland, and Norway for two-year vocational training in leatherworking and clothing design.

Today, Malung is part of an amalgamated municipality of about thirteen thousand residents known as Malung-Sälen, with only a few heritage leather companies and summer farms still in operation. The past of pastoral and craft specialization, however, still deeply informs local identity, actively promoted through a network of cultural heritage organizations. Several outdoor farmstead museums (*hembygdsgårdar*), consistent with the principles of the hembygd movement, can be found in communities throughout the municipality, including in Lima, Transtrand, Rörbäcksnäs, and the municipal seat of Malung. A few working summer farms also welcome visitors curious to learn more about the fäbod system of livestock pastoralism.

These organizations are joined by influential educational resources also built on local cultural foundations. In 2012, the Malungs riksskinnskola was resurrected in the face of growing demand for training and apprenticeships, reopening to both Swedish and international students.[119] A nationally recognized folk high school, Malungs folkhögskola, not only offers courses in a variety of regional crafts (including those related to leather and fur) but also organizes hands-on training in sustainable, small-scale livestock farming according to the fäbod tradition. The Malungs folkhögskola, however, is best known for its focus on regional folk music, including vocal training in the local *kulning* tradition, a haunting style of unaccompanied singing developed by women to communicate with distant neighbors and to call their cows home from summer forest pastures.[120]

Historically, artisans from Malung played a significant role as expert specialists, maintaining knowledge of a diverse repertoire of distinctive parish styles for winter clothes throughout Sweden, especially within Dalarna province. *Skinntröjor*, shearling coats, were typically made of white sheep or lamb's skin with the fleece turned inward for warmth, except at the cuffs, collar, and hem, where curly fleece was turned outward for decorative effect. As with other highly localized garments worn around Lake Siljan, parishes developed their own designs for skinntröjor with silhouettes and embellishments that echoed local style and aesthetics. Women's skinntröjor in the parishes of Rättvik and Boda, for example, are remarkably short, following the lines of the empire-waisted bodices typical of local dress. In Orsa and Mora, they feature long peplums similar to the cut of women's wool jackets worn during warmer weather. Likewise, skinntröjor for men tend to repeat the length of their wool coats—long in Leksand, shorter in Åhl. While shearling coats may have served as outerwear on regular days, the matching silhouettes also allowed individuals to treat them as extra winter layers, wearing them underneath their more formal wool jackets for church with the curly fleece edgings peeking out.

With the introduction of apparel companies, factories, and tanneries during the twentieth century, fur and leather specialists turned toward making more cosmopolitan products,

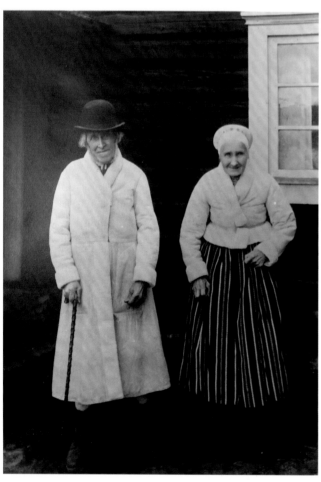

Skinntröjor (shearling coats) for Leksand parish, ca. 1910. Worn by Kersti Jobs-Björklöf's maternal great-grandparents Hallmans Carl Olsson (1821–1914) and Djeken Margareta Persdotter (1831–1913) at Hallmans Farm. *Courtesy of Kersti Jobs-Björklöf.*

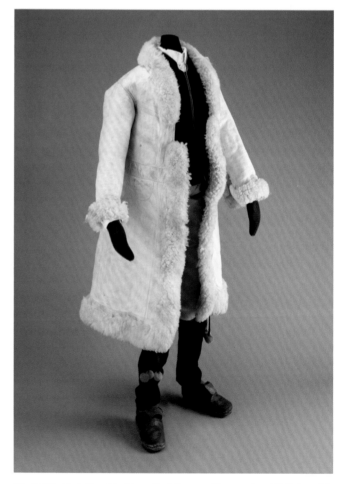

Man's Rättviksdräkt with skinntröja. Museum of International Folk Art, gift of Florence Dibell Bartlett (V.2019.33.1–8). *Photo by Addison Doty.*

Täpp Lars Arnesson holding a *skräppa* (field bag) he made. *Photo by Chloe Accardi, 2018.*

resulting in fewer knowledgeable artisans available to make localized styles. Many family collections still contain shearling coats and winter skirts, but with age most of these become too stiff and brittle to wear. Skinntröjor are rarely seen with folkdräkter today. As with other forgotten elements of parish dress, however, contemporary artists are beginning to reintroduce them into living practice. One such artist is Täpp Lars Arnesson, a sixth-generation leatherworker from Malung parish who advertises his family background by professionally highlighting his Dalarna farm name, Täpp.[121] Most of Täpp Lars's known ancestors have participated in the local leatherworking trade in some capacity, with his great-great-grandfather counting as part of the last generation to work as itinerant tailors.

I visited Täpp Lars in 2015 and 2018, spending time at his professional studio located in the Malung county seat (formerly the site of the leather company H.P. Erikssons skinnvaru), his home studio on his family farm, and his working fäbod in Arvselen.[122] Like Knis Anna Ersdotter Björklöf, Täpp Lars understands his relationship to parish dress as inextricably tied to his personal philosophies for leading a satisfying and responsible life grounded in family traditions and pastoral cycles. As a man in his forties, however, Täpp Lars followed a

more circuitous path toward this realization. As a dedicated artist, he is especially invested in researching, reviving, and creatively adapting traditional forms.

In his youth, Täpp Lars dreamed of becoming a stage actor in Stockholm, but he found little enjoyment living in the city. "I was living in Stockholm learning theater to be an actor," he told me, "but I couldn't stand living a life in the city. For me, it's not a life. That's not *my* life. I just couldn't stand it." In Stockholm, training as an actor and working as a fashion model, he felt especially disconnected from the comforts of family and nature. "It's too far away," he explained. "It's too far away from everything. *Here* [in Malung] I have everything." Anticipating that others may view his desires as a sign of provincial naivete, conservatism, or close-mindedness, he is explicit about his cosmopolitan interests. "I like traveling," he said. "I like to see new things, like to get inspiration from other things. I like to see innovation, different kinds of innovation. Absolutely! I'm not like this," he said, creating blinders around his eyes with his hands. Täpp Lars stresses that he is a worldly, self-aware person making an informed decision about his lifestyle. He cites the loss of his parents, who both died from degenerative illnesses when he was still in his early

twenties, as the turning point for him: "In that time, I was thinking that it's necessary to do what you want to do in life." Returning home was a way to both remain close to his parents and prioritize what he decided he valued most—feeling in tune with nature and focusing on creative satisfaction. He looked to family traditions and resources—leatherworking and livestock farming—for direction.

Täpp Lars had demonstrated a youthful interest in leatherworking. When he was around twenty-five, he asked his maternal grandparents to teach him how to make his own shearling coat in the Malung style. Not having made anything for years, however, they helped him look for an apprenticeship. "My grandmother took me to two other persons," he said. "One was so senile, he was asking me my name ten times for each minute. So, it was too late. The other one told me that he didn't want to teach me, because I wasn't born under the sewing machine." Concluding that Täpp Lars was too old, the man refused to train him, which only strengthened Täpp Lars's resolve. "Then I got angry," he explained. "So, I ordered some leather, some sheepskin, and started to cut out all the pieces. Then, my grandfather came and saw me and said, 'No, wait. What are you doing? Have you done *this*? Have you done *that*? And everything comes back [to him]. So, it's my grandparents who taught me." He supplemented their training with close study of historic examples found in museum and private collections. "I have been to nearly every local museum," he confirmed, "and also this kind of fur coat, they are quite many in the old houses in villages." Since many skinntröjor in private collections are unwearable, owners were eager to give them to Täpp Lars to deepen his knowledge of diverse construction methods and shapes. He has kept many of these to serve as ongoing reference models and hopes to eventually write a book.

When Täpp Lars returned permanently to Malung in his twenties, he became increasingly serious in the leatherworking craft, making a diverse repertoire of garments and accessories but specializing in skinntröjor. Since few were doing so, he quickly earned a reputation for reviving and adapting the old styles. He produced many of the shearling coats now worn by costumed interpreters during winter months at Skansen in Stockholm.

After his daughter, Kerstin, was born, she began traveling with him to artisan markets across Sweden and Norway where he sold his leather goods. When she was two years old, he created a complete winter *Malungsdräkt* for her to wear at the outdoor winter market held in Røros. The ensemble included a white sheepskin dress edged in red felt, a goat leather apron, a pocket, a fleece-trimmed embroidered wool cap, and, of course, a skinntröja (sometimes referred to as a *Malungspäls*, or a Malung fur coat). At the time, winter clothes were rarely if ever used locally, and few examples were well documented.

Wanting to make something strikingly beautiful for his daughter, he drew inspiration for his design from the more decorative elements found in neighboring parishes, specifically the red piping and punched leather hearts and floral shapes seen on pockets and aprons in Äppelbo or Mora. In 2015, representatives for the royal family learned about the outfit and commissioned the same skinntröja for Princess Estelle. She wore it, paired with jeans and snow boots, for a public photo shoot to celebrate her third birthday. Heavily circulated, those images raised awareness of Täpp Lars's work and demonstrated its flexibility outside of strictly localized practice.[123]

Today, Täpp Lars fashions a wide variety of styles of skinntröjor and winter clothes intended for use with specific folkdräkter. Some of these have also become popular with a more international clientele who desire artisanal, customized coats. When I visited Täpp Lars in May 2018, he had recently completed two men's shearling coats, practically identical in appearance. One was destined for a man in Dala-Floda, the other for a man in New York City.

Considering the protective nature that can exist around parish dress in much of Dalarna, I asked Täpp Lars how people have reacted to his creative adaptations—in terms of both formal modifications and marketing local styles as fashionable options to international buyers. Overwhelmingly, Täpp Lars has received encouragement and praise for reviving traditional winterwear and other forgotten styles. He admitted that some people (dräktpolis) disapprove, but shearling coats, for example, are often viewed with less rigidity than other elements of dress. Historically, even as rural populations increasingly reserved folkdräkter for special occasions, they commonly continued wearing their skinntröjor daily with cosmopolitan clothes. Therefore, the coats were less strongly associated with conscious ceremonial displays. Another factor may be the nature of the local leatherworking industry and its history of material and stylistic adaptations, as well as commercialization. With the development of leather businesses in Malung, local craftspeople had long directed their skills toward designing products for both localized appeal and an international fashion industry.

Most people today, furthermore, lack the necessary expertise about the diversity of winter styles used at different times in specific parishes to trigger the same level of emotional attachment seen with more familiar elements of dress. While many individuals have grown up wearing and observing local festive dress, far fewer wore the matching shearling coats, since new ones became difficult to acquire. Täpp Lars believes that because most lack direct experience with specific skinntröjor, they often feel freer to adopt styles from other parishes simply as a sign of their aesthetic preferences without worrying about the ideological implications. "Sometimes," he said, "people want to buy, you could say, the *wrong* model for their folk

costume, because they think another village has a better one. So, they just get it." What this trend means for the future, if historical awareness and contemporary practice both continue to deepen, is unclear.

Täpp Lars believes strongly that his work should reflect a living tradition, one that responds to changing preferences and circumstances. "I think," he explained, "if you *try* to keep it alive, it's already dead. If you say, you're not allowed to do *that*, and *this* is the only way, then it's dead. But if you say, this *was* the way in the old days, now take it and do whatever you want with it, then it's alive." Despite his personal stance, he understands why people feel loyal to the idea of a predictable, shared continuity. He, too, emphasizes his own desire for a clear link with the past: "*Everything* I make has a connection to a traditional form," he said, but unlike some people, he worries less about maintaining strict stylistic divisions between parishes, commonly blending elements as he did for his daughter's winter Malungsdräkt. When observers asked him if Kerstin's clothes were part of Malung's traditional dress, he answered, "Yes, it is! It's a folkdräkt for girls in 2015."

Täpp Lars believes that the history of intentional, self-conscious distinctions between parishes is real but perhaps overly exaggerated today. Many parishes historically shared a variety of fashionable elements, especially accessories and imported cotton prints that reflected little geographic specificity. Some borrowing and blending for basic garments likely also took place at various times. In his own research, for example, Täpp Lars has discovered examples of shearling coats that defy expectations. "Two years ago," he recounted, "I found a fur coat in a village between Malung and Mora. And that fur coat was 50/50. The model was 50/50 [percentages] from Mora and Malung. And that shouldn't exist, but it does!" In his opinion, the ideological expectation for territorial distinction was reinforced by institutional collecting that ignored artifacts like these as aberrations rather than as evidence of existing diversity. Variation, he explained, was driven not only by aesthetic preferences but also by material necessity. While museum collections are full of exquisitely crafted shearling coats, private collections can contain curious versions made with scraps or altered by repairs. Poor farmers needed to make do with the materials at hand, including adapting customary patterns to damaged or poorly cut skins or creatively altering a son's outgrown coat to later fit a daughter. The clarity and uniformity of design in contemporary practice, in contrast, reflects improved wealth and reliable access to standardized materials.

Täpp Lars believes that Swedes, in general, have strayed too far from a past way of life that celebrated creativity within limited means, a type of conscientious creativity that was more in tune with the natural world. He points to the fashion industry for illustration: "I'm afraid of how we're consuming the world. I'm doing it too; I'm not better than anyone. But I'm

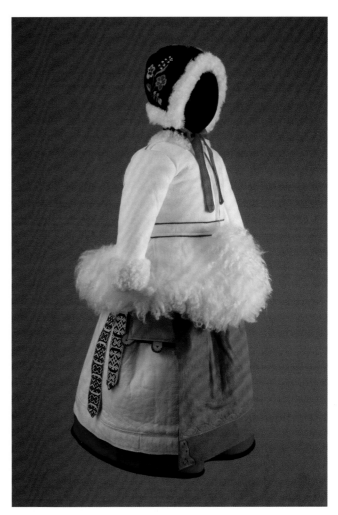

Girl's winter Malungsdräkt by Täpp Lars Arnesson, 2016. Museum of International Folk Art, IFAF collection (V.2016.1.1–5). *Photo by Addison Doty.*

very afraid. I think it's important that we stop doing it. When I was working as a model twenty-five years ago, at that time we had the spring collection, summer, autumn and winter. But that's twenty-five years ago. Now we have so many more collections. In the spring we could have three collections, six in summer. And I think it's absolutely dangerous living that way." Both folkdräkt and corporate fashion, in Täpp Lars's opinion, reflect a desire for the security of social conformity as well as the thrill of novelty through fashionable change. Folkdräkt, however, is potentially less ecologically destructive than the other, being less focused on rapid cycles of production, acquisition, and disposal. The source of social pressure, too, is more or less intimate. "What's [considered] wrong and right is moving all the time," he explains. The boundaries of appropriate practice within wearing folkdräkter ideally rely on the negotiation of neighbors, people often living in relatively similar situations and invested in shared space. Transnational corporate fashion, however, is driven by amassing profits for a few, often with minimal responsiveness to localized concerns

or social interconnectedness. According to Täpp Lars, individuals today are promised an unsatisfying pathway to belonging by constantly consuming the latest thing in a never-ending pursuit of staying "modern": "I think the world today is so much: you should eat modern things, you should wear modern things, just because a big company told you that *this* is modern. You should eat, drink, use it, because you are modern. And if you're not, you are a jerk. And you won't fit in, and it's dangerous to not fit in. That's our instinct." Täpp Lars wanted to escape this kind of thinking, a pattern he saw as arbitrarily and destructively rejecting traditional ways of doing things simply for being deemed old-fashioned. Making a curving, looping motion with his hands, he explained, "The road isn't straight. It turns like this. I take the best from yesterday and the best from today. I'm not a fundamentalist. Because not everything was good in the old way of living, and not everything is good in modern life. I just pick. And I pick everything that fits me."

Over the past couple of decades, Täpp Lars has designed a modernized and personalized lifestyle that resembles the ones led by many of his ancestors. During the winter, he sews leather garments and accessories at his studios in Malung and travels throughout Sweden selling his work at artisan markets and giving hands-on workshops in leatherworking. He spends his summers at the family fäbod in Arvselen, raising cows and goats and welcoming tourists who, for a fee, can experience traditional methods for making butter and cheese or baking bread over an open fire. Fee packages range from a three-hour guided tour with coffee for 100 SEK (about US$11) to two-day overnight accommodations with a full roster of meals and activities for 3,970 SEK (about US$425). Through the Malungs folkhögskola, Täpp Lars also teaches a practical six-week summer course on managing a fäbod, focusing on sustainable livestock farming, food production, and other traditional practices. When he can, he also pursues his passions for acting in local theater productions and writing children's books. His first publication (in 2013), *Trollguldet i fäboden*, recounts a folk tale he used to tell his children about a gold-stealing troll that lived in Arvselen with illustrations by his aunt, Täpp Marit Nilsson.

In May 2018, Täpp Lars invited me to visit his fäbod, located about a fifteen-minute drive or a two-hour walk from the Malung county seat. Like many traditional summer pastures in Dalarna, Arvselen is an area of common grazing with individually owned plots sprinkled throughout the woods. Täpp Lars inherited a piece of property held by his family since the seventeenth century. Sometimes referred to as Johansgården, the farm comprises a cluster of small dwellings and outbuildings, including a little timber house built in 1862 by Täpp Lars's great-great-great-grandparents, Johan Daniel Danielsson and Pä Anna Olsdotter. In its little kitchen, Täpp Lars made us thin, Swedish-style pancakes for lunch. We ate them with fresh cream at a picnic table, enjoying an unusually warm day. We were joined by Kerstin, then fourteen years old, and Rebecca Antonsson, a family friend who began working at the fäbod annually after attending music classes at the Malungs folkhögskola. While a student, she studied kulning and became enamored with the fäbod lifestyle. During my visit that afternoon, she applied her training, calling the cows home for milking, her clear soprano echoing across the foothills.

Täpp Lars has spent summers at the fäbod since 1994. Every May, he walks a few cows and goats from his farm in Malung to Arvselen, staying there with his daughter, Kerstin, and son, Erik, until September. Before Täpp Lars took over, his grandparents cared for the buildings, but they used Johansgården primarily as a vacation home—a common fate for many old fäbodar. Täpp Lars told me, "They were modern people. They didn't like this way of living." Like many summer farms, Johansgården has no electricity or indoor plumbing. The only bathroom is a little outhouse with composting toilets and a lovely view of a babbling brook. Few people want to live without common amenities in the forest for months. "Everybody thought I was totally crazy. Absolutely nuts," Täpp Lars admitted. "Fifty years ago," he explained, "people stopped with this, because it's unmodern. It's more comfortable to live in a house with hot water and electricity, but when you [reflect] on the society, then you start thinking . . . is this smart or is it stupid?"

He was attracted to the idea of being more fully immersed in nature, tending to daily needs, such as milking the cows and soothing their udders with a traditional salve he made from tree sap. On the fäbod, different facets of life can come together, feeling contained, logical, and interconnected: "I love being here, because when I'm here, I'm in the middle of life. I'm not living near the forest; I'm living *with* the forest. If I don't milk the cow, I don't have milk to drink. If I take care of the cows, they give me milk, and I can give you pancakes. We're living here together. I'm serving them; they are serving me. It's the best part of life—to be here and live with the forest." Though running the fäbod can be challenging, as both a working summer farm and an occasional tourist destination, Täpp Lars prefers it to his understanding of typical careers in urban contexts. In his opinion, such careers fragment people's lives and poorly impact personal creativity, artificially separating what could otherwise be experienced more holistically. Describing life on the fäbod, he said, "It's very long days. It's hard physically. It's very, very hard. But for me, it's harder to work in an office. I like the way of being tired in the evening. I feel *healthy* tired. I'm tired here [pointing to his head] and in my body. [I'm] not only tired [in my mind], 'cause I've been in an office, and then need to go to the gym to run. I have *all* the stimulation here. And all my creativity can grow here, just

Täpp Lars and his daughter, Kerstin, near Arvselen. *Photo by Carrie Hertz, 2018.*

because I'm in harmony with the forest. That's why I'm living here and doing all this." At Arvselen, Täpp Lars feels a sense of calm and daily purpose that sparks new artistic ideas. He does most of his leatherworking during other seasons, but his experiences running the summer farm have led to new designs.

Recently, Täpp Lars began making waist pouches inspired by a traditional accessory worn by *vallkullor*, the young women who historically cared for livestock at summer farms and produced milk, butter, and cheese. The pouches, known as *skräppor*, held salt, flour, or other treats that could induce the cows to follow them.[124] When Täpp Lars first started spending summers at Arvselen, he met many elders in the area who were eager to share stories, passed down generations, about the vallkullor in their families—stories about their physical endurance, ingenuity, and independence living in the woods. Knowing firsthand some of the challenges of fäbod life, Täpp Lars wanted to promote their memory with newly designed pouches. "I wanted to remember all these strong women who live in the forest," he said. "If they didn't do it, people couldn't

[have] lived in this part of Sweden." Thinking of his daughter, he also added a feminist motivation to his efforts: "It's written so much about strong men in all the history books. It's about superheroes. These women are also superheroes. Without their work, the family up here couldn't exist. Of course, it was teamwork between men and women, but in the books, we don't remember all the strong women." To serve this end, each skräppa is named for a real woman and includes a tag that recounts her story, as told to Täpp Lars by her descendants. Historically, a typical skräppa was plain and functional, made from any available material. In contrast, the pouches created by Täpp Lars are made from local moose leather and elaborately decorated with punchwork, appliqués, and ribbons. "When the girls were in the forest," he explained, "the bag wasn't so beautiful. I want to give them these beautiful bags. The beautiful bags they never got." His designs cull and combine different motifs, techniques, and ribbons from folkdräkter found around Lake Siljan. The skräppor are popular souvenirs for visitors to Arvselen, but a number of handicraft shops in

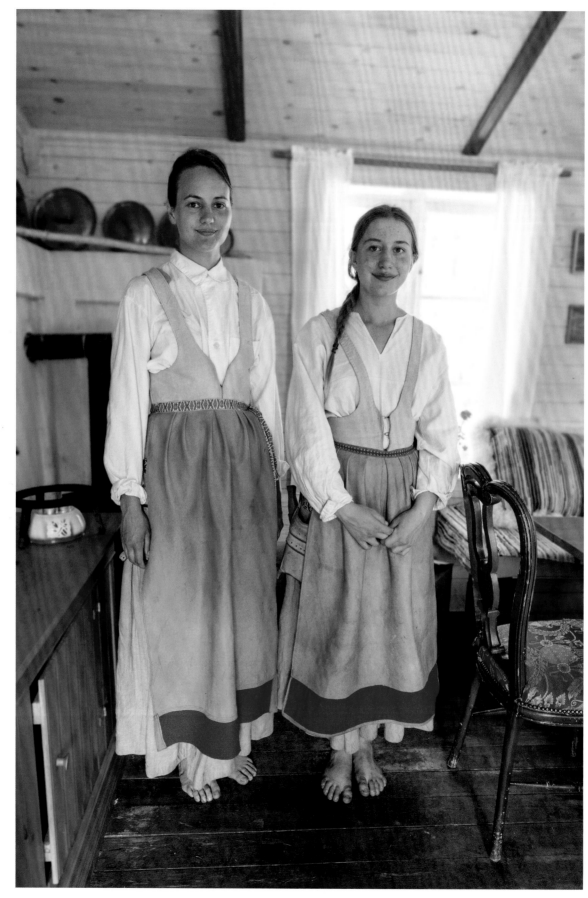

Rebecca Antonsson and Täpp Kerstin Arnesson dressed in outfits based on traditional Malung work clothes made by Täpp Lars Arnesson. *Photo by Chloe Accardi, 2018.*

Dalarna also sell them. Kerstin wears a skräppa every day at the fäbod, though it more likely holds her cell phone, lip balm, or other small necessities, rather than salt and flour.

While the family wears festive Malungsdräkter for special occasions throughout the year, they also incorporate a broader repertoire of locally inspired clothing and accessories into their wardrobe. Like the skräppor, many of these were designed specifically for daily life at the summer farm. During my visit, Täpp Lars was dressed, as he often is, in jeans, a white button-down shirt with the sleeves rolled up, and a full leather apron finely decorated with red wool and heart-shaped punchwork reminiscent of Mora style. Kerstin and Rebecca both wore outfits based on summer work clothes from Malung parish: long, loose, unbleached linen dresses paired with white blouses, leather aprons edged in red wool, and skräppor tied around their waists. The garments were further trimmed with band-woven ribbons, which Täpp Lars has been teaching Kerstin how to weave on a portable band loom.

Täpp Lars designed and made these clothes, inspired by old models, for everyday use on the fäbod. As Rebecca explained, "This is sort of how people used to be dressed around here . . . probably. It *feels* right somehow."[125] Rather than being historic reconstructions, the clothes represent intentional adaptations that evoke Malungsdräkten in material, construction, and general aesthetics but that have been tailored specifically to fit practical and philosophical desires. Kerstin and Rebecca value these outfits as their daily dress during summers for both their comfort and their symbolic connection to their ideals of fäbod life. "They're very, very comfortable," Rebecca told me. "And it also feels good in this environment to wear them. You feel a bit extra well-dressed, but at the same time, very free." The loose shapes move easily, and the durable natural fibers breathe. Unlike more festive styles, these garments feature minimal embellishment or bright colors, and they can easily withstand regular laundering in a washing machine.

For Kerstin, summers at the fäbod represent principles that can be difficult to achieve during other times of the year. Slipping into her summer clothes helps her briefly separate from what she considers a less desirable way of life. "I think I'm in my fantasy when I wear it," she told me. Like her father, she wishes to reject a life disconnected from nature and dependent on disposable consumption: "*This* is my fantasy—to live here and wear these clothes. My fantasy is back in the time [when] people lived like this. I don't really like the world we live in now. Det är tillgjort [It's artificial]; it's not real. Everything is in plastic. I like big cities, but only if I can visit them and go home. This feels like home."[126] Täpp Lars echoes Kerstin's sentiments, saying, "I feel more comfortable and more in harmony with these old-fashioned clothes in the forest." The traditional aspects of his garments—being handmade of natural materials

with designs that evoke localized aesthetics and a past way of life—reinforce the family's values and ambitions.

In this chapter, we have bored down from the national mythmaking of romantics such as Hazelius, now normalized as the canonical representation of Swedish folkdräkt, to closely consider the assessments of individuals living today in idealized parishes of Sweden's most celebrated province. We can see how folkdräkt remains embedded in daily and ritual life, adjusted both materially and conceptually to serve the ethics and aspirations of its practitioners, who are often well aware of the many multilayered constructions of past and place around them. Both the Arnessons in Malung and the Björklöfs in Leksand embrace local styles of dress in their personal pursuit of continuity with ways of living in harmony with family traditions, neighbors, and pastoral cycles. By combining what they determine to be the best of the past and the present with their hopes for the future, they purposefully dress for the lives and communities they want.

Notes

1. "Death blow" comes from Bernhard Salin's foreword to P. G. Wistrand's *Svenska folkdräkter*, quoted in translation in Hellspong and Klein, "Folk Art and Folklife Studies in Sweden," 26.

2. Even within this patriarchal structure, women played pivotal though often unsung roles. See Klein, "Women and the Formation of Swedish Folklife Research." A tendency to construct cultural histories for folk art through the actions of upper-class men who "discover" it is not unique to Sweden, of course. See, for example, Hegard, "Collecting, Researching, and Presenting Folk Art in Norway." Provincial dress, however, appears to play a less mythic role.

3. Anttonen, *Tradition through Modernity*, 107.

4. Frykman and Löfgren, *Culture Builders*, 5.

5. Klein, "Women and the Formation of Swedish Folklife Research," 130.

6. DeGroff, "Artur Hazelius and the Ethnographic Display," 231.

7. Magelssen, "Performance Practices of [Living] Open-Air Museums," 133. While representations of Sámi culture were incorporated into national displays at Skansen and Nordiska museet, they were interpreted as something categorically different from peasant or "Swedish" culture. See Silvén, "Staging the Sami." See also Scheffy, "Sámi Religion in Museums and Artistry," for an examination of how Hazelius's exhibition techniques specifically drew inspiration from racist theories of social evolution, a legacy with far-reaching implications for later museum representations in Sweden.

8. Hillström, "Nordiska museet and Skansen," 36.

9. Barton, "Skansen and the Swedish Americans," 168.

10. Björkroth, "*Hembygd*—a Concept and Its Ambiguities," 34.

11. Barton, "Skansen and the Swedish Americans," 168.

12. Klein, "Cultural Heritage, the Swedish Folklife Sphere, and the Others," 61. As many have pointed out, Hazelius was recognized as a "Scandinavianist" who believed that regardless of national borders the region shared a unified culture, but as Daniel Alan DeGroff has argued, through the Nordic-wide focus of his

collecting, Hazelius also "asserted Sweden's right to act as the cultural guardian of a multifaceted region through a museum . . . located in Stockholm" ("Artur Hazelius and the Ethnographic Display," 237–240).

13 Hellspong and Klein, "Folk Art and Folklife Studies in Sweden," 22; Edenheim, *Skansen*, 7.

14 DeGroff, "Artur Hazelius and the Ethnographic Display," 229. Hazelius's interest in preserving aesthetic exceptionalism is evidenced by his collecting goals: Gradén, for example, reveals that Hazelius's collecting manuals for museum staff specifically requested that only "extraordinary" and pristine festive versions be acquired ("Folk Costume Fashion in Swedish America," 168–172).

15 See Magelssen, "Performance Practices of [Living] Open-Air Museums," for a comparison of Skansen and US living history museums.

16 Crang, "Nation, Region and Homeland," 451. Magdalena Hillström describes Skansen similarly as a "bourgeois Eden" ("Nordiska museet and Skansen," 37).

17 Hellspong and Klein, "Folk Art and Folklife Studies in Sweden," 17–21.

18 Facos, *Nationalism and the Nordic Imagination*, 27.

19 Crang, "Nation, Region and Homeland," 454.

20 Eldvik, *Power of Fashion*, 101. Carte-de-visite portraits and clothing in Nordiska museet collections also show the use and adaptation of Sámi dress by urban Swedes around the turn of the twentieth century. Curator Marianne Larsson, however, argues that Sámi dress was rarely "discussed in connection with folk costume," and its use was often related to romantic fantasies about women's greater bodily freedom and mobility that were assumed to exist within Sámi culture. The adapted clothes housed in the museum's collection, for example, were created by women's dress reformers looking for practical skiing and sporting outfits. See M. Larsson, "Class and Gender in a Museum Collection."

21 Quoted in translation in Hellspong and Klein, "Folk Art and Folklife Studies in Sweden," 26.

22 Kaminsky, "Keeping Sweden Swedish," 75.

23 The history and use of the Sverigedräkt summarized here is drawn from I. Bergman, "När den första sverigedräkten lanserades i Falun"; Gradén, "FashioNordic," 344–349; and Shukla, *Costume*, 105.

24 Readers may wish to compare this positive outpouring for Heidi's innovation with the vitriol directed at another immigrant, Sahfana Mubarak Ali, profiled later in chap. 4.

25 A recorded interview with Heidi Mattsson, filmed by Chloe Accardi, took place at her home in Gothenburg on May 15, 2018. During the same visit, I picked up a copy of her "Frakta Sverigedräkt" made especially for the Museum of International Folk Art. Additional email correspondence took place between 2017 and 2019.

26 Shukla, *Costume*, 105.

27 Alexander Maxwell makes this argument throughout his book *Patriots against Fashion*. See pp. 84–91 for his discussion of Gustaf III's ultimately unsuccessful attempt to establish a national costume for social elites in Sweden during the late eighteenth century.

28 Gradén, "Folk Costume Fashion in Swedish America," 170.

29 Arnö-Berg and Hazelius-Berg, *Folk Costumes of Sweden*, 131–132, 135.

30 Skov, "The Study of Dress and Fashion in Western Europe," 4.

31 The revitalization of arts and crafts as a response to industrialization was a widespread phenomenon across Europe and North America. For a comparative treatment from the perspective of art and design history, see Kirkham and Weber, *History of Design*, 427–435.

32 Klein, "Women and the Formation of Swedish Folklife Research," 123–124.

33 Ågren, "Handicrafts and Folk Art," 197.

34 Arnö-Berg and Hazelius-Berg, *Folk Costumes of Sweden*, 48. For more on the history of study circles in Sweden, see Waldén, "Women's Creativity and the Swedish Study Circles."

35 Gradén, "Folk Costume Fashion in Swedish America," 171.

36 Facos, *Nationalism and the Nordic Imagination*, 66. The quotation comes from a Swedish Social Democratic Party statement made during a parliamentary session in 1928 by Per Albin Hansson.

37 "Imagined sameness" is borrowed from Gullestad, "Invisible Fences."

38 Arnö-Berg and Hazelius-Berg, *Folk Costumes of Sweden*, 11. Around the same time that folkdräkter experienced broad popularity in Sweden, Swedish Americans, too, began pulling out heirloom clothes brought to the United States by immigrants, as well as creating their own idiosyncratic versions. By studying their development in places such as Lindsborg, Kansas, Gradén has shown how these styles, while influenced by Swedish traditions, have followed their own trajectories for form and function, bound to the logic of local makers who create and revise in response to their own situations. See "Folk Costume Fashion in Swedish America" and *On Parade*.

39 Arnö-Berg and Hazelius-Berg, *Folk Costumes of Sweden*, 47–48. For a discussion of the popularity surge during the 1970s from a single parish-level perspective, see Eklund and Ek-Nilsson, "Folk Costumes during the Ritual Year," 162–163.

40 Shukla, *Costume*, 114.

41 Klein, "The Moral Content of Tradition," 171; also cited and described in Shukla, *Costume*, 102. Shukla argues that despite "national boredom," "folk art and folk costumes are still center stage" at the local level. As we see later in this chapter, tiny details of dress can also be considered vitally meaningful to some wearers.

42 Kaminsky, *Swedish Folk Music in the Twenty-First Century*, 9, 104n. Kaminsky also reveals that regional dress is commonly described as "*töntighet*" within the Swedish folk music scene, which he glosses as "lame" (79).

43 Klein, "Cultural Heritage, the Swedish Folklife Sphere, and the Others."

44 Klein, "Folk Art and the Urbanized Landscape," 144.

45 Pettersen and Østby, "Immigrants in Norway, Sweden and Denmark."

46 Trotter, "Breaking the Law of Jante," 7.

47 Ronström, "The Forms of Diversity."

48 Schall, "Multicultural Iteration," 356, 363; Billig, *Banal Nationalism*.

49 Löfgren, "A Flag for All Occasions?"

50 Sweden played an especially prominent role in the international eugenics movement after the parliament established Statens institute för rasbiologi (the State Institute for Race Biology) in 1921. See Rudling, "Eugenics and Racial Biology in Sweden and the USSR."

51 Ågren, "Handicrafts and Folk Art," 207.

52 Kaminsky, "Keeping Sweden Swedish," 76–82. Gradén has documented the rising politicization of Swedish folk costume by the Sweden Democrats, using a famous example of politician Jimmie Åkesson wearing a *Blekingesdräkt* to the official 2010 opening of Parliament for the US traveling exhibition *Dressing Swedish: From Hazelius to Salander*. See Gradén, "FashioNordic," 337–338. This particular instance sparked a nationwide conversation in Swedish media. Read, for example, fashion journalist Daniel Björk's take in his editorial "Sverigedemokraterna klär sig som eliten."

53 Hartley, "Sweden's Folk Musicians against Racism."

54 Kaminsky, "Keeping Sweden Swedish," 76–82.

55 Bohman, "Nationalism and Museology," 283.

56 Export Music Sweden, "Interview: Folk Musicians against Racism."

57 I met Karin Eksvärd, along with other residents of Vuollerim who graciously gathered at the community center to speak with me about folkdräkt, on June 10, 2018. In addition to Karin, I am especially grateful to Audun Otterbech and Gudrun Amundsson, who shared fascinating stories about the town and the recent design of a *Vuollerimsdräkt* led by Gudrun and Karin Grenström.

58 Other European folk dress traditions have gone through similar patterns, transitioning from romantic nationalist notions of descent to consent. See, for example, Michael, "(Ad)Dressing Shibboleths."

59 P. Aronsson and Gradén, *Performing Nordic Heritage*, 3.

60 Kaminsky, *Swedish Folk Music in the Twenty-First Century*, 53.

61 For more historical background on regional revivals following municipal mergers, see Ekman, "The Revival of Cultural Celebrations in Regional Sweden."

62 K. Hansen, "Emerging Ethnification in Marginal Areas of Sweden," 300–301.

63 Noyes and Abrahams, "From Calender Custom to National Memory," 84–85.

64 See, for example, Löfgren, "The Nature Lovers," 59–61.

65 Crang, "Nation, Region and Homeland," 457.

66 Rosander, "The 'Nationalisation' of Dalecarlia," 113–114; Arnö-Berg and Hazelius-Berg, *Folk Costumes of Sweden*, 33–36; I. Bergman, *Folk Costumes in Sweden*, 3; Nylén, *Swedish Peasant Costumes*, 17–18.

67 Rosander, "The 'Nationalisation' of Dalecarlia," 108–109.

68 Nylén, *Swedish Handcraft*, 22.

69 Rosander, "The 'Nationalisation' of Dalecarlia," 116. Carved wooden horses were common in great variety throughout Sweden, including many parishes of Dalarna. Mora, however, is usually credited for developing the characteristic painting style and putting the horses into wide-scale production as tourist items. See Jacobsson, "The Arts of the Swedish Peasant World," 73–74.

70 Bush, "The Hair Workers of Sweden." Hair workers peddled not only popular jewelry but also more localized specialties, such as woven hair strainers (*siltapp*) used in cheese-making at Dalarna's fäbodar. See Brashers, *Sing the Cows Home*, 54.

71 Eldvik, *Power of Fashion*, 85; Sandström, *Hairwork in the Zorn Collections*. Hair workers from Dalarna have also been credited with introducing new fashions that have since become iconic features of local dress, such as the Turkey-red dyed, floral cotton prints brought back from Russia in the 1830s and 1840s. See Resare, "Swedish Shawls and Kerchiefs."

72 Rosander, "The 'Nationalisation' of Dalecarlia," 119–120.

73 State-mandated reforms (known as *Storskiftet*, or "the Big Redistribution") were eventually pushed through in Dalarna, though they were long resisted and did not ultimately disperse settlements. For historical overviews of the rollout of, resistance to, and results of government-led property enclosures in Dalarna, see Sporrong, "The Province of Dalecarlia"; J. Larsson, "Boundaries and Property Rights."

74 Rosander, "The 'Nationalisation' of Dalecarlia," 109–110.

75 Sporrong, "The Province of Dalecarlia," 206.

76 Crang, "Nation, Region and Homeland," 457–458.

77 Rosander, "The 'Nationalisation' of Dalecarlia," 115.

78 Klein, "Women and the Formation of Swedish Folklife Research," 126–129.

79 For a detailed history, see Björklöf et al., *Leksands Hemslöjd*.

80 Frost and Karlsson, *Mora Dräktbok*, 50.

81 Rosander, "The 'Nationalisation' of Dalecarlia," 132, 135. One well-known example of a Leksand-born pioneer is Jones Mats, who opened the Leksands Hembygdsgård in 1899, the first of its kind in Dalarna.

82 Shukla, *Costume*, 114.

83 That some Dalarna transplants demonstrated respect for local people and their customs should not be mistaken for an acceptance of social equality. For example, in "Women and the Formation of Swedish Folklife Research," Klein points out that some artists, writers, and scholars never abandoned a typical parlance that exoticized locals, often depicting them as naive fairy-tale creatures. She cites Ottilia Adelborg as an exception, being an artist whose work shows a progression toward more humanistic and compassionate representations over time (128–129).

84 Rosander, "The 'Nationalisation' of Dalecarlia," 132–133.

85 Näsström, *Dalarna som svenskt ideal*.

86 Quoted in translation in Sporrong, "The Province of Dalecarlia," 195.

87 Ibid., 201.

88 Sporrong, "The Swedish Landscape," 154.

89 We can see that urbanites have been flocking to the countryside with the hope of curing their alienation from nature and finding relaxation since at least the romantic period. See Löfgren, "The Nature Lovers."

90 *The Local*, "Sweden's Urban-Rural Divide Growing."

91 Möller and Amcoff, "Tourism's Localized Population Effect," 40.

92 Jansson, Maandi, and Qviström, "Landscape Research in Sweden," 4.

93 See, for example, Nylén, *Swedish Peasant Costumes*, 27. For a broader discussion of the church's role in the development and preservation of Swedish folk costumes, see Arnö-Berg and Hazelius-Berg, *Folk Costumes of Sweden*, 29–32.

94 Many beautifully illustrated publications, often produced by local craft associations, delineate these codes for parish dress. See examples from Boda, Åhl, and Mora, respectively: Eklund, *Dräktalmanacka Boda socken, Dalarna* (with an English summary available as Eklund and Ek-Nilsson, "Folk Costumes during the Ritual Year"); Kallin and Frost, *Åhldräkten*; Frost and Karlsson, *Mora Dräktbok*.

95 Shukla, *Costume*; Shukla, "The Maintenance of Heritage." Consult these sources for a more detailed biography.

96 For the image, see Klein and Widbom, *Swedish Folk Art*, 79.

97 These efforts entailed regular correspondence between 2015 and 2020, usually including Kersti's longtime collaborator Kerstin Sinha, former director of Ljusdalsbygdens museum in Säter. Kerstin was also involved in the planning for *All Tradition Is Change* and commissioned a young man's Ljusdalsdräkt for the Museum of International Folk Art in 1992.

98 For a more thorough and focused description of the full repertoire of Leksandsdräkter than possible here, as well as its history, code, production, and circulation, see Shukla, *Costume*, 71–116.

99 Many published sources use the term *svartstickkläde*, which translates roughly as black embroidered cloth. See, for example, Nylén, *Swedish Handcraft*, 258. Locals, however, prefer the dialect name *tupphalskläde*, which places emphasis not on the embroidery but on the hanging tassels (*tuppor*: tassels; *halskläde*: neckerchief/cloth for the neck). Personal correspondence with Kersti Jobs-Björklöf and Kerstin Sinha, June 18, 2019.

100 Nylén, *Swedish Peasant Costumes*, 25–26.

101 The shopping scenarios for folkdräkt are less visible than for bunad and gákti, as becomes apparent later in this volume. Until recently, as Shukla describes in detail in *Costume* (94–98) and as I observed last in 2017, the Leksands Hemslöjd managed secondhand sales through consignment. By my last trip to Leksand in May 2018, consignment had mostly been suspended, and locals were holding town-hall-style meetings to consider starting a cooperative for online sales. Seasonal secondhand markets, often held in church meeting rooms, still take place throughout the area.

102 Quotations come from interviews filmed with the help of Thomas Grant Richardson on February 19, 2017, and Chloe Accardi on May 13 and 14, 2018.

103 To read more about the revival of the green skirt, see Shukla, *Costume*, 106–108.

104 The audio-recorded interview with Charlotte Lautmann took place on June 20, 2015. See Garnert, "Rethinking Visual Representation," for a discussion of early twentieth-century photographer-researchers staging "ethnographic" scenes to illustrate their work.

105 For a discussion of the Leksandsdräkt in relation to contextually bound typologies of dress, see Shukla, *Costume*, 110. Charlotte's points about the differences between tourist performances and local custom also echo Kersti's assessments in her discussions with Shukla about public spectacle, missed messages, and burial customs (*Costume*, 85–86).

106 In her examination of Swedish folk costume, I. Bergman mentions that "records from various parts describe occasions when women had dressed incorrectly [for church] and felt obliged to return home," suggesting corroborating documentation for similar events in the history of Leksand dress practice (*Folk Costumes in Sweden*, 8).

107 A number of scholars of Nordic dress have mentioned the importance of "costume police" and have outlined active community conflicts centered on the boundaries of "correct" practice. Gradén

108 An interview with Margaretha Johannes was filmed at Knisgården on February 16, 2017. Many pieces from her wardrobe of Leksandsdräkt are now housed in MOIFA's permanent collection.

109 I. Nilsson, "Rättviksmössa med norska rötter."

110 An audio-recorded interview with Anna-Karin Jobs Arnberg took place on June 18, 2015, at the Dalarnas Museum. I am also grateful to Erik Thorrell for joining us and generously contributing to a fascinating conversation.

111 See, for instance, Goldsmith, "Cloth, Community and Culture."

112 For examples, see Klepp and Tobiasson, "Bunadens revansj"; and "Eco-Express Yourself with a Traditional Costume," on the Norwegian slow-fashion blog *Idealist Style*.

113 DuBois, *Sacred to the Touch*, 21.

114 The interview with Knis Anna and Jerk was filmed on February 19, 2017, with the help of Thomas Grant Richardson. Email correspondence with Anna also took place between 2017 and 2020.

115 Nicklasson, *Fårskinn för dräkt och mode*, 3.

116 Hoppe and Langton, *Peasantry to Capitalism*, 142.

117 Boëthius, *Dalarna*, 93, 137.

118 Britta Jonell-Ericsson's *Skinnare i Malung* traces the transition from a primarily domestic cottage industry to a full-blown manufacturing industry during the twentieth century.

119 Mojanis, "Skinnskolan återuppstod."

120 Folklorist Kerstin Brashers references kulning as a defining tradition in the title of her ethnography of Swedish fäbod, *Sing the Cows Home*. See this work for a fine overview of some of the many practical and artistic traditions associated with fäbodar.

121 Farm names that precede personal names are typical of Dalarna. During the nineteenth century, farm names were increasingly rejected as provincial, but since the 1970s, much like local dress, there has been a trend to revive and celebrate their use. See Rosander, "The 'Nationalisation' of Dalecarlia," 126–127.

122 Recorded interviews with Täpp Lars took place on June 15, 2015, and May 13, 2018. I am indebted to Ingrid Samuelsson for assisting with our introduction in 2015 and providing occasional English-Swedish translation, as well as to my MOIFA colleague Chloe Accardi for assisting with filming, photographing, and interviewing in 2018. Additional email correspondence took place between 2015 and 2020. In 2016, MOIFA commissioned a girl's winter Malungsdräkt identical to one he made for his daughter, Kerstin, for the museum's permanent collection.

123 See, for example, Mojanis, "Prinsessan i Malungspäls."

124 This enticing mixture carried in herding bags is sometimes referred to as *sletje*. See Brashers, *Sing the Cows Home*, 65.

125 Interviews with Rebecca and Täpp Kerstin were also filmed with the help of Chloe Accardi on May 13, 2018.

126 I am indebted to B. Marcus Cederström for his assistance translating the Swedish in this quotation.

2

They Are at Peace Here, like Old Friends in Their Caskets

Traditional Dress Collections as Heritage-Making

Lizette Gradén

Dressing for Several Purposes

On November 11, 2017, at the age of eighty, Kersti Jobs-Björklöf took center stage as family, friends, and colleagues gathered at Tällbergsgården in the village of Tällberg, Dalarna, to celebrate her birthday. As guests arrived in the foyer, they were all met by a life-size, foam-cut watercolor image of Kersti adorned in traditional *Leksandsdräkt*, a festive assemblage in the version worn for Midsummer complete with a blue apron. The life-size depiction was a gift from Katarina Edenheim, and the artist's painting was in turn based on a portrait that had appeared in Pravina Shukla's book *Costume*. The photo-turned-painting thus performed both Kersti's national and international connections. Guests from Sweden and the United States gradually filled the living room, chatting over refreshments, but they were silenced when Kungs Levi Nilsson and his fellow *Riksspelmän* fiddlers filled the foyer with *Solskenslåten*, a tune of welcome and a sign of Kersti's arrival.

Flanked by her two daughters, son, and grandchildren, Kersti walked through the main entrance into the foyer. She was apparently taken by great surprise, and tears welled up as she witnessed how friends, family, and colleagues emerged from the crowded living room and spilled into the foyer to greet her, many with mobile phones and cameras at hand to capture Kersti as she made a round to greet everyone.

Kersti was dressed in a Marimekko tunic created by Maija Isola (1927–2001), worn with a necklace by a Finnish designer and stylish flats. The fact that folk culture preservationist and heritage-maker Kersti Jobs-Björklöf had arrived at her birthday celebration adorned in a Unikko-patterned Marimekko outfit rather than traditional dress had confused some guests who had traveled to Dalarna for the occasion. As if sensing the unfulfilled expectations, Kersti repeated when hugging her guests during the reception and when speaking during dinner, "If I only had known! I thought I was going out to dinner with the kids and my grandchildren. I didn't expect a big party." Over the course of the evening, guests continued to comment on Kersti's appearance. Micael, a man who identified himself as a *sommarboende*, a seasonal resident, pointed to the foam-cut version and explained, "To us, who live in Tibble in the summer, Kersti epitomizes the image of Dalarna. She loves her village. She lives the traditions and is willing to share them with us." Expectations about what kind of dressed body ought to be performed before this audience, at this particular occasion, in this place, echo previous heritage performances in Dalarna. The discrepancy between the stylized portrait of

Kersti in traditional dress and the Kersti present in the room, adorned in Marimekko, a brand with high design capital, articulated with bright brilliance that people dress for a purpose and are judged accordingly.[1]

The Making of This Chapter

This chapter is based on ethnographic fieldwork and applies theories of performance and curatorial agency to explore how living cultural practices are being rethought, reframed, and refashioned when outfits and garments are moved, reorganized, and transformed into private collections following a range of rationales from family tradition to museum standards. What are the frames of reference for such heritage-making? How can a deeper understanding of heritage-making inform heritage studies and museum practice?

For this chapter, I draw on field notes and photos taken during visits to Tibble and Leksand, as well as interviews and conversations.[2] Through this material, I analyze both dressing and dress collections as situated performances, as heritage in action. To provide context for Knisgården's collections and Kersti's curatorial agency over them, I also discuss the early performances of traditional dress at two major museums in Sweden, institutions that have both impacted the ways in which traditional dress is viewed and understood today. It is my hope that through comparison, I can provide insights into some of the diverse choices and motivations involved when transforming living dress practices into collections—whether vernacular or institutional.

As in other Scandinavian countries, the disciplines of ethnology and folkloristics have a long-standing relationship with the emergence of cultural history museums in Sweden. Studies of these museums, the making of their collections, and their performance of the past still play an important part in ethnological research. Through these studies, we gain an understanding of the asymmetrical power relations established between museums and vernacular heritage practices, tensions that still echo today, one being the curation of traditional dress in relation to gender. Current heritage studies are dominated by critical questions about the ways the past is remembered in museum settings. In line with Barbara Kirshenblatt-Gimblett and Laurajane Smith, I view heritage as both a cultural process and a performative practice that sets standards for how cultural memory and traditions are negotiated, produced, and reproduced.[3] This practice is in flux, and we may ask, How is the performative practice of heritage-making affected when it is framed as a vernacular or a museum issue?

In the following discussion, I look at emerging traditional dress collections as heritage in action, moments of performance that reveal in the present the heritage-maker's interpretations of the past and thus her motivations for negotiating what to save for the future. More specifically, I analyze Kersti Jobs-Björklöf's making of the traditional dress collections at her home, Knisgården, the farm her family has occupied for four hundred years. By following Kersti's curatorial process and comparing it to museum practice, I ask, How are notions of personal and family practice performed when old and new garments are handled, sorted, labeled, and moved from wardrobes to purpose-built storage and reframed as collections? How do such vernacular curatorial practices relate to museum curatorial practices? How do living traditional dress practices relate to dress as a field of knowledge in museums? Can vernacular collections be repositories for personal treasures and alternative histories waiting to be activated, and if so, who can make and activate them?

Traditional Dress Practice and Heritage-Making through Performance

Traditional dress, like dress in general, can be understood as stylized performances of who we are.[4] Analyzed as performance—an activity that is framed, presented, highlighted, and displayed before an audience—traditional dress is affective communication.[5] When worn, handled, sorted, displayed, or collected, traditional dress is a mode of performance in which body and dress influence and shape each other.[6]

When approaching traditional dress through the lens of heritage-making, we recognize distinctions between interlocking contexts of performance: the making of traditional dress, the dressed body in social action, and the building of collections that intend to preserve and show the other contexts of performance for the future.[7] My theoretical approach understands cultural heritage as a metacultural practice through which phenomena in a group's past are given high symbolic and financial value and therefore are safeguarded for the future.[8] Understood as such, cultural heritage-making is a self-conscious act, a practice that inevitably shapes the self-perceptions of cultural practitioners as they respond to each new performance.[9] Thus, heritage-making is entangled with broader systems of political, social, and cultural power, aptly described as "heritage regimes."[10]

Even Kersti's private collections at Knisgården are entangled with public collections and institutional curatorial practices through the incorporation of professionalized storage, labeling, and preservation efforts. But Kersti's choices also deviate from these through self-conscious choices meant to contextualize her collection for anticipated audiences, including the ways she assembles garments and groups them into outfits. When Kersti—herself a wearer of traditional dress—composes her dress collections, her actions can be understood as performances of heritage-making, a mode of cultural practice *about* cultural practice that strings together select versions

of the past through a self-conscious wish to influence how knowledge is shaped in the future, how it should be shared, and with whom.

Kersti Jobs-Björklöf and the Dress Collection at Knisgården

As they still do today, individuals at Knisgården and elsewhere in the nineteenth century and earlier displayed their ambitions and manifested their social status by wearing fine clothes. People dressed in their very best for regular church services on Sundays and other festive days in the Lutheran religious calendar. As we have seen, residents in Leksand and other parishes in Dalarna knew and followed a shared dress code, wearing particular combinations of garments to mark holidays and the rituals of life: baptism, confirmation, weddings, and funerals. Kersti honors this local tradition by dressing accordingly for her regular church visits and following the festive year. She also keeps the family dress collection, numbering more than four hundred objects amassed over generations. Both acts, wearing and keeping, pay tribute to her mother's similar efforts to use

traditional dress and preserve it for future generations. Kersti is also a professional—she spent her working career as an ethnologist who collected, documented, and displayed regional folk art. Local forms of traditional dress for both women and men were at the center of her work as curator and manager at Leksands kulturhus (the local cultural history museum, archive, and library). Understanding herself as both a practitioner of a living tradition and a museum professional, Kersti recently began organizing her family's accumulated items of dress and adornment at Knisgården, including her own wardrobe.[11]

When first sorting the garments, she separated two groupings and placed them in different dressers in her house: one for the garments she still wears and another for items selected for the purpose of showing to students and researchers. She also created another category for older garments in her possession. These were set aside for preservation and "rest," put into acid-free boxes, and moved into purpose-built storage on the property of Knisgården. These categories resemble those of typical institutions: props for demonstration, collection items for study and display, and what I call sleepers, objects put to

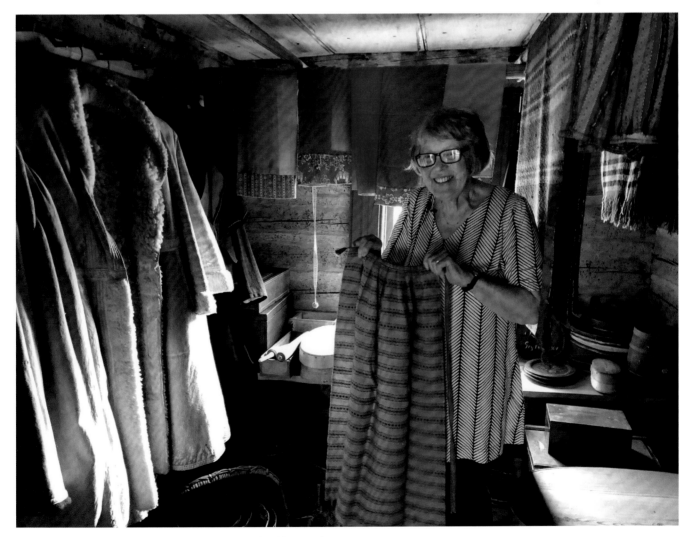

Kersti Jobs-Björklöf in *klädkammaren* at Knis Farm. *Photo by Chloe Accardi, 2018.*

rest with the potential of being activated (in this case, items of more fragile and valuable character kept safe in special storage). The difference between a typical museum collection and a folk collection like Kersti's, however, is found in the more subtle ways the garments are handled—touched, organized, and contextualized.

Traditions of Storage

How clothing is stored depends on how the owner classifies it. Kersti has stored the traditional clothes of Knisgården in the same manner as her parents, grandparents, and even earlier generations stretching back to the sixteenth century. Until recently, Kersti kept most of the family's traditional dress and textiles in the farm's *klädkammare* located in a separate building (*källarstugan*). When I conducted fieldwork at Knisgården in 1994 in preparation for *Swedish Folk Art: All Tradition Is Change*, klädkammaren in källarstugan was still the primary storage space for the family's collection of about four hundred garments.

In my field notes from this time, I noted how the ceiling rafters held dozens of aprons and skirts. Solid-colored aprons made from yellow, blue, red, and green *rask* (imported, fine wool fabric with a waxed surface) were kept on one rail, while homespun yellow aprons for mourning were separated from the others. About eight winter jackets made of white lambskin (with the fleece turned inward) were placed between the aprons and skirts. Chests—filled to the brim with skirts and trousers—lined the floors along the thick timber walls. Large and small *svepaskar* (handcrafted wooden boxes) placed on handcrafted benches held ribbons, hats, buckles, and purses. Rag rugs, handwoven from recycled clothes and bedsheets, covered the wide planks on the floor.

In 1994, I was stunned by the assemblage of brilliant colors, textures, fabrics, and shapes in the room, lit only by subdued daylight seeping through the windows. I also noted the faint smell of mildew, reminding me of later conversations with Kersti and her daughter-in-law, Ulla, about problems with moisture in the storage spaces. There were other preservation concerns. A few linen shawls had been folded and were now creased yellow. Aprons made of rask had faded from being placed too close to the window. Kersti was managing the Leksands kulturhus at the time and was contemplating moving her collection into a similarly climate-controlled space. This idea was abandoned, however, since Knisgården's klädkammaren had been arranged by relatives over several generations. Keeping this arrangement as it was at the farm, she thought, was keeping her family's heritage intact. After all, she reasoned, most of the garments were in impeccable condition, having been stored in a cool and somewhat drafty space. Being without electricity or heating, the storage spaces offered a low-light environment and temperate climate for most of the year. The

storing of dress for easy access, inspiration, and family view was in itself part of the heritage-making and dress legacy at Knisgården.

Collections Performing Change

When I returned to Knisgården in 2017, a lot had changed. Most of the dress collection had been moved from klädkammaren to a new purpose-built storage unit at the back of a garage. Instead of walking by apple trees across the front yard to the freestanding timber storage building, we walked behind the house to the edge of the property and into the modern garage. To access the new storage area in the rear, we passed cars, tools, the lawnmower, garden furniture, and bicycles to reach a locked door. Inside, the fully insulated storage room included floor-to-ceiling shelving that held museum-quality, acid-free archival boxes. Some of these carefully labeled boxes held complete outfits, and some held a single object, such as a purse or a shawl. Kersti said, "You remember what klädkammaren in källarstugan looked like [I nodded], which was much prettier and more accessible in many ways. And it took some time to make the decision to move it all. But källarstugan wasn't all that good for the garments and especially not for linen garments, some of which had turned yellow. Källarstugan was a bit damp, so it wasn't a really healthy environment for textiles."[12] For Kersti, moving the garments from their original storage in klädkammaren was not an easy choice but one of ambivalence. In the end, it was the future condition of the garments that necessitated the move, a choice that many private collectors and museums must make.

Once the decision was made to remove the garments and accessories from the timber structure where they have been accumulated for generations, where to put them became a challenge. Since many farms like Knis were built with a separate storehouse for textiles and clothing, there was no room available to store them in the house. Kersti explained the new location: "Erik [her son] suggested this garage, because it is the most fireproof building on our property. Swedish building regulations stipulate that garages must be well-insulated and fireproof. There were no such regulations when our homes were built [she laughs]. So, we decided to put shelves in this room to host all the boxes." Kersti accepted her son's advice and help, as he and his wife would be the next generation of collection keepers. The transfer of the garments from the center of the farm to its vicinity—from klädkammaren and källarstugan to the garage—also marked a change of status. In preparing to move the collection, Kersti wished for a better overview of the possessions in her custody. As any museum would do before a major relocation, she made a thorough inventory before conducting the move. Kersti explained, "I had hired help, a registrar, to help me sort the garments and label all the boxes." Handled and moved, these garments went from being part

Labeled and stacked storage boxes in new purpose-built storage.
Photo by Lizette Gradén, 2017.

Example of collection labels at Knis Farm. *Photo by Lizette Gradén, 2017.*

of a living collection kept for generations in the family store-house to being objects in a heritage collection. Although the status of the items had changed, the move itself maintained the farm tradition of holding the dress collection in a designated building.

Collecting, sorting, labeling, and preserving material collections is a way of creating order, making sense of the cultural worlds we live in, and structuring individuals into groups.[13] Kersti engages in these heritage activities in order to fashion a future for local dress before an anticipated audience of family, neighbors, and researchers. Combining her professional knowledge, gained as a curator, with her own traditional dress practice, she curates a collection that sits at the nexus of scientific classifications and folk taxonomies that are based on cultural traditions related to family and place. The traditional outfits are assembled in acid-free boxes, wrapped with acid-free tissue paper, labeled, and placed on shelves in purpose-built storage. On a closer look, however, these neatly stored garments are also curated according to individual wearers, family relationships, and time lived on the farm.

They are used to elicit stories from the past, string together several generations of wearers, and bring forth historic life events. The material collection that Kersti cares for and shapes anew is both a burden bestowed on her by family, which she has shouldered, and a responsibility she has chosen to undertake as a form of caretaking for the community. Although the outfits are put to rest in purpose-built storage, Kersti seems to have no intention of keeping them away from public view. She wants to forward knowledge about them. Kersti is proud that Knis family traditions have impacted local heritage and the work of national museums. Anna Maja Nylén (1912–1976), for example, documented the Knis family's dress practices in the 1950s when she was a curator for Nordiska museet. Kersti wants to continue this heritage of recognition by sharing with students and researchers what she owns and knows: "I want them [the garments] to be used for research, and I want them to be known. I was really happy when the ethnology students from Stockholm University were here. And there have been several students from Säterglänten [a municipally owned folk high school] that have studied some of the older garments. Last year, I received five students that each created new garments based on garments in my collection. One worked with the bodice from 1846. She even managed to find red silk, and she sewed the item exactly as it had been handsewn in 1846." Kersti's wish for the collection to be used is no different from many museums' wishes for their collections to be relevant in the present and used to produce new knowledge. Unlike museums with paid professional staff, Kersti's engagement is all volunteer work. When she opens her home and performs her collections for researchers, she extends a gift of access and time, but she also anticipates a return gift in the form of analysis and furthered knowledge about her collection. Perhaps even more important, though less measurable, Kersti values the ability to ponder the collection with others (such as myself). These acts, performed for one another, render mutual recognition and extend a sense of community that is propelled by traditional arts.

Sometimes this sense of community can be far-reaching. A worldwide interest in traditional arts and dress brings students from abroad to study in Leksand. As Kersti explained, "I have had two Japanese weavers here to study the aprons. They worked from these garments, found inspiration, and created aprons but used different colors. And the student who made the bodice, she will be back to study a *svarttröja*, where there have been numerous changes in design and use over the years. You know, it is a jacket made of black cloth, stitched together with thread of unbleached flax. It is created to perfection, and if turned inside out, you find it even nicer on the reverse side."

Kersti also welcomes many students from the nearby folk high school, Sätergläntan. Whereas the school teaches the technical skills necessary for making textiles and items of dress, Kersti provides the local and cultural context. Just like Kersti's forebears when they passed the knowledge on to her, she has the privilege of selecting what knowledge to pass on and to whom. Students from Sätergläntan take that shared knowledge, study the garments from the past, and then apply what they have learned to their current work, thus providing the tradition of gradual change required for sustainable heritage-making.

Collecting and Performing Traditional Dress: Hybrid Practices

As we can see throughout this volume, traditional culture was a source of inspiration for the national romantic movement in the Nordic countries. Dress drawn from local and regional tradition took center stage when museum activist Artur Hazelius (1833–1901) engaged local *skaffare* (providers) to help build his foundational folkdräkt collection for Skandinaviska etnografiska samlingarna in 1873, collections that would evolve into Skansen in 1891 and Nordiska museet in 1901. Inspired by Hazelius, as well as museum builders in Denmark and Norway, Georg J:son Karlin (1859–1939) in the university town of Lund took a similar yet different route when he engaged his fellow university students in assembling folkdräkt. Originally, he used these outfits for his student-esque living history performances. They were, in short, props that would eventually grow into a collection at Kulturen in Lund.[14]

Internationally traveling living history displays of the late-nineteenth-century national romantic period emphasized the costume-clad bodies of Dalarna (Dalecarlia) and Skåne (Scania) and celebrated images of these embodied regional styles. Through these curatorial and artistic processes, the costume-clad body became intrinsically connected with the performance of local and regional culture, both of which were then used as building blocks—the ideological tools—in shaping the idea of the nation and its people.[15] In Dalarna, against a landscape of tightly clustered timber cottages, open pastures, and breathtaking views over lakes Siljan and Runn, the traditionally dressed body has continued to take center stage—on the ground and circulated through media and virtual spaces. These performances, however, are codirected by new generations of artists and curators in collaboration with contemporary entrepreneurs, the regional tourism board, and the nation-branding industry.

No matter how beautiful a stage or how skillful the codirectors may be, there is no play without actors and costumes—that is, the makers and wearers of traditional dress and their personal collections. And just as all actors dress for particular roles and sets, the way they talk about their act is a key part to understanding their performance. To understand such performances of heritage-making, including the building of dress collections, we must look at the choices and motivations of individual actors, regardless of whether those actors are cultural practitioners, museum professionals, or both. As Kirshenblatt-Gimblett contends, ethnographic objects are "made, not found," and traditional dress, I argue, is no exception.[16]

To a certain extent, Kersti's collections of traditional dress, both old and newly organized, seem to suggest that many people would be happy to forget about the people and their stories and just have the material collections and objects neatly stored and available for research. Such an attitude, I would argue, is an occupational hazard of long-term curatorial efforts and museum work; at some point, artifacts may seem more reliable than people. Kersti builds on best practices of storing traditional dress but also deviates from these curatorial practices. As a heritage-worker and maker, she wants for her collection a more complex documentation and preservation situation and more accessibility than a national museum can offer.

Making Collections in Museums: A Gendered Heritage

In the disciplines of ethnology and folklore, most research on traditional dress has been devoted to the role of museums as they have collected, sorted, preserved, and displayed individual garments, ensembles, and wardrobes. It has become almost cliché among scholars to mention that the first artifact that Hazelius accessioned into his Scandinavian ethnographic collections was a wool skirt from the parish of Stora Tuna in Dalarna.[17] Perhaps more important is how he engaged in sorting dress while in the field (*gallring vid källan*), which impacted how people think about what is considered traditional Swedish dress today. By instructing his mainly male collectors to focus on the most spectacular, colorful, and adorned pieces, Hazelius set a standard for museum practice that excluded everyday wear and tattered objects. Hence, Hazelius selected, collected, and museumized the peasant past while simultaneously shaping an idealized version of "folk" culture from which the future nation of Sweden and its people hailed.

When turning to available scholarship on traditional dress in Sweden, *folkdräkt* (literally, "folk dress") is commonly used as a collective term for clothing with local or regional character.[18] Such traditional dress is often associated with specific historical origins, namely a specific social class of people that used to dress in a specific way, in a certain place, and during a particular time. *Bygdedräkt* or *sockendräkt* for "parish costume" were terms later used for traditional dress that was designed in the twentieth century. The design and literal production of this dress were often initiated by local handicraft and historical societies or regional museums for parishes that

lacked documentation on dress heritage. As a consequence, museum specialists often distinguish between traditional dress that is considered "genuine" and evolving and costumes that are considered invented and constructed.[19] Measured by these curatorial standards, the rich collections at Nordiska museet in Stockholm and Kulturen in Lund often set the norms for how regional museums, historical associations, and individuals measure and view their own collections.[20] While vernacular collections are dynamic through continued use, most exhibition displays of Swedish folk dress are based on nineteenth-century collections and museum practices. In the nineteenth-century period room at the new Nationalmuseum, which reopened in Stockholm in 2018, visitors learn that "with the rise of industrialism came a need to preserve the disappearing folk culture, including Swedish folk costumes. When these costumes were depicted and displayed at Skansen, they ceased to change and evolve."[21] This quote, drawn from one of the labels in the new core exhibition at Nationalmuseum, demonstrates how early collection practices and performances of dress at Skansen continue to impact the curatorial performance of traditional dress as fixed and stagnated.

When we turn our attention back to private collections such as Kersti's at Knisgården, we can see that the notion of traditional dress is often less rigidly defined than it is in museums, and the performance of right and wrong depends on social context. In vernacular settings, as opposed to museum settings, traditional dress comes across as dynamic, having survived through gradual changes of personalized design, interpretation, and performance.[22] Kersti's grandchildren, for example, were allowed to wear sneakers when they dressed traditionally for Midsummer, a combination that was unheard of when Kersti's children were growing up. Kersti appreciates that they still wish to wear traditional dress. The most important goal may be to make traditional dress work in contemporary life. As Kersti's daughter Anna says, "I often chose dräkt for practical and financial reasons; there is no need to buy a new dress when attending a wedding or festive event." Another Tibble resident demonstrated similar concern for practicality. When Karin Danielsson (1891–1980) could no longer fasten and tie her *kärringhatt*, the married woman's headpiece for daily wear, she crocheted a "kärringhatt," a headpiece that was similar in appearance but easy to put on—just like any cap. She adorned her knitted cap with her traditional *kärringhattband*. When Kersti approached Danielsson's daughter to borrow the headpiece for a dress exhibition at Leksands kulturhus in 1985, she learned that Danielsson had died in 1980. She had been buried in traditional dress and adorned in her last kärringhatt, her own invention of tradition.[23]

When Kersti shares stories about her collections at Knisgården, the protagonists we meet come from outside the village—researchers and students from Stockholm, the United States, Japan, or Sätergläntan. They add to the narrative fabric of Kersti's mother's stories about visits from Anna Maja Nylén and other scholars, long after they were gone. Kersti's mentions of her son and daughter-in-law come into the stories not through using or wearing the clothes but through helping prepare for their future storage and preservation. In a sense, preserving and storing the collections become a kind of wearing—not of garments per se but as an expressive engagement with traditional dress heritage as forged at Knisgården. While museum collections are materially fixed but can be interpreted anew, vernacular collections are kept dynamic through additions and use and by their palimpsest of stories.

The collection at Knis farm is a potential resource for shaping knowledge and perpetuating traditional dress practice in Leksand and beyond, and in the process, it contributes to a collaborative characterization of place. While Leksandsdräkt has a basic form that is recognizable as traditional, it has been subject to changes based on the availability of materials and the innovative influence of creative individuals who perform traditional dress on various social stages, including the curation of vernacular collections. Like folk taxonomies that emerge today in online communities on the internet, Kersti's

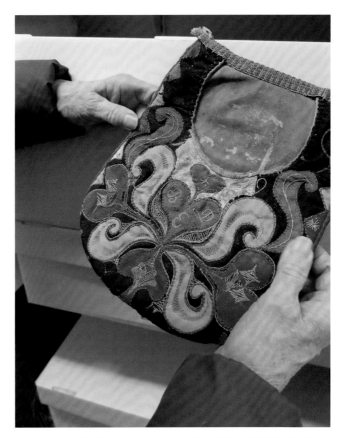

Kersti Jobs-Björklöf showing her great-grandmother's *kjolsäck* (pocket) from 1846, stored in the multigenerational family dress collection. She explained, "They all belong here. It is the people, the people we wish to remember. Otherwise it [the material] is dead. They are at peace here, like old friends in their caskets." *Photo by Lizette Gradén, 2017.*

dress collections are classified on the basis of localized cultural traditions, not entirely on the universalist scientific principles most often used in professionalized museums.[24]

Kersti, operating at the nexus of professional and vernacular practice, positions herself, her family, and Knisgården as significant heritage-makers in the future of traditional dress in Sweden.[25] Her choices both adhere to and challenge typical museum methodologies. In her family, traditional dress was cherished and used, not regarded as museum objects. In fact, she says, it was not people in Leksand but museum founder Hazelius and other male officials who identified a need to interpret local dress practices for people outside the community as part of their objective to unify regional differences into a united vision of the nation.[26]

In comparing vernacular settings with museum settings, especially in a historical framework, we can also see that expertise about traditional dress can be gendered. The dress collections at Knisgården, for example, not only embody Kersti's knowledge but also highlight the skillful, performative acts of numerous women, including those who harvested flax, spun threads, and wove fabric. Handmade garments were touched by generations of hands, carrying the imprint of many women in community.

From Male Heritage-Makers to Women's Heritage in Action

The male curatorial assessments and collection efforts of Hazelius and Karlin had their local counterpart in Gustaf Ankarcrona (1869–1933), a well-traveled artist who, inspired by Hazelius and other museum entrepreneurs, took an interest in the folk culture of Dalarna. He eventually moved to Dalarna and created the open-air museum Holen in Tällberg, which also became his home. Ankarcrona collected folk dress and textiles and also interviewed the wearers and makers of these items. Leksands kulturhus houses extensive dress collections created by Ankarcrona in the nineteenth century. This venerable collection of traditional dress may perform provenance in terms of place, but as Kersti points out, "they [museum collections] often fall short in stories about their makers and wearers." Reflecting on the history of male curatorial interest in documenting and collecting women's traditional dress, Kersti walked over to a shelf in her living room, took out a cardboard box, and retrieved a small, tattered book. She handed it to me and explained, "This is Albert Alm's dress almanac from 1923. It is the first almanac made. Alm was a lawyer, and he was a friend of Gustaf Ankarcrona and of Johan Nordling, editor of the magazine *Idun*. And with him being a lawyer, everything is very systematically organized, and he talks about the first tier of apron, the blue version, which one uses for weddings. Then he lists the second tier, the third, the fourth, and so on. The book is still the best one around." The

almanac bears similarity with Hazelius's interest in characterizing and categorizing individual garments. But Alm's attempt goes beyond collecting and categorizing material culture. Following Ankarcrona, Alm took an interest in the actual dress practice—how the garments were used and why. Kersti continued, "The women knew their practice. It was second nature to them. When Alm collected all the material, people still knew it by heart. They knew how to use *raskförklädena* [aprons made of rask], but they didn't use them often. And already back then it was difficult to buy certain fabric. These fabrics were fashion material and not easy to get in the countryside. These fabrics are not practical. One drop of water and the fabric is ruined."

Based on interviews with women in Leksand during the early twentieth century, Alm's almanac managed to document traditional knowledge, which people in the community had taken for granted. By highlighting and framing women's dress practice, Alm and Ankarcrona transformed this practice into heritage. They also thereby changed the ways in which the practitioners came to understand themselves, a change that has impacted future heritage-makers.[27]

Kersti picked up another book, the second edition of *Almanacka för Leksandsdräkten* (1978), and she read the first paragraph aloud: "In the late nineteenth century and early twentieth century, there were major shifts in dress practice in Dalarna. When Gustaf Ankarcrona established the Leksand Craft Association in 1904, one of the goals of the association was to preserve the parish dress and weed out garments that were perceived as deviant in style. An important task for the Leksand Craft Association has since then been to preserve this dress tradition that was established then." Although the passage she read is short, it reveals clearly that the heritage of the Leksand dress, like Hazelius's collections, had been marked by careful curatorial evaluation and selection. The refining of the Leksand dress style in the early twentieth century continued in the 1970s when curators and practitioners forged in the present a cohesive Leksand dress style from the past. The forging of traditional dress practice that Alm started has continued, now led by the practitioners themselves.

Kersti picked up another book, *Leksandsklädd* (2013), a lavishly illustrated handbook for how to dress in Leksand dress, produced by Kersti and other practitioners as a follow-up to the former almanacs. She explained, "I and other churchgoers were receiving all sorts of questions from younger people in the community about how to dress for this and that occasion, and there were newcomers who did not know how to distinguish between the aprons because they don't go to church." As the living practice has become increasingly replaced by heritage performances associated with male museum founders and museums, the still-living connection is less known, and so is the church heritage connection. The almanac *Leksandsklädd* describes the major church holidays and life events along with

expected dress variations for each particular occasion. Moreover, the book demonstrates the rituals involved in traditional dressing—in which order particular garments ought to be put on the body, how to tie particular shawls and ribbons, and how to fasten women's hats. In the name of outreach and preservation, Kersti transforms her embodied knowledge into a written and visual form that can be distributed and shared beyond the farm and beyond Leksand. In this respect, Kersti is moving away from a practice connected to her own history and toward taxonomies and display in line with a history of museum practice. In order to better understand the significance of her activities, let us turn to a few Swedish examples in the history of folkdräkt-related museum practices.

The Shaping of Institutional Heritage Collections in Sweden

The ways that traditional dress has become a key actor in the performance of heritage at Knisgården and in Dalarna have been informed by a 130-year-long museal approach to

allmogekulturen (the peasant society).[28] The role assigned to dress is apparent in the shaping of folk culture, both in museums and in academic settings. At the turn of the twentieth century, the time of romantic nationalism in Europe, there was a tendency to regard industrialization as a threat to what we today know as folk culture and to traditional handicrafts and artistic skill. Simultaneously, a successful nation in the making needed a solid cultural history to build on.

Traditional dress is most often characterized as symbolizing geographical place—a deliberate effort of nation-building, drawing on regional or local identities.[29] As traditional dress was laden with social value associated with geographical place, such dress was used deliberately in performances to invoke local identities in the city. For example, young women from Dalarna, *Dalkullorna*, were recognized in the city by their way of dress when they came to Stockholm to seek work in a time of industrialization.[30] Traditionally dressed people (mostly women) from around Sweden were also used by Hazelius at Skansen to populate the open-air museum and attract

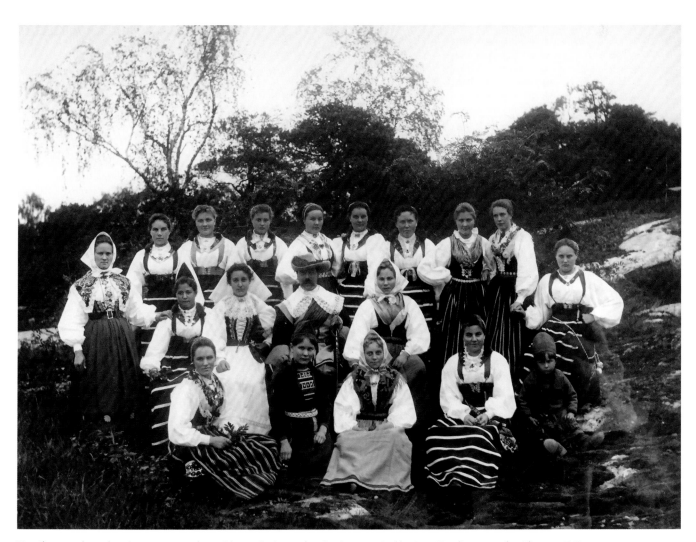

Kersti's paternal grandmother, Knis Kersti (*second from right, last row*) with others recruited by Artur Hazelius to populate Skansen, 1897. *Courtesy of Kersti Jobs-Björklöf.*

audiences at the end of the nineteenth century. Thus, staged performances in museum settings such as Skansen and Kulturen and living dress practice coexisted.

With increased focus on depicting the local and regional life in the city sphere, wearing folk costumes became popular among the upper classes in Stockholm as they engaged in festive, theatrical performances, such as the spring festival *vårfesten* at Skansen. For these temporary, staged performances of the Other in which the open-air museum became the stage, the department store Nordiska Kompaniet played along and sold stylized retail "costumes" from Rättvik, Norra Ny, Vingåker, and Lapland to upper-class city women participants. Photos taken at the museum Kulturen in Lund depict similar festive events on the open-air museum grounds in the 1890s and later. These performances included "folklife displays," *tableaux vivants* that showed before an audience peasant life as it was imagined to be lived in southern Sweden. Georg J:son Karlin (the museum founder) and his fellow students took on all the parts in these performances, regardless of gender. The

photographs in Kulturen in Lund's collection portray young men dressed for the heritage stage they are to act on, clad in traditional dress from Skåne and Dalarna to attend imagined "peasant weddings" and "harvests." In these complex performative events, people dressed for one another; the audience and performers blurred. The props collected from nearby farms eventually grew into the museum's permanent collection of dress and material culture. In his notes, Karlin describes what he envisioned: "We needed folkdräkter and household items to grant our performances authenticity and a sense of life, and particularly for me, who produced these dramatized events, making the event real was a priority, for me as for any directors of plays. Therefore, I proposed to my fellow students during spring term the idea to collect props over the summer. The idea was received with great enthusiasm as all these objects would be of great help for us also in the general aspirations in building the local history associations."[31] Karlin's museum vision contained several paradoxes. First, he wished to perform the past in the present by making it all "authentic." Second, these plays

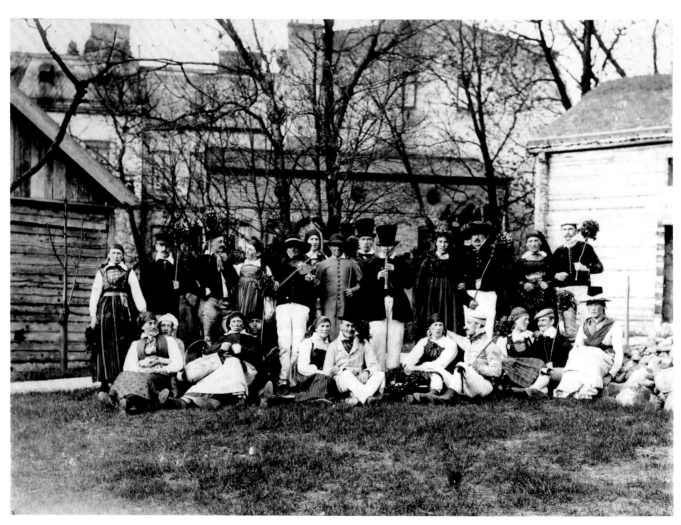

Kulturen's Fall Festival (Höstfesten) with all male participants, ca. 1882–1900. George Karlin appears standing to the right. *Courtesy of Kulturen (KM 94627).*

Dressing with Purpose

were used to engage townspeople and university students in the museum while celebrating life in the countryside. Whereas Hazelius mobilized women from Dalarna and other provinces to act on his stage and later opened the grounds for vårfesten where city women dressed as the female peasant Other, Karlin mobilized university students and drew on the tradition of Shakespearean theater. With few women enrolled at Lund University at the time, all actors involved were male, regardless of the gender they depicted. Karlin recalls,

> *Having grown up in the area I was familiar with the old inventories and traditional dress put to rest in the cabins, dressers and chests, in the attics and other storages, traditional dress which was still worn by the eldest. . . . At the time of our moving to Huaröd, in 1868, during the great famine, the female side of the parish church was still packed full at communion with women dressed in black and white with white starched headpieces and colored aprons as contrast to the black outfits. We embarked on collecting material at farms and in cabins and the treasures grew by the day, mostly through gifts. By August 31, when I returned to Lund, I had 242 numbers of which 90 were gifts and 152 purchased for SEK 223.25.*[32]

Karlin's depiction of his early years of collecting demonstrates that these collections at Kulturen were formed while traditional dress was still in use. The fact that Karlin collected material to create "living history," in which he and other university-educated men simulated "life in the country" in the open-air museum setting, may have generated both ambivalence and distrust in source communities. The performances, which Karlin directed, became widely popular in the university town of Lund. In these performances, young generations tested alternative identities and socialized while putting a heritage of famine, Sweden's peasant past, and the Other in place, invoking a future of modernization and progress. The upper-middle class and emerging middle class used traditional dress to ensure their position in a changing society.

The idea of a "national dress" had emerged among royalty in the seventeenth and eighteenth centuries, drawing inspiration from uniforms, fashion, and traditional dress.[33] It is therefore not surprising that Gustav III, much devoted to theater, performed the nation by dressing the elite in 1778.[34] As sociologist Georg Simmel teaches us in his seminal work on fashion, the dressed body emerges as desirable for people to assume higher status and climb a social ladder.[35] Pairing Simmel's statement with Kristin Kuutma's suggestion that "heritage privileges and empowers an elitist narrative of place, while dominant ideologies create specific place identities," the cultural uses of heritage by less powerful individuals or communities may

become characterized not as a threat but as an effective way of engaging followers and gaining trust and support.[36] To at least pay attention to the hegemonic and the counterhegemonic, the empowered and the disempowered, in "negotiating" cultural heritage in Sweden is important to grasp the transforming of traditional dress practice into performances of heritage.

Museums in Sweden have created an idealized, singular, anonymous Other, one that can serve many stories but that was meant foremost to allude to a singular group identity and history—a common Swedish heritage. Kersti, in contrast, works with common museum organizational structures but takes an opposite interpretative approach by highlighting multiple stories of particular known individuals. These choices anchor her to a place and history through a lineage of specific people and material culture.

Conclusion

Heritage-making is a fragile practice and needs to be studied in action. By focusing on Kersti's way of curating her collections at Knisgården against the backdrop of long-term museum practice, I illustrate different heritage practices and productions and how they are interrelated. The study shows how heritage practitioners, such as Kersti Jobs-Björklöf, both play along with and intervene in the standards generated by the metacultural heritage-making that characterizes museums of cultural history. It also shows how the authority of traditional collection-making and the interpretation of dress has shifted from a male heritage-making—such as Hazelius's focus on dress as objects and Karlin's collecting for performances and props—to women's heritage in action, in which choices, practices, bodies, and relationships connected to traditional dress are just as important as the objects themselves. With this shift, it is increasingly important to further contextualize the objects, the outfits, and the collection itself and include the knowledge of makers and wearers of dress, as well as the individualized stories about them.

By using best practices from the professional museum world and pairing them with in-depth knowledge of family- and community-based dress practices, Kersti's performance of heritage at home challenges established museum values about what should be remembered, when it should be remembered and by whom, and how these memories ought to be organized and packaged. Heritage in action reveals power structures and provides insights into present negotiations of cultural norms in society, professionalization of museums, and values emerging from folk collections based on folk taxonomies. At Knisgården, such contextualized performances draw on museum standards for cataloging and staging objects with personalized stories but deviate from them by keeping these objects within reach—on the farm. Moreover, the ways in which they are

Getting dressed as performed in photos and Swedish art, examples from the archives kept at Knis Farm. *Photo by Lizette Gradén, 2017.*

available for touch by hands, grouped together, and recounted verbally brings a full lineage of makers, users, and collectors of objects onstage. The collection is made and maintained in situ. Wearers, makers, and collectors become actors in a drama that strings together objects, collections, individuals, and actions over several generations in an embodied shaping of family heritage and place.

Vernacular traditional dress collections resist official museum taxonomies and simplified characterizations of people and place, perhaps because they are led by actors with intimate knowledge of those who have come before them in an ever-evolving community performance. These ancestors, evoked by the traditional dress they have worn, are at peace in a space of their own, separated, like actors waiting backstage in a theater. They become sleepers, like objects in a single archive that can be activated periodically and have the capacity to jog memories for select view. Materialized through tangible dress and intangible stories about their practice, they are called onstage to provide glimpses of the past and bring them to life

in moments of heritage in action. These garments, when packaged and stored as heritage collections, organize people and cultural practices in a manner that will impact future collectors, collections, and heritage-making.

I claimed at the beginning of this chapter that studying moments of heritage-making (that is, heritage in action) can make a difference, because it focuses the analysis on living practice and process, thereby allowing researcher and practitioner to cross each other's paths. The word *heritage* has become an increasingly formalized way of addressing present interest and engagement in practices from the past. At the same time, understanding the process of heritage-making has become all the more important, and one of the roles of ethnologists and folklorists is to explore the field and to keep questioning why certain practices are being singled out as heritage and thus considered important for the future. Traditional dress, through musealization and recontextualization as heritage objects, becomes something to remember, something from the past, something of interest to museums,

professional heritage-makers, and nation-branding industries. Heritage-making shows that collections rooted in practice, when kept connected to the context from where they emerge, can provide unique opportunities to shape knowledge, and not only about material objects. Heritage-making when studied in action demonstrates that folk collections are about the life lived and life itself, in which singled-out bodies are ephemeral, but traditional dress and the stories about the people who wore it interweave them and prolong their presence in everyday life, long after they have passed.

Notes

1. Marimekko, founded in 1951, grew popular among culturally engaged women of Kersti's generation and thereafter. The brand sports high quality, comfortable fit, bold patterns, and stark colors. In Sweden, Marimekko is associated with a high design factor but is considered less political than Swedish brands such as Vamlingbolaget and Gudrun Sjödén.

2. My choice to explore Kersti's efforts at Knisgården is equally propelled by work as a museum professional and an ethnographic fieldworker. This chapter contributes to theoretical discussions about museum practice and follows up on fieldwork that I first carried out in preparation for *Swedish Folk Art: All Tradition Is Change*, a traveling exhibition produced by the Cultural House in Stockholm in collaboration with and opened at the Museum of International Folk Art in Santa Fe in December 1994. Such collaborative work shapes relationships, both individual and institutional. These can evolve over decades, responding to societal and cultural changes, life events, and our own maturation as scholars. The combination of such continuity and change make possible the testing of previous analytical insights. In previous longitudinal studies, I have shown that individual's self-identification may change over time and such changes may be expressed in traditional dress. See Gradén, "FashioNordic."

3. Kirshenblatt-Gimblett, *Destination Culture*; Kirshenblatt-Gimblett, "Intangible Heritage as Metacultural Production"; Kirshenblatt-Gimblett, "World Heritage and Cultural Economics"; Smith, *Uses of Heritage*.

4. Eicher, Evenson, and Lutz, *The Visible Self*; Entwistle and Wilson, *Body Dressing*; Gradén, "FashioNordic"; Shukla, *Costume*.

5. Schechner, *Performance Studies*, 2, 28, 40. See also Goffman, *The Presentation of Self in Everyday Life*.

6. Eicher, Evenson, and Lutz, *The Visible Self*; Entwistle and Wilson, *Body Dressing*; Shukla, *Costume*.

7. Traditional dress is laden with anticipation and value. Therefore, traditional dress may also be used in social performances of self as well as in performances of the Other, and in some cases to build a persona. See, for example, Sverige Radio, "George Sand."

8. My understanding is inspired by Barbro Klein's definition: "Heritage is phenomena in a group's past that is given high symbolic value and therefore needs to be protected for the future," with an additional emphasis on the financial value and investments involved in heritage-making. See "Folklore, Heritage Politics and Ethnic Diversity," 25.

9. Bauman, "Performance"; Kirshenblatt-Gimblett, *Destination Culture*; Kirshenblatt-Gimblett, "Intangible Heritage as Metacultural Production"; Kirshenblatt-Gimblett, "World Heritage and Cultural Economics."

10. Bendix, Eggert, and Peselmann, *Heritage Regimes and the State*; Hafstein, *Making Intangible Heritage*.

11. Russell W. Belk ("Collectors and Collecting," 318–320) has argued that individual objects in a collection maintain a relationship to the collection as a whole through the collector's expertise. Such collectors often make plans to ensure the continued preservation of both their collections and their knowledge about them.

12. All interviews were conducted in Swedish on request from the interviewed. Recordings and field notes are in my possession. All quotes in English are my translations and have been shared with the interviewed. In addition, I wish to thank Kersti Jobs-Björklöf, Anna Björklöf, Kerstin Sinha, Tom O'Dell, and the anonymous peer reviewers for reading and providing comments to the text.

13. Pearce, *Museums and Their Development*, 33, 148–149.

14. Karlin, *Kulturhistorisk förening och museum i Lund*.

15. Bennett, *The Birth of the Museum*. Tony Bennett was greatly influenced by the writings of theorist Michel Foucault, particularly his work on methods of social contral as illustrated by *Discipline and Punish*. Bennett contends that museums can be viewed as a form of organizing not only things into collections but also collectors and audiences into groups, categories, and nation-states.

16. Kirshenblatt-Gimblett, *Destination Culture*, 149–151.

17. Nylén, *Folkligt Dräktskick i Västra Vingåker och Österåker*; Centergran, *Bygdedräkter, bruk och brukare*; Eva Bergman, *Nationella dräkten*; Eldvik, "Dräkten som kulturarv"; Liby, *Kläderna gör upplänningen*; B. Nilsson, "Att förkroppsliga nationen."

18. Eva Bergman, *Nationella dräkten*; Eldvik, "Dräkten som kulturarv"; Eldvik, *Möte med mode*; Nylén, *Folkdräkter ur Nordiska museets samlingar*. See also Gradén, "FashioNordic"; Shukla, *Costume*.

19. Centergran, *Bygdedräkter, bruk och brukare*; Eldvik, "Dräkten som kulturarv"; Eldvik, *Möte med mode*.

20. Liby, *Kläderna gör upplänningen*.

21. See also Olausson, *Konstskatter ur samlingarna*, 186.

22. Gradén, "Folkdräktsmode i Svenskamerika"; Gradén, "FashioNordic"; Gradén, "Selected Stops along the Norwegian Highway"; Shukla, *Costume*.

23. Recounted in conversation with Kersti Jobs-Björklöf and email correspondence, August 1, 2019.

24. Cocq, "Sámi Storytelling as a Survival Strategy."

25. Kersti's professional experience makes a difference to her role as curator of the family dress collection. Her daughter Anna Björklöf explains that, having grown up with traditional dress, she has taken it more or less for granted and does not know the dress traditions or family lineage beyond her grandmother. She also recounts dress practice as being more liberal for children today than when she grew up in the 1970s and 1980s.

26. Klein, "Cultural Heritage, Human Rights, and Reform Ideologies," 115.

27. Shukla, *Costume*.

28. Although the four estates (the class society consisting of nobility, clergy, burghers, and peasants) ceased to exist legally in Sweden in 1865, the differences between these collectives were shown by the style of clothing one wore. One dressed according to class, and the perception of such divisions lingered into the twentieth century, especially in museums. For example, the exhibition of traditional dress at Nordiska museet was relegated to the basement galleries, whereas *borgerlig dräkt* (burghers' dress) took center stage in upper-floor galleries. The fact that the collections

were organized according to the four estates also affected staff organization. Curators with expertise in traditional dress belonged to a separate department than curators with expertise in dress of the burgher estate. This organizational separation remained until 2010, when traditional dress and fashion were brought together in the core exhibition *Modemakt*, and curators of folkdräkt and borgerlig dräkt worked together.

29 Eldvik, *Power of Fashion*; Liby, *Kläderna gör upplänningen*; Lönnqvist, Bergman, and Lindqvist, *Brage 100 år*.

30 Rosander, "Herrarbete." See also Johansson, "Nationens pigor."

31 Karlin, *Kulturhistorisk förening och museum i Lund*.

32 Ibid., 5–6.

33 Ibid.

34 Eva Bergman, *Nationella dräkten*; Rangström, "Livrustkammarens dräktsamling," 74.

35 Simmel, "Fashion."

36 Kuutma, "Between Arbitration and Engineering," 23.

Part Two:
Bunad in Norway

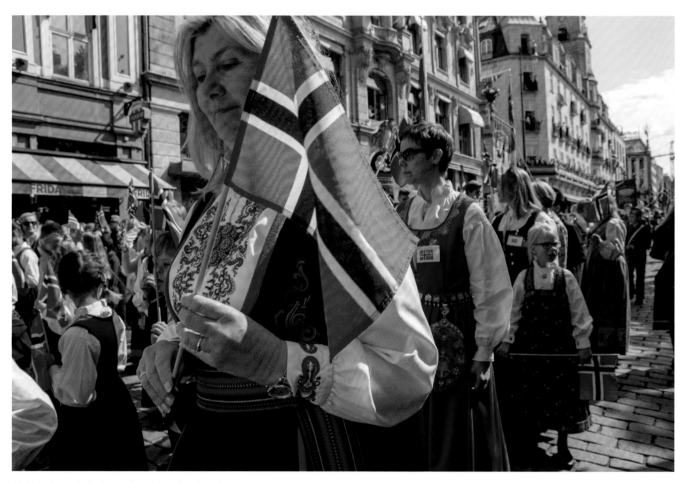

Children's parade for Søttende mai in Oslo. *Photo by Carrie Hertz, 2018.*

3

Norwegian Bunad

Carrie Hertz

Every May 17, Norwegians dressed elegantly in bunader crowd the streets of Oslo. From the early hours of the morning, women in full skirts and swinging capes and men in knee-breeches with pattern-knitted stockings make their way to Karl Johan's street, where parades will start at Egertorget Square and end at the Royal Palace. Along the sidewalks, vendors sell patriotic paraphernalia, such as tricolor cockades and small Norwegian flags. Florist shops offer bouquets of carnations dyed in unnatural shades of red, white, and blue. The city buildings and light posts are draped lavishly in bunting.

Known alternately as *Grunnlovsdagen* (Constitution Day), *Nasjonaldagen* (National Day), or most commonly *Søttende/Syttende mai* (Seventeenth of May), the holiday marks the anniversary of the democratic state constitution, ratified on May 17, 1814.[1] Norway's constitution, one of the first in Europe, has been celebrated annually since its signing, even before the nation won full independence in 1905, but only more recently did the bunad become an essential part of the day's festivities. Though one may see individuals in bunader any day of the year, for many Norwegians, this day is a major reason for owning and wearing a bunad.

Often considered to be "national costumes," bunader at Søttende mai simultaneously celebrate the local and national identities of their wearers. On this day, communities across the country, rural and urban alike, hold civic festivities featuring speeches and public parades. In some places, the majority of revelers will come out in similar clothes, particularly in smaller regions with long histories of distinctive local dress. In a big metropolis like Oslo, the diversity of styles is remarkable, not only for bunader but also for other forms of special-occasion dress worn for the Seventeenth of May.

Inclusiveness is nowhere more visible than during the children's parade. Children are the main focus of official Constitution Day events, strengthening the metaphor of the nation as an extension of home and family with youth as the inheritors of Norway's civic and cultural traditions. In the days leading up to Søttende mai, students are selected to write and deliver speeches about the constitution at public events held in schools or town halls throughout the country. In most places, not least the capital of Oslo, the children's parade (*barnetoget*) serves as the day's centerpiece. The parade in Oslo is televised and attended by more than one hundred thousand people. Every school in the metropolitan district participates, involving thousands of children and resulting in an event that spans hours. Groups of kids, organized by school and accompanied by parents and teachers, are punctuated by marching bands,

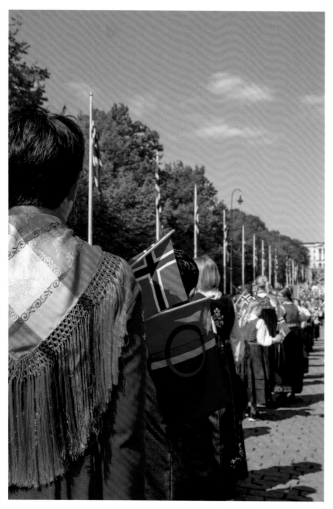

Displaying dual national pride with both Norwegian and Sámi flags during the children's parade in Oslo. *Photo by Carrie Hertz, 2018.*

Russ (high school seniors) dressed for Søttende mai in customized jumpsuits. *Photo by Chloe Accardi, 2018.*

cheerleaders, and drill teams in uniform. Each class or school carries identifying banners designed by the students.

Like the observing crowd, those on parade wear a vast array of fancy dress. Besides the hundreds of varieties of regional bunader, others wear school uniforms, suits, or summer dresses. Diverse ethnic and religious identities are also highlighted. The majority of Sámi people reside within Norway's national borders, with a significant population living in Oslo. Gávttit is regularly seen during Seventeenth of May festivities, worn by individuals waving both Norwegian and Sámi flags. Muslim girls and women wear hijabs, not only with modest clothes common to international Muslim fashion but also paired with bunader. Exchange students, temporary residents, and immigrants from all over the globe wear clothes associated with their home regions: Swedes in *Sverigedräkten* and regional folkdräkter, Hmong women in indigo-batiked and appliquéd skirts, and men in Scottish Highland kilts. The *Russ*, the equivalent of high school seniors, are also highly

visible, dressed in color-coded jumpsuits and caps that identify their area of study. These have often been flamboyantly personalized with iron-on patches, pins, stickers, written messages, and baubles hanging from knotted strings, earned by completing daring acts (known as *russeknuter* or "russ knots"). For the Russ, May Seventeenth marks the last day of a month-long celebration (*russefeiring*) and functions as a rite of passage—a sort of extended high school graduation ceremony characterized by rowdy, youthful excess.

National days, in some form or another, are celebrated in all the Nordic countries, but Norway's is considered uniquely popular, drawing in large, enthusiastic crowds.[2] Scholars have pointed out the surprising lack of military pageantry for an event dedicated to the nation's fight for independence.[3] The earliest observances of Norway's Constitution Day had been more revolutionary in spirit, foregrounding rabble-rousing speeches, processions, and debates meant to mobilize political action against Sweden. When it became an official holiday in

Dressing with Purpose

Young couples dressed for Søttende mai in Oslo. *Photo by Chloe Accardi, 2018.*

1829, Carl Johan, king of Sweden-Norway, considered it an act of open rebellion against the union and attempted unsuccessfully to forbid it.[4]

In 1870, schoolmaster Peter Qvam and Nobel laureate Bjørnstjerne Bjørnson arranged the first children's parade in Oslo (then named Kristiania), though it included only boys until 1889. Bjørnson hoped to pivot the day away from political agitation and toward merriment and concern for future generations, who would need tutoring in becoming democratic citizens.[5] By independence in 1905, children's parades had sprung up in communities throughout the country. Today, the parades simultaneously offer "a performance of community and a spectacle of the state," meant to showcase Norway's future in the form of delighted, well-dressed children.[6]

Apart from civic parades, speeches, memorials, and concerts, Søttende mai is celebrated in more idiosyncratic ways by individuals, families, and friends. For young adults, the day may be an excuse to dress up, stay out all night, and get drunk. Along the Torgatta, lined with restaurants, bars, and nightclubs, young Norwegians in formal wear pub crawl into the wee hours in a scene more reminiscent of unruly prom nights.

For families and more mature adults, the day may end in parties and private gatherings. Social networks are acknowledged and honored at these events. Many women busy themselves with sewing projects in the months before Søttende mai, making garments for loved ones to debut on the big day. Through this event, it becomes strikingly apparent how much more widely bunader are worn by Norwegians than folkdräkter are by Swedes—and not just by women but also by men and children in both rural and urban settings.

In 2018, I spent Søttende mai in Oslo. After participating in the morning and midday civic events, I joined a backyard barbecue thrown for relatives, friends, and colleagues in one of the city's affluent residential neighborhoods. Most guests, sitting around picnic tables, drinking beer, and eating hot dogs, were dressed for the day in bunader from East Telemark. Others wore cosmopolitan dresses, skirts, and suits. One man wore an elaborately embroidered shirt, just completed by his wife. Although an entire outfit had been planned, this was the only garment finished in time, so he paired it with a pinstriped suit jacket. Such a combination would likely receive sour looks from strangers on the street, but no one took offense

Wearing Sunnfjordsbunad for Søttende mai in Oslo. *Photo by Chloe Accardi, 2018.*

at a private party. Another woman confessed that she loved to dress up in bunad for the day but had little patience for the official events, believing Norway had become "too showy, too proud of itself, too focused on progress." She said, "Soon people will wake up to what they've lost." She was uncomfortable with the nationalist gestures of Søttende mai but nonetheless relished an excuse to wear something unusually beautiful.

Even on the most patriotic of days, not all individuals prioritize the national character of their "national costumes." As one man told me, dressed in a *mannsbunad* from Valdres made by his mother, the clothes were not political at all. They were "for fashion and tradition." They combined an interest in "being cosmopolitan *and* locally-minded."

In this chapter, we explore the history, meaning, and use of bunader in contemporary Norway. In the following chapters of this section, Camilla Rossing considers the limits of who may claim authority within this nationalized and increasingly professionalized phenomenon today and illustrates how the bunad, depending on one's perspective, can be seen as a symbol of both freedom and social control. Then Laurann Gilbertson introduces us to bunad practice beyond national borders in the Norwegian diaspora, where it accrues new forms, meanings, and customs. Before the bunad, however, there was the *Nasjonaldrakt* (literally "National Costume," sometimes shortened to just *Nasjonalen*, "The National"), a nationalized form of clothing borrowed from a single regional tradition. We begin and end this journey in that very region, the traditional district of Hardanger.

Nasjonaldrakten

At the turn of the twentieth century, locally distinct dress was still very much in use in the Hardanger district, an area of western Norway nestled around the Hardangerfjord in Hordaland county (a county merged in 2020 with Sogn og Fjordane to make Vestland county). From this region, Norway's first national costume emerged, the Nasjonaldrakt, inspired by the local dress traditions of inner Hardanger. Of all the districts of Norway with characteristic folk costume, inner Hardanger became especially meaningful to the nation and how it was imagined.

Between 1814 and 1905, the country had freed itself from the kingdom of Denmark, ratified a democratic constitution, and quickly lost that nascent independence to its more powerful Swedish neighbor. Held in an unequal union, Norwegians rallied around symbols of national resilience and distinction. To revolutionaries, the dramatic vistas of the western fjords came to represent everything that was wild, unspoiled, and indomitable about Norway.

The combination of proud costumed farmers and imposing landscapes—the cultivated among the untamed—proved to be a subject of romantic fascination for artists, nationalists,

and curious tourists wishing to escape the "overrefinement and corruption of the cities and luxury-loving elite."[7] Patriots contrasted Norway's urban culture, which they considered essentially Danish culture, with the traditional folkways of Hardanger, now championed as pure Norwegian survivals that had heroically resisted modernization and foreign dominance. As quintessential Norwegian rebels, farmers became simultaneous symbols of the mythic past and of progress.

Perhaps the most famous artwork to emerge from the romantic nationalist period in Norway, *Brudeferd i Hardanger* (*Bridal Procession in Hardanger*), was a collaboration between the landscape painter Hans Gude and Adolph Tidemand, who specialized in depictions of peasant life and dress. The pair traveled together through Hardanger to make sketches in the summer of 1843. Completed in 1848, the painting depicts a wedding party, grouped into small rowboats, crossing a fjord on their way to a medieval stave church peeking out from a distant copse of trees. In the foreground, one boat carries the crowned bride sitting at the bow and a fiddler at the stern. The little procession of boats is dominated on either

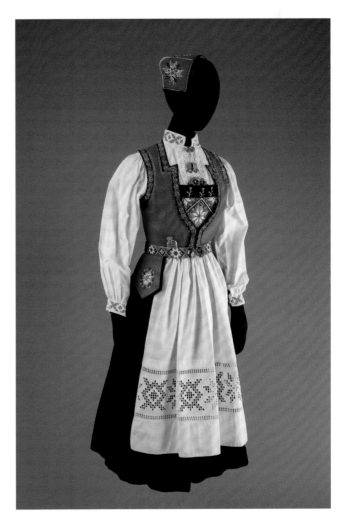

Woman's Nasjonaldrakt, ca. 1900. Museum of International Folk Art, gift of Florence Dibell Bartlett (V.2019.26.1–11). *Photo by Addison Doty.*

Bridal Procession in Hardanger, by Adolph Tidemand and Hans Fredrik Gude, 1848. *Courtesy of the Nasjonalmuseet for kunst, arkitektur og design / the National Museum of Art, Architecture and Design (NG.M.00467).*

side by looming, snow-capped cliffs. This artwork, popularly reproduced in prints and living tableaux, captured the presumed dignity of ancient rituals within an equally ancient and impressive landscape.

Norwegian artists who captured the Hardanger region's sparkling waterfalls, towering mountains, forests, glaciers, and charming folk in resplendent dress were followed by a steady stream of international travelers enticed by thrilling images reproduced as postcards, cartes de visite, art prints, book illustrations, advertisements, and travel brochures translated into English, French, and German and distributed to foreign consulates.[8] Romantic nationalist images of Norway were often intended for international spectators in an effort to prove the nation's unique qualities and to rally support for its political, cultural, and economic liberation. In Sweden, similar messages about a distinctive folk culture, though also appropriate for a world stage, more commonly targeted Swedish city dwellers looking for reassurances of a strong national identity. Both promoted touristic visions, one tailored for foreigners, the other

for urban nationals. Tidemand, for example, eager to capture living images of "beautiful national costumes" for an international audience, lamented that Norway could be perceived by other Europeans as an unworthy backwater.[9] Until the nineteenth century, most travelers avoided the untrodden path. During grand tours of the Continent's artistic achievements, elites visited monuments to European civilization in the form of urban architecture, ancient ruins, and public galleries, but the romantic turn championed adventure and exploration.[10] Just as Swedish cosmopolitans from Stockholm sought the sublime in Dalarna, so did Europeans from all across the Continent look to Norway as a cold, vast dreamscape. The popular penchant for majestic nature over crumbling civilization brought many new foreigners, especially artists, poets, and writers, to Norway's western fjords.

In the peace that followed the Napoleonic and the Swedish-Norwegian wars, both domestic and foreign tourism in Norway increased, but it was steamships coming from Britain that multiplied most dramatically. British adventurers

published nearly two hundred travel accounts of their time in Norway during the nineteenth century, far more than any other group of international visitors at the time. Historian H. Arnold Barton has argued that travelers from that era's global superpower, the "industrial and imperial Great Britain," found a "fascinating attraction of opposites" between their homeland and the raw and mythical beauty they projected onto western Norway. For these travel writers, the country stood for something heroic, rapturous, and free, "the land of simple living and primitive innocence."[11] Norwegian folklife had become an emblem of a future forged from the picturesque past not only for Norwegians but also for far-flung Europeans. Romantic philosophers from diverse backgrounds—English, Swiss, German, and even Spanish descendants in Latin America—claimed Norwegians as their spiritual forefathers, imagined as fierce Goths who had successfully resisted Roman tyranny. As ancient Greece was increasingly understood as the birthplace of Western democracy, so did Norway become "the cradle of European 'liberty.'"[12]

Despite this Edenic depiction by early visitors, the topography of western Norway made it difficult to farm.[13] Fields hugged the narrow shores of the fjord, overshadowed by cliffs prone to rockslides and avalanches. Agricultural activities centered on cultivating fruit trees—mostly cherry, plum, pear, and apple introduced by monks in the fourteenth century—and raising grazing animals, moving them to steep mountain pastures during the summer. (Known as *sæters*, these seasonal dwellings were similar to Swedish *fäbodar* in Dalarna county). Farmers supplemented their livelihoods with fishing and trade, taking advantage of the waterways to buy up and transport surplus goods, such as woolens, woven blankets, dyestuffs, smoked meat, fruit, and liquor.[14]

For inner Hardanger (the areas along the Sørfjord branch of the Hardangerfjord), the first decades of the nineteenth

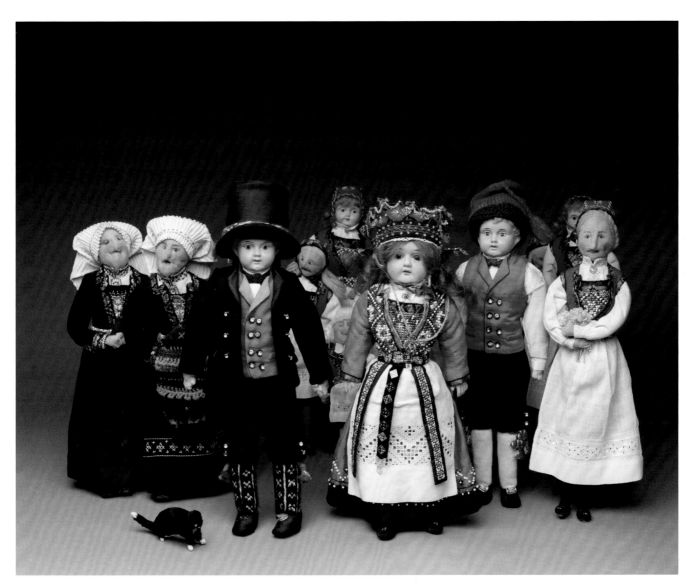

Hardanger bridal procession doll set. Museum of International Folk Art, gift of Florence Dibell Bartlett (A.1955.86.27–40). *Photo by Addison Doty.*

century were blighted by failed harvests, rampant inflation, and dramatic population increases offset by emigration to the United States. By midcentury, several Hardanger parishes had lost a third of their populations to emigration.[15] The growing tourist traffic brought by cruise ships and pleasure yachts traveling up and down the Sørfjord presented new financial opportunities during desperate times.

Residents of Hardanger made money ferrying visitors to nearby waterfalls, guiding hikes and salmon fishing expeditions, selling handicrafts, and opening guesthouses, cafés, and souvenir shops. Major hotels began popping up, joining one of the oldest guesthouses in all of Norway, the Utne Hotel, built in 1722.

Utne is situated at the confluence of four arms of the Hardangerfjord, which made it an ideal place to stop. After 1830, the Utne Hotel expanded, and its beloved proprietor, Torbjørg Utne, became known as Mor Utne (Mother Utne). In 1888, Norwegian artist Eilif Peterssen painted Mor Utne's portrait, showing her dressed in the local, all-black style for older women, including the dramatic white *skaut* (cap) signaling her married status. She sits knitting in the parlor of her hotel next to a window looking out onto the fjord. The original painting is now housed at the Nasjonalmuseet (National Museum) in Oslo, but a copy hangs in the parlor of the Utne Hotel, which is still hosting guests after nearly three centuries.

Once touring companies launched regular routes from Bergen down the Sørfjord in the 1860s, the tiny village of Odda (with a population of approximately 250 people) found itself perfectly situated at the end of the cruise ship line. Tourism altered daily life throughout Hardanger, but nowhere more so than Odda, which lacked even a pier for the ships to dock until the 1870s. By the 1890s, there were cruise lines with names like *The Viking* and *The Midnight Sun* sailing directly from England to Odda. Writing in 1898, the English poet Edmund Gosse wondered at the transformations he had witnessed in Hardanger over the last two decades. "Perhaps no village," he suggested, "shows more violently what change has taken place in Norwegian travel than Odda. Now it is the Zermatt of Norway, and swarms with life in its five or six large hotels. In 1872 there was not even a lodging house there, and one had to put up with dirty rooms at the posting station."[16] Less than a decade later, the Irish writer Jessie A. Gaughan described his trip down the Sørfjord to Odda in glowing terms:

> On either side rise mountains from three to four thousand feet high; waterfalls, magnificent and wonderful, beside which our finest falls are but miniature, rush down the hillsides from the melting glaciers; some of these falls look like white ribbons stretched on the face of the cliff, others are great sheets of swirling foam with the spray blowing far out from them. In the fjords it is not one or two fine falls,

> but hundreds, that delight the eyes, and so high are they that, especially when the mountain tops are shrouded in the morning mist, they seem to come right out of the clouds. Here and there along the lower slopes of the mountains nestle pretty cottages gaily painted, each in its tiny patch of green.[17]

Now a fashionable destination, Odda became an annual retreat for European royalty. King Leopold II of Belgium, King Haakon, and his brother the Crown Prince Christian of Denmark stayed at the premier Hardanger Hotel in Odda. Kaiser Wilhelm II, emperor of Germany, visited nearly thirty times on his imperial yacht *Hohenzollern*. During the kaiser's first visit in 1889, a reporter who accompanied him, Paul Güssfeldt, described a scene in which local townspeople rowed out one night to get a closer look at the *Hohenzollern*. The crew shined searchlights onto the little boats and exposed the common penchant for a voyeuristic male gaze. "Especially the blonde girls in the red Hardanger costumes," Güssfeldt wrote, "looked strikingly attractive in the brilliance from the searchlight. If it

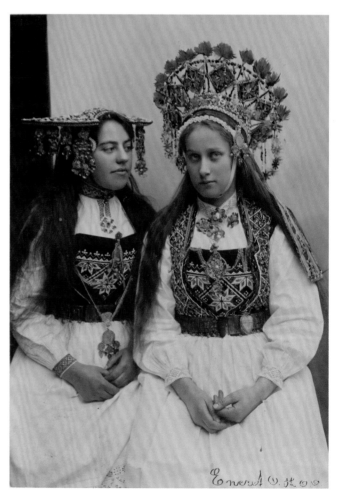

Hand-painted souvenir photograph of models dressed as brides from Hardanger and Voss, by Ole Theresius Ohm, ca. 1900. Museum of International Folk Art, gift of Kraftmuseet—Norsk vasskraft- og industristadmuseum (A.2019.41.1). *Photo by Addison Doty.*

Dressing with Purpose

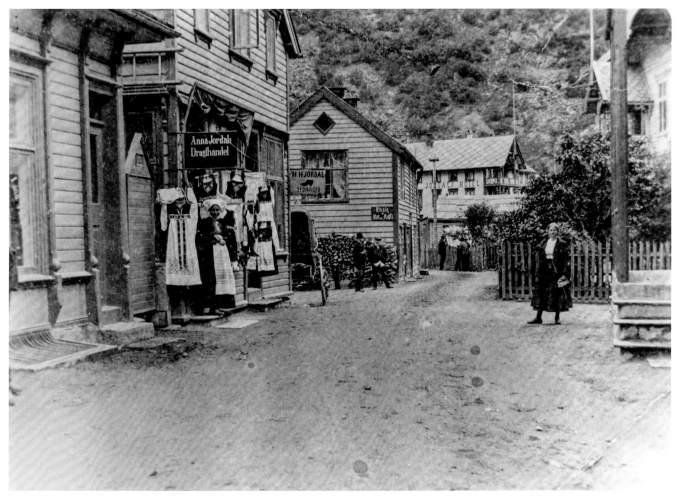

Anna Jordal in the doorway of her dragthandel in Odda, ca. 1900. *Courtesy of Kraftmuseet—Norsk vasskraft- og industristadmuseum.*

had not been invented for other purposes, it should have been invented for this."[18]

While the magnificent, unspoiled scenery of Hardanger remained the greatest enticement, the exotic local folk culture was also a tourist attraction, much of it focused on young and provocatively dressed women. Like Tidemand's depiction for *Brudeferd i Hardanger*, the image of Hardanger brides in their Renaissance-style bejeweled crowns and red beaded bodices became emblematic of the survival of a glorious past, as well as worldly innocence. Like a virginal bride, pockets of Norway could still be considered free of modern corruption. Simultaneously, brides suggested new beginnings. Young women were traditionally bedecked in silver and sparkling beads for their weddings to protect them during dangerous transitions, since the reflective surfaces confused malevolent forces.[19] A bride was a perfect metaphor for protecting new futures by honoring the past.

The idealized depiction of Hardanger brides proliferated in images, songs, poems, and theatrical performances. Not surprisingly, tourists wanted to see the real thing when they

arrived in Hardanger. One wealthy English aristocrat, Lord Hillsborough, paid a young woman a gold ring to dress up in bridal finery for his party's amusement.[20] To meet demand, locals began staging "country weddings" for tourists, recreating bridal processions with whole wedding parties accompanied by fiddlers. This new innovation likely drew inspiration from a widespread tradition in the region known as *jonsokbryllup*, a customary event during Midsummer in which children dress up for mock weddings. With growing tourist fascination, souvenir dolls of spectacularly dressed brides and their wedding parties also became popular. An entrepreneur, Ole Theresius O. Ohm, who already owned tourist shops in Voss, Sogn, and Bergen, opened one in Odda in 1896. His hand-painted studio portraits of young women with thick, flowing hair dressed as Hardanger brides were especially in demand.

Men's appearance did not inflame the romantic imagination in the same way as women's and rarely received as much attention. Hardanger men had, for the most part, traded their distinctive local dress for more cosmopolitan suits by the 1840s. Before falling out of use, the provincial style had been

influenced by Napoleonic military uniforms with wool jackets featuring shiny rows of silver or brass buttons. The jacket was worn with a white shirt, a waistcoat, black knee-breeches, and pattern-knitted stockings held up by woven garters. Unlike the men, Hardanger women in their festive "red bead-embroidered national costume" made regular appearances in travelogues and sketches.[21]

The focus on women, their bodies, and their craft skills did, however, result in novel opportunities for women's financial independence, as they were able to earn more than they could working their husbands' or fathers' farms. As hotel staff, they began donning simplified festive versions of *Hardangerdrakter* as work uniforms. Anna Persdotter Jordal, married to a shoemaker in Odda, opened a dress shop called Anna Jordals Dragthandel, where she sold similar versions to tourists. Customers could try on costumes to pose for souvenir portraits, or they could buy them to take home.[22] Much like Americans dressed up as cowboys and barmaids for Wild West–themed photos, tourists in Norway modeled Hardangerdrakt at studios specializing in nostalgic souvenir portraits.

These tourist versions of local dress, repeated in image and costume, borrowed the look from one formal style common to the Sørfjord area. Women's dress in Hardanger at the time reflected a variety of garments used for different areas, seasons, occasions, and social roles. Like Mor Utne, older married women and widows tended to wear dark, plain clothes.

Younger women showed considerably more flair. Aprons and bodices were made in a wide assortment of fabrics, colors, and prints with embellishments of bobbin lace, ribbons, or the region's characteristic cut-thread embroidery, *utskurdsøm* (now more widely known as *Hardangersøm,* or "Hardanger embroidery").[23] Blouses, though typically white, could be accented with whitework or blackwork embroidery. Bodices had wide openings filled with removable inserts called *bringklutar* in local dialect.[24] An easily changeable element, a *bringklut* demonstrated one's skill, creativity, and taste; they often served as gifts between women. Fashions for new bringklut designs came and went, rendered in various techniques, including weaving, pattern darning, beadwork, and embroidery. Wardrobes also included different possibilities for jackets, belts, jewelry, headdresses, and other accessories.

In contrast, the outfit that became known as a national costume invariably included a red bodice and dark skirt, paired with the most formal option for aprons—one of white linen with a wide band of Hardangersøm. The bringklut was always beaded, usually in an eight-pointed star pattern familiar throughout Norway.[25] Scholars have argued that the striking heraldic colors of this combination were favored because they echoed the Norwegian flag.[26] These choices also more closely matched the combination worn by Hardanger brides. By the end of the nineteenth century, these standardized Hardanger outfits were adopted by political agitators demanding full

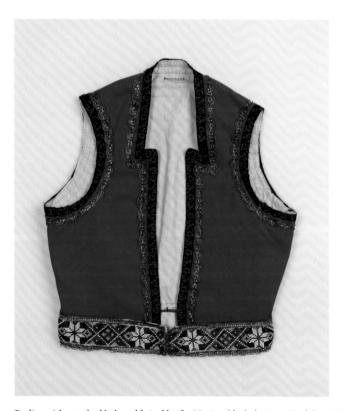
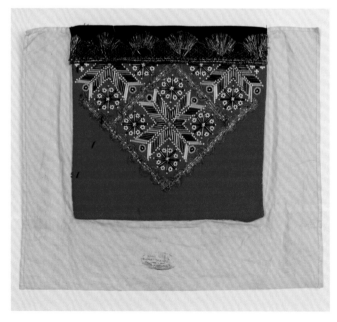

Bodice with attached belt and *bringklut* for Nasjonaldrakt by Anna Jordal, ca. 1900. Museum of International Folk Art, gift of the Friends of Folk Art (A.2017.64.14–15). *Photos by Addison Doty.*

Dressing with Purpose

national sovereignty for Norway. Activists promoted wearing them as signs of the exceptionalism of Norwegian culture as well as one's loyalty to the ongoing fight for independence. Their vivid colors and regal appearance "contrasted with the grey and muddy colors people felt were typical of the industrial era"—that is, "everything they were disassociating themselves from."[27]

The recontextualized function of the Hardanger outfit was further emphasized by its simplified construction. Sometimes the bodice and skirt were joined into a dress, and the bringklut, apron, and belt were sewn together permanently as a single unit. These features made an ensemble less expensive to produce and easier to wear. Women who wore Hardanger clothes as national costumes had little interest in the complicated and cumbersome skaut that identified married status, choosing instead the small beaded caps worn by unmarried girls. The tourist creations Anna Jordal sold in her shop could be quite fine examples of handwork, but as Hardanger dress traditions increasingly became copied throughout the country and sold in Oslo shops and elsewhere, the quality of materials and construction could vary considerably.

The Nasjonaldrakt became a common sight at political demonstrations, public gatherings, youth organization meetings, parties, and folkdance performances across the country. Students began sewing national costumes as part of the politicized curriculum of folk schools newly established across the country.[28] The cause for Norwegian independence united the nation as well as the diaspora. Even sympathetic Norwegian Americans, most of whom had abandoned provincial dress after it incited discrimination in the United States, began proudly wearing (sometimes quite imaginative versions of) the Nasjonaldrakt as a public display of solidarity and ethnic pride.[29] Some groups also began staging mock weddings in the Hardanger style with a crowned bride at center stage.[30]

Residents of Hardanger were just as politically engaged as patriots in the cities, forming numerous youth organizations interested in studying Norwegian history, organizing May 17 Constitution Day parties, debating current issues, and reading books in *landsmål* ("language of the land"), a written form of Norwegian based on rural dialects and developed by 1850 to replace the more Danish-inflected *riksmål*. Landsmål was later adapted into *nynorsk*, "New Norwegian."[31] Romantic nationalism helped bring new life to local tradition, but it did not wholly replace it. Women's local festive dress traditions remained unbroken, though certainly impacted by international attention. Though the tourist gaze had not inspired a revival of men's local dress in Hardanger, the independence movement certainly did. For both men and women, local tradition had now become something shared with an entire nation, adding new layers of meaning.

Hans Lybeck in the 1906 Søttende mai parade in Oslo. *Courtesy of Vesterheim Norwegian-American Museum, Decorah, Iowa (2002.051.001).*

When the union with Sweden dissolved in 1905, Prince Carl of Denmark was crowned Haakon VII of Norway, the first independent Norwegian monarch since 1387. His wife, the English princess Maud, had toured the Hardanger fjords a decade earlier. A souvenir studio portrait of her wearing a Nasjonaldrakt created during her trip in the 1890s became the justification needed for affirming a foreign queen of Norway.[32] As a popular postcard, the image flattered national pride.

In the first decades of independence, the Nasjonaldrakt, as well as the image of the Hardanger bride, continued as important unifying symbols, both at home and abroad in the new homelands of Norwegian emigrants. In the collection of the Vesterheim Norwegian-American Museum, a photograph of a wedding couple perched on a horse-drawn carriage festooned in flowers is identified as Hans Kristiansen Lybeck and "Fru Bul."[33] A handwritten inscription reveals they are dressed, in the tradition of mock weddings, for the 1906 Søttende mai

Spelemannsbunad (fiddler's bunad) from Hallingdal worn for Søttende mai in Oslo. *Photo by Chloe Accardi, 2018.*

children's parade in "Kristiania" (Oslo). The woman's Hardanger dress and beaded bridal crown are unmistakable, but the groom's outfit is less discernible. Lybeck's clothes, illustrated in the photo, are also housed at the museum, brought to the United States by his siblings when they emigrated in 1912. The garments are fascinating examples of creative ingenuity.

While men, too, adopted Hardanger dress for political display, it was still seen far less than women's Nasjonaldrakter. Since men typically abandoned provincial dress before women, there were fewer models on which to base new practice, especially for distant city dwellers. Lybeck, needing something suitable to wear as the groom to his Hardanger bride, fashioned an effective fantasy. His ensemble includes a red flannel double-breasted waistcoat, a black wool cutaway jacket with tails, and black wool drop-front breeches engineered from a modified pair of suit trousers. The jacket and breeches are elaborately hand-painted with blue and red vining flowers imitating embroidery. Brass buttons, red twill tape piping, and appliquéd hems of red, white, and blue stripes add patriotic flair. In the photograph, Lybeck completes his look with striped stockings, a top hat, and a dashing waxed moustache. This fanciful creation was unlikely an attempt to mimic Hardanger clothes, taking inspiration instead from more ornate examples of men's dress from Hallingdal or Telemark.

Janice S. Stewart, in her book *The Folk Arts of Norway*, writes that, while women across the country adopted Hardanger dress during the early twentieth century, "the majority of men chose the Telemark costume." Unlike the military pomp of men's dress in Hardanger, a typical man's outfit from Telemark included a "long white jacket and black breeches, both beautifully embroidered."[34] Similarly, fiddlers in the Oslo folk music scene were so enamored by the men's embroidered outfits from Hallingdal that they became known as the *spelemannsbunad* (fiddler's bunad). These brightly colored, lavishly decorated clothes stood in stark contrast to visions of modern, capitalist, utilitarian masculinity fashioned by the rise of men's sober black suits throughout the nineteenth century.[35] The modern suit was the costume of urban industrial power, while flowery *folkedrakt* could imply an earthy, romantic masculinity that evoked the eternal forces of nature, not unlike the appeal of Hardanger's waterfalls. The new wellspring of popular interest, not just in the wilds of Hardanger but in folk costume more generally, set the stage for Hulda Garborg and a new type of dress she called bunad.

Embroidered and Reconstructed Bunader

The Nasjonaldrakt, based on the clothing traditions of Hardanger, is known today as the "first bunad," though at the time Hulda Garborg had not yet introduced the term for a new style of special occasion dress. Hulda and her husband, Arne (a Nobel Prize–nominated writer, political reformer,

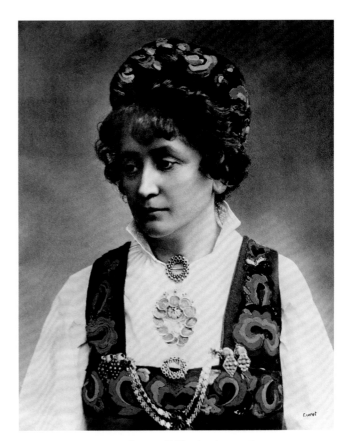

Hulda Garborg. *Courtesy of Nasjonalbiblioteket / National Library of Norway (blds_03014).*

and champion of nynorsk), were active in cultural revitalization efforts leading up to Norwegian independence.[36] While her husband focused on philosophies of linguistic and literary nationalism, Hulda was more concerned with the tangible and customary traditions that shaped daily experience, such as cooking, housekeeping, the performing arts, and dress. She was especially devoted to the folkdance movement, traveling across the country to learn, teach, and perform regional dances. She became frustrated with the widespread use of what she considered to be inferior copies of Hardanger clothes as performance costumes. In an amusing photograph of Garborg's folkdance group from 1902, she stands out as the only member not pictured in a version of Hardanger dress.[37]

Like her counterpart Märta Jörgensen in Sweden, Hulda Garborg grew up in an urban center and moved within fairly elite social circles dedicated to romantic nationalist endeavors and women's dress reform. Both Jörgensen and Garborg, from their position as outsiders, looked to rural women's dress traditions in order to create new inspirational clothes that could be adapted to the aesthetic tastes, practical needs, and ideological demands of women like themselves. Garborg, however, rejected the notion of a singular, nationally unifying model like Jörgensen's Sverigedräkt.

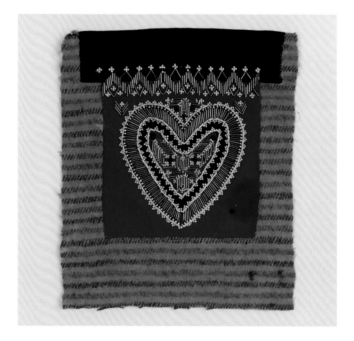

Bodice inserts from Hordaland and Hallingdal counties. Museum of International Folk Art, gift of Florence Dibell Bartlett (A.1955.1.449, 534, 535, and 538). *Photos by Addison Doty.*

In her influential pamphlet *Norsk klædebunad* (*Norwegian Dress*), published in 1903 and later expanded in 1917, Garborg outlined a new philosophy that would preserve a sense of regional diversity within a larger system for sartorial nationalism. She encouraged Norwegians to put away their Nasjonaldrakt and return to the local dress practices of their own ancestral regions. During her travels, she collected examples of provincial dress still being worn and offered new designs based on them, which she called *Norske reformkjoler* (Norwegian Reform Dress).[38] She herself began wearing an outfit adapted from church clothes found in Gol parish in Hallingdal, an ensemble that later became known as "Hulda's bunad." She may have been attracted to the extravagantly colorful woolen embroidery in Hallingdal, as well as the empire-waisted silhouette that already corresponded with the design principles championed by women's dress reform

movements. For her reinterpretation, however, she rejected other typical features, especially the presence of imported silk scarves, commercial aniline dyes, and *fyrierma* (decorative cuffs) ornamented with glass beads. As was typical for dress in Hardanger, the women's regional dress in Hallingdal featured beaded, woven, or embroidered bodice inserts. These were also left out of Garborg's redesign.

For her early designs, as foreshadowed by those for Hallingdal, Garborg paid the greatest attention to rural dress from districts with existing embroidery traditions, such as Telemark and Sunnmøre. Through a regular column on dress that she produced for the magazine *For bygd og by*, she published embroidery and sewing patterns for both areas, adapted from existing garments. In 1915, she introduced a West Telemark design based on an embroidered bodice dating from the nineteenth century found on the Vaa Farm in Vinje municipality.

She preferred the shape of this older model to the one then in use, which she considered too similar in appearance to her era's fashionable boned corsets. She preserved the characteristic racerback cut but added additional embroidery to the front of the bodice and recommended using only naturally dyed wool yarn for it instead of the more common silk thread.[39]

In 1914, Garborg published a pattern for a *Sunnmørsbunad* that had been developed by the Møre folkehøgskule (folk high school) in Ørsta. Based on mid-nineteenth-century ensembles worn in villages around the inner fjords of Sunnmøre, this design was sewn in dark fabrics and embroidered in bright, stylized florals for both the bodice and apron. Seeing an opportunity, village women had begun reviving the style around the turn of the twentieth century for urban women engaged in national politics, the youth movement, and cultural heritage activities. In the years leading up to independence, Sunnmøre had been a hotbed of activism, and people there were already looking for more locally relevant clothes to replace the Nasjonaldrakt. Skilled seamstresses from the villages surrounding Ålesund began setting up shops and adapting the old clothes from their home communities. Their ideas were soon taken up by a host of new folk schools and craft preservation organizations who offered sewing instruction. Garborg is usually given credit for the widespread revival and revision of regional dress in Norway. These local innovations, however, preceded Garborg, but her attentions did help broadly promote them. After visiting Sunnmøre in 1908, Garborg praised these modernized designs for their beauty and practicality, recognizing them as the new *estetiske idealet* (aesthetic ideal) that could embody her vision.[40]

In her efforts to create a modern reform dress, Garborg's choices for inclusions and exclusions were driven partly by an explicitly nationalistic philosophy. Her sturdy, utilitarian designs could be made solely from nationally sourced wool and linen, promoting Norwegian independence from foreign products as well as self-sufficiency through home production. Easy to sew and easy to wear, bunader could be made inexpensively, even by busy urban women with limited sewing skills.

Additionally, Garborg believed that a scheme for national dress, while built on a foundation of tradition, should be tailored to fit her progressive ideas about contemporary women and their place in society. The old costumes, she argued, were too cumbersome for modern use, unfit for folk dancing and reformist attitudes about women's health and liberation. Besides purging her redesigns of any fashionable "foreign silliness," she also favored loose-fitting, sleeveless dresses made of dark wool and decorated with matching wool embroidery on the bodice and skirt. These could be worn with simple white blouses and, importantly, without corsets. As patriots had done before with Nasjonaldrakt, she advised women to give up the fussy headdresses signifying marriage and replace them

with matching embroidered caps, regardless of marital status. Though her earliest designs kept the traditional apron, she soon abandoned it, perhaps for the garment's implication of servile femininity.[41]

Bunad, understood as festive dress "tied to a specific area" with "roots in the forms of dress of the past," proved to be a popular idea.[42] While the term applied to function rather than to any specific style or form, new adopters also found Garborg's arguments about design persuasive. By the 1920s, and continuing through midcentury, bunad committees assembled in communities all over Norway to invent localized styles of dress following Garborg's formula: a dark wool jumper decorated on the bodice and skirt with colorful embroidered designs that had been adapted from antique garments, rosemaling patterns on painted furniture, or natural flora from local landscapes. Silhouettes remained relatively uniform, but unique embroidery patterns and colors could connect a new bunad to a specific place, whether a town, parish, or traditional district. The flexibility of *broderte bunader* (embroidered bunader), as they are now often called, provided a framework for any community, however defined, to enjoy their own distinctive local dress without the necessity of a living or historic tradition.[43]

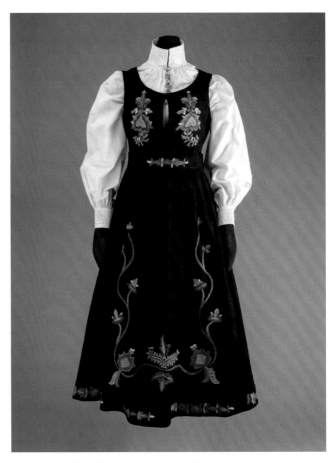

Sunnmørsbunad, likely made from patterns developed at the Møre folkehøgskule, ca. 1910–1915. Museum of International Folk Art, gift of Florence Dibell Bartlett (V.2019.23.1–5). *Photo by Addison Doty.*

The bunad movement of the first half of the twentieth century embraced a unifying aesthetic. Outfits were conceived as complete, unvarying units rather than as they had been before—assembled from various garments and accessories in a diverse mix of colors, patterns, and fabrics, acquired over time and responsive to the availability of new materials and fashionable ideas. While local dress practices of the past did follow shared norms and aesthetic standards, one's ensemble was highly personalized, guided by individual tastes and circumstances. The bunad philosophy of design, in contrast, promoted standardized and simplified outfits, matching perfectly from head to toe. The clothes were first and foremost meant to serve as signs of belonging to place and therefore needed to be easily recognizable. They were also meant to set wearers free from concerning themselves with changing fashions and unnecessary expense. In the introduction to her pamphlet, Garborg quoted a familiar proverb to support her moral stance: "The one who wears homespun clothes does not spend more than he earns."[44]

In places with distinctive living traditions, such as the valley of Setesdal or East Telemark, locals continued wearing and making the same festive clothes they were used to, often with renewed interest from younger generations. A holistic

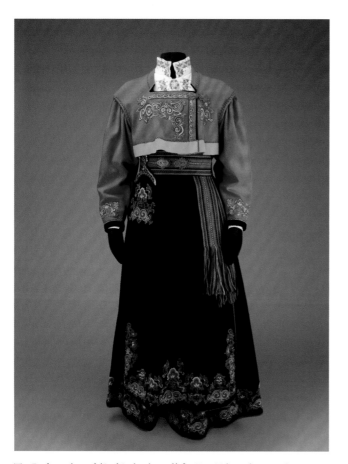

The Rødtrøyebunad (Red Jacket bunad) for East Telemark, ca. 1960. Museum of International Folk Art, gift of Andrew Nuquist, in memory of Reidun Dahle Nuquist (V.2019.39.1–5). *Photo by Addison Doty.*

repertoire of local dress and the bunad movement overlapped. In Setesdal, older residents were still wearing locally produced styles daily until the 1960s. In East Telemark, it lasted until the 1980s. The new bunad ideology, however—valuing clothing's symbolic connection to the past and to place within a clear visual scheme for nationalized special-occasion dress—discouraged younger people from accepting changes that might undermine continued mainstream legibility. Nonfestive clothes, too, received diminishing attention. Unlike embroidered bunader, older clothing styles often preserved more complicated constructions, diverse materials, and idiosyncratic color combinations, but they nonetheless became less varied as new makers copied garments faithfully.

These historic styles could also be reworked to better fit the aesthetic expectations for embroidered bunader. A popular version of the *Rødtrøyebunad* (Red Jacket bunad) for East Telemark, for example, was developed by Anne Bamle, an embroiderer from Heddal who was inspired by Garborg's philosophy. In the 1920s, she adapted older garments and earlier bunad designs created for the area by translating local embroidery patterns found on outmoded wool stockings and mittens and transferring them to extensive areas of the skirt, attached apron, and jacket. She also introduced a waist pocket, also with matching embroidery.

Some areas got novel designs. In 1932, for example, Norwegian painter Alf Lundeby created a new bunad as a fiftieth-birthday present for a friend living in Lillehammer. He followed Garborg's template, designing a dress out of dark blue wool in the conventional silhouette with wool embroidery on the bodice and skirt in rococo-inspired flowers and ribbons. Though he had not intended it for wider production, his design was admired, so he licensed it to Søstrene Julin to make and sell from her embroidery shop in Lillehammer. Today the *Lundebybunad* is popular in both Oppland and Hedmark counties (merged in 2020 as Innlandet county) and can be purchased from bunad producers around the country.

Over time, many areas—through costume committees, cultural heritage associations, single creators, or emergent bunad businesses—introduced their own patterns. Creators also presented revised designs or new variations for the same areas to better reflect changing tastes and ideals. The style, scale, and color palette of a bunad's embroidery can often suggest when it was designed, following the fashionable preferences of its period.

The bunad movement of the early twentieth century was an artistic attempt to make preindustrial folk costumes useful and appropriate as ceremonial components of modern everyday life, while also demonstrating an aesthetic appreciation for the ideals of a shared communal past. Philosophical and aesthetic opinions dictating the proper appearance and inspiration for bunader have continued to vary, but the basic and

widely shared desire for special-occasion clothing that is both localized and reminiscent of traditional styles from the past remains constant. As Norwegian dress scholar Bjørn Sverre Hol Haugen has argued, the process of revitalization, adapting tradition to present concerns, does not create frozen cultural forms that remain artificially unchanged forever. Bunad is "an evolving part of contemporary culture," embedded in many Norwegians' sense of everyday dress codes, no more unusual than choosing special clothes to wear for church, funerals, or the workplace.[45] Just as the dress codes of daily life undergo continual review and "reflexive reinterpretation" in line with diverse views on identity, morality, and beauty, the bunad is part of living tradition, meaning different things to different people at different times.[46]

The bunad concept today incorporates a range of approaches to traditional dress, including philosophies diametrically opposed to Garborg's initial plan for it. Klara Semb, Garborg's fellow folk dancer, was an outspoken proponent of another way of thinking about the use of rural folk costume in contemporary life. She devoted herself to researching historic garments and preventing what she considered "abuses" of local dress practices by reformers like Garborg. Summarizing her life's work during a speech in 1946, she said, "I realized at an early stage that we must rid ourselves of the completely ruined and modernized costumes—we must do our utmost to re-establish the stylistically correct and genuine costumes: textiles, colors, cut, embroidery, silver, headdresses—they must all be correctly reconstructed."[47]

At the time of Semb's speech, Norway was recovering from World War II and the destruction wrought by the scorched-earth tactics of Nazi occupation. The material culture of entire communities in the north had been utterly erased by arson and bombing. Homes, crops, churches, schools, municipal buildings, bridges, and fishing boats were all burned. Wells were poisoned. More than seventy thousand refugees were evacuated from Finnmark/Finnmárku and north Troms/Romsa counties.[48] Many people lost everything. The years following the war were preoccupied with reclaiming and recovering a sense of continuity with a cherished past. Many Norwegians were hungry for Semb's notion of dress traditions fashioned from reconstructed historic practices as opposed to the representative modernizations and simplified symbolism of Garborg's embroidered bunader.

In 1947, the state government established a special committee that eventually became the Norsk institutt for bunad og folkedrakt (Norwegian Institute for Bunad and Folk Costume,

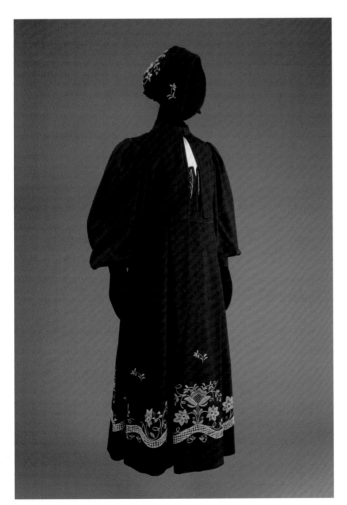

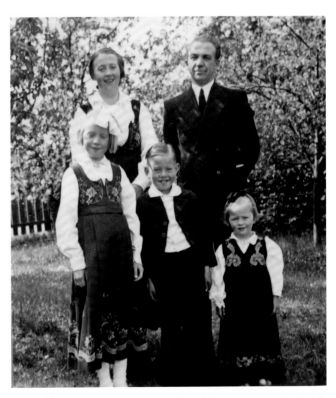

Above, The Joner Family, ca. 1947. Berit (*lower left*) wears the Lundebybunad, while her younger sister wears a version of "Hulda's bunad." *Courtesy of Berit Joner Leonard.*

Left, Girl's Lundebybunad made by Margit Joner for her daughter Berit, ca. 1947. Museum of International Folk Art, gift of Berit Joner Leonard (V.2019.29.1–4). *Photo by Addison Doty.*

or NBF), a research and advisory organization under the Ministry of Culture. Today, NBF shares space with the Valdres folkemuseum in Fagernes, where employees are tasked with researching and disseminating information about traditional dress practices, past and present, through collections, archives, publications, symposia, hands-on instruction, and exhibitions. Aagot Noss, the much-celebrated expert of Norwegian traditional dress, collaborated with the organization for many years before her passing in 2015. Noss stressed the importance of fieldwork, inspecting and registering surviving clothes found in private collections throughout the country. Just as Kersti Jobs-Björklöf serves as caretaker to Leksand garments worn for generations in her Swedish family (as discussed in Lizette Gradén's chapter in this volume), individuals across Norway tend their own family collections. NBF's archives now contain more than seventy thousand garment patterns, photographs, fabric samples, drawings, and descriptions of old clothes that can offer guidance for communities wishing to reconstruct and revive historic dress practices in their home regions. Entrepreneurs, too, rely on these public records. Companies such as Durán Textiles, for example, specialize in reviving fashionable fabrics from the eighteenth and nineteenth centuries for use in today's bunad-related businesses.[49]

Reconstructed bunader—based on historic garments, written descriptions, and artistic depictions—tend to be more elaborately fabricated, expensive, and individualized than embroidered bunader. Rather than creating a single uniform outfit, the research process gathers a whole constellation of options documented within a given period. Individuals can then select their preferred combinations from extant examples for various fabrics, colors, motifs, patterns, embellishments, and accessories. The goal is not simply to revive the use of a few garments but to recreate, if possible, a whole communal repertoire of festive dress, sometimes incorporating everyday styles as well.

Though personalization is highly valued, so too is the notion of historical authenticity. Many wish for assurances that the choices they are presented with represent verified forms actually worn in the past. Reconstructed bunader can be challenging for amateurs. Apart from necessitating historical awareness, making a reconstructed bunad often entails more advanced technical knowledge and craft skills. This makes them harder to mechanize or mass-produce, but it also makes their production a more economically viable business model for artisans whose expertise is required and esteemed. Both professional makers and scholars of traditional dress in Norway are treated like celebrities in the glossy pages of *Bunad magasinet* (*Bunad Magazine*), a biannual publication devoted to sharing the latest news on bunad research, reconstruction, and manufacture illustrated with sumptuous photography and advertisements in a style more often associated with high fashion magazines.

While the twentieth-century bunad movement emphasized simplification, uniformity, broad accessibility, and modernization, the prevailing twenty-first-century paradigm prioritizes elaboration, variation, professionalization, and historicization. Today, embroidered and reconstructed bunader coexist, each with passionate proponents. Increasingly, even small geographic areas may boast a variety of choices, including an embroidered bunad with one or more variants as well as reconstructed bunader reflecting different stylistic periods from the past. In an impressive three-volume encyclopedia, *Norsk Bunadleksikon*, edited by Haugen and published in 2006, contributors profiled more than five hundred styles of bunader currently in use.

Urban centers, such as Bergen, Oslo, and Lillehammer, have introduced city-specific designs, first for women, then for men. Some of these, such as the pale blue *Oslobunad* designed in 1947, are copyrighted with exclusive manufacture. An individual could sew one for herself, but only after purchasing an official kit from the company Oslobunaden, located in the capital. Like other embroidered bunader made according to the Garborg template, the Oslobunad offers limited room for creative interpretation, even less so for being proprietary. As if in response, a new option for Oslo appeared in the late 1990s. The *Jubileumsdrakt* (Jubilee Costume), created to celebrate the city's millennial anniversary in 2000, was designed by Eva Lie for men, women, and children. Jeweler Elise Thiis Evensen of Huldresølv designed matching *bunadsølv* (bunad-specific silver jewelry). Like Garborg, the designers wished to update historical Norwegian dress traditions, but they differed in their aesthetic approach to notions of fashion and modernity. The women's Jubileumsdrakt includes a silk shirt, velvet belt, and silk damask bodice, skirt, and apron in various combinations of black, blue, and gold. The selection of fabrics is inspired by patterns from Hjula Veæierier, Norway's first mechanized textile mill. At its height in the 1890s, the mill employed eight hundred people in Oslo and was the largest in the country. Rubina Rana, the first Pakistani Norwegian city councilwoman, debuted the new design during official Søttende mai festivities in 1999. Since then, the Jubileumsdrakt has become the most popular choice for Oslo, a symbol of the city's cosmopolitanism and industrialized textile fashion history.

The bunad movement, once drawing inspiration exclusively from preindustrial peasant culture, now attempts to fold historic urban dress into the same traditional scheme. Not surprisingly, having kept these styles conceptually separate for so long, some Norwegians have mixed feelings about this. One woman in Hordaland county told me she understands

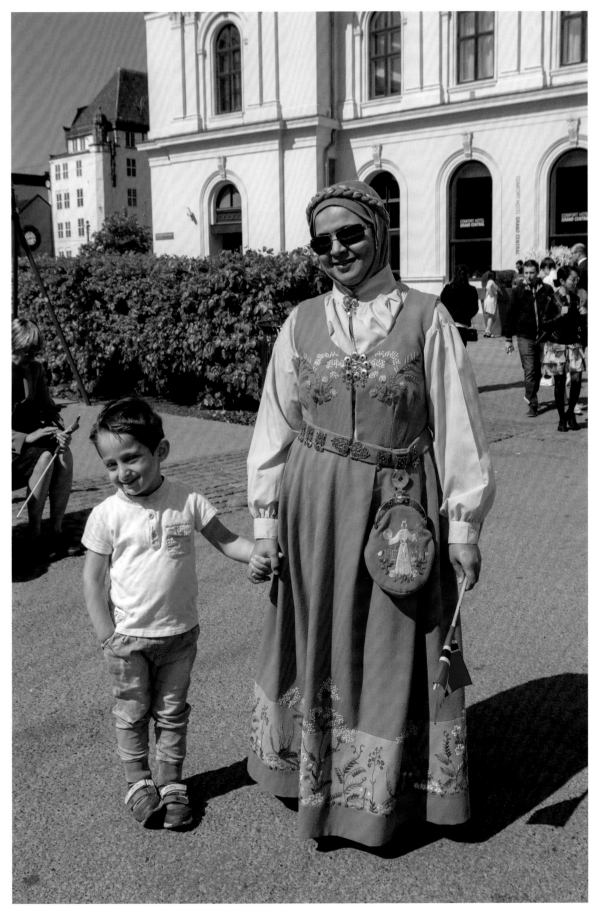

The Oslobunad worn with hijab. *Photo by Carrie Hertz, 2018.*

the appeal of these "fashionable bunader," resplendent in the luxurious fabrics that poor farmers could have only dreamed of wearing. "Those kinds of costumes," she said, "seems more dated, I think. It's so '90s . . . 1890s." In her opinion, the rigid periodization of fashionable clothes locks them into a cultural moment that flashes and then quickly fades. She explained that the first time she saw someone wearing the Jubileumsdrakt, she thought it was exciting and beautiful, but now it just looks outmoded.

Why do particular examples of embroidered and "fashionable" bunader strike people as old-fashioned, while those reconstructed from folk dress may not? Perhaps the answer is related to the slow evolution of regional rural styles, in contrast to the single point of creation for a complete, contemporary ensemble. Maybe the disconnect simply stems from the lack of repeated exposure to similar imagery over time. For those growing up in Hordaland county, for example, diverse representations of local dress traditions are pervasive. Varied historical examples can be seen in relation to cultural heritage and tourist productions, road signs, and wall murals as well as in family photo albums and saved heirlooms. Even though distinctive regional dress practices changed over time, following fashionable cycles of their own, enough remained stylistically consistent over multiple generations to engender a lasting impression of timelessness, as well as a more emotional response to their appearance. In the fashion world, a "classic" white button-up shirt or little black dress may provide the same illusion and recognition, seen in ubiquitous representations, from photographs of Audrey Hepburn to Gap advertisements. Even small alterations to these basic forms can feel fresh, while remaining familiar. Today, the current emphasis on expanding options for reconstructed bunader through historical research regularly infuses these traditions with new ideas, and individuals can follow fashionable preferences for new garments, fabrics, combinations, and accessories. If the Jubileumsdrakt remains in variable circulation, in person and image, for several generations, will it cease being viewed by some as old-fashioned?

The boundaries for what can qualify as a "bunad" continue to be debated and redrawn. In many of the conversations I had with people about making, wearing, and acquiring it, the diversity of English-language terms and modifiers they used, meant to separate and define subtypes, reveal the manner in which individuals evaluate quality, purpose, and authenticity. Low-quality or mass-produced versions, made with cheap fabrics, lower thread counts, machine embroidery, or poor technique, may be called "bargain bunads" or "Walmart bunads." Those produced overseas, whether by hand or by machine, may be disparagingly deemed "China bunads." Other outfits, making no claims of connection to a specific geographic origin, will often be named *festdrakt* or "fantasy drakt," especially

appropriate for parties or immigrants without regional affiliations. Lise Skjåk Bræk, one of the most well-known designers of festdrakt (written about in more detail by Laurann Gilbertson in chap. 5), specializes in high-end, one-of-a-kind creations that draw inspiration from the silhouettes and styling of Norwegian folk costume and therefore have been referred to as "bunad couture." Evident in these categorizations are nuanced projections of class, ethnicity, and race.

The majority of women and an ever-growing number of men in Norway own and wear a bunad—according to some estimates, two out of every three women and one out of every five men.[50] The sale of bunader adds up to more than US$13 million annually.[51] Embedded in both Norwegian tradition and its fashion industry, the experience of acquiring a bunad today reveals a diversity of opinions about and relationships to the idea of traditional dress.

As with folkdräkt in Sweden, individuals may inherit clothes, receive something made for them by relatives, or make their own garments with skills learned through formal or informal instruction. Many young women receive their first complete bunad as teenagers for church confirmation. Men may wait until their weddings or thirtieth birthdays. Miniature bunader for children often circulate within families, passed between members as the need arises. Bunader, unlike folkdräkter, can also be purchased from an increasing variety of commercial sources in a range of quality and shopping contexts.

In the following section, we explore the commercial landscape of bunad shopping, looking at typical businesses in the city of Oslo, the valley of Setesdal, and Upper Valdres. In all cases, buying a bunad is not like shopping for everyday clothes. The process is highly mediated and can entail a great expenditure of time and money. A useful comparison is the ritualized and revered activity of wedding-dress shopping for mainstream American brides.[52] The same elation, pressure, etiquette, and family involvement are commonly present, yet unlike "once-in-a-lifetime" bridal wear, individuals are selecting clothes they anticipate wearing again and again throughout their lives.

Shopping for Bunader

Oslo

The capital of Norway is home to dozens of bunad boutiques and workshops, the majority of which specialize in clothing that was not historically worn in or associated with the city. Apart from the Oslobunad (available only from Oslobunaden) and the more widely available Jubileumsdrakt, both discussed earlier, the bunader that most Oslo residents wear represent someplace else.

Heimen Husflid, with two locations in Oslo, advertises its wide selection and expertise in hundreds of models from

all over the country. Many of the employees hold formal degrees in *kjole og drakt* (dress and costume) earned through trade schools, universities of design, or official apprenticeship programs working alongside masters. Opened in 1912 at Rosenkrantz' Gate, Heimen was started by Aksel Waldemar and Anna Johannessen at the height of Norway's *husflid* (handcraft) movement (one that mirrored the hemslöjd activities in Sweden). They were encouraged by Hulda Garborg and together created several new bunad designs for Valdres and Gudbrandsdalen. Today, the business is owned by Bondeungdomslaget (BUL), a cultural heritage organization founded in 1899 to serve the many youth migrating to Oslo from rural districts for work. The second location, just a short distance from the original site, is housed on the lower level of GlasMagasinet, a luxury department store in Oslo's city center. An escalator ride to the showroom glides past elegant fashion mannequins in bunader posing on a dais.

In the summer of 2015, I met Yonas Bennour, a sales representative at Heimen. He walked me through the process of selecting and ordering a bunad. In most cases, a customer will need to place a special order, waiting anywhere from eight weeks to more than six months. Many accessories, however, can be purchased in the store immediately—scarves, shoes, belts, stockings, hats, and jewelry. Limited off-the-rack offerings may also be available, such as embroidered blouses, bodices, and beaded bodice inserts specific to Hardanger and elsewhere.

A complete ensemble can be ordered made-to-measure, sewn according to one's closest aligning pattern size. To fit properly, it may need additional alterations later, but this option is less costly than made-to-order garments, cut to one's specific measurements. Made-to-order will take longer and require multiple store visits to accommodate one or two fittings. Customers may also opt for different combinations of handwork and machine sewing. While much of the sewing and assembly is completed by in-house specialists, all Heimen bunader are sent abroad to be embroidered in China, Vietnam, or Estonia. The cost of hand embroidery is otherwise too prohibitive.

One way of controlling both the cost and personalization is to make one's own bunad with the help of Heimen staff. Heimen Husflid will put together kits for certain bunader with all the necessary materials and stamped-on patterns included. For an additional fee, a customer can receive personal assistance costing 900 NOK (a little over US$100) per consultation. Individuals who adopt this method may complete only parts of a garment themselves, such as the embroidery. The final tailoring can be the most difficult step, shaping a garment in a way that best fits and flatters an individual's body. Some make as many elements of the outfit as they can and then take the completed parts to a professional for final assembly.

Before a customer settles on a production method, however, the first and perhaps most challenging step is determining which of the hundreds of possible models to pick. Customers are encouraged to make an appointment with consultants who can advise them.

For urban residents, unlike those living in rural communities with strong local dress histories, there is considerable flexibility in choice of which bunad to wear. Most Norwegians agree that one should possess some material or emotional connection to a bunad's home region, regardless how tenuous. Distant relatives, whether by blood or by marriage, could qualify. Temporary or seasonal residence in a place, even briefly, could probably be defended. Nevertheless, the home region of one's birth or the birthplace of one's parents or grandparents is preferred. Most Norwegians attempt to balance the customs of ancestral lineage with personal aesthetics, looking at the possibilities first narrowed by their family history, and then selecting the one that most appeals to them.

Some people with means, of course, decide not to limit themselves to just one, instead owning multiple bunader, each from a different area. Though much of the discourse surrounding the selection process characterizes it as a singular and monumental event, plenty of Norwegians will own more than one outfit during their lifetime by replacing specific parts, acquiring new accessories, or receiving an entirely new bunad. In Oslo, for example, it is not uncommon for men and women to buy a new bunad to wear for their fiftieth or sixtieth birthday parties.

As a young man in his twenties, Yonas has not yet acquired his own bunad, but he wants one. He will likely choose the mannsbunad from Nordland, where his mother was born. (His father is Algerian.) If a bunad is not gifted by family members, it could require savings that a young person cannot easily produce. "You have to ask," Yonas said, "do you buy your own place or buy a bunad?" A pair of men's moose-skin breeches alone can cost 20,000 NOK (nearly US$2,500).

Regional models range dramatically in price depending on the associated materials, number of components, and construction techniques involved. Cost can be a significant factor in the selection process. One of the few off-the-rack options, the *Råndastakk-og-rutaliv* in stripes and plaid from Gudbrandsdalen, can be purchased for around US$1,000. Yonas said that people in a pinch sometimes buy it, just to have something to wear. On the other end of the spectrum, the *Beltestakk* from East Telemark, especially in the very fashionable purple variation, was the most expensive option at that time. Yonas believes some women prefer it simply for status—the bunad equivalent of wearing a designer label from an haute couture fashion house. As a more recent reconstruction, though, it also benefits from the incorporation of luxurious silks and velvets as well as a flattering silhouette that may appeal to urban

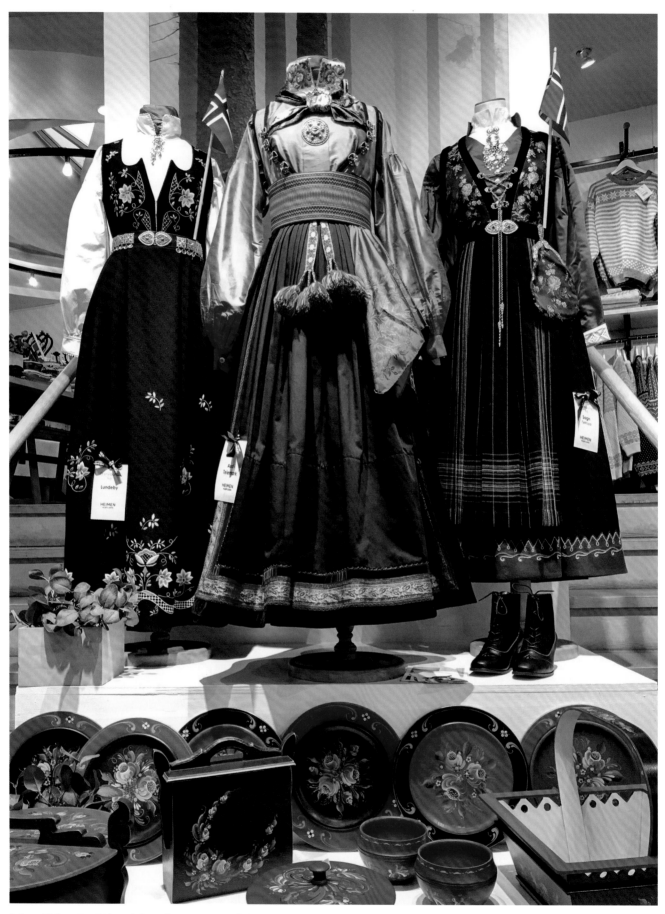

Beltestakk from East Telemark (*center*) at Heimen Husflid in Oslo. *Photo by Carrie Hertz, 2018.*

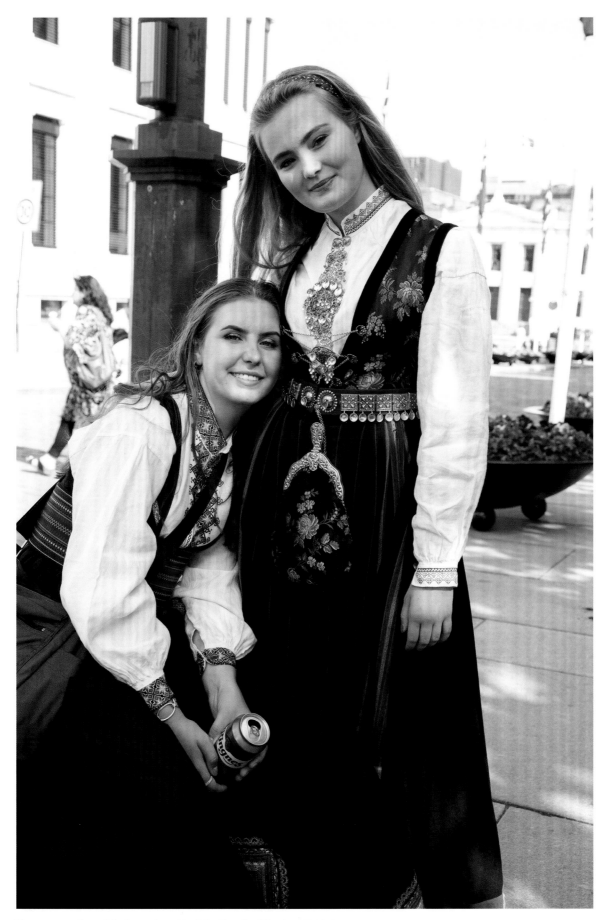

Young women dressed for Søttende mai in Oslo. *Photo by Chloe Accardi, 2018.*

shoppers with its cinched waist and full skirt reminiscent of contemporary ball gowns.

The extent and flexibility of available choices found in Oslo, not surprisingly, can create anxiety for individuals faced with a costly, lasting, and meaningful decision. Like an American wedding dress, the bunad is expected to clearly communicate something about the identity of the person wearing it, though opinions about precisely what that ensemble says or should say vary. Girls, especially, when choosing a confirmation dress bought with someone else's money, may feel either pressured or relieved by the guidance of family traditions and expectations. One young woman in Oslo described her experience to me as an "existential crisis," choosing one outfit to wear her whole life. What if she grows tired of the colors she picks? An older woman told me *she* was tired of seeing "all of these pink and purple bunads chosen by thirteen- and fourteen-year-old girls and ordered eight sizes too big." Will they even want to wear them by the time they fully grow into them?

The power of choice enjoyed by young girls is a common topic of discussion. At Stakkeloftet, a small bunad boutique located in the trendy neighborhood of Majorstua, I met Molle Horn.[53] Trained as a textile artist and teacher, Molle has worked in the bunad business for more than thirty years. Before Stakkeloftet, Molle was an employee at Heimen Husflid for ten years. In her experience, she has witnessed a revolution in interest among Norwegian youth. When she began, she told me, "We rarely made for the young. When we did, it was for confirmation, and they hated it." Now, she says, young girls clamor for it and pressure each other in school. As popularity has grown, she believes the strictness that once guided choices about which bunad to wear have loosened: "Thirty years ago, it had to be where you're born. Most still pick where they're from, or mother or father or grandparents." But now, some also just pick what they see as "the nicest one." Though wearing a bunad should inspire "national feeling," she argued, it should also make an individual feel proud and beautiful, so that "when you put it on, you straighten your back." Bunad is a symbol of "freedom" and "independence," so why should it not reflect freedom of choice?

Despite this cornucopia of choice, not every model of bunad can be purchased in Oslo. Yonas characterized the varieties available at Heimen as only those "safe to make"—that is, "not too local" or from places where local economies depend on their production. He described this as an unofficial "gentleman's agreement" honored by most but not all Oslo bunad producers. A few reasons prevent places like Heimen from carrying particular models. *Setesdalsbunad*, from a place with an unbroken dress tradition, is not only challenging to streamline alongside other bunader, being unique in its appearance, construction, and variability; the style also inspires feelings of protective ownership from those living in its home region.

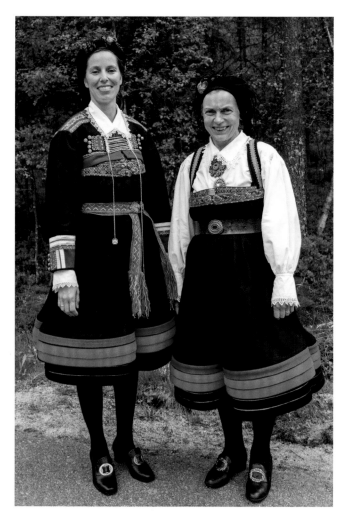

Fatima Aakhus and Randi Myrum wearing Setesdalsbunader. *Photo by Carrie Hertz, 2015.*

To include it as one among many is bad public relations. (In fact, almost every industry insider I spoke with named, without prompting, the same Oslo business as a poor example of respectful conduct.) Another type of bunad commonly excluded from the available catalog is newer, highly localized historical reconstructions, such as the *Bringedukdrakt* in Upper Valdres. These require specialized knowledge and expertise that urban artisans simply may not possess. To better explore the diversity represented by these special contexts, let us visit those involved in the production of bunader in Setesdal and then Upper Valdres.

Setesdal

The Setesdalsbunad is one of the most recognized and celebrated in all of Norway, distinguished for being from a long, distinctive, and continuous tradition for local dress. Both the men's and women's church clothes retain a unique appearance, diverging in silhouette and styling from other bunader. The woman's bunad is knee-length and bell-shaped with a short

bodice and a high-belted waist. A black wool dress with braces (*svartestakk*), voluminous and needle-pleated at the back, is layered over a white wool underdress (*kvitestakk*). Both layers are lavishly embellished with colorful embroidery (*løyesauma*) and sometimes silver ribbons (*sylverborur*). A basic ensemble also includes a headscarf, typically in a floral print on a black or white ground, and black knit stockings (*krota*) held up with band-woven or leather garters fastened with silver buckles (*sprette og sprot*). Additional accessories are plentiful, from heavily embroidered jackets, patterned bands, half gloves, and shoes to a variety of handwoven shawls. The main garment for a man's ensemble is a pair of woolen overall trousers with a leather seat, suspenders, and trim. The bib (*bukselok*), appliquéd with green wool, and a short matching waistcoat (*brjosduk*) are both covered in embroidery. Matching jackets, hats, knives, silk scarves, and the famed "lice-patterned" Setesdal sweater (*lusetrøya* or *lusekofte*) are common additions. Both men and women wear white linen or cotton shirts edged with crocheted or tatted lace (*hedebosaum*). Both bunader may be

further adorned with a wide selection of silver or brass buttons, clasps, buckles, brooches, and chains.[54]

In Setesdal, you can buy a basic bunad from the Setesdal Husflid in Valle for around 50,000 NOK (almost US$6,000). The garments will be tailored in-house by Husflid staff with help from a handful of talented embroiderers, weavers, and tatters in the community. Bunadsølv can be ordered separately from local jewelers, such as Hasla, located just down the road.[55]

In Setesdal, however, most bunader are made at home. In contrast to those in urban centers, people who wish to acquire one are more likely to purchase hands-on training than commodities. Knowledgeable makers have consciously and, for the most part, collectively decided not to provide many kits for sale. For locals who cannot learn from family members, the employees and volunteers at the Husflid can assist anyone working on a bunad. Informal sewing circles often gather in private homes so that participants can learn from an elder or help each other through projects. Randi Myrum, curator at Setesdalsmuseet in Rysstad, holds private classes and a monthly sewing circle

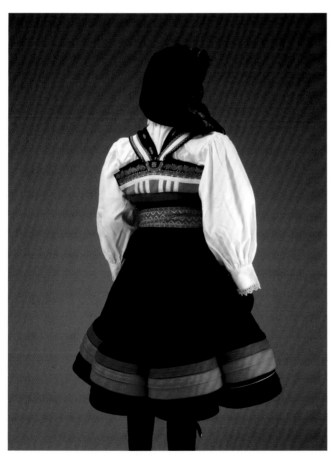

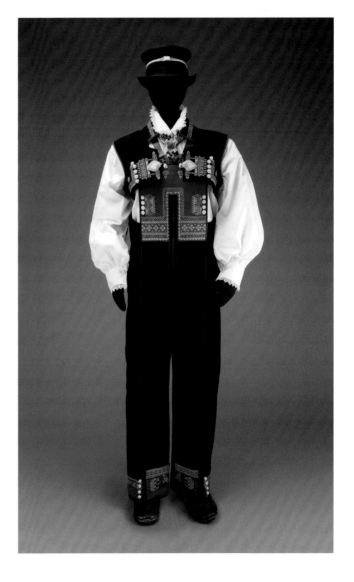

Woman's and man's Setesdalsbunader made by Setesdal Husflid artists with silver made by Ornulf Hasla, Tom Ståle Moseid, and Anne Vatnedal Brokk of Hasla, 2018. Museum of International Folk Art, IFAF collection (V.2019.38.1–11 and V.2019.37.1–9). *Photos by Addison Doty.*

in her home.[56] The museum has produced a number of films depicting detailed sequences of making and dressing, such as putting on a headdress or needle pleating a skirt.[57] Randi hopes these, broken up into useful segments, will eventually appear on the organizational website. Some films can be purchased in the gift shop as DVDs.

Randi believes that one important strategy for maintaining a living tradition is to avoid common standardizing methods such as printed patterns and kits. While these can be affective tools for preservation, education, and income, they do not teach the underlying processes and philosophies of design. Hesitant beginners may never move beyond copying, especially when materials are expensive, and they fear wasting them on risky projects. The printed patterns may become more than simple guides, soon considered the "official" or "correct" versions. Traditionally, Setesdal-style embroidery is done freehand, without fixed patterns. General consensus demands that each embroidered design be unique and consistent with an individual's personality, yet it should also conform to shared aesthetic traditions, recognizable as being from Setesdal—ideals not always met in practice.[58] Beginners need to master not only manual skills but also a deeper knowledge of repertoire and style.

"People living here," Randi explained, "they are enthused and interested in making their own bunad. All the techniques, they want to do it." Not long ago, girls learned to sew at home or in school, but today, "young people can't sew very well," Randi said. Without even basic skills, they wish to construct highly complicated garments from scratch in a flexible but narrow style, a daunting task even for those raised in Setesdal. So, when outsiders contact the Husflid, asking for kits and patterns, they are told to visit instead. "To keep the tradition," Randi argues, "you need to keep contact with people who know. You can't just give a recipe. You need to sit by another person to get guidance and information, so they can follow you through the production."

While many models of bunader are made throughout the country (or even overseas, as we have seen), the Setesdal bunad rarely is. Setesdalsbunaden is unique in both appearance and production. If someone in Oslo wants one, they may need to travel to the region. Whether they buy one from the Husflid or learn to make it from local teachers, they are forced into face-to-face relationships with others. People from across Norway, especially from Oslo, regularly make repeat visits to receive instruction, working on a portion at home, then returning for evaluation and next steps. It takes approximately 240 hours to complete an outfit, if no mistakes are made.

Randi, a skilled craftsperson, does not consider the garments that difficult to make, but she said, "You need the training and teaching of another person to explain why you need to use those colors *there*, these stitches *here*, to understand it. The whole design doesn't give itself; you have to learn from *someone*." Once this social and intangible cultural knowledge is mastered, individuals can strike out on their own, creating more idiosyncratic designs. If people learn directly from living masters, it does not matter to most locals if they have ties of kinship to the area or not. They have made the appropriate effort. Randi, for example, grew up in Hedmark in eastern Norway before marrying a local man and resettling in Setesdal in 1980. Her wedding marked the first time she wore Setesdalsbunad; the ensemble was compiled from borrowed garments. She learned to make an outfit for herself soon after through classes offered by the local chapter of the Farm Women's Association. Now she wears bunader from both places—the Hedmark of her birth, made by her mother, and the Setesdal of her marriage, made by herself. Randi considers it only right that outsiders should admire and covet the Setesdal bunad: "It's the best one, and it's the hardest to get."

When I asked Randi why she thought Norwegians were still interested in wearing bunader, she said, "I think they are proud of these clothes." I asked for clarification: "The clothes themselves? Rather than pride of place or identity?" She confirmed with great enthusiasm, "Yeah, the *clothes*! And how they've done it themselves." Randi believes that much of the attention paid to historical accuracy and maintaining variation today is less about the revival of a glorious national or even local past than it is about a revival of masterful craftsmanship in an age of global consumer capitalism. Looking at older garments, as she does quite often as a curator of local history, she is taken aback by the high quality of materials and construction. By reconstructing older models and reviving forgotten forms, contemporary makers can regain lost skills and artistry. "I have big respect for costumes here," she explained.

An important aspect of Hulda Garborg's ideology for bunad was that everyone should be able to make their own, but she was also concerned with women's equality and education outside of the home. The simplified versions she designed served these goals, freeing women from what she saw as tedious handwork. Today, however, many of the women I spoke with emphasized their excellence in craftsmanship, mastering complex technical processes, and through this relationship, valuing traditional dress for more than its symbolic potential, seeing it instead as a pathway to artistry and entrepreneurialism. As a celebrated art form, bunad is an avenue for the professionalization of what may have been formerly viewed less favorably as women's required and unpaid labor. Professional makers today, men and women alike, still cannot expect commiserate pay for their efforts and expertise, but they may find other types of compensation in the appreciation of others and in personal, creative satisfaction. Taking inspiration from older

models, many in Setesdal hope to nurture technical and aesthetic practices that represent the best of local achievement long into the future.

Upper Valdres

In the district of Valdres, women have four main choices for bunad: two embroidered and two reconstructed. The embroidered options include the "Old Valdres" style with big, bright florals designed by Hulda Garborg in 1914 (with Aksel Waldemar and Anna Johannessen, the founders of Heimen Husflid in Oslo) and the "New Valdres" style. Revised in 1948, the new style was also the result of a collaboration with Heimen Husflid but this time spearheaded by a local committee in Valdres. The committee wished to create an updated bunad that more closely resembled the cut of historical garments found in the district and to accommodate changing preferences for more delicate embroidery in deeper tones.[59] Both versions, new and old, can be fabricated in either black or blue wool and personalized with a range of minor embellishments or accessories. The first reconstructed bunad, *Rutastakken*, is based on a style that was fashionable in the area between the 1840s and 1870s. The bunad has a joined bodice and skirt in red plaid wool, often worn with a white blouse, a silk apron, a shawl, and a

headscarf. There are at least eighteen historically documented plaids to choose from, most of them associated with specific municipalities in the region. Matching belts, jackets, and silk scarves are also available. All of these options can be purchased from a variety of bunad producers throughout Norway. In contrast, the most recent regional bunad reconstruction, known as the Bringedukdrakt, can be acquired or learned only from a few professionals working in Valdres.

Based on clothes worn in Upper Valdres between 1750 and 1860, the Bringedukdrakt includes a black wool pleated skirt worn with a striped wool apron or a cotton one printed in a variety of floral or scrolling patterns. An attached bodice—available in a wide array of fabrics, from silk damasks to colorful wool brocades—is paired with a linen blouse trimmed in whitework. Like other highly valued dress traditions in Norway, as with those found in Hardanger, the Bringedukdrakt revives a regional style for decorative bodice inserts, the *bringeduk* in the local dialect, for which the bunad gets its name. Bringedukar feature designs rendered in beadwork, embroidery, and appliquéd ribbons. Accessories include pleated peplum jackets, jewelry, silk scarves, waist pockets, and belts embellished with beadwork or silver ornaments. Different headdresses, some quite complicated in construction, are

The "New Valdres" bunad in a promotion for a local fish festival in Fagernes. *Photo by Carrie Hertz, 2015.*

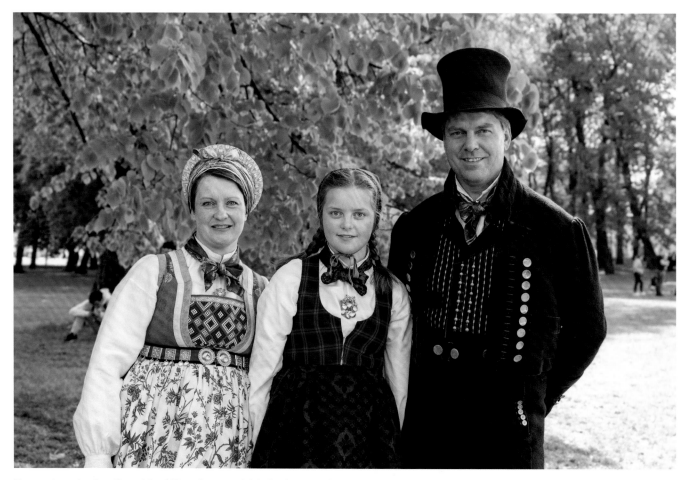

Three registered styles of bunad for Valdres: the Bringedukdrakt, the Rutastakk, and a man's reconstruction introduced in 1962. *Photo by Chloe Accardi, 2018.*

offered for married and unmarried women. Each outfit can incorporate many possibilities for fabrics, colors, patterns, trimmings, and techniques—each one linked to a verified, historical, and localized precedent but re-sorted in a countless number of unique combinations.

The Bringedukdrakt, introduced in 1971, was the result of years of research. This reconstruction relies on early descriptions, watercolors painted by Johannes Flintoe in the 1820s, and more than four thousand registered antique garments found in the Valdres folkemuseum, as well as private farm collections held in the Vang and Slidre municipalities. Before her retirement, Magny Karlberg devoted many of her twenty-six years as director of the Institute for Bunad and Folk Costume to the Bringedukdrakt's reconstruction.[60] She was assisted in her endeavors by knowledgeable local artisans, including Grethe Rudi Bråten.

Since 1989, Grethe has operated, with Gunhild Nørsterud, the Valdres Folkedraktsaum, a custom-bunad business housed in a historic building in the Valdres folkemuseum's open-air park in Fagernes. Offering only varieties of Valdres bunader, Grethe specializes in women's clothes on the main floor, and

Gunhild works with menswear on the upper level. Their location, nestled on the museum grounds, means they can maintain cozy relationships with the collections, archives, and staff of both the museum and the Institute for Bunad and Folk Costume.

I first met Grethe at the folkedraktsaum during the summer of 2015.[61] The small timbered building that houses the workshop was built around 1807 in the vernacular style of Akershus county. By 1978, it had been moved from its original location, Jonsheggji farm in Øystre Slidre, and reassembled in the open-air park. A little more than ten years later, Grethe and Gunhild launched their business in the repurposed space.

Inside, the main room is warm and bright. High-wattage lighting fixtures hang incongruously from the ceiling's exposed wooden beams. Finished garments hang from a clothing rod installed in an unused open hearth. Underneath, stacks of shoeboxes offer Klaveness-brand *bunadskoen* (bunad footwear). The workshop retails a few other bunad-related accessories from companies with national distribution, such as multicolored silk scarves from Tyrihaus and bunadsølv by Sylvsmidja. Near the back of the room, two large worktables bear

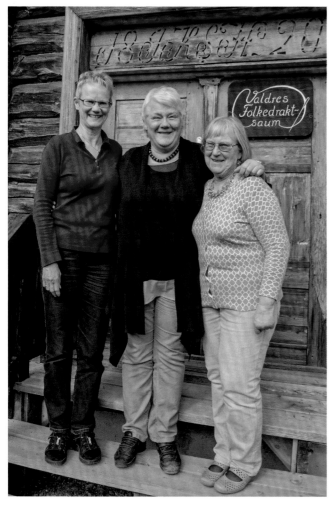

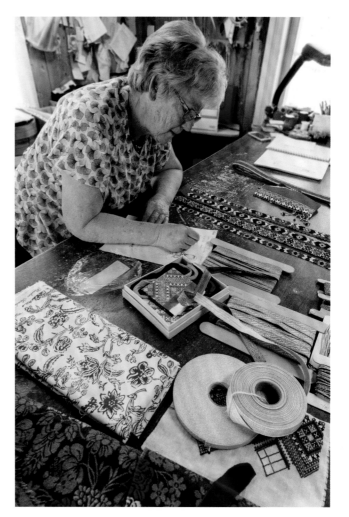

Grethe Rudi Bråten (*right*) with her apprentice Karen Marie Tvedt (*center*) and Gunhild Nørsterud (*left*) in front of their bunad workshop Valdres Folkedraktsaum. *Photo by Carrie Hertz, 2015.*

Grethe Rudi Bråten surrounded by fabric swatches and trimmings for making Bringedukdrakter. *Photo by Chloe Accardi, 2018.*

various garments in progress. Shelves hold supplies and bolts of fabric—wools from Gudbransdalen Woolen Factory, linens, silks, and printed cottons by Barbro Sandell of Gotland, a textile artist specializing in reconstructed eighteenth-century patterns.

A corkboard near the entrance displays newspaper clippings about the folkedraktsaum and photographs of customers posing in bunader made for them by Grethe and Gunhild. Some of these were taken by photographer Eva Brænd for a feature spread in the February 2008 issue of *Bunad Magazine*. A side table holds books and brochures about local dress traditions produced by the Valdres folkemuseum. These are supplemented by thick binders holding detailed photographs, diagrams, and descriptions of the various patterns, designs, and materials that customers can select to design their own bunad. A board posted nearby also includes eighteen plaid fabric swatches for making Rutastakken stapled to it and grouped by municipality—Nord-Aurdal, Sør-Aurdal, Øystre Slidre, Vestre Slidre, Vang, and Etnedal.

Though Grethe makes all varieties of bunader for Valdres, she prefers working on the Bringedukdrakt. This option is the most enjoyable to create again and again, being the most variable. As she is a small-business owner, it is also the most economically rewarding for her time and effort. An embroidered bunad may cost less than US$3,000, and the Rutastakk could total less than US$4,000. Both are offered by other producers across the country at competitive prices. Only a handful of people make the Bringdukdrakt professionally, and depending on an individual's selections, one ensemble will likely run between US$6,000 and US$9,000.

Grethe, now in her seventies, first learned to sew from her mother and then spent three years training through a formal apprenticeship program for traditional dress. She later taught sewing and bunad tailoring as director of the Valdres folk school for more than twenty years. Grethe grew up wearing the Old Valdres embroidered bunad, but now all the women in her family wear the Bringedukdrakt. When custom orders back up at the workshop, she may receive help from her sister, Liv

Skattebo, or her daughter, Hilde. Grethe maintains a waiting list several years long. Her work is in demand not only because few can compete with her expertise but also because she is devoted to technical excellence, insisting on patient handwork. Many of Grethe's ensembles are completely hand sewn using waxed linen thread. She occasionally employs a hand-crank sewing machine for long seams. Skirt hems are edged with finger-woven ribbons, never machine-made alternatives.

Grethe told me that with this high demand she could have chosen to make "the business bigger or more advanced," but she prefers doing the work herself, laboring with her hands. Grethe's adherence to these methods is more aesthetic than ideological; they produce, in her opinion, the finest appearance, the strongest seams, and the best fit. "There's a big difference," she explains, "between a machine-made bodice and one made by hand. By hand, you can shape it; sewing by machine, it's flat." A hand-sewn garment can be better molded and "shaped to individual bodies." Everyone who leaves her workshop, she assured me, will be "well-dressed" beautifully in an outfit designed to last a lifetime.

Karen Marie Tvedt, who was apprenticing with Grethe in 2015, said of her mentor, "She has an uncompromising, respectful commitment to quality." Karen appreciated Grethe's demanding yet encouraging approach to craftsmanship. Grethe, for example, requires that customers make at least some small piece of an outfit for themselves, often the bringeduk or, for teenagers, the beaded headpiece worn by unmarried girls. I asked her why she thought this was important. "It's important," she answered, "that teenagers get a personal relationship with the costume. It's not something you can simply *buy* at the shop, but something you need to invest in." The investment she imagines is indeed monetary but more crucially emotional and intellectual. Knowing how to make something alters one's experience of it and the wider material world. She went on to explain her own experiences with dressmaking. At seventy-five years old, she rarely changes the way she does things now. Though she would eagerly incorporate new forms and techniques derived from historical discoveries, after a lifetime of researching examples and perfecting your skills, she said, these methods have "become a part of you and the way you think." The hands guide the mind.

The material challenge and creative opportunity embodied in the Bringedukdrakt appeal to Grethe. Unlike the embroidered bunader, each one like the other, "this one" she described as "so nice and individual. There's no two alike." She owes this diversity in part to acts of preservation by locals, both conscious and unconscious. "We're very fortunate in Valdres," she said, "to have so much opportunity. People have kept [the clothes]." In this valley, people were "very traditional, very conservative." Not only did families carefully save cherished garments, but they also left remnants as rags insulating windows and walls

that can now be studied and maybe revived. For many artisans like Grethe, the preservation of materials, forms, and styles of the past is one important strategy for ultimately sustaining fine handwork, techniques, and know-how.

Centers and Peripheries

Enormously popular throughout Norway, the tradition of wearing bunader has only grown more dynamic with time, accommodating a diverse set of relationships, perspectives, aesthetics, and objectives. In conversations with experts of Norwegian dress, I asked why this was so. Kari-Anne Pedersen, a curator at the Norsk folkemuseum (Norwegian Folk Museum) in Oslo and a skilled artisan in the Telemark dress tradition, told me that a Swedish reporter once asked her why Norway's revivals of traditional dress have enjoyed more enduring and sweeping popularity than Sweden's.[62] Both countries, after all, enthusiastically preserved and celebrated their provincial, preindustrial clothes. While a majority of women in Norway wear bunader, perhaps less than 10 percent of women in Sweden wear folkdräkter.[63] Kari-Anne answered the reporter, "Because we *gained* independence, while you lost parts of yours." While a Norwegian brand of nationalism suggests the perseverance of an underdog, Swedish nationalism, in Kari-Anne's opinion, was meant to compensate for the loss of regional dominance, making it less palatable to most people today. The Swedish empire, like Denmark's, was built on the concentration of colonial power and wealth. "For Norway," Kari-Anne explained, "there were no palaces or big estates, or much aristocracy at all." The vast majority of Norwegians' ancestors, she told me, were poor farmers, and Norwegians still think of themselves that way, regardless of the country's newfound wealth. "A Norwegian," she said with some bemusement, "has to come from someplace." And if he or she can claim a home region with local dialects and distinctive dress, all the better. Imagining strong connections to rural roots can be especially important to those whose families have chosen to leave those places. Kari-Anne believes that many of the most outspoken "bunad police" are those who cling tightly to their limited understanding of these places and their past realities. For this reason, she encourages dress experts to think of themselves not as bunad police but as "bunad detectives," helping the broader public grasp a more nuanced understanding of history.

Kari-Anne's assessment was mirrored by others in the cultural heritage sector. Camilla Rossing, director of the Institute for Bunad and Folk Costume and a contributing author in this book, agreed that the historical disparities between Swedish and Norwegian nationalism and social class structure are still deeply impactful to contemporary dress practices. "Sweden was a great force, a great country with an imperialistic outlook," she said. To display too much enthusiasm now for the cultural

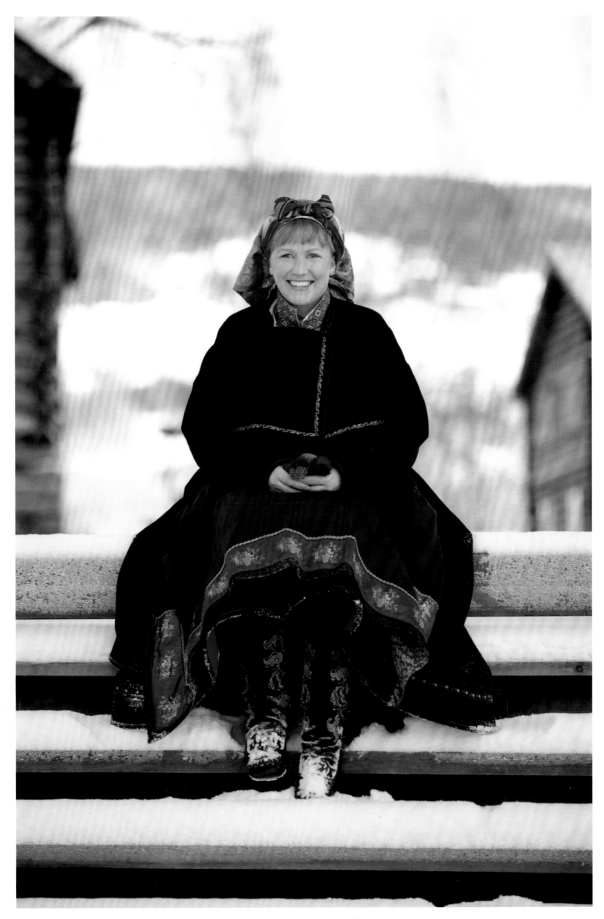

Camilla Rossing in Beltestakk for East Telemark. *Photo by Laila Durán, courtesy of NBF.*

traditions formulated in romantic nationalism may, on the global stage, make them appear "as the bully." Like Kari-Anne, she also contrasted the way she imagines that Swedes and Norwegians think of themselves through nationalist comparisons. In Sweden, wearing traditional dress is considered "nerdy, a little bit ridiculous," she said, because "they have upper class, so to identify yourself with the little farmer isn't cool. We put our pride in being down to earth." Some of the Swedes I met in Dalarna county, in fact, said very similar things about how they imagined people living in Stockholm thought about them.

Camilla does see some similarities, however, between the use of traditional dress in Sweden and that in Norway, especially in the enduring importance of localism in modern life. "When people talk about pride in Norway or national pride," she said, "it's always connected to *their* village, *that* valley, *that* particular place where you're from. It's very local. So national pride in Norway is very local."[64] Camilla believes that for most Norwegians, herself included, the bunad, like we have seen with the Swedish folkdräkt, is first and foremost about family tradition and the personal identity that one derives from that relationship. These emotional, substantive foundations have ultimately sustained sartorial practices in both countries. But the widespread popularity in Norway today, growing well beyond families and communities with long-standing dress histories, relates to the adaptability of the bunad concept to reflect changing contexts, preferences, production models, and levels of commercialization. These translations across various social and conceptual boundaries do not always go smoothly, as Camilla illustrates in the following chapter in relation to the growing participation of nonwhite Muslim Norwegians.

The idealization of what constitutes folkdräkter in Sweden has remained deeply entrenched in a pride derived from remaining loyal to rural peripheries and the lifestyles that such commitment affords. For people like Knis Anna Ersdotter Björklöf and Täpp Lars Arnesson, their use of traditional dress (and traditional farm names) is guided by their ideologies about the primacy of family history, agricultural knowledge, quality of life, and care of the land. Their mutual concerns over the excesses of modern life—the damaging effects of unchecked ambition and environmental degradation—do not welcome widespread popularity, and indeed, the use of traditional dress in Sweden is strongest in those places that most value ongoing connections to rural identities, histories of handicraft, or mutual accountability. While the tradition for making and wearing bunader has been folded into a growing national fashion industry, the tradition for folkdräkter has remained largely separate from it, arguably by design.

Camilla described the growing enthusiasm in Norway for historical bunader specifically as "a response to more complex lives today," lived without the experience of belonging to any single, grounded community. Though rural people regularly migrated for work in the past, contemporary Norwegians can point to ever-more-complicated biographies—a "mother from this place, father from another place," and frequently moving from city to city for jobs. Reconstructed bunader, tied as they are to more "authentic" materializations of place, may foster a sense of rooted stability for some, even if they suggest a more mythic homeland than an actual one. "I think, perhaps," she explained, "people realize, even if you have these individual, colorful, complex bunads, they still work as a symbol." In this way, the simultaneous reverence for and commoditization of the bunad illustrates an inherent tension that many Norwegians experience between the reality of modern, neoliberal individualism and inequality and the idealization of rural, egalitarian self-identifications.

Traditional dress, because it helps define and communicate our identities and personal ideologies, can become a flash point for conflict. I spoke with many people living in rural communities who characterized urban Norwegians' relationship to bunader as "shallow." Not everyone celebrates the transition of bunader from Norway's peripheries to center stage. If we return to Hardanger, the site where the local literally became "the National," we can take a closer look at this potential for disagreement.

Hardanger

Tourism remains an important part of the local economy in Hardanger. A thirty-minute ferry ride from Kvanndal offers stunning views of the Hardangerfjord, as it slowly pulls into the small town of Utne, a cozy grouping of white and red timber houses crouched between the shore and a steep mountain wall. Just a few yards from the ferry landing, the Utne Hotel, built in the eighteenth century, still hosts visitors to Hardanger. The hotel staff still wear "traditional dress" as uniforms, based no longer on *Hardangerbunader* but on less locally specific *hverdagsbunader*.

Hverdagsbunader, or "everyday" bunader, became popular in the mid-twentieth century as sensible, cotton house dresses worn with simple blouses and aprons. Lightweight and knee-length, they evoke an older style of dress (and feminine caretaking) while remaining practical for the demands of working in a service industry. The current manager of the Utne Hotel, Bente Raaen Widding, told me she wanted to honor the hotel's traditions but knew it would be physically uncomfortable, as well as potentially disrespectful, to ask employees to wear versions of the Hardangerbunad while waiting tables and registering guests. Hverdagsbunader, on the other hand, fit into the hotel's historic environment and make the staff identifiable to customers. The dresses are in fact vintage 1960s, sourced from online vendors and donors who wanted to see them used. A local woman in Hardanger made the matching

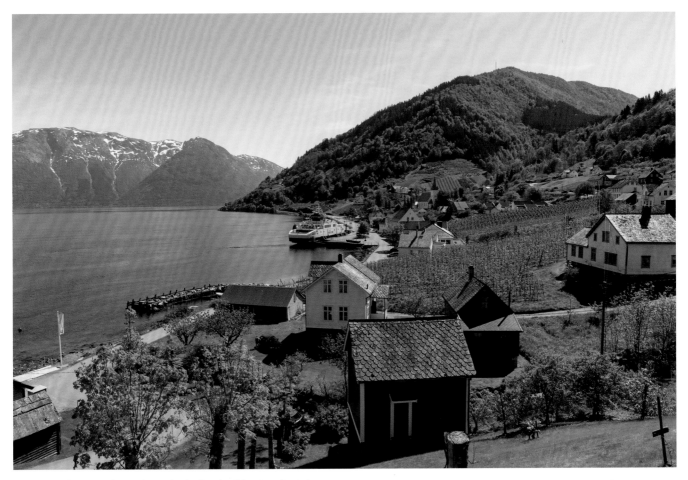

The village of Utne on the Hardangerfjord. *Photo by Chloe Accardi, 2018.*

blouses with practical short sleeves, and Bente's mother sewed the aprons. Bente wears her uniform with a traditional Hardanger brooch more than one hundred years old, a conscious nod to the importance of Hardanger's enduring, dynamic culture to the success of the tourist industry.

As they did more than a century ago, gorgeous scenery and the living local culture persist as the main motivators for tourists today, both foreign and domestic. World War I devastated Hardanger's tourist industry, from which it never fully recovered, but visitorship to the nearby Hardangervidda National Park and especially the Trolltunga rock formation (literally, "Troll's Tongue") has exploded in the last decade after they were immortalized in countless geotagged Instagram selfies.[65] Hardanger fruit trees attract special attention when they bloom in the spring and help support a vibrant small-batch hard cider industry. In the parlor and restaurant of the Utne Hotel, guests can enjoy signature cocktails mixed with the area's craft ciders. At the registration desk, postcards featuring photographs by Elisabeth Emmerhoff juxtapose images of local foods with details of traditional Hardanger dress: the close-up of a woman's bodice appears with a bunch of cherry blossoms; embroidered trimmings are shown next to a stack

of *krotekaker* (a local variety of flatbread); and a young woman wearing a bridal crown, ribbons trailing down her back, is paired with a tabletop of ripe red apples. As before, women's dress and the iconic Hardanger bride express local distinction and the cultural renewal offered by tradition, presented with an appeal to tourists' appetites.

Hardanger styles of dress, nonetheless, have remained diverse and meaningful within local experience. Most girls, as elsewhere in Norway, receive a bunad for confirmation in their teens. Traditionally, grandmothers assume the responsibility of making and acquiring all of the necessary garments from private or professional producers in the district, a process usually initiated when a child is small. Women in the region often specialize in one element—embroidery, beadwork, weaving, or tailoring—so putting together an entire ensemble is a demonstration of one's social network in the community. If she lacks personal contacts, a grandmother may call on the assistance of the Hardanger Husflid in Eidfjord to buy bunad supplies or to arrange custom orders. Like other regional craft shops throughout Norway and Sweden, the one in Eidfjord can serve as a resource center, consolidating information about local artisans, producers, teachers, and training courses. Additional

Bente Raaen Widding, manager of the Utne Hotel, wearing *hverdagsbunad* (everyday bunad). *Photo by Chloe Accardi, 2018.*

organizations in the area provide information and advice through hands-on classes.

Marit Bleie Mannsåker, a resident of Ullensvang, shared with me her fond memories of receiving a bunad as a teenager.[66] Over many years, her mother collected the necessary pieces, storing them until Marit's confirmation. "I knew what drawer my stuff was kept in," she said. "I always wanted to look at it and touch it." Unlike that of her older sister, who inherited a few heirlooms, Marit's outfit was entirely new, made just for her. The anticipation, the longing to wear beautiful garments for the first time, was a joyful rite of passage. Marit now has two granddaughters of her own for whom she has been making bunader over the past few years. "Girls today," she said, "they are so proud to wear it. You can tell by the way they stand." The pleasure and self-esteem derived from one's first bunad, Marit believes, comes not only from the opportunity to dress up but also from feeling loved and cared for by others. What she values most about the dress traditions of Hardanger is that they "strengthen family connections." For this reason, she disapproves political uses of the local bunad.

When Marit was growing up, Hardanger dress was still widely known as the National. In Marit's recollection, her teachers in school would discourage the children from calling it that, saying, "No, it's *our* bunad. It belongs to *this* area." By the 1960s, the broader term disappeared from local speech, but the gaps between provincial experience and national imaginaries continue to play out in daily life.

A short walk from the Utne Hotel, the Hardanger folkemuseum displays permanent exhibits of Hardanger dress and adornment. During one of my visits to the museum, I sat down with curator Agnete Sivertsen to learn more about the unfolding history of Hardanger dress.[67] Agnete summarized a general shift in values since the time of romantic nationalism: "At the beginning of the century, the bunad was—when it was more like a national symbol, it was also more like a uniform. And nowadays no one is interested in wearing a uniform. You want something that shows your personality. In our society now, that's how we like to dress, and bunad also followed that. In one way, the Hardanger costume and the bunad tradition are giving traditional clothes this new life, which is still going on. But at the same time, they're making choices that kind of sort out parts of tradition." Local dress in Hardanger has always been responsive to wider cultural developments, fashions, and preferences. Though the typical outfit was simplified and standardized as the Nastjonaldrakt throughout Norway, in local practice, dress remained dynamic, at least in memory and material evidence if not always in action. So, when local enthusiasm for wearing traditional dress grew, in step with nationwide trends, younger generations were able to revive historic elements that had fallen out of use, incorporating more expansive choices for outerwear, accessories, colors, and fabrics.[68]

At the same time that residents look to past material for contemporary revival, they also draw inspiration from the wider contemporary bunad movement in Norway. An embroidered pocket, for example, has been introduced with a metal frame clasp similar to those found in other regions and worn hanging from a belt or waistband. "We don't have a single [example of] one at the museum," Agnete explained, "and it's no problem. It's a balance. People like to include completely new stuff, too." Interestingly, small beaded pockets and purses fashioned to match the Nasjonaldrakt were common tourist innovations made and sold by local artisans before the bunad movement. Now, Hardanger residents make for themselves a new style of pocket, representative of place as well as national bunad fashions.

As Agnete emphasized, contemporary practice is a selective process. Some garments, though acknowledged as historically important, will not be preserved or revived. The museum, for example, has struggled to keep alive the craft knowledge associated with the skaut, the complicated starched and pleated headdress for married women, historically made by specialists. Though some women wish to keep wearing it, almost no one knows how to make it. Recently, the museum teamed up with local artisans and heritage organizations to "try to take care of this tradition," but demand for using the skaut may not keep pace with their efforts.

Agnete, using a phrase I heard repeated often, explained that individual variations in bunader should "stay within the frame." She admitted, however, that this intellectual framework that guides preservation and innovation is regularly redrawn. Individuals often disagree about what can be added and what should be forgotten. She summarized for me, "As long as we've had bunad, there's been this awareness and fear of bunad getting altered. On the one hand, you have people that think, in the early days they used whatever they had. And nowadays, we can use whatever *we* have. [On the other hand,] *we* have lots of things that would have never been used before." Ancestors were creative, inventive, and pragmatic, but people today, with few material restrictions on their choices, fear they will make so many changes that an outfit can no longer be recognized as a Hardangerbunad. There will no longer be a frame to hold it. In Hardanger, as in many places across Norway, the localized specificity of traditional dress as an iconic link to the past endures as its most valued feature, and this relies on a certain level of consensus.

I asked Agnete if she thought the Hardangerbunad still had nationalist connotations today. She said yes but then interestingly offered a series of examples of locals using bunad while protesting the interference of the Norwegian state in

provincial affairs. The most recent protests began in 2010 and lasted for years in a failed attempt to prevent the construction of high-tension power lines and "monster pylons" that would mar the area's celebrated natural beauty. To activists, not only would this expensive and possibly unnecessary modernization harm local tourism and poorly impact the environment, but additionally, the proposed benefits of increased electricity generated from the region's hydroelectric power plants were intended primarily for export.

A documentary by Hardanger filmmaker Vigdis Nielsen, *Kampen om fjordane* (*Fight for the Fjords*), released in 2016, details the controversy from the perspective of local activists.[69] In the film, a representative for Statnet, the state-owned energy company, explains the purpose of this new development: "It's infrastructure that a modern society depends on. The power line will ensure that the people of Bergen and others have a bright future." Hans Uglenes, a landowner whose summer farm in Ulvik falls within the planned building zone, disagrees: "It is the fjords, the nature and thriving villages, and the people who live here, weighed against profits. . . . People say that they feel overruled. We are not being listened to." The opening scenes of the documentary transition from a midcentury promotional film proclaiming in English voice-over the virtues of Hardanger's scenery while bunad-clad women wave at the camera to a contemporary home interior. In it, the young environmentalist Synnøve Kvamme slowly and soberly dresses in Hardangerbunad, as if putting on battle armor.

During protests, Kvamme, in her Hardangerbunad, occupied a Statnet building site and was arrested. A photograph of the event later went viral; it showed police officers forcibly lowering Kvamme down from a shipping container, her arms outstretched like a crucified messiah, while surrounded by protest signs warning "Hardanger in Danger." The image struck a chord, harnessing the long history of both the landscape and the local dress to evoke feelings of romantic patriotism yet reframe it as a repatriation of local resources by provincial rebels.

Agnete explained that since at least the eighteenth century, Hardanger dress has been politicized. It has been "used by people far left and far right and in between. Everybody uses it." People living in Hardanger, however, wear it primarily to support personal and regional concerns over national ones. Because local practice is vibrant, widespread, and dynamic, "it's not so easy to take." Nonetheless, Norwegians have a different relationship with the Hardangerbunad than with dress from other areas. Because of its unique history, citizens throughout the country may feel a sense of personal ownership over Hardanger dress. It continues to be worn by those without direct ancestry, especially in the United States after immigrants took up the cause for Norwegian independence.[70]

Agnete recently stumbled upon an open Facebook group devoted to the Hardangerbunad and populated by members living outside the district. They share images of their in-progress handwork and comment on each other's projects. "They're so self-assured," she said, as if they think, "*We* can do whatever we like with this." She was confused by the terms members of the group used to refer to the garments. They clearly were not aware of dress terminology in the Hardanger dialect, demonstrating their outsider status alongside their honest enthusiasm. Generally, as we have seen, Norwegians argue that local areas should retain jurisdiction over the ongoing development of their dress traditions, but sometimes the Hardangerbunad is exempted from consideration. This use has increasingly been interpreted by a faction of residents as cultural misappropriation, especially when led by wealthy city dwellers in Oslo or Bergen. Urban entitlement to the Hardangerbunad is paralleled with national claims over local land and resources in a never-ending cycle of state-centric prerogative. As some locals see it, the state government in Oslo, in collaboration with national and transnational corporations, repeatedly makes demands on rural peripheries, exploiting what they can from the countryside, whether folk art or hydropower.

Even before the tourist industry in Hardanger was decimated by World War I, Odda, the premier destination in Hardanger, was transformed by foreign investment in private industry. In the first decade of the twentieth century, British industrialists and energy speculators began buying up the water rights and waterfalls located on private farmland for their potential as hydroelectric power. The ice-free, sea-level port that made Odda ideal for cruise ships made it equally convenient for large-scale commercial export. Chemical plants, refineries, factories, and smelting operations soon sprang up.[71] The building of the Tyssedal Hydroelectric Power Station began in 1906 to power the new, mostly foreign-owned industries of Odda municipality. These developments resulted not only in well-paying jobs but also in pollution and blighted scenery. As smoke and odorous chemical emissions began choking the air, runoff endangered the salmon, and dams dried up the waterfalls, tourists stopped visiting, and many of the remaining families who had lived there for generations packed up for the United States.

Many advantages came with industry, including a higher standard of living and economic growth. For much of the twentieth century, Odda had excellent schools, hospitals, cinemas, libraries, athletic clubs, and municipal swimming pools. Strong unions agitated successfully for safer, stable working conditions, and workers' families maintained a "strong reciprocal network of mutual trust."[72] In the last twenty years, however, most of the industries have pulled out or declared bankruptcy, citing the pressures of globalization, leaving

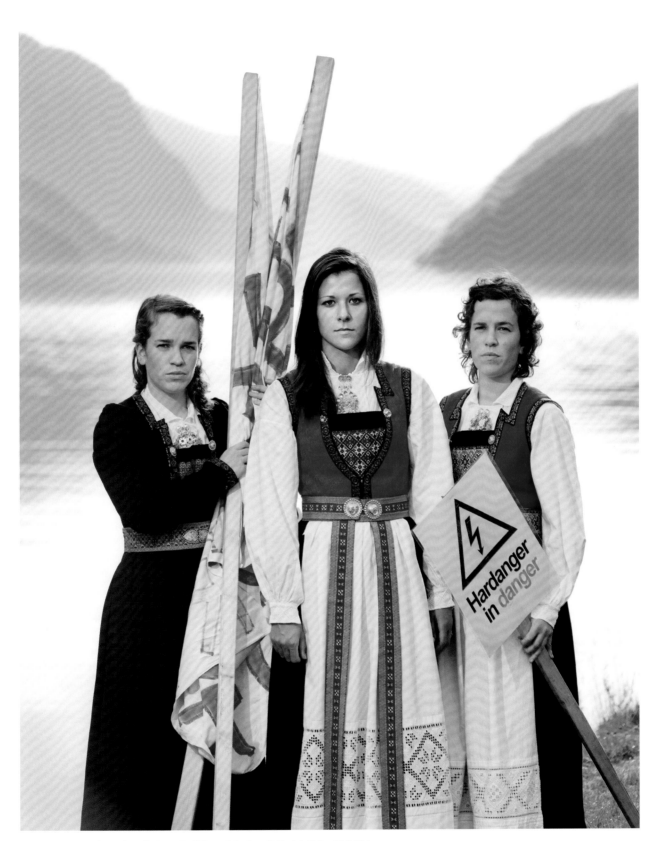

Synnøve Kvamme (*center*), with sisters Halldis and Gudrun Folkedal. © *Jan M. Lillebø.*

thousands of the seventy-five hundred residents without work. In this aftermath, and embittering to some, the landscape, once the main resource for livelihoods, is no longer viable for fishing, farming, or tourism.[73] While other areas of Hardanger enjoy renewed success with outdoor adventurers and cultural heritage enthusiasts, Odda has lagged behind. Tourism guides such as Lonely Planet, in fact, have deemed Odda "Norway's ugliest town."[74]

For the past couple of decades, some residents have been pushing for a tourism renaissance, this time focused on "industrial heritage," transforming industrial history into a cultural history attractive to visitors. Since 2000, the former power station in neighboring Tyssedal has been protected as a historic landmark by the Norwegian Directorate of Cultural Heritage and managed by Kraftmuseet (the Norwegian Museum of Hydropower and Industry). An orientation video at the museum quotes the early twentieth-century Norwegian engineer Harald Hansen, his words backed by triumphant music: "*We* have the waterfalls. We have the white coal. Technology has come so far that we can make practical use of them. Our falls are beautiful to behold. This is true. In one sense, they're lost, but in another, the falls are resurrected with a thousand times more beauty, as they give our country richness and greatness." In other words, the natural resources of Hardanger supported the wealth and grandeur of Norway as a new, developing nation, contributing to the rich, modern country it is today. The periphery's assets made the center hold. This can be a compelling narrative of pride for many people living in Odda municipality today, especially those who grew up during the boom years of the 1960s.

Randi Bårtvedt, the first director of Kraftmuseet and now director of the system of local institutions known collectively as the Hardanger og Voss museum, described her childhood in Odda to me as idyllic.[75] "We had the best of everything growing up," she said. "I'm proud of the industry here. It created a good life for a hundred years." At the same time, most of the companies in Odda have been foreign owned, which some have interpreted as shameful, both in Hardanger and in other parts of the country. When Randi went to university in Bergen, she discovered that people from Odda "were looked down upon." "Sometimes," she explained, "it feels we're not a part of Norway. Everything is in foreign hands." Through the lens of romantic nationalism, Odda was the epicenter of everything once considered "purely Norwegian." That contrast—being viewed today as a symbol of the failures of capitalist globalization—is striking and disturbing. The transformations in Odda have left many experiencing a crisis in their ability to define themselves and the character of their community.[76]

According to Randi, locals are deeply "divided about industrial heritage," through which she hopes to build a new future for Tyssedal-Odda. Industrial heritage, as a cultural

preservation movement, has been gaining traction throughout western Europe by seeking meaningful ways to reinterpret and reuse the relics left behind by industrialization. Norwegian scholar Torgeir R. Bangstad has argued that heritage processes help us cast a critical eye onto the excesses and waste of mass production and consumption, structuring the way we can understand, revalue, or purposefully forget it. "In short," he writes, "it is an indication of how we deal with ruination and obsolescence."[77] From the perspective of promoting more egalitarian histories, industrial heritage offers pathways for contemplating working-class experiences and contributions. Yet most heritage projects are reparative in intent—a form of celebratory compensation for future generations to lessen their experience of cultural loss. Which history do Odda's inhabitants prefer to preserve and revere for future generations—the wild lands, the provincial culture, or the technological innovations of Norway's industrialization? Randi, despite fierce opposition, believes there is room to remember all these versions of the past.

Locals on all sides of the issue can be dubious. Those invested in Hardanger's scenery, environment, and outdoor recreation would rather erase remnants of abandoned and bankrupted factories and plants. Industrial detritus and the stain of pollution diminish their own enjoyment as well as the potential for enticing throngs of visitors already coming to Hardanger for the national park and nearby Trolltunga. Like these anti-industrialists, those hopeful that industry will return also prefer to see old buildings and smelt works torn down, but to make room for new development. This faction has reservations about renewing tourism of any kind, regardless of whether modeled on nature, culture, or histories of technological innovation. After the secure livelihoods of union-backed factory jobs, Randi explained that the tourism industry can seem like "low-paid women's work" in comparison. To the labor unions, identifying with the preindustrial past seems like "the antithesis of development and progress."[78] To them, returning to tourism is seen as going backward.

At the grand opening of Kraftmuseet, Randi wore her Hardangerbunad, proud of the contradictions it embodied at that moment. Not only did wearing the traditional dress, one of the most enduring aspects of local culture, unite diverse phases of Hardanger's past economies, but it also foregrounded cycles of shifting priorities and privileges. The local dress had long been a vehicle for female industry and empowerment, providing an outlet for personal self-expression and social influence, as well as financial independence. Beautifully dressed women symbolized the region during the era of romantic nationalism, but women were less celebrated in Odda's industrial modernity, as this became the sphere of masculine power and ambition. But at the opening, Randi, a woman in traditional bunad, stood empowered as the interpreter of that same industrial past. For

Dressing with Purpose

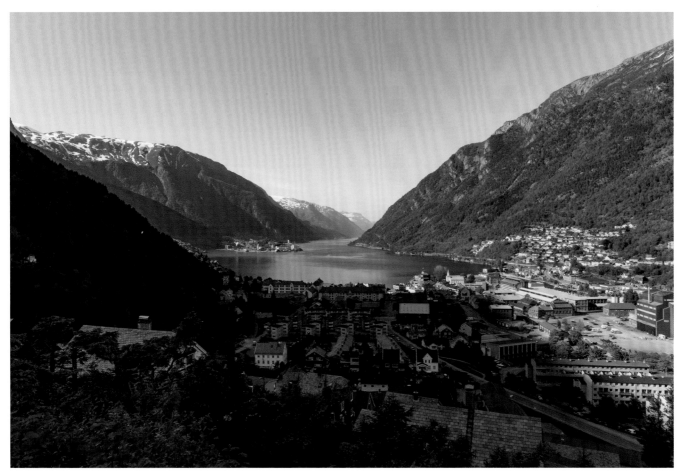

Odda. *Photo by Chloe Accardi, 2018.*

a range of reasons, some locals were not pleased with Randi's choice to wear the Hardangerbunad in this context. The values embodied in folk costume and the relics of industrialization felt incompatible to them, perhaps disrespectful. Like Odda itself, Randi argued, "I embody many contradictions."

Randi grew up in a family employed by local industry, and she grew up wearing Hardangerbunad. Her mother and grandmother were always "occupied with the costume," making garments for themselves and their relatives. Randi's mother, in fact, is well known for developing a novel way of weaving the bringklut, for which she was formally honored. To Randi, the dress and the factories are not opposing facets of irreconcilable perspectives. They are integrated aspects of her lived experience.

In popular consciousness, the local dress has become entwined with cultural tourism and a romanticized view of provincial land, but Hardangerdrakter existed before the region was "discovered" by romantics and continues today in the context of postindustrialization. The local dress did not endure unchanged but instead remained responsive. Since traditional dress and industrial modernity coexisted, Randi asks, why must they be presented in opposition to each other

in memorial celebrations and future plans for Odda municipality?

As Randi illustrates, the layering of associations for local dress can be contradictory, juxtaposing rhetorical opposites: pre- and postindustrial, regional and national, provincial and cosmopolitan, traditional and modern, personal and communal, nature and development, reciprocity and commerce, stability and progress, and past and future. Choosing which aspects to prioritize, celebrate, and cultivate in one's life becomes an expression of values. Marit Bleie Mannsåker, for example, characterized the Hardangerbunad as most importantly a manifestation of social and familial nurturing. From this perspective, thriving traditions for local dress suggest healthy relationships between kin and neighbors. They suggest healthy communities. For those in Hardanger who feel abandoned by industry, for those who believe the state-owned power companies have acted in bad faith, for those who sense smug entitlement from urban elites, these situations imply a breakdown in community and exacerbate the sense that outsiders do not care about the well-being of local people and their environment. Like tourists and prospectors of the past, they simply take what they want and move on.

When Agnete Sivertsen answered my question about the national character of Hardangerbunad with examples of provincial protests against the state, she was making an important point. By protesting in Hardangerbunader, locals not only wish to agitate for more local control over their lives. They also hope to conjure up the romantic-national history of the local dress to inspire Norwegians across the country to consider themselves mutually responsible. They are imploring their fellow citizens to simultaneously respect their autonomy and care about what happens to them. Their local dress calls on notions of unity in diversity, a hallmark of schemes for nationalized dress across Scandinavia, to activate collective sentiment: when one region is polluted and overruled, it damages the health of the imagined whole.

The fight for Norwegian independence at the turn of the twentieth century and the development of the welfare state after World War II were both justified by championing universal principles of solidarity, equality, and social security. For many citizens in Hardanger and other parts of Norway, wearing a bunad articulates a desire that the country will actually live up to these principles. Many fear it will not. A 2018 survey found that a majority of Norwegians are losing faith in the welfare state and anticipate growing social inequality in the future.[79] Meanwhile, the proportion of people dressing in bunader continues to rise.

Over the past few years, women have been taking to the streets again dressed in bunader and hoisting protest signs, this time to fight against diminishing access to health care, especially from the closure of maternity wards and birth centers in rural areas, compelling pregnant women and mothers with newborns to travel long distances. Calling themselves *Bunadsgeriljaen* (bunad guerillas), they are resisting the enactment of consolidation schemes for the presumed sake of improved efficiency and profits, similar to those being denounced in Sweden. As one protestor explained to a reporter, it is because bunader are widely associated with family tradition, healthy lineages, and "warm thoughts about our own country" that they can "become a symbol of the battle for what kind of health and welfare services we want to keep for the future."[80]

Norwegian anthropologist Thomas Hylland Eriksen has argued that bunader are simultaneously "meaningful" and "instrumental," helping individuals not just reflect ideology but also generate it by formulating a "personal attachment to history" and actively shaping their social reality.[81] Just as the Nasjonaldrakt helped Norwegians envision the nation of their dreams more than a century ago, as bunader, traditional dress remains a persuasive medium for interpreting the past and advocating for thriving futures.

Notes

1. In the United States, it is common to see this celebration written with the bokmål spelling as *Syttende mai,* but in Norway it is increasingly rendered (and pronounced) using Old Norse as *Søttende mai,* a nod to notions of a more distinctive national past separate from Denmark and the influence of Danish language. As Camilla Rossing, a contributor to this volume, wrote to me after reading a draft of this chapter, "'syttende mai' seems like something my grandfather might say, today people say (or write) 'søttende mai'. But maybe that won't work with American readers?" In keeping with our efforts to honor contemporary, vernacular terminology, we follow this current preference for spelling.

2. Tønnesson and Sivesind, "The Rhetoric of the Norwegian Constitution Day," 204. Gabriella Elgenius ("The Politics of Recognition," 397) cites 2011 data indicating that nearly 80 percent of the Norwegian population participates in national day activities.

3. Blehr, "Sacred Unity, Sacred Similarity," 175; Kapferer, "City, Community, Nation, State," 111.

4. Elgenius, "The Politics of Recognition," 398–399.

5. Tønnesson and Sivesind, "The Rhetoric of the Norwegian Constitution Day," 205.

6. Kapferer, "City, Community, Nation, State," 110.

7. Barton, "The Discovery of Norway Abroad," 26.

8. Kolltveit, *Odda, Ullensvang og Kinsarvik*, 67–71. I am grateful to Håkon Brattespe, archivist at the Hardanger Folkemuseum, for making me aware not only of this community history but also of the English translation produced for the museum by Hans H. Coucheron-Aamot and provided to me as a digital file.

9. Noss, "Norwegian Folk-Dress as Seen by the Artists," 78–82.

10. Fjågesund and Symes, *The Northern Utopia,* 40–42.

11. Barton, "The Discovery of Norway Abroad," 28–30.

12. Ibid., 27–28.

13. For a representative example of such Edenic depictions, see the rapturous poem "Hardanger" by nationalist Henrik Wergeland in Dahl, *Norwegian and Swedish Poems,* 113–118. Some historians, however, have questioned whether Wergeland even visited Hardanger in person and suggested that he instead based his observations on romantic lithographs of the landscape. See Kolltveit, *Odda, Ullensvang og Kinsarvik,* 71–72.

14. Kolltveit, *Odda, Ullensvang og Kinsarvik,* 2–11.

15. Ibid., 184.

16. Gosse, "Norway Revisited," 535. Zermatt was a popular resort town in the Alps of Switzerland.

17. Gaughan, "Notes from the Norwegian Fjords," 602.

18. Quoted in translation in Kolltveit, *Odda, Ullensvang og Kinsarvik,* 252.

19. Gilbertson, "To Ward Off Evil," 207–208.

20. Kolltveit, *Odda, Ullensvang og Kinsarvik,* 71.

21. Gaughan, "Notes from the Norwegian Fjords," 603.

22. Ohm and Jordal are mentioned in Kollveit, *Odda, Ullensvang og Kinsarvik,* 213; and in Bårtvedt and Mykleby, "The Tourists, the Landscape and the Fantasy Hotels." Anne Britt Ylvisåker writes about the commercialization of Hardanger dress for the purposes of tourism in "National Costume," 301–302. I am very grateful to archivists at the Norwegian Museum of Hydropower and Industry, Brita Jordal and Marit Bleie Mannsåker, for their assistance

finding images and additional information related to Ohm and Jordal.

23 Despite being known internationally as Hardanger embroidery, the style shares similarities with other open work. In her book *Folk-Costumes of Norway*, Gunvor Ingstad Trætteberg speculates that the tradition may have been influenced by techniques found in Holland and Italy (34).

24 This garment is often referred to as a stomacher or placket in standard fashion histories written in English.

25 This motif is ancient and widespread, used prodigiously across Scandinavia in knitting, beadwork, embroidery, and weaving. In Norway, it is also said to represent a rose, as in the *selburose* design. See Sarappo, "The Star of Norwegian Knitwear."

26 See, for example, Colburn, "Norwegian Folk Dress in America," 162.

27 Storaas, "Clothes as an Expression of Counter-cultural Activity," 155–156.

28 In his article "Norwegian National Myths and Nation Building," Dag Thorkildsen describes the new network of folk schools as "a cradle of Norwegian nationalism" intended to educate students in the "historical-poetical" myths of national identity (269–270). The folk high school movement, popular across much of northern Europe and driven by romantic and nationalist impulses, was especially strong in Scandinavia. See Fain, "Nationalist Origins of the Folk High School"; Coe, "The Education of the Folk." It may be important to note, however, that all public education curricula are politicized to some extent.

29 Williams, "From Folk to Fashion."

30 Colburn, "Norwegian Folk Dress in America."

31 For descriptions of political activities in inner Hardanger, see Kolltveit, *Odda, Ullensvang og Kinsarvik*, 146–168.

32 Ylvisåker, "National Costumes as Political Propaganda." Queen Maud's Nasjonaldrakt is now housed at the Museum of Applied Art in Oslo.

33 The bride's name, "Miss Bul," may actually be a misspelling of the common surname "Bull," or she could have been bestowed with this honorific by Bondeungdomslaget (known by the abbreviation BUL), a cultural heritage organization for rural youth living in Oslo. I am grateful to Laurann Gilbertson for sharing related archival materials at the Vesterheim Museum, as well as her insightful thoughts on this image caption.

34 Stewart, *The Folk Arts of Norway*, 207.

35 Commonly referred to in fashion studies as the "great masculine renunciation," the popular move toward the modern suit is seen as a rejection of the showy dress associated with aristocracy and an embrace of class mobility, consumption, and middle-class values in capitalist democracy. See Entwistle, *The Fashioned Body*, 153–155. For more on the spelemannsbunad and the early folk music scene in Norway, see Moe, *Broderte Bunader*, 44–47.

36 Van Elswijk, "Spread the Word," 15.

37 This image is reproduced in Skavhaug, *Norwegian Bunads*, 10.

38 Moe, *Broderte Bunader*, 82.

39 Ibid., 95–99. See also Noss, "The Transition of Traditional Folk Dress to the *Bunad* in West Telemark."

40 Moe, *Broderte Bunader*, 60. See also pp. 60–84 for a more thorough history of the early Sunnmørsbunad than has been briefly outlined here.

41 Blom, "Gender and Nation in International Comparison," 13.

42 Karlberg, "Traditional Costumes Yesterday and Today"; Skavhaug, *Norwegian Bunads*, 7.

43 For a thorough account of the development of "embroidered bunader," see Moe, *Broderte Bunader*.

44 Quoted in translation in Skavhaug, *Norwegian Bunads*, 9.

45 B. Haugen, "The Concept of National Dress in the Nordic Countries," 18.

46 "Reflexive reinterpretation" is borrowed from folklorist Sallie Anne Steiner's article "Woven Identities," 82.

47 Skavhaug, *Norwegian Bunads*, 11; Fossnes, *Folk Costumes of Norway*, 15.

48 Knudsen, *Refugees in Their Own Country*, 13, 22–23.

49 Laila Durán, founder and CEO, told me (June 10, 2015) that around two dozen styles of Norwegian bunader currently rely on her company's "reconstructed" fabrics. She confided that she worries about being the lone supplier for some of these, questioning what would happen if she stopped producing them.

50 Recently, a coalition of cultural heritage organizations submitted a 2018 application to add Norwegian bunader to UNESCO's list of representative intellectual heritage. According to a press release posted by the Institute for Bunad and Folk Costume, 70 percent of women and 20 percent of men in Norway own a bunad. Visit Norsk institutt for bunad og folkedrakt, "Bunad på UNESCO-lista."

51 Schmiesing, "Norway's Embroidered Bunader," 33.

52 See Hertz, "White Wedding Dress in the Midwest," 174–261.

53 I visited Stakkeloftet on June 8, 2015.

54 In 2015, Laila Durán published a sumptuously illustrated book on Setesdal traditions titled *Bunader og Tradisjoner fra Setesdal* that offers useful histories and images of dress. Like other books in her photography series, this one includes pictures of local residents dressed in their own bunader or in exceptional examples from private collections in collaboratively staged scenarios.

55 I am grateful to Inger Homme and Bodil Moseid Bygland for the time they spent with me at the Setesdal Husflid in 2015 and 2018, as well as their assistance with custom ordering a man's and woman's Setesdalsbunad for the Museum of International Folk Art. I am also thankful to Grete Fossen and Tom Ståle Moseid of Hasla for supplying the bunadsølv for the museum's Setesdalsbunader and for their collaboration filming short videos of the silversmithing process for exhibition.

56 I met with Randi on several occasions. Interviews were audio-recorded on June 10, 2015, and May 24, 2018, and conducted in a combination of English and Norwegian with the assistance of Laila Durán in 2015 and Camilla Rossing in 2018.

57 The first of these films was created in the 1960s and 1970s with the help of Aagot Noss and the Institute for Bunad and Folk Costume. She writes about them briefly in her book *Stakkeklede i Setesdal*, 213.

58 Several people complained that sweaters, especially, were losing their variability, now more commonly created using knitting patterns and premade embroideries. The sweaters, however, are driven by broader commercial interests, worn throughout the country as daily dress paired with jeans or trousers. They have also been embroiled in well-known copyright scandals, as with the iconic "Marius" sweater designed in the mid-twentieth century based on the Setesdal sweater tradition. For those wishing to make a living, knitting the same pattern repeatedly can improve efficiency, speed, and profit. For a more thorough history of the role of the Setesdal sweater in the development of Nordic knitwear, see Sunbø, *Setesdal Sweaters*.

59 Later, in 1962, the committee completed a design for a man's bunad consisting of a plaid vest worn with a black jacket and knee-breeches. The garments were copies of historical examples found in museums and private collections. See Ugland, *A Sampler of Norway's Folk Costumes*, 62.

60 Much of this work is outlined in Karlberg's recent, beautifully illustrated publication *Frå Versailles til Valdres*.

61 I have corresponded with Grethe and her daughter, Hilde, on numerous occasions between 2015 and 2020, in part to custom order a Bringedukdrakt for the Museum of International Folk Art's permanent collection. Recorded interviews were made in Valdres on June 12, 2015, and May 18, 2018. The 2018 interview was conducted in a combination of English and Norwegian with the assistance of Camilla Rossing.

62 I first met Kari-Anne Pedersen in 2015 at her museum office. These quotations are drawn from that interview on June 8. We have corresponded regularly since, and I visited her again when I returned to Oslo in May 2018.

63 For Swedish practice, Eriksen quoted an estimate of 6 percent for 2005. See "Keeping the Recipe," 9.

64 I first met Camilla Rossing in June 2015. We have corresponded regularly since, and we traveled across southern Norway together from May 18 to 26, 2018. She has been a critical collaborator on this project. These quotations are drawn from interviews audio-recorded on June 12, 2015, and May 18, 2018.

65 In fact, there is growing concern about "overtourism" in respect to fighting climate change, adopting aggressive sustainability standards, and preserving *allemannstretten* (right-to-roam laws). In 2018, Trolltunga attracted ninety thousand visitors, a remarkable increase from the usual one thousand annual visitors it received the previous decade. See Pearson, "Norway's Bold Plan to Tackle Overtourism."

66 The recorded interview with Marit Bleie Mannsåker took place on May 22, 2018. Additional correspondence took place by email between 2018 and 2020.

67 I met with Agnete Sivertsen at Hardanger folkemuseum in Utne on May 21 and 22, 2018. The May 21 interview was audio-recorded. We were joined at both meetings by Camilla Rossing, who assisted with occasional translation.

68 For more on this well-documented change as well as available variety, see Stuland, *Hardangerbunaden før og no*.

69 I am grateful to Vigdis Nielsen and producer Geir Netland for providing me with access to view an English-captioned version of *Kampen om Fjordane*. To learn more about the documentary, visit the website for the production company Hardingfilm at http://www.hardingfilm.no/.

70 See, for instance, Anne Kløvnes Høidal's *Bunads in America*, in which the author profiles Norwegian Americans in southern California and their bunader. The Hardangerbunad is disproportionately represented, including a number worn by those who do not claim any familial connection to the Hardanger region.

71 For a timeline of industrial development in Odda, see Cruickshank, Ellingsen, and Hidle, "A Crisis of Definition," 149.

72 Ibid., 152.

73 A 1974 environmental assessment of Odda municipality found that pollution had left the sea bottom of the fjord "essentially lifeless" and the soil "had high levels of the heavy metals mercury, lead, cadmium, copper and fluoride." See Eitrheim, Skaar, and Brekke, "Odda."

74 Torpey, "Industrial Revolution."

75 I met with Randi Bårtvedt at Hardanger folkemuseum in Utne on May 22, 2018. We were joined by Agnete Sivertsen and Camilla Rossing.

76 Cruickshank, Ellingsen, and Hidle explore this in their article "A Crisis of Definition" by examining competing discourses between culture and industry through interviews and debates in local newspapers.

77 Bangstad, "Industrial Heritage and the Ideal of Presence," 93.

78 Ibid., 101.

79 Berglund, "Half Losing Faith in the Welfare State."

80 Berglund, "Bunads Turn into New Battle Gear."

81 Eriksen, "Traditionalism and Neoliberalism," 282–283.

4

Headdress and Hijab

Bunad in Multicultural Norway

Camilla Rossing

Where we come from is only one factor that we may use to define ourselves. We also mark our identity, in part, through gender and educational, professional, religious, and political affiliations. Our personal history is often complex, with a mixed heritage that reflects relationships with different places, traditions, and cultures.[1] Many Norwegians feel the need to strengthen their emotional attachment to place or family by wearing bunader. Bunader, often perceived as traditional or timeless, are carefully put together and constructed to signal one's cultural heritage, family ties, and nationality. Every bunad is designed to answer the question, "Where are you from?" As Norwegian society becomes more diverse, we have seen growing use of bunader by families and individuals from foreign-born groups that represent minority ethnicities or religions. For these groups, wearing bunader is a way of showing pride in their Norwegian identity as well as taking a step forward in an individual integration process. As we see later in this chapter, immigrants who signal a Norwegian identity like this are positively confirmed by most Norwegians, but not by all. The perception that bunader reflect a singular ethnicity can lead to conflict. Is the bunad phenomenon inclusive or exclusive in its nature?

In this chapter, I discuss bunad within the context of an increasingly multiethnic society from both social and historical perspectives. As the director of the Norwegian Institute for Bunad and Folk Costume (NBF), I meet people and groups with a wide range of agendas and with distinct expectations for what a bunad is and what it ought to be. In my work, it is important to have a certain understanding of the normative uses of bunader in Norway, as well as maintain a personal dialogue with diverse makers and wearers. Since NBF is a public institution with a public collection, it is open and available to everyone. The institute often functions as an advisory body in both practical and academic matters, which can compel it to take a stand in questions concerning the appropriate wear and production of bunader or comment on evolving political debates in the media. Being a visible, transparent public institution, it is, of course, vital that NBF has integrity, that it is reliable and dependable. However, I have always thought that NBF must be aware of its impact as a known arbiter of the conservative norms governing bunad production and practice. It is also my opinion that NBF must be capable of considering the various roles that the bunad phenomenon plays in Norwegian society today. Finally, I believe that NBF, precisely because of its visible role, must take an active stand and articulate clear opinions in public political debates. This level of thought and consideration can be reached only through research and curiosity. This is part of the reason why I have chosen to study

bunader in contemporary Norway using information from personal interviews as well as records of public debate. Much of the public discourse concerning bunader in multicultural Norway has taken place in the media, in newspapers, online news and social media sites, TV, and radio.

Through its seventy-five-year history, NBF has often been called on to judge what is right and wrong in making and wearing bunader, a role instigated by a thoroughly normative approach in its early history that has resulted in its nickname "the bunad police." Sometimes, though, discussions occur at an academic level with scholarly views on the potential functions, symbolic meanings, and cultural significance of the bunad. These discussions have been taking place since the bunad movement first started at the end of the nineteenth century. In an ever-changing world moving toward a more multicultural society, such questions have gained renewed relevance and serve as the main focus of this chapter.

Bunad in a Multicultural Society

The most elaborate celebration of patriotic sentiments in Norway today is Søttende mai, the National Day, where children's parades are organized by schools all over the country. The children's parades have for the last forty years been an occasion for children of all cultures and color to march together under the Norwegian flag. Even though the celebrations are seen as an inclusive arena, right-wing activists and others have protested against the participation of non-Western immigrants in the parades. Søttende mai continues to incite national conversations about who has the right to take part in these national celebrations, who has the right to wear a bunad, and by extension, who has the right to call themselves Norwegian. Previous research in Norway has pointed out that a multicultural nation does not have to be a society without national rituals and symbols.[2] National rituals and symbols, furthermore, do not need to be exclusive and can instead cultivate qualities of inclusiveness. However, even if this is true, one must question whether foreign-born immigrants and their children are given the same opportunity as their majority counterparts not only to adopt such national symbols but also to adapt them. What happens if they do?

In the 1980s, schools with many immigrant pupils were harassed and threatened by right-wing activists.[3] In the days before Søttende mai in 1983, for example, a threatening message was delivered to Sagene Primary School in Oslo demanding that the school not march in the children's parade that year, claiming that the presence of so many immigrant students would be a disgrace to national pride. The city council of Oslo did not want to bring public attention to the incident, but teachers at the school reported the threat to the police, informed parents, and canceled the school's attendance in the parade. When the press published the story, local politicians,

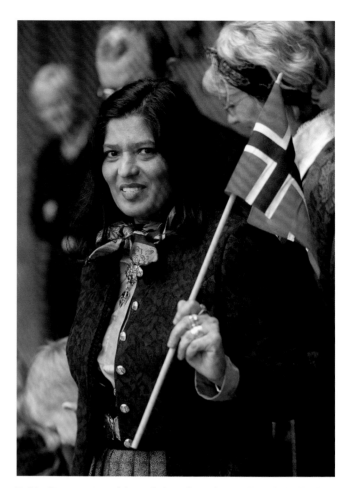

Rubina Rana wearing Jubileumsdrakt and marching in the Oslo children's parade, 1999. *Photo by Heiko Junge, NTB SCANPIX.*

as well as representatives from the national parliament, decided to march with the school as a demonstration in support of a democratic, multicultural National Day celebration.[4] When the same threat was repeated the following year, the pupils marched with rainbow-colored banners stating, "Søttende mai for everyone! No to racism!"[5] Because of incidents like this one, many Norwegians feared that large displays of bunader and Norwegian flags on Søttende mai might feel exclusionary and promote feelings of estrangement among immigrants. However, the opposite was the case: this was a day during which many immigrants said they felt involved and included in the public celebrations.[6]

Rubina Rana (1956–2003) was an immigrant from Pakistan and a member of the Oslo City Council from 1995. She was elected head of Oslo's Søttende mai committee in 1999, and as such, she was scheduled to lead the children's parade. This caused a debate, and the Norwegian newspapers gave the story lots of space. In addition, Rana decided to wear her new bunad, the new *Jubileumsdrakt* made for Oslo's millennium anniversary the same year.[7] In fact, Rana was the first woman to wear it. In an article she wrote, she explained how

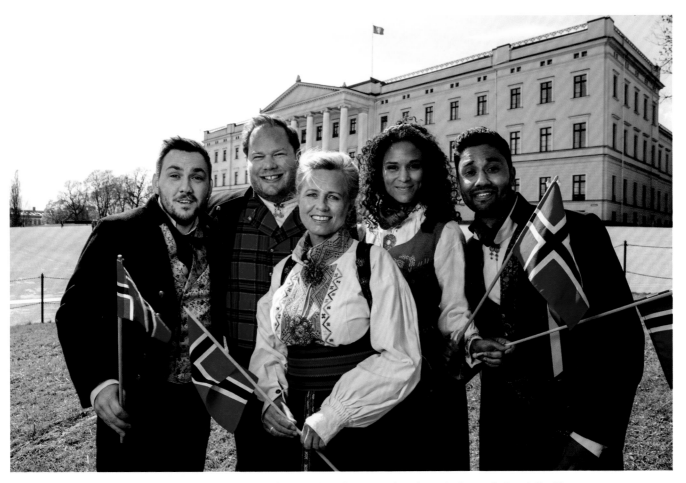

NRK publicity photo for the annual Søttende mai national broadcast in Oslo with reporters from diverse backgrounds: Dennis Vareide, Pål Plassen, Hege Holm, Haddy N'Jie, and Noman Mubashir. *Photo by Tore Meek, NTB SCANPIX.*

she considered purchasing a bunad to be part of her integration process into Norwegian society, a way for her to express a new sense of belonging in the country.[8] In the days leading up to the parade, she received several death threats, but she decided to march anyway. People on both sides of the issue reacted strongly. While critics viewed Rana's performance as a violation because she was foreign-born and part of an ethnic minority, most Norwegian newspapers called the parade a victory for a multicultural Norway. The Norwegian newspaper *Dagladet* interviewed her after the parade was over, and she said, "The thing that was most heart-warming was people along the road calling my name. I really felt that they saw me as an individual and not just as an immigrant."[9] Like the threatened schoolchildren's participation in the 1983 and 1984 parades, Rana's march in 1999 is largely considered to have been a symbolic act of antiracism.[10]

As Carrie Hertz states in the introduction to this volume, "when dress is understood as traditional and therefore mutually shared, the act of dressing is consciously recognized as representing something greater than individual choice." In 1983, Johan Asplund argued that it is irrelevant whether or not bunader share concrete connections with the places and the old folk costumes that inspired them.[11] The important thing is the modern perception of and general agreement about this connection between bunad and place that make it possible for Norwegians and immigrants alike to use bunader to signal their identity and origins. However, the Swedish researcher Ulla Brück uses the term *legitimerande* (legitimizing) to understand the social performance of local identity.[12] From a cultural point of view, the intention to signal certain aspects of identity must be legitimized by being socially acknowledged. When signals are not acknowledged, it creates feelings of estrangement. As mentioned earlier, some Norwegians would not accept or acknowledge Rana's attempt to signal a Norwegian identity. They did not view her use of the bunad during the Søttende mai parade as legitimate because of her origins in Pakistan. However, the majority of people in Oslo did seem to acknowledge and welcome her performance of Norwegian identity and pride.

Norwegians disagree about the use of bunader by non-Western ethnic minorities, but the issue that stirs the greatest controversy relates to religious difference, particularly the

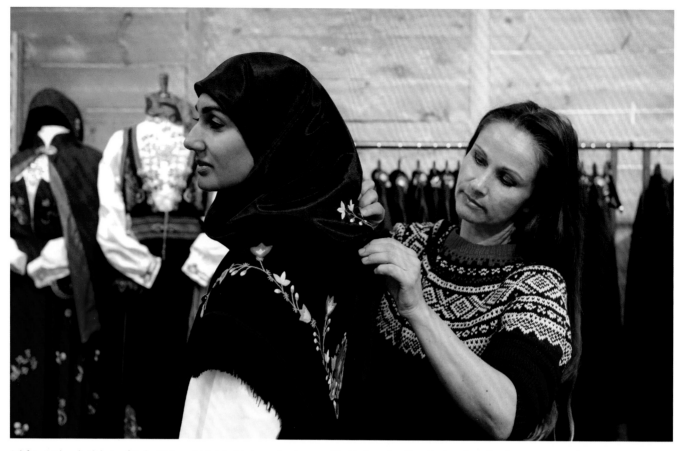

Sahfana Mubarak Ali being fitted with bunad-hijab by Marianne Lambersøy of Embla Bunader. *Photo by Leiv Åmund Hoftun, Stavanger Aftenblad, 2016.*

Islamic faith. During NRK's broadcast of the 2014 children's parades, journalists interviewed young Muslim girls wearing bunader and hijabs. In the parade, they marched with their schools, and like most participating children, they wore bunader and carried Norwegian flags in their hands. The next day, NBF received multiple emails and telephone calls from people upset about what they had seen on television. They wanted to express their opinions and hoped NBF would be sympathetic to their views. They demanded that NBF take action to protect their bunader, their cultural heritage, from what they perceived as an improper Islamic influence. One of the callers declared her bunad soiled and ruined, stating she would never use it again. Considering the Islamic religion to be oppressive to women, they rejected the pairing of hijabs with bunader, a symbol of freedom, especially as they had been worn in the parade by young, impressionable girls.

In the past decade, there has been an increase in racist reactions to Islamic immigrants wearing bunader. In the following sections, we meet Sahfana Mubarak Ali, an immigrant from Sri Lanka, who recently found herself the target of right-wing attacks after collaborating with a local producer of bunader to design a matching bunad-hijab.

Sahfana Mubarak Ali

After she appeared in national news, I met and interviewed Sahfana Mubarak Ali in 2017. Sahfana is a young, Muslim woman from Stavanger in southwest Norway. Born in Sri Lanka, Sahfana came to Norway with her family as a three-year-old. As an adult, she married a Norwegian man, who wanted to give her a bunad as a wedding present. After she was elected to the Stavanger city council as a member of the local Labor Party in 2015, she decided to place the order for her new bunad. She visited the two local Husflid shops in Stavanger, but while there, she felt that her hijab made the staff uneasy about her motives for being there. After she explained that she wanted to order the local Rogaland bunad, the staff seemed uncertain whether to take her seriously. Sahfana ended up leaving both workshops without having placed an order, surprised by the way she had been treated. Soon after, Sahfana decided to contact Embla bunader, a third producer of Rogaland bunad in Stavanger. Here, she was welcomed with open arms.

Sahfana worked closely with Marianne Lambersøy at Embla, who suggested making a hijab with embroidery that matched the local bunad.[13] Sahfana explained to me that the

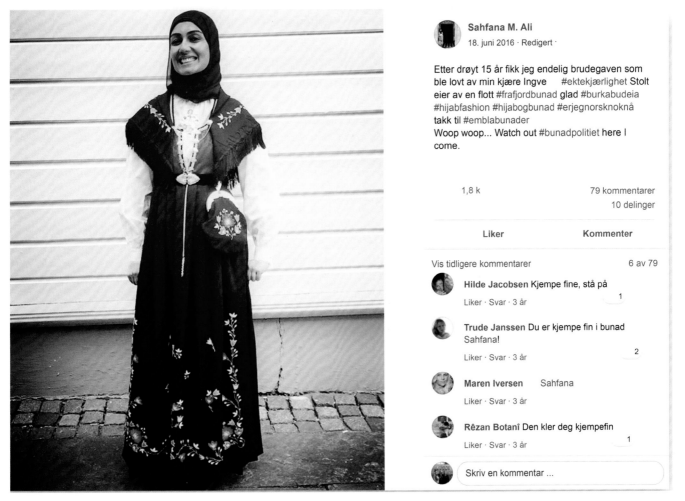

Sahfana M. Ali
18. juni 2016 · Redigert ·

Etter drøyt 15 år fikk jeg endelig brudegaven som
ble lovt av min kjære Ingve #ektekjærlighet Stolt
eier av en flott #frafjordbunad glad #burkabudeia
#hijabfashion #hijabogbunad #erjegnorsknoknå
takk til #emblabunader
Woop woop... Watch out #bunadpolitiet here I
come.

1,8 k 79 kommentarer
 10 delinger

 Liker Kommenter

Vis tidligere kommentarer 6 av 79

 Hilde Jacobsen Kjempe fine, stå på
 Liker · Svar · 3 år 1

 Trude Janssen Du er kjempe fin i bunad
 Sahfana!
 Liker · Svar · 3 år 2

 Maren Iversen Sahfana
 Liker · Svar · 3 år

 Rêzan Botanî Den kler deg kjempefin
 Liker · Svar · 3 år 1

 Skriv en kommentar ...

Sahfana Mubarak Ali's Facebook post, 2016. *Courtesy of Sahfana Mubarak Ali.*

headdress belonging to the Rogaland bunad is a small cap, placed on the crown of the head. The cap would not cover her hair and neck as her faith requires. Some bunader do have headdresses, such as the Renaissance-inspired veils belonging to the Hardanger bunad, that can be adopted more easily by Muslims. Because Sahfana had chosen to solve this dilemma by designing a new headdress for her bunad, a special hijab, she was prepared for reactions from the "bunad police" defending the "correct" headdress.

In May 2016, Sahfana returned to Embla's workshop to collect her new bunad and matching hijab. Proudly trying it on for the first time, she posted a picture of herself on Facebook. In the days and weeks that followed, Sahfana was overwhelmed by racist comments and hateful remarks communicated through social media posts, emails, phone calls, and even face-to-face on her own doorstep. A prominent right-wing protester, Merete Hodne, reposted Sahfana's picture on Facebook with the text, "This is an insult to our Norwegian culture. Stay clear of Embla Bunader if you are an opponent of

this."[14] Hundreds of hateful comments about the bunad, and especially Sahfana herself, soon followed. Meanwhile, supporters of Sahfana's choice and her right to wear the bunad came from both political wings. In my interview with her, Sahfana explained that she was surprised by the intensity of the reactions but was especially taken aback that people harassed her not only on social media but also in person. The debate that followed had a specific focus on Sahfana's person, as a politician and as a Muslim woman. People accused her of promoting the "Islamification" of the bunad and Norwegian culture in general. Sahfana felt emotionally attacked and physically endangered, and in the end, she was offered police protection.

Many of the people who publicly defended Sahfana's choice, among them representatives of Norsk folkemuseum (Norwegian Folk Museum) and NBF, argued that the participation of Muslim children and adults dressed in bunader for Søttende mai celebrations is positive proof of their integration into Norwegian society. The regional newspaper *Rogalands Avis* posted an editorial on June 21, 2016, asking, "When is a

person considered to be Norwegian enough to wear bunad?" The editor, Bjørn G. Sæbø, argued that Sahfana—a woman fluent in the Norwegian language as well as the local dialect, married to a Norwegian, and politically active—should be allowed to wear not only a bunad but also a hijab. Furthermore, he argued that the bunad was not uniquely Norwegian but rather a mix of foreign and local influences. Sæbø emphasized that people must be allowed to present their multifaceted identities, which we all possess. By choosing to wear a bunad with her hijab, Sahfana was signaling her dual heritage as a Muslim woman and a Norwegian citizen with strong ties to overlapping communities.[15]

On February 26, 2017, I met with Sahfana at the Bristol hotel in Oslo to learn more about her perspective on the events that followed her Facebook post in June the year before and on wearing a bunad-hijab. Having grown up in Norway with parents from Sri Lanka, Sahfana has always considered herself to have a dual identity. She still owns several saris from Sri Lanka, but as a Norwegian, she also felt it was natural for her to have a bunad from her home region of Rogaland. Sahfana feels that immigrants in Norway should be proud to be Norwegians and to integrate into Norwegian society. To wear a bunad is a symbol of that pride, she explains, and it is therefore an important statement. For her, it was a personal and natural choice to wear a bunad, "as it is for other Norwegian women," she said. Concerning her choice to wear a matching hijab with her bunad, Sahfana explained in an interview with *Dagbladet*,

> I do not believe it is wrong to wear hijab with bunad. In fact, most of the bunader traditionally had headdresses, so I can see nothing wrong with it. On the contrary, the hijab fits the bunad. In this way, we show the diversity we have in Norway today by combining these. That's what is so great with Norwegian society: If other girls are in the same situation as me and they see me in my bunad, I may have broken some boundaries for a more inclusive Norway. And I can become a symbol of the diverse and the tolerant society.[16]

Sahfana is a Norwegian but also a Muslim—a combination of identities that some find unacceptable. As a visual symbol of the faith, the hijab can become the focus for debate. Sahfana chose to start wearing a hijab when she was twenty-one years old after making a pilgrimage to Mecca. According to Sahfana, this was a choice she made freely for herself, on her own. When I asked what the hijab means to her, she simply said it was a religious choice, a demonstration of personal faith and, as such, something very private. This helps explain why the strong reactions following her Facebook post surprised her. As a nation, Norway proudly promotes freedom, especially personal freedoms of speech and religion, but Sahfana pointed out that she has experienced the limitations of these ideals.

Hijab and Bunad Headdress

To fully understand the debate surrounding Sahfana's bunad-hijab, it might be useful to study the historical context of traditional headdress in Norway and elsewhere. Christian, Muslim, and Jewish women have all covered their hair in the name of religion at different times through history. The square linen veil, the earliest known form of religious and traditional headdress, has a long history, going back perhaps four thousand years. The veil was commonly used in both the ancient Persian and Greek cultures and later in Rome.[17] In her article "Resistance against the Veil / Resistance with the Veil," Berit Thorbørnsrud writes about different practices, beliefs, and symbolic meanings associated with veiling in different times and places.[18] In many instances, veiling was intended not only to protect women from harm but also to regulate their behavior.[19] From the perspective of visual communication, the many shapes and forms of head coverings have also proved a practical medium for expressing religion, ethnicity, social status, and other aspects of identity. Despite diverse and widespread examples of veiling throughout history, the practice has become primarily associated with Islam in contemporary Norway. Covering the head for religious purposes, however, was an important feature of Norwegian regional dress traditions long before the introduction of bunader.[20]

Traditional headdresses were perhaps the most important parts of folk costumes in preindustrialized Norway. The headdress was often ruled by stronger and more conservative norms than other garments. According to dress historian Aagot Noss, a married woman was not considered properly dressed without a headdress. It might be embarrassing for her if anyone saw her without it, depending on the time and place.[21] In many communities with strong local dress traditions, a woman would wear some form of headdress every day of her life.[22] In fact, among the women Noss interviewed in the 1960s and 1970s, there were many who still wore their hair bound and covered in traditional ways every day, even though they otherwise wore modern clothes. The headdress was commonly the last garment to be abandoned when adopting more cosmopolitan styles.[23]

Headdresses revealed social status. In some parts of the country, special headdresses not only declared that a woman was married but might also identify (and publicly shame) unmarried mothers.[24] The headdress marked the various stages of a woman's life, from baptism to confirmation and marriage.

Noss describes in detail several different, regional headdress traditions for girls, brides, and married women in her publications.[25] It was common in many areas for girls to wear their hair braided with ribbons and sometimes tie the braids around their head. For certain occasions, such as for Sunday best, they might also cover their braids with extra ribbons or pieces of fabric decorated with pearls and pieces of silver. Noss mentions

Aagot Noss (*left*) with interviewee Birgit Leksvol in dress from Øvre Hallingdal, including traditional headdress for unmarried women. *Photo courtesy of Norsk folkemuseum, 1961.*

multiple times in her research the importance for women to possess thick, long hair as a sign of health and beauty, especially for girls, whose hair was visible.[26] Klara Semb mentions in her notes from Hardanger that "when a bride who had lots of long hair, was dressed in the veil for married women, she would give away long locks of hair to the younger girls to use when they wore their hair up."[27] In 1912, Semb, together with Hulda Garborg, visited Brita Utne at Lofthus, "who was about 80 years old or so," and she told them about the second day of her wedding when she was about to be dressed in the veil for married women. *Brudekoner*, or "wedding-wives" (who dressed the bride both before and after the wedding), cut off all of her hair, according to local tradition. "I was only 17 years old, and I cried because I had such beautiful hair, yellow and long and curly it was too."[28] When the bride was dressed and ready to have her veil put on, it was customary in Hardanger for the husband to lay the veil on her head. It was important to lay it straight, or the marriage would not end well.[29] When the new

wife was dressed properly, the bride and groom and all of the wedding guests were given a drink of liquor. Then, the "dance of the veil" was performed by the couple.[30]

As mentioned earlier, the oldest known type of headdress for married women is a white veil, a square piece of linen cloth, fashionable in Norway and the rest of Europe from the Middle Ages through the Renaissance. This cloth would often be starched, folded, and ironed to give it a particular form and volume before it was worn. Veils like these, called *skaut* in Norwegian, have existed since at least the Viking Age. Variations of this headdress might be found as white linen hoods in the seventeenth and eighteenth centuries or as smaller linen hoods covered with silk scarves in the 1800s. Some headdresses required the support of an underlying structure, while others could be secured to a woman's braids. In a few areas, women used a combination of structural supports and braids.

The headdress of a married woman would always cover her hair as a sign of her wedded status. One woman explained to

Noss that "it's how you honor your husband."[31] Others mentioned that being properly dressed, with hair and head covered, was a way to respect the church and to honor God.[32] When asked if she would still enter the church when she was too old to put on her headdress, an elderly woman simply answered, "No." These practices were inspired by biblical passages. First Corinthians reads, "Every man praying or prophesying, having his head covered, dishonors his head. But every woman that prays or prophesizes with her head uncovered dishonors her head: for that is even all one as if she were shaven. For if the woman be not covered, let her also be shorn: but if it be a shame for a woman to be shorn or shaven, let her be covered. For a man indeed ought not to cover his head, forasmuch as he is the image and glory of God: but the woman is the glory of the man."

Local practice may infuse the veil with religious significance, as we have seen with traditional dress in Norway. The veil, however, has served as a general religious marker for various faiths, worn at different times and places by women in Christian, Jewish, and Muslim communities. During the 1970s, this changed when the hijab, as "the new veil," was developed to serve as a particular political and religious symbol, embraced by female university students in Iran around the time of the 1979 revolution.[33] These women primarily came from the lower classes and fought for their idea of a more just society. As a symbol of this fight, they wore Islamic dress, designed to highlight their desire for a new Muslim society. It is important to remember that these women did not revive the style of headdress their mothers wore.[34] Much like Garborg's intentions for bunader, they chose to design something new, identifying themselves as modern, well-educated women and as Muslims. Created to serve a particular ideology, the hijab soon became very popular, and as its use spread, its intended meanings also became manifold.[35]

Though the women that Noss interviewed in rural Norway during the 1950s and 1960s described their headdresses as emblematic of both religious piety and marital duty, recent debates over the hijab show a striking lack of knowledge about Norwegian sartorial history. In an 2004 article for *Dagbladet*, Elise Ingebretsen strongly differentiated the hijab from the tradition of Norwegian skaut, writing, "The skaut is an honorable Norwegian headdress . . . a garment which has been used for protection against the weather through many generations, mainly by aging wives."[36] Ingebretsen positioned the Norwegian skaut as a symbol of something practical and sensible, neglecting its other possible functions, but saw the hijab as singularly and exclusively a sign of women's suppression.

The Norwegian word *likhet* may be translated variously in English as "equality" (in the sense of equal rights and opportunities) or as "similarity" (meaning cultural likeness).[37] In

2008, Norwegian scholar Thomas Hylland Eriksen analyzed the debate about whether to allow or ban the use of the hijab in public schools, following the French ban in 2004.[38] He examined 232 articles published in Norwegian newspapers during the winter of 2004. He shows how the debate tended to demand similarity before equality, even though ironically, most of the anti-hijab articles based their argument on the belief that hijabs were signs of discrimination. In other words, to be equal, you must be similar. We may see the same tendencies in the debate surrounding Sahfana Mubarak Ali and others wearing bunader and hijabs. The Norwegian word *likhet* is mostly used positively in Norway, in the sense of *equality*, but it can also be used to reject cultural difference.

Conflicting Key Symbols

As symbols, styles of dress may serve different functions and meanings depending on context, and they may vary in their emotional strength for observers. Sherry Ortner's term *key symbol* is relevant to our discussion, especially the subcategory of "summarizing symbols."[39] She defines summarizing symbols as "those symbols which are seen as summing up, expressing, and representing for the participants in an emotionally powerful and relatively undifferentiated way, what a larger system means to them."[40] As a category of signs, summarizing symbols are essentially "sacred" catalysts of emotion, like a national flag, the cross in Christianity, or in my mind, the Norwegian bunad. Summarizing symbols do not usually encourage nuanced reflection, instead condensing complex ideas about an imagined whole into a single representative sign.[41] The bunad, in this mode, can encourage allegiance to an imagined familial, regional, and national heritage.

Norwegians have worn bunader for more than a hundred years. As we explored earlier in this volume, since the turn of the twentieth century, Norwegians have worn bunader as a representation of revitalized preindustrial traditional dress and as a political symbol in the battle for national independence. After 1905, when Norway gained independence, and again after World War II, bunader surged in popularity as a way of signaling national pride as well as local identity. Since then, the bunad has continued to gain additional layers of historical and cultural significance. This significance is strengthened by the personal contexts in which bunader are normally worn, such as baptisms, confirmations, weddings, and other family celebrations, including, most importantly, Søttende mai. These practices combine the mythic and the personal, contributing to the potential of the bunad to serve as an emotionally powerful symbol.

Ortner argues that summarizing symbols usually inspire greater cultural restrictions around their use. For both the bunad and hijab, there can be a great number of socially

Bunad from Vest Agder worn with *vase* (underpinning) and *skaut* (veil), the traditional headdress for married women. *Photo by Anne Marte Før, NBF.*

enforced rules as well as sanctions meant to prevent their misuse. We have already seen in this volume how Hulda Garborg simplified complicated patterns, promoted the use of local materials, and encouraged people to sew their own garments, thus making bunader accessible to a large segment of the population.[42] Though she worked hard to promote the making and wearing of bunad, she also had strong, normative opinions about how it should be done.

This normative approach was strengthened by Garborg's successor, Semb. Semb introduced a new philosophy with even stricter rules concerning "correct" practices.[43] Championing a scientific approach, Semb thought it possible to deduce a singularly correct way to make and use a bunad based on historical accuracy. Today, we might find her rhetoric both condescending and aggressive, but Semb saw herself as a public enlightener and expert. Semb even helped create the Norwegian Institute for Bunad and Folk Costume, a government organization that has had a profound impact on how the general public understands and interprets the bunad tradition. NBF's approach, however, has changed over the years.

The Norwegian Institute for Bunad and Folk Costume

In 1947, Ragnar Nordby, an employee of the Ministry of Agriculture in the department of Home Industry, proposed the creation of a new governmental board focused on bunad. Supported by Semb and others, the purpose of the board was to act as experts, advising the public about the proper making and wearing of bunader. By this time, bunader that had been created during the 1920s and 1930s were increasingly seen as lacking authenticity and craftsmanship. Influenced by Semb, there was now a desire to focus not only on embroidery and decoration but also on how the patterns were cut and how the bunad fit the body. The board also gave advice on where to find the best materials and fabrics. In 1957, in a collaboration between the advisory board and the national Husflid association (then both located in Oslo), a new bunad from East Telemark was created. This bunad established a new method of reconstruction and demonstrated how community organizations could work in cooperation with the Governmental Board for Bunad to introduce reconstructions of local dress. The bunad shows very well how the term *reconstruction* was understood at the time, in sharp contrast to Magny Karlberg's later understanding of the term. The need to adapt the bunad to modern demands is apparent in the following quote from Halvard Landsverk, who later became a member of the board. He writes about the East Telemark bunad in 1965:

> A bunad is a folk costume that is reconstructed for use in our day. The result is therefore a compromise between the tradition and the demands made by today's use. The

> *bunad has therefore undergone some changes. With these changes, the bunad should be able to adapt to a modern era and largely preserve the old and distinctive costume tradition. Many will surely think that by making such a model bunad we uniformize this bunad. Nevertheless, it must be remembered that, as a contrast to the blossoming period of the original folk costume, 1820–1850, we do not have tradition as a guiding corrective anymore. At a time when craftsmanship still flourished with tradition as a guide, it was easier to make a proper costume and it was harder to take a wrong turn. Today it is sadly evident that we'll soon be in trouble if we leave everything to chance.*[44]

Landsverk was part of a diverse group of craftspeople and academics affiliated with collaborative efforts between the Norwegian Husflid in Oslo and the Governmental Board for Bunad in the 1950s.[45] Their interpretation of bunad was limiting, as seen in the quote above. At the same time, and parallel to the board's work, many groups around the country designed and made new bunader, unaware of or indifferent to the official guidelines coming from Oslo and following in the footsteps of Garborg.

Historical Reconstruction: A Paradigm Change

Starting in the 1960s, the advisory group centered in Oslo took a slightly new approach to their work. In 1967, the board was completely reorganized with its own secretariat and new statutes. It was decided that members of the board should promote cultural historical research and have expertise in the fields of textiles and sewing. Following the new guidelines, bunader should be made and worn in accordance with historically documented local dress traditions, and the board would give advice based solely on historical knowledge of these practices rather than on aesthetic judgments.

In 1980, Magny Karlberg became the new director of the Governmental Board for Bunad. In the 1970s, she had reconstructed the old folk costume traditions in Valdres. This reconstruction project, one of the first in the country, set a new standard for developing new bunader. Her work was based on the idea of authenticity—she believed that revitalized bunader ought to be accurate copies of older clothes. In terms of bunader, this new ideology demanded an exact copying of surviving clothes using the same materials and sewing techniques. When creating a new bunad, it was also considered important to combine only garments that would have been worn together during the same historical period. Finally, the uniform manner in which many bunader had been previously produced was now discarded in favor of greater diversity, typically resulting in multiple choices in terms of ribbons, colors, and fabrics.

This new ideology had a clear educational and moral ambition. Advocates not only made their own bunader according

to this ideology but wanted everyone else to do the same. In the following decades, several existing bunader were reviewed and updated accordingly, given more historically appropriate headdresses or additional options for aprons and bodices to encourage variety. During this process, the movement caused a lot of turbulence because it challenged and critiqued well-established bunader, made and worn over the previous seventy years.

Karlberg's paradigm change has certainly impacted the way craftspeople work with bunader, encouraging the use of historical sources as a foundation for their choices in material and construction. Perhaps more importantly, however, Karlberg continued a normative philosophy, focusing on what a bunad should or should not be and promoting official rules for judging what was right or wrong. This was perhaps what led to NBF being nicknamed the bunad police. Regardless of what type of bunad they own, many Norwegians worry about the rules associated with it.

Today, the foremost task of NBF is to document and research the existing collections of traditional dress in private homes. This information is archived, researched, and made publicly available. Much of NBF's outward-facing work consists of teaching classes at the university level on the history of fashion and traditional dress and arranging seminars and courses in both practical and theoretical matters. NBF receives daily requests for guidance in aspects concerning the making and wearing of bunader. This guidance involves instructions in practical matters (such as sewing and embroidery techniques), advice on how to mount and wear a complicated headdress, or advice on more complicated projects. Projects may include reconstructing parts of a bunad or a completely new one from scratch.

When reconstructing a new bunad, the work often includes fieldwork in the relevant areas, often over a long period of time, usually several years. Creating sewing templates and testing different combinations of clothes can be time-consuming tasks. Both of these main tasks, the fieldwork and the practical hands-on research, are completed in close collaboration with local craftspeople, cultural historians, and other interested parties. At the end of a lengthy reconstruction process, NBF will evaluate the work results and give an official endorsement of the new, reconstructed bunad. Within communities invested in historical reconstruction, NBF's advice and critical guidance are highly valued. When NBF positively and publicly supports a reconstruction project, it is taken as a mark of quality and respect for local craftspeople.

The legacy of NBF can be seen in the strong norms guiding the use of bunader in Norway today. The institutionalization of bunad "rules" was probably strengthened during Karlberg's time as a director of NBF. Looking back, however, we should also note that Karlberg's work advanced both practical and academic education in the field of bunader. Her efforts raised the level of knowledge among students and academics, as well as bunad producers and craftspeople. Her focus on the need for professional craftspeople has been especially important. With this focus came an improved understanding of how old folk costumes had been made and worn, and by extension, a greater awareness of the wide variety of fabrics, patterns, and types of clothes worn by preindustrial farming families. This new idea of diversity has been especially important in the development of a more tolerant and relaxed view on how to wear bunader. Reconstructed bunader have the opportunity for greater diversity and freedom within the bunad itself and, as such, more room for the individual. The focus on historical reconstructions has also led to increased knowledge of folk culture in general, as well as traditional headdresses.

In my view, and in consideration of the institute's history, NBF must remain aware of the potential influence and power it possesses in a shifting cultural landscape of ideas, identities, and symbols. Therefore, NBF now works more widely and broadly with the bunad phenomenon today. These new efforts include researching both historical and contemporary issues, adopting a greater willingness to speak publicly about political issues, and initiating cooperative relationships. NBF has increased efforts to maintain open dialogues with immigrants and minority groups living in Norway, including the Sámi and Romani peoples. NBF has also been involved in several projects researching the use of bunader among minority and immigrant groups over the last decade. Most importantly, NBF's advisory board, the Bunad and Folk Costume Council, now includes members from varied backgrounds. Members of the council are appointed by the Ministry of Culture, and all government agencies in Norway have an obligation to elect members that reflect diversity in terms of gender, ethnicity, and physical capability. This infusion of new perspectives has had a fundamental impact on the activities and orientation of the institute. The council, for example, has encouraged engagement in more international networks in order to gain important experience and to widen NBF's perspectives on cultural heritage.

In the next section, we meet Ayesha Kahn, a current council member whose perspective can help us better understand contemporary conflicts that arise around the use of hijabs and bunader.

Ayesha Kahn

Ayesha Kahn was one of the children who attended Sagene Primary School in the 1980s and who marched in the National Day parades with a banner across her chest saying, "No to racism," in 1984. In 2012, she was appointed by the Ministry of Culture to the Bunad and Folk Costume Council, where she has a seat until 2022.

Ayesha was born in Pakistan in 1974. Her parents brought her to Norway in 1976 to improve their financial situation. The plan was to earn enough money for their family before returning home a few years later. However, they found that life in Norway gave them opportunities they would not find in their home country. Ayesha tells me she is grateful they decided to stay, giving her the freedom to choose her own education and future. Ayesha has a bachelor's degree in social anthropology and is employed by the City of Oslo to work with immigrant families. During her adult life, Ayesha has been determined to take an active part in the society around her, whether it is on her son's soccer team or as a member of the board of the Norwegian Association of Women's Rights (founded in 1884).

In her interview with me on Friday, February 21, 2020, she described her parents as people who never fully committed to life in Norway. They were always "going back" and told her, "Even though we live in the land of opportunities, it is not our land." Ayesha describes this attitude as growing up "traveling on two boats." Ayesha's parents sent her to Koran school on the weekends, giving her a proper Muslim religious education. At the same time, Ayesha participated in the classes in her Norwegian primary school about Christianity and the history of world religions. She was also allowed to attend the school's annual Christmas church service. Some Muslim pupils, in contrast, are removed by their parents from these classes and events, as are some ethnic Norwegian students with secular parents, in fear of religious influence. Ayesha explains to me that it was important for her to learn about these things and that she has wanted to give her children the same opportunity to learn about different religions.

As an immigrant woman with a thorough knowledge and understanding of both Norway's immigrant communities and Norwegian majority culture, Ayesha is in a unique position to provide insight into the use of the bunad and hijab in a multicultural society. Ayesha grew up with a mother from Pakistan's upper classes, who had a college degree and never herself wore a hijab. Her mother was therefore surprised when Ayesha decided to do so. Ayesha explained to me, in similar ways as Sahfana, that the inspiration came after a pilgrimage to Mecca in 2008 when she was thirty-three years old. During the five months she spent in Mecca, she made the decision as part of a deeper realization of her religious beliefs. According to Ayesha, so much in Islamic culture and religion is decided and executed by men. "The male perspective underlies everything in Islamic culture and religion," she explained. For her, electing to wear the hijab may be seen as a rare act of women's unique and gendered religious agency within Islamic practice. By actively and independently choosing to wear a hijab, a visible symbol of her faith, Ayesha makes a political as well as a religious choice.

In most Norwegian Muslim communities, women are expected to stay at home and bear children, something the Norwegian government has inadvertently encouraged by introducing the so-called *kontantstøtte*, or "cash support" system, for stay-at-home mothers. The majority of Norwegian parents, in contrast, send their children to kindergarten or day care. The cash support system has received a lot of criticism, since it leaves many immigrant mothers secluded rather than encouraging them to take part in Norwegian society through employment. Ayesha believes this policy characterizes immigrant women as burdens on the state rather than as potential resources for improving their wider communities. Ayesha herself, as noted above, has chosen to take an active role in Norwegian civil society, and as a consequence, she has been appointed to several councils and boards (including at her own mosque as the first and only woman to have been so honored). By taking part in women's associations, she has learned a lot about the fight for women's rights during the twentieth and twenty-first centuries in Norway. She tries to bring this knowledge back with her to her own network of women, working as a bridge builder.

When I asked Ayesha if she owns a bunad, she laughed and said no, "not yet." She tells me that many of her friends expected her to buy a bunad when she was appointed to the Bunad and Folk Costume Council, as if it were a requirement. Ayesha explained that she wants a bunad to reflect her home in Oslo, but she is not attracted to the available options. She describes the *Oslobunad*, for example, as being grey and dull with little decoration. If she were to eventually acquire a bunad, however, she would wear it with a hijab.

As a council member, Ayesha underlines the importance of NBF in a multicultural society, believing NBF should work for greater tolerance and acceptance of different cultures and identities and treat people as equals, even when they are not similar to each other. People should feel free to integrate, being active members of society without fully assimilating or giving up important facets of their complex cultural identities. For that reason, she sees no contradiction between a bunad and a hijab, even when worn together. Ayesha explained, "If I ever was to start wearing a bunad, I would want to wear my own hijab with the bunad." She does not, however, see herself free to create a special, matching bunad-hijab, as Sahfana Mubarak Ali did, which in her mind would be to take inappropriate liberties with the bunad tradition. She was not surprised when Sahfana's bunad-hijab raised a lot of negative attention. She points to the early bunad movement and its association with the fight for an independent Norwegian state. Ayesha believes these proud national feelings might easily rise to the surface whenever there is a perceived threat to Norway's autonomy and distinctive cultural identity. She believes the level of aggression

that Sahfana experienced had to do specifically with the hijab's Islamic origins: "In Norway, Islam is viewed as something very threatening, something totalitarian, and Sahfana's actions were viewed as an attempt to Islamize the Norwegian bunad. There are people who change or add something to their bunad, which the so-called 'bunad-police' might comment on, but you'll not see headlines in the newspaper over it."[46]

Ayesha believes that traditions will always change, as the bunad tradition has done through its 150-year-long history, but changes may be resisted when first introduced. She mentioned that many more immigrants wear hijabs with their bunader nowadays and that the practice is becoming more normal, but very few, if any, have copied Sahfana's style of hijab with bunad embroidery. "I see the bunad tradition as something sacred, specifically curated by certain professionals. There is a difference between those people who craft the bunader, and those who simply wear them for Søttende mai or their confirmation," she explained, perhaps implying that a certain level of expertise or authority is required to change an established bunad. Even within the majority culture, only particular people may be ordained with the authority to introduce innovations. Individuals seen as foreigners are granted even less leeway. This may be especially true for Muslim women, whose faith can be viewed as threatening not only to Norwegian society but particularly to women's freedom and equality. Ironically, both Sahfana and Ayesha describe their own use of the hijab as representative of a woman's voice and independent agency.

A conservative understanding of tradition is perhaps typical of key summarizing symbols; they are in a sense untouchable and sacred. What is possible or not possible to change within a tradition may be defined differently from person to person and shifts through time. Many Norwegians, however, would agree with Ayesha's thinking about bunad as unchangeable. Even though most Norwegians will allow minor concessions, such as omitting their cap, wearing different jewelry, or even skiing while wearing bunader, fundamental changes are frowned upon. I believe most Norwegians would not allow themselves to change their bunader unless it was done with the help and presumed authority of professionals for sensible or historical reasons. Of course, bunader are altered, adapted, or changed all the time, to fit, repair, or "upgrade" the bunad to its owner's tastes and needs. Most Norwegians, though, seem to agree on a basic understanding of the norms guiding the tradition, and Ayesha's view on the subject seems very much in line with common opinion.

Ayesha's point of view might be called normative, then, but her opinions might also have been affected by her time as an informed member of the council. I believe this shows the strength of the current consensus in Norwegian society about the rules of wearing bunader and not that Ayesha somehow sees herself as outside of or passive within the tradition. She seems, quite to the contrary, to understand it perfectly.

Bunad, Hijab, and Identity

The goal of this chapter has been to understand the potential conflicts that arise when adapting symbols established in the romantic nationalist era to contemporary life in a multicultural Norway. Even though Norwegians tend to praise themselves for their belief in equality and equal rights, some people interpret equality as homogeneity and integration as assimilation. Though most Norwegians welcome immigrants to wear bunader, when Muslim women wear hijabs with their bunader, it can cause fierce reactions in public debate.

For Rubina Rana, purchasing a bunad was a way for her to express her integrated belonging in Norway. Sahfana Mubarak Ali understood her introduction of a bunad-hijab as a logical blending of important markers of identity as a Muslim Norwegian. Despite being Norwegian citizens and elected civil servants, both of them experienced negative reactions from some people who rejected their claims of a Norwegian identity. These examples suggest that, in some minds, the bunad can still be linked to former ideas of a single national ethnicity, religious background, or culture. The symbolic link between the hijab and Muslim identity makes it especially problematic for some Norwegians, who, as Ayesha Kahn believes, hold a deep-rooted skepticism of Islam as a totalitarian religion that oppresses women.

Ayesha, however, raises another, broader issue that makes the ability to adapt the bunad within Norway's multicultural society challenging. Looking back over the last 150 years of bunad use, it becomes apparent that what a bunad is, how it is worn, and how it relates to the past has varied greatly, but there is a generally accepted assumption that strong norms should guide the making and wearing of bunader. This idea originates in the preindustrial farming communities where folk costumes were governed by a strict, local tradition. These sartorial customs dictated acceptable ways of dressing every day of the year, from work clothes to Sunday best, as well as dictating rituals during life-cycle events such as confirmations and weddings. The norms governing women's use of traditional headdresses were particularly strong and long-lasting. The idea that traditional dress, or bunader, must be somehow governed or restricted still prevails, even as the bunad also serves as a symbol for democracy, freedom, and rebellion.

With the establishment of the Bunad and Folk Costume Council in 1947, the Norwegian people were given a public authority on making and wearing bunader. Norway has now had a council, appointed by the Ministry of Culture, for the last seventy-five years. During these years, the council has suggested, advised, and influenced how Norwegians make and

wear bunader. Since its establishment, NBF has positioned itself as a knowledgeable arbiter of culture. NBF's claim to authority, however, is a problematic one. Many Norwegians turn to the institute to authoritatively weigh in on what is right and wrong. This has been true in relation to the use of bunader by immigrants. Many people, having grown up trusting the normative view of bunader promoted by NBF, are surprised that the institute shows a tolerant view of the way immigrants wear their bunader. By including members in the council from a wider range of backgrounds and identities, NBF has been challenged to expand its scope of interest and diversify its perspectives.

In today's multicultural society, a more pragmatic and practical view of the bunad is perhaps both necessary and sensible. We all have complex identities and backgrounds. As Sahfana Mubarak Ali argues, it should be possible to acknowledge such complexity through dress. By combining key symbols in her life, she states, "I am both Norwegian and a Muslim. My bunad and hijab reflects that, and I am proud of it." The status of the bunad in Norway today as a summarizing symbol, almost sacred and very personal, helps explain aggressive reactions to new uses and adaptations. The strong ties that many people feel to family traditions and national heritage might also, for some people, provide them with a sense of ownership over the tradition itself and therefore let them feel justified in their right to define it for others.

Notes

1. Brück, "Identitet, lokalsamhälle och lokal identitet," 65. All English translations are mine.

2. Bjørgen and Hovland, "I takt med nasjonen."

3. Bjørnholt, "Hvorfor er folkedrakt så viktig i Norge."

4. Bjørgen and Hovland, "I takt med nasjonen," 27, 49.

5. The 1984 threat said, "We have lots of weapons! We will blow up the school!" *Aftenposten*, May 16, 1984.

6. For a proper discussion of this question, see Bjørgen and Hovland, "I takt med nasjone"; Brottveit, Hovland, and Aagedal, *Slik blir nordmenn norske*.

7. Bjørgen and Hovland, "I takt med nasjonen," 50; Moe, "Den visuelle dialekta," 40.

8. Rana, "Den norskeste av de norske," 95.

9. Larsen, "Seiersmarsjen."

10. Bjørgen and Hovland, "I takt med nasjonen," 50.

11. Asplund, *Tid, rum, individ, kollektiv*, 177.

12. Brück, "Identitet, lokalsamhälle och lokal identitet," 68.

13. I had never before heard of a bunad-customized hijab, so this was not common in Norway at the time of Sahfana's adaptation.

14. Lofstad, "Sahfana fikk sydd bunad med hijab."

15. Sæbø, "Norsk nok for bunad?"

16. Lofstad, "Sahfana fikk sydd bunad med hijab."

17. Vogt, "Historien om et hodeplagg," 23.

18. Thorbjørnsrud, "Motstand mot slør, motstand med slør."

19. Ibid., 36–37.

20. See, for example, Noss, *Krone og Skaut*; Noss, *Lad og Krone*.

21. Noss, "Hovudbunad og norsk drakttradisjon."

22. Noss, "Frå folkedrakt til bunad."

23. Ibid., 227.

24. Noss, *Krone og Skaut*, 51.

25. See, for example, Noss, *Krone og Skaut*; Noss, *Lad og Krone*. These books focus specifically on traditional headdress, but many of her other more general books also deal with headdress.

26. Noss, *Krone og Skaut*, 55.

27. Notebook of Klara Semb, undated, A-1001/F/Fa/L0003/0005, Klara Semb archives, box L003, folder 0005, Norwegian Institute of Bunad and Folk Costume, Fagernes, Valdres, Norway.

28. Ibid.

29. Noss, *Krone og Skaut*, 55.

30. Ibid. This tradition was common in Hardanger. In other areas, such as Hallingdal, Noss found the "dance of the hood," also including a toast of liquor.

31. Noss, *Nærbilete av ein draktskikk*, 72.

32. Ibid., 71–72.

33. Thorbjørnsrud, "Motstand mot slør, motstand med slør," 46.

34. Ibid., 47.

35. A thorough historical or theoretical accounting of the hijab is impossible here. For more on the hijab in Norway, see Høstmælingen, *Hijab i Norge*.

36. Eriksen, "Hijaben og 'de norske verdiene,'" 104.

37. Ibid., 103.

38. On February 10, 2004, the French National Assembly banned students from wearing prominent religious clothing or symbols at public schools, consequently forbidding girls from wearing a hijab to school.

39. Ortner, "On Key Symbols," 1339.

40. Ibid., 1340.

41. Ibid.

42. For more on the history of the bunad and the role played by Garborg, see chap. 3 in this volume.

43. Klara Semb archive, A-1001 Klara Semb, Norwegian Institute of Bunad and Folk Costume, Fagernes, Valdres, Norway.

44. Landsverk, "Tradisjon og nydanning i våre folkedrakter," 46.

45. B. Haugen, "New Look i Norsk bunadkaleidoskop," 68–69.

46. The term *bunad-police* is used here in the sense of common people, busybodies, or others who have an opinion about what others are wearing.

5

The Transnational and Personalized Bunad of the Twenty-First Century

Laurann Gilbertson

According to the United States Census Bureau, more than four million Americans identify as being of Norwegian birth or ancestry.[1] Many of these Norwegian Americans choose to create and express an ethnic identity by observing family traditions, joining cultural organizations, attending festivals, or wearing a bunad. A bunad is typically defined as a Norwegian national costume.

Bunader worn in the United States range from reconstructions of historic folk dress to contemporary designer outfits inspired by traditions to personalized and freely composed interpretations. Since about 1960, there has been a proliferation of "US bunader," outfits created to represent American communities in the same way that bunader have been designed in Norway to represent the cultural history and natural environment of Norwegian communities.

Dress is an important marker of ethnic identity in the United States today. This essay explores choices in Norwegian dress and how the bunad has been adapted and transformed in the American context. There has been a shift from first expressing a national and then regional Norwegian identity to sharing a more personalized Norwegian or Norwegian American identity. The recent popularity of reconstructed styles, US bunader, and couture bunader suggests that Norwegian Americans are

increasingly interested in expressing their personal identity at the same time as they express a Norwegian group identity.

This discussion is informed by interviews with Americans and Norwegians, the activities and histories of Norwegian American cultural organizations, artifacts and archives preserved at Vesterheim Norwegian-American Museum, and my twenty-seven years of experience working at Vesterheim.[2] These sources contribute to an understanding of the still-evolving bunad experience today and help illuminate the ways this experience fosters a sense of belonging among members of the Norwegian American community, ultimately reflecting an American perspective on Norwegian heritage and history. As curator for a museum dedicated to both historical and living Norwegian heritage in America, it is my job (and my pleasure) to try to understand how individuals interpret their belongings. Curators not only care for objects—we care for memories and meanings. And because meanings evolve, conversations happen regularly, not just when an object is created or donated.[3]

For this chapter, I spoke with forty-nine women and men in the United States and Canada and two in Norway. My approach to finding individuals to interview began by contacting people that I knew personally through my work at Vesterheim. I first reached out to those who owned a bunad

and were involved with making bunader. I wanted to explore the range of bunad use in the United States from the 1950s to today, so I then sought out people in specific communities and organizations who could speak about their experiences in order to broaden our view in terms of geography, gender, emotional investment, and financial investment. I had long been aware of a few styles of US bunader, but I searched for more of them in the publications of cultural organizations, such as Sons of Norway. I also requested information on US bunader on social media, leading me to new contacts. Most of the interviews were conducted over the telephone, but some were conducted in person. Although I have contacts nationwide and overseas, I did not have the opportunity to travel to meet with each person face-to-face. I am grateful to the many individuals who kindly answered my questions and made introductions to friends, enabling me to speak with a diverse set of wearers and makers.

National Costumes

By the late nineteenth century in Norway, rural customs—including dancing, music, fine handcraft, and folk dress—were in decline. A cultural revival soon began. In both small communities and large cities, dedicated men and women researched, taught, and celebrated traditional skills and products. The Norwegian Handicraft Association (Den Norske Husflidsforening or Husfliden) coordinated a national network of craft classes, exhibitions, and shops selling objects made by local artisans, as well as supplies for folk art. This period of nationalism culminated in independence from Sweden in 1905.[4]

At this time, a national costume became popular. Carrie Hertz explores the origins of this simplified version of the *Hardangerbunad* earlier in this volume. *Nasjonaldrakten* or *Nasjonalen* (the National Costume) differs from the Hardangerbunad in materials, fit, and length, among other details. The Nasjonaldrakt tends to be made of lightweight fabric, less fitted in the bodice, and only midcalf in length. The Nasjonaldrakt was very popular in Norway in the early part of the twentieth century but has now been largely replaced by regional styles of bunader. Many Norwegians in the United States adopted the Nasjonaldrakt at the time of independence but continued to wear it longer than people in Norway. Although many Norwegian Americans have acquired regional styles, the Nasjonaldrakt remains popular today especially in communities on the East Coast of the United States—including New York, New Jersey, and Connecticut—and among dance groups nationwide. It is iconic and identifiable as Norwegian to all audiences. American materials can be substituted, making it relatively easy to create without special patterns or imported elements. Although the Nasjonaldrakt can be seen as generically Norwegian, some groups and individuals have tried to come closer to what is considered a Hardangerbunad

in Norway today by using handmade lace on the apron instead of machine-made lace, for example.[5]

During the cultural revival in Norway in the early twentieth century, there was interest in regional bunader as well as a national costume. Folk dancers were among the first to try to revive the different styles from rural Norway. When folk dress had completely died out in some areas, work often began to create a bunad for the community. Depending on how much historic material was available, some regional bunader are firmly rooted in tradition, and others are merely inspired by it.

There have also been creative interpretations of bunader, particularly in North America. Working from memory or photographs of bunader, some Americans have sewn Norwegian-looking costumes from locally available materials. A couple of example outfits found in Vesterheim's permanent collection can illustrate this variety.

In Ames, Iowa, Semalina Stevenson (b. 1892–d. 1989) followed the general cut of a Voss bunad but departed from tradition in the choice of fabric.[6] She used silk charmeuse. Both the bodice and skirt are a rich oxblood red trimmed in soft green. Why Semalina used silk instead of wool and velvet might have had to do with availability, and it may also have been to better match the tastes of the wearers, her college-age daughters.

In anticipation of what would become an annual city festival, organizers of Nordic Fest in 1967 encouraged the residents of Decorah, Iowa, to make bunader to add to the Norwegian atmosphere of the event. Many women responded to the call and made outfits for themselves and family members. Although photos of the festival show a great number of creative interpretations of the Nasjonaldrakt, there are also dresses that appear to have been made with Norwegian sewing patterns and Norwegian fabric.[7] Louise Ness Flickinger's (b. 1907–d. 1999) outfit consisted of a blue-and-white-striped skirt, a deep-blue bodice with pewter clasps, and a white blouse and apron with patterned blue ribbon trim.[8] The fabric of the skirt and bodice is similar in weight and texture to cotton fabrics sold in Norway in the 1960s and 1970s for everyday bunader. Louise wore the costume at Nordic Fest for twenty-five years while she was working. She could celebrate her own heritage and honor the many Norwegians and Norwegian Americans that passed through the doors of her grocery store, one that her immigrant father had established in 1893.

Regional Costumes

Increasingly, Norwegian Americans are choosing regional and historically based bunader, such as the embroidered bunader and reconstructed styles described earlier by Hertz, rather than creating their own interpretations. The shift in the United States toward regional styles reflects trends in Norway to have more historically authentic bunader as well as ones that may

The dancers of Bondeungdomslaget, Lake Telemark, New Jersey, wore their own regional bunader, though many of the dance groups in nearby Brooklyn, New York, wore and continue to wear Nasjonaldrakt. *Photo courtesy of Bondeungdomslaget of New York Collection, Norwegian-American Historical Association, Northfield, Minnesota, 1978.*

be more similar to clothing worn by ancestors. Information on styles, as well as sellers and makers, is much more available due in large part to the internet. Americans interested in acquiring regional styles of bunader do not necessarily have to travel to Norway. There have been numerous businesses in North America offering fabric, patterns, and assistance in sewing bunader. I now provide profiles of three businesses, and later in the essay, I share other makers' stories.

One early bunad business was L&M Fabrics, which opened in Decorah, Iowa, in 1976. The M in L&M is for Mette Bowen, who grew up in Oslo.[9] Her father trained as a textile engineer and owned two fabric stores in the city: "I grew up behind the counter. Sewing, embroidery, and knitting were part of my grade-school education." She probably would have owned the stores eventually, but she ended up in the United States in 1970. She attended Nordic Fest in Decorah a few

times and was dismayed by the haphazard use of garments and costumes: "We can do better than this, I thought." Although she had never worn or sewn a bunad in Norway, she had skills and her father's contacts. When a fabric store came up for sale, she bought it and began to specialize in budget-friendly cotton bunader in regional styles.

For twelve years, Mette sold complete kits with fabric imported from Norway, trim, hooks, needles, thread, and patterns. She advertised widely, took kits to festivals and cultural organizations' meetings around the country, and sold kits by mail order. There were some generic Norwegian costumes in her stock, but Mette is proud to have offered specific cotton bunader from more regions of Norway than before or since.

Jody Grage is known in Seattle, Washington, as the "bunad lady."[10] When someone comes to her for a bunad, she starts by asking where his or her people are from. She encourages people

to consider more historically based bunader, which often means more options: "The Hardangerbunad can have a purple, striped, or brocade bodice. It's not nice to go to a party and see several women with the same dress. It shows off heritage better if you have a variety in a community." Jody made her first bunad about forty years ago. "I ended a relationship and decided to relearn Norwegian, start dancing, and get a folk costume," she said. "I decided to gather information and share with other dancers." She spent nine months living in Norway. She found it difficult to learn about bunad techniques, because the Norwegians assumed she knew nothing about sewing. She wanted to do things the right way but had to know how to do it. She also assured them she would share the information they provided: "I feel responsible to all those in Norway that shared with me." With assistance from another woman in Seattle, she estimates that she has made at least a hundred bunader: "People really want one to honor their heritage even if they don't wear it more than a few times a year."

Another entrepreneur I spoke with, Sue Sutherland, started embroidering and sewing bunader in about 1990.[11] Odden's Norsk Husflid, an importing business in Wisconsin, sold bunader and brought instructors from Norway. Sue took classes there but quickly shifted to teaching classes. She now finds it difficult to keep up with the demand from around the United States for bunad sewing classes.

Most of the bunad makers in Norway specialize in the bunader for their area. In contrast, Sue works on all bunader and needs to know many different techniques. She loves learning and sharing the sewing techniques, some of which have been used on folk dress since the eighteenth century. Men's bunader are especially challenging because of the complicated fitting and sewing required for the jackets. When she was an undergraduate, she attended a small Catholic college. One of her teachers was a nun who had been a tailor in New York. She taught the old techniques for sewing by hand: "The old skills are exactly what I need for sewing men's bunader."

Sue continues to hone her skills by taking courses in Norway. When I talked with her in May 2018, she was preparing to leave Ely, Minnesota, for Oslo. She had enrolled in a new course on sewing the styles of bunader that are reconstructed from historic folk dress. Norwegian Americans are becoming more interested in reconstructed styles, which often include pattern-woven fabrics. She explained, "People see the fabrics and fall in love. They are beautiful even without embroidery. Norwegian Americans are proud of their heritage. More people want to make bunads. They want to do it right and themselves." Parallel to an increase in Norway, more Americans are choosing styles of bunader reconstructed from historic folk dress.[12] In North America, this may relate to the upswing in interest in genealogy and participation in *bygdelag*.

As Americans learn more about ancestors from rural Norway, they may wish to connect to their heritage through garments similar to what their ancestors wore.[13]

A bygdelag (plural: bygdelag) is a national organization of Americans who come from—or whose ancestors come from—a certain part of rural Norway. These groups began to form in 1899 as a way for members to celebrate local Norwegian customs, including dialect. Many bygdelag are active today, and each offers genealogical resources and an annual gathering called a *stevne* (plural: *stevner*). Stevner feature a variety of educational programs about Norwegian history, traditions, and genealogy. Members can meet and reconnect with relatives and spend several days exploring and celebrating heritage.

At these events, bunader function as visible symbols of identity. As Elaine Hasleton, president of the national council of bygdelag, explained, "The stevne plays an important role in the Norwegian American arena. It is a time to show off ethnicity. At every stevne, the bunad plays a key role. Part of your identity is your bunad. It tells what your ethnicity is and differentiates you from other Norwegian Americans."[14] In addition to being president, Elaine is a professional genealogist in Salt Lake City, Utah. She and her husband belong to seven bygdelag, representing the different areas of Norway their ancestors came from. Elaine has a West Telemark bunad that she can wear to any and all of the stevner.

Although the number of Americans with bunader is greater now than in past years, that number is still a small percentage of people with Norwegian ancestry.[15] Even among members of active cultural organizations, numbers may seem low. For example, in her regional survey for *Bunads in America*, Anna Høidal reported that among the 345 members of her Sons of Norway lodge in southern California, 1 man and 55 women had a bunad.[16] In my experience, Americans with Norwegian ancestry give many reasons for why they do not wear bunader. For some, it is the complexity and expense of acquiring one. Others feel that they do not have enough occasions to wear one. A bunad may feel more like a theater costume. Some do not feel a need to express their heritage at all, or at least not through dress. Two women explained to me that the reason they did not have bunader was that their mothers did not. This follows, though more literally, the Norwegian interpretation of bunader as family tradition, as described earlier by Camilla Rossing.

Bunad Stories

Wearing a bunad can make a strong visual statement of Norwegian ethnicity, and sharing the story of the bunad furthers the experience for both the wearer and audience. The "bunad story" is often shared informally as the wearer gets questions

or compliments about the outfit. The story can also be shared as part of the narration for bunad "style shows" that are the highlight of most stevner.

The bunad story includes information on how the person acquired the bunad—for example, whether it was made in Norway or inherited. In explaining why the wearer has that particular bunad, he or she also shares some personal history. Was a grandfather or a great-grandmother from that part of Norway? Although it may seem that genealogical information is shared in order to legitimize one's connection to the bunad, it is more about the opportunity that the story gives for discovering that the wearer and his or her audience have a connection. The connection might be through family or a shared experience, such as travel.

Elaine Nordlie's bunad story is representative, though it starts in a unique way with a love story.[17] A music major at Winona State University, she spent the 1967–1968 academic year in Norway. She joined a folkdance class and was paired with Kjell Nordlie. Elaine explained that she fell in love with dancing and with Kjell. They married, lived in Norway for fifteen years, and then settled in Dassel, Minnesota. Elaine's West Telemark bunad was a gift. Her mother-in-law's health was failing, and she wanted to give Elaine some money to spend in Norway. Most of Elaine's ancestors were from West Telemark. Her mother-in-law thought it was very appropriate to use the money for a bunad: "I went to Oslo and ordered it. They said to come back in two years and it would be done. We returned regularly for visits, so I stopped in for fittings. It was completed in about 1992. My husband bought all the jewelry for me."

For some wearers, it is not enough to have a bunad that represents the county or district from which their ancestors came. They want to have a bunad that is closely tied to the ancestor's family farm or church parish. For example, as Amy Boxrud of Northfield, Minnesota, has begun to connect with family near Eidsvoll, she said she would like to find out what was worn there:[18] "I would do 'due diligence' and find the most appropriate outfit if my father had stayed on the farm." Similarly, Michael Bovre of Madison, Wisconsin, had not considered getting a bunad until he visited friends in Norway in 1978.[19] One of his friends was on the committee for a bunad for Toten, the community where his grandfather's grandfather had lived. He told me, "There was no close bunad option until Toten developed their own. There was Valdres and Gudbrandsdal [also in Oppland county], but that wasn't Toten."

While some Norwegian Americans think that reconstructed styles—bunader copied from folk dress of the late eighteenth and early nineteenth centuries—look too old-fashioned, it is those very stylistic elements that help some wearers feel close to the place and the time of their ancestors. Bunad

stories can reveal the far-reaching networks that wearers and makers develop in order to restore antique garments for their continued use. Elizabeth Bruening of Kensington, Maryland, has the outfit her great-grandmother first wore in Seljord, Telemark, in 1848.[20] Elizabeth is able to wear the bunad and share its story at stevner with help from Deborah McConaghy. Deborah, who lives in Charlotte, North Carolina, taught a class in sewing Norwegian costumes at Elizabeth's Sons of Norway lodge in Fairfax, Virginia, in 2014. While the other students sewed new outfits, Elizabeth altered her ancestor's outfit. Deborah teaches classes throughout the eastern United States and sews new bunader, but she finds a special satisfaction in altering and restoring garments so that people can wear—and keep wearing—family bunader. Her Norwegian immigrant grandmother in Brooklyn, New York, made her a Hardangerbunad for confirmation, and Deborah has remade it several times to continue to wear it.[21]

Some wearers want to be personally involved in creating a bunad, sewing garments by hand or weaving some of the fabric or trim.[22] Ellen Levernier of Hopkins, Minnesota, can illustrate this point.[23] She told me that she was always interested in obtaining a bunad. She is close to her Sigdal relatives, and they suggested she look at the bunad based on folk dress from the 1800s. She had the skirt and bodice made for her in Norway, and she has sewn one of each of the blouse options for the bunad. One blouse is solid white, one is of print fabric, and one is white with an embroidered collar and cuffs. "It's unique," she said about her bunad. "No one has anything else like it." She often gets the question, "What is it?" but if she is among Norwegian Americans, the question is "Which one is it?" because they recognize it as a bunad. Ellen likes having connections to relatives and Norway through the bunad.

The bunad story is not only shared at bunad style shows. It is shared whenever and wherever bunader are worn. The combination of wearing a bunad and recounting family history is an essential part of Norwegian American identity.[24]

I met Lois Pieper and Carolyn Benforado, mother and daughter, in May 2018.[25] They had traveled from their homes in southern Wisconsin so that Carolyn could study an artifact in the Vesterheim collection. She asked to see a *valk*, the support for the headdress for married women from Voss. She was going to try to make her own to go under a linen cloth that she had embroidered with blackwork. She brought the cloth to show me and was excited to soon have the headdress to make her bunad complete. Her bunad was originally her mother's. Lois had the Voss bunad made in the 1970s because she had started doing "Norwegian things" in the city of Stoughton. She wore her bunad when she emceed the local parade for Norwegian Constitution Day, or Søttende mai (more commonly spelled in the United States as Syttende mai), on public

Carolyn Pieper Benforado wearing bunad from Voss. *Photo by David Benforado, 2020.*

television for fourteen years. When Vestlandslag, a bygdelag for the west coast counties, organized in the early 1980s, she became involved and served as president. Three of her four grandparents were from Voss. She told me, "I grew up in Minnesota and lived in Stoughton, but Voss is the heart. Having a Voss bunad is really important."

Carolyn has been modeling the bunad in the Søttende mai style show for twenty years. In about 2016, Lois gave the bunad to Carolyn. "I was a textile design major, so I love the garment itself and to look at the details," Carolyn said. "It's a totem of heritage—a connection to my mother and other relatives and back to Norway." Carolyn said that she has thought about getting a Stoughton bunad because Stoughton, Wisconsin, is her hometown: "The Stoughton bunad is a symbol of Stoughton's heritage, with elements from different Norwegian groups that came to Stoughton. But I like the Voss one because it was my mother's."

United States Bunader

The Stoughton bunad is one of a handful of US bunader designed to represent communities in the United States, much as bunader have been designed in Norway to represent communities. The Petersburg, Alaska, bunad was the first US bunad, completed in about 1960. It was more than twenty years, though, before another regional American bunad appeared. At least eight have been developed, and most of those are still in use.[26]

Petersburg is Alaska's Little Norway. "The identity of Petersburg is connected to Norway," Glorianne Wollen explained to me while on a break from her job as harbormaster.[27] "Bunads keep the connection. And it's easy to connect. You don't have to learn the language or study cooking techniques. You just pull it out of the closet and put it on. You instantly feel Norwegian."

Petersburg's Søttende mai observance expanded sixty years ago to become the Little Norway Festival, celebrating the signing of the Norwegian Constitution, US Armed Forces Day, and the opening of fishing season. Alma Wallen and Solveig Simonson helped start the festival and, soon after, designed a Petersburg bunad. Using the bunad for Bergen as inspiration, they embroidered flourishes of Alaska and Mitkof Island flowers for twenty-four inches up from the hem. The dress is bright blue with a coordinating purse and cap. The bunad was especially popular in the 1970s and 1980s for residents who did not have a strong connection to a particular region of Norway.

Another reason for the popularity of the Petersburg bunad at this time was that it was difficult to get bunader from Norway. Glorianne remembers that the Norwegians were particular about who could acquire them from Husfliden, the Norwegian Handicraft Association's stores: "Husfliden didn't think the Americans were serious enough. I went to college and had a minor in tailoring. I was considered qualified enough to do business with Husfliden to get kits and do the proper embroidery. I have helped a lot of people get bunads from where their families are from. Now they are publishing books on proper embroidery. That was under lock and key! There's all sorts of information out now." Glorianne made her first bunad at age twelve. Since then, she has always had one or two in progress. She has made two or three Petersburg bunader and approximately forty other bunader for women, men, and children. She especially likes the handwork: "It's relaxing and so pretty when you're done. It's so fun to have people connect with history and pride. Bunads are a labor of love. They are part of a culture and folk art. You can make things beautiful, show your identity, and be proud about it."

In the late 1960s and early 1970s, a group of women from the Sons of Norway lodge made simplified Petersburg bunader, with only ten inches of embroidery on the hem of the skirt, for the local youth dance group. The senior dancers of Petersburg Leikarring still dance in the outfits made in the 1970s by Sons of Norway members. Lodge members continue to help by maintaining the garments.

The original Petersburg bunad has had a life of its own as an option for adult members of the local community, though some other US bunader have been designed primarily as performance outfits. Norwegian costumes can enhance the cultural experience of the performers and the audience. While some dance and musical groups like the effect of many different bunader, other groups prefer a more unified look and wear a Nasjonaldrakt or a bunad they have created especially for the group. The process of designing and wearing a US bunad can strengthen the bond among members and set members apart from other cultural groups, thereby helping create a special identity within a larger Norwegian American group identity.

Founded in 1975, Metroplex Leikarringen was a dance troupe made up of Norwegian Society of Texas members from Fort Worth, Arlington, and Dallas. They had performed a few times wearing a hodgepodge of garments described as "attic bunads" and decided they needed an official outfit for an upcoming tour to Norway.

Director Eudoris Dahl (b. 1934–d. 2007) headed the Texas group that created the dance costumes. They started with a design that a Minnesota artist had created in rosemaling—Norwegian decorative painting—that included Texas wildflowers (bluebonnets and Indian paintbrush), the tail of the state bird (mockingbird), a lone star, and crosshatching to represent oil derricks, because the oil industry is important to both Texas and Norway. The motifs were machine-embroidered onto trigger fabric, a polyester-cotton poplin.

The women's dresses were made of deep-blue fabric with embroidery on the hem, belt, and purse. The hem was faced in red fabric. "I danced, and so did my mother," Mary Blaha

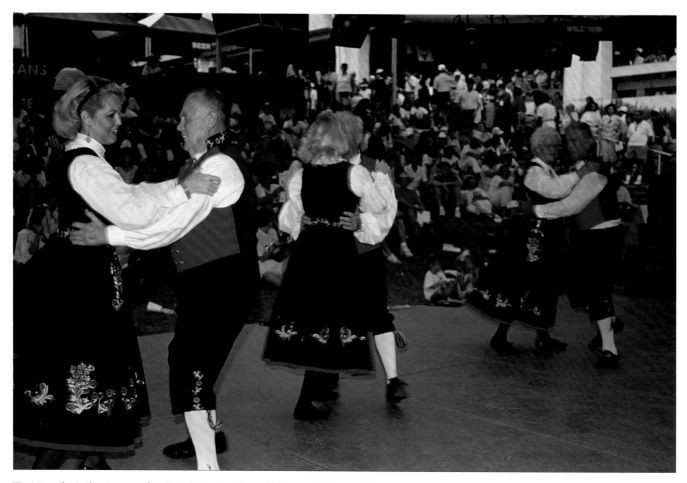

The Metroplex Leikarringen performing in Texas bunader at the Texas Folklife Festival in 1992.
Courtesy of University of Texas San Antonio Libraries Special Collections.

explained to me on the phone from Fort Worth:[28] "We weren't sure about the length, so we arbitrarily decided on ten inches off the floor. That was long enough to twirl and modest enough not to flash anyone. Many Norwegian bunads have fantasy flowers; I like that ours has real flowers." The men danced in black knickers and vests that were red in front and blue in back.

Eudoris completed the first dress in January 1988. Although it was quickly adopted as "the official bunad for the Norwegian Society of Texas," it was generally reserved for the dancers. Metroplex Leikarringen disbanded in about 2015, but the retired dancers continue to wear their Texas bunader at NST events, including the fall banquet honoring Leif Erikson as the first European to reach North America.[29]

Inger Langsholt and the students in her Norwegian language class designed a bunad to represent Illinois.[30] In the same way that many Norwegian groups have developed bunader for their own communities, the Illinoisans placed meaningful motifs on a dress with a common bunad silhouette. They selected the state tree (white oak), bird (northern cardinal), and insect (monarch butterfly), as well as regional wildflowers for the embroidery designs. All of the students grew up on

area farms, so there is corn. Inger suggested adding an element to represent barbed wire, a local invention. The wool dress is black to represent the rich Illinois soil.

Barb Johnson finished her bunad in the fall of 2013. She told me, "We are celebrating our heritage and history. The ancestors wanted land and to farm. [The Illinois bunad] represents the past and the present." Inger explained, "We are not trying to outdo Norway or upset anyone. I felt we needed something that was American *and* Norwegian." Barb and Inger were speaking about the Illinois bunad specifically, but their desire to show something of their ancestry as well as of themselves, their Norwegianness and Americanness, all in a single outfit, is a sentiment expressed by many wearers of bunader and especially by wearers of US bunader.[31]

Some US bunader, including the Texas bunad, offer adaptations for climate and practicality of use. The bunad for Spring Grove, Minnesota, was planned as a working bunad and as a bunad for summer, the season of special community events. Many festivals and events involve food and take place in warm-weather months. It is not always comfortable to wear a wool bunad or appropriate to wear it when preparing or

Dressing with Purpose

serving food.[32] A cotton bunad meant there was no need to compromise on cultural expression. For the group of women in Minnesota, though, the primary reason for creating a bunad for their community was to express a local identity. As a daughter of one of the original group members explained to me, "The Spring Grove identity is very strong. People identify as being from Spring Grove first and Norwegian American second. They could have all worn different Norwegian bunads, but they wanted a Spring Grove bunad."[33]

The Stoughton Bunad

The approach to the design of the Stoughton, Wisconsin, bunad was different from the other United States bunader profiled here. Marion D. Keebaugh (b. 1918–d. 1999) moved to Stoughton in 1969. Although she did not have Norwegian ancestry, she was quickly caught up in the Norwegian character of the city and became interested in folk art, especially embroidery. She saw that people had an interest in Norwegian costumes, but they were just wearing a red vest or a black skirt. Soon she began making bunader and teaching others. Keebaugh is remembered as having pioneered bunad sewing classes. "She was on a mission to get everyone dressed," a former student told me.

Someone suggested the idea of a bunad for Stoughton to Marion, but for many years she didn't consider it because she didn't feel she knew enough about Norwegian bunader, sewing, and traditions. In 1990, she began to work seriously on the project. She wanted the Stoughton bunad to be an artistic design, made from locally available materials, that reflected the specific Norwegian heritage of Stoughton. It took her a year to create an outfit that was "thoroughly Stoughton."[34]

The bodice, in red or green wool trimmed with black velvet and braid, is similar in cut to bodices from Sogn and Voss. There is a breastplate like Voss, but rather than with beads, it is decorated with embroidery based on flowers found in old Trøndelag folk art. The embroidery on the blouse is reminiscent of that on Telemark blouses. A Numedal-style apron brings the outfit together. The various components reflect the places in Norway from which many early Stoughton settlers had come. The outfit further reflects the spirit of Stoughton because Ethel Kvalheim, a local resident and nationally recognized decorative painter, created the design for the breastplate.

Marion debuted the bunad at the 1997 Søttende mai celebration in Stoughton. She and festival "queen" Susan Albright wore one, as did Becky Greiber. Becky does not have Norwegian ancestry but had always wanted a bunad to feel more a part of community events. To have a bunad from a specific place in Norway "wouldn't mean very much. Having one from here, which is where I've been for the last twenty years, is a wonderful solution for me," she said.[35] Several of the people I interviewed identified themselves as "Norwegian by osmosis"

Oak leaves, violets, and prairie flowers on the skirt of an Illinois bunad. *Photo by Barb Johnson, 2013.*

or "Norwegian by marriage." I have observed over the years that it is not uncommon for people who live in Norwegian communities or who are involved in cultural activities to develop a strong sense of belonging and choose to include Norwegian elements in their expressions of identity.

In 2000, Rose Schroeter and Ruth Dietzman created a man's bunad for Stoughton, using colors and embroidery motifs to complement the woman's bunad. In Norway and especially in the United States, fewer men than women own and wear bunader. There are several reasons for this lack of interest, including the perception that bunader are "primarily a female thing."[36] Among wearers of the Stoughton bunad, however, the interest is more balanced. According to Marg Listug, who now sells the kits for Stoughton bunader, there are at least a dozen women's and a handful of men's Stoughton bunader.[37]

When I visited Helen and Kent Karberg at their home in Cambridge, Wisconsin, they met me at the door wearing Stoughton bunader.[38] They were completely at ease in them and with the many questions I had about the outfits. Helen decided to get a Stoughton bunad soon after Marion Keebaugh debuted the design in 1997. She is from Stoughton and was in the Norwegian dance group in high school. Although most wearers have the red bodice, she chose green on Kent's recommendation that it looks more regal. Kent became the first man to have a Stoughton bunad in 2000. "It's so much more fun to have him in a bunad when I wear mine. We look like we go together," Helen said, smiling. It is clear from his demeanor that Kent is not just window dressing for Helen. He loves wearing the bunad. They both do, and they wear them as often as they can, including the bunad show held on the Saturday of Stoughton's three-day Søttende mai celebration. During the festival, they are frequently stopped on the street with questions and requests for photographs.

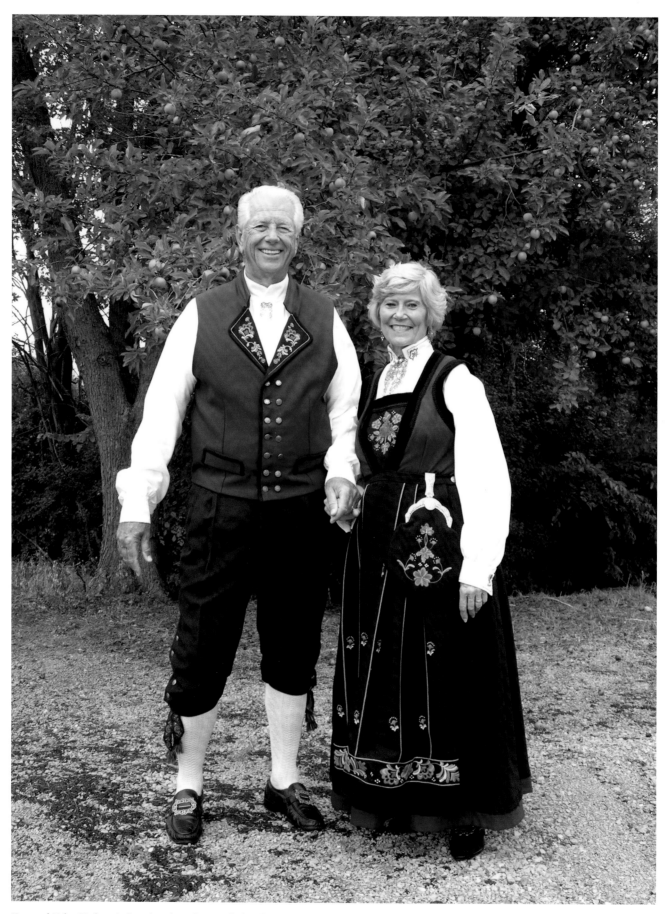

Kent and Helen Karberg in Stoughton bunader outside their home in Cambridge, Wisconsin. *Photo by Laurann Gilbertson, 2018.*

Regional bunader, such as the Stoughton bunad, seem to be a United States phenomenon, not a North American one. There is no Canada bunad, and there is unlikely ever to be one, according to Susan Strang, a cultural director for Sons of Norway who lives in British Columbia. In an email response to my inquiries to her, Susan wrote that there is a distinct preference among Norwegian Canadians for "traditional" bunader and other historic traditions: "It's more important where people are from than who people are now."[39]

Not all Norwegian Americans know where exactly their ancestors are from, yet they want to take part in cultural activities and express their ethnic identity by wearing a bunad. Kathe Synnøve Nilsen (d. 2002), from Sandefjord, Norway, had the idea to create a bunad for Americans who did not know which district their ancestors had come from. The motifs on the resulting "Norwegian-American emigration bunad" include symbols of popular culture to celebrate both the very first Norwegians to arrive in North America—explorer Leif Erikson and his crew in the year 1000—and the mass emigration that began in 1825.[40]

When I have spoken to bunad wearers about the US bunader, the reaction is mixed. Most Americans are unaware of them, but many think that the idea of a bunad for a place that is not located in Norway is absurd. "There is no need to develop a new bunad," said Jerry Paulson of Madison, Wisconsin. "The bunad is already a new phenomenon."[41] Several people commented that these should not be called bunader because they are not recognized as bunader in Norway. Aesthetically, some think that the designs on US bunader are too literal and not artistic enough. I have heard many positive comments as well. Helen Karberg shared with me the reactions she usually receives when she wears her Stoughton bunad: "A lot of people are impressed. They think it is pretty nice that [Stoughton] thought so much about Norwegian culture to have their own bunad."[42]

Whether there should or should not be bunader for places in the United States, US bunader do exist. Many Norwegian Americans feel a close connection to the place their relatives came from in Norway and want to show the connection through dress. A bunad says where your people are from. Other Americans want to celebrate their personal identity as Norwegian *and* American. A United States bunad says that you are Norwegian by the very fact that it is styled like a bunad. It can also say that you are American by the selection of motifs and symbols. Expressing both Norwegian heritage and American pride of place can be important and appears to be increasingly important to women and men in the United States with Norwegian ancestry. Steven Schnell observed a similar trend in Lindsborg, Kansas, where Swedish costumes have come to symbolize the present more than the past and "have become local, current symbols of place and community."[43] Although

there is not a distinctive Lindsborg costume like there is a bunad for Petersburg, Alaska, for example, there is a desire to show where you are from at the same time you show where your ancestors are from.

Bunad Couture

Not all Norwegian Americans relate to the traditions of rural Norway. They want to express their Norwegian heritage through dress, but not by dressing as romantic visions of peasants. *Festdrakt* is the term used in Norway today to describe a festive outfit that falls somewhere between ball gown and bunad, almost "bunad couture." Whereas a bunad strongly represents historic, rural, and regional Norway, a festdrakt has a modern, urban, and national Norwegian appeal that resonates with many Norwegians and some Americans with Norwegian ancestry.

Lise Skjåk Bræk has been at the forefront of festdrakt.[44] Trained in design and art history in Norway, England, and Italy, Lise has had her own studio in Trondheim since 1972, where she designs haute couture collections and garments for commercial production. Increasingly, she has taken inspiration from Norway's rich cultural heritage of folk dress, textiles, and other folk art. Tradition and aesthetics are equally important in her designs for festdrakt.

Because bunader are rooted in rural traditions, she finds that many contemporary urban Norwegians feel little attachment to any local region. They are among her clients, as are brides who might be marrying for the second time and girls who want something beautiful for confirmation. "Festdrakt can go where bunad can go and to a party where bunad could not go," Lise explains. Originality is important to Lise and her clients:

> *Forty years ago, there would be four girls wearing bunad in a confirmation. Now there are four not wearing bunad. All the clothes look alike, which creates the urge to have something that is special and relates to you and to your country. When bunader became so popular, they also became a stereotype. Now they all look alike. In the old times, we had variations by color, embroidery, scarves, and trim on the apron. It was the same style, but with variety. Where we created new bunader, "they must look like this," which created the bunad police saying you can't embroider the purse without taking a course. Festdrakt gives you an opening to not look like everyone else in your community.*

Lise is not reacting against "the bunad police" or Norway's modern national costumes. Rather, she seeks to honor the traditions that national costumes represent and looks to the heritage of rural folk dress as her source for new creations. She is most strongly influenced by the East Telemark bunad,

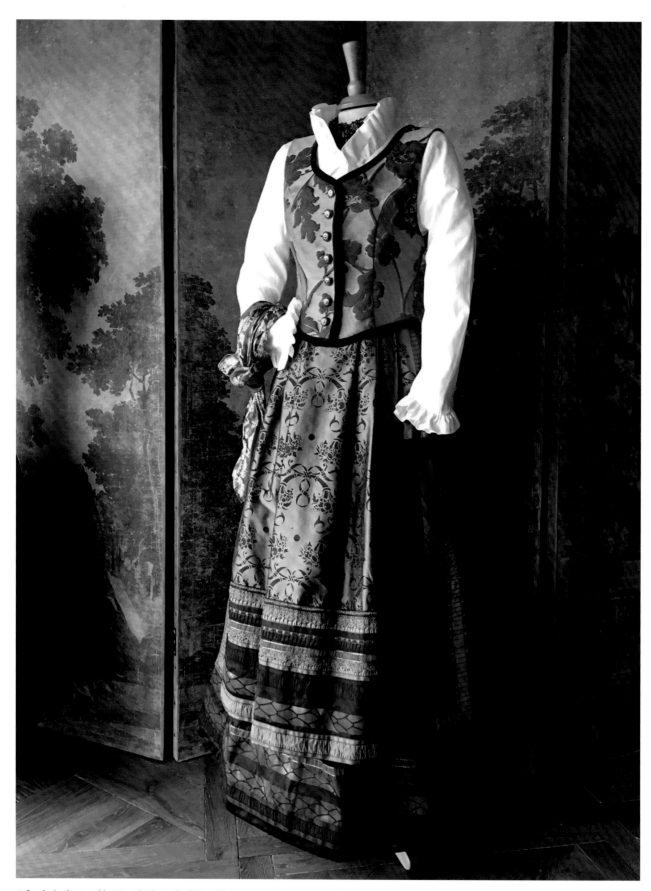

A festdrakt designed by Lise Skjåk Bræk of Trondheim, Norway, 2017. © *Lise Skjåk Bræk*.

which she considers very feminine. The combination of full skirt, decorated apron, short jacket, and wide belt takes on a very contemporary look in silk instead of wool. The silhouette is reminiscent of gowns typically worn by Hollywood movie stars for red carpet events.

Lise borrows elements from other traditions in Europe and the world. She is not the first in her country to do so. As she explained, "The Norwegian bunad is not from the time of Christ. It picked up patterns from the world. We made it ours." This comment will likely shock some Norwegians and many Americans for whom the bunad represents a long and distinctively Norwegian history. The bunad is a twentieth-century creation, an "invented tradition" according to Eric Hobsbawm's definition.[45] Few of the elements from historic rural dress that inspired bunader date from before the eighteenth century, and folk dress has long incorporated ideas from fashion as well as imported materials.

In addition to hundreds of clients in Norway, Lise has a handful in the United States, the result of a special exhibition in 2015 at Norway House, a cultural center in Minneapolis, Minnesota. I reached out to some of Lise's Norway House customers. Linda Brekke Mona said that the exhibition and gala style show were very well received:[46] "These interpretations of cultural iconic things into contemporary art are very exciting." Linda, who has been chair of the board of directors at the center, purchased a festdrakt because she "wanted something contemporary, evocative of Norway." She explained, "Wearing a bunad seemed like it would be a 'costume.' Where festdrakt seemed like a beautiful gown that I could wear at special events in my everyday life."

Another buyer, Shirley Lillehaugen Santoro, is a violinist.[47] She selected a two-piece festdrakt to wear while performing. Kim Hakensen is not Norwegian American but loves feeling part of festivities at Norway House and in the community.[48] Unlike some designers, perhaps, Lise Skjåk Bræk encourages some customization of her designs to fit the occasion. While Kim always wears all of the pieces of her festdrakt together, Linda leaves off the apron for non-Scandinavian events, and Shirley wears the iridescent gold skirt only for formal occasions.

Because many of Lise's Norwegian clients are attracted to the urban feel of festdrakt, I was curious if that was the same for the three women who live in the Twin Cities, the sixteenth-largest metropolitan area in the United States. I asked them if festdrakt appealed to them as urban Norwegian Americans; they said no, not particularly. However, the complexity of the outfits and the formality of silk fabric seem to better fit a big-city setting than a smaller town. For example, it is hard for me to imagine an occasion formal enough in my Iowa town—Decorah, population eight thousand. For these wearers, the

appeal of Lise Skjåk Bræk's designs are as contemporary Norwegian works of art.[49]

Conclusions

For many Norwegian Americans, acquiring and wearing a bunad is a significant expression of ethnic identity. More than other markers, such as joining a cultural organization or preparing traditional food, wearing a bunad is a very public act and requires a commitment of time and money. Wearing a bunad, any bunad, shows that you are Norwegian or have Norwegian ancestry. In addition to expressing this group identity, the choice of bunad and the choice of specific elements of the bunad can further express an individual identity. As Lizette Gradén found most dramatically demonstrated in the Swedish community of Lindsborg, Kansas, wearers of Nordic costumes in the United States seek increasingly individualized outfits to reflect personal taste, genealogy, a sense of place, and even specific life experiences.[50]

The desire to wear a bunad is not necessarily related to how recently family members emigrated from Norway. Some of the immigrants I interviewed had grown up with bunader, but others had not. Sixth- and seventh-generation Norwegian Americans are now seeking bunader as a way of connecting with their ethnic heritage. The bunad can be an expression of ethnicity by ancestry (descent) or choice (consent).[51]

Wearing a bunad is not always enough for some Americans with Norwegian ancestry. I contend that the "bunad story," shared informally through conversation or formally through the narration in public bunad style shows, is also an important form of expression of Norwegian ethnicity in the United States. It is an opportunity for wearers to demonstrate both Norwegian group identity and personal identity, as well as to make connections with other Norwegian Americans through the details revealed in the story.

The "bunad story" is also one of the forms of lively communication between the two countries. The stories are part of a steady stream of information about bunader, styles, meanings, rules, and evolving options. The stream is also fed through family relationships, travel, participation in US cultural organizations and festivals, and popular literature, such as Sons of Norway's *Viking* magazine. Although direct connections with the homeland may not be as frequent or as intensive as what scholars might deem transnational, these activities, taken as a whole, have indeed shaped the customs of wearing bunader—and, in some cases, the bunader themselves—in the United States.

At first it may seem that bunader in Norway and in America are on divergent paths. The Nasjonaldrakt has remained popular in the United States for decades longer than in Norway. Norwegian Americans are creating dress designs that

have little or nothing to do with the communities in Norway in which they or their ancestors once lived. Immigration and a new American context have transformed bunader and bunad use, yet the paths are almost parallel. Bunader in both Norway and America symbolize and express their own sense of place.

Notes

1 In 2019, the number was 4,295,923, with 99 percent born in the United States (see US Census Bureau, "Selected Population Profile—Norwegian").

2 I conducted interviews with forty-nine women and men in the United States and Canada and two in Norway. I sampled the activities of numerous organizations, reviewing ten organizations in more depth. The artifacts consisted of thirty-seven adult costumes that are complete or nearly complete and were acquired by the wearers between 1960 and 2018.

3 Many Norwegian Americans choose to connect and reconnect with others in order to learn about and share history and heritage. Connections take place on local, regional, and national levels, in families, communities, organizations, and institutions.

4 For more on the network that supported the revival of folk dress and creation of bunader, see Lien, *Norwegian National Organization.*

5 For a more detailed history of bunad use in the United States, see Colburn, "Norwegian Folk Dress in America"; Colburn, "Norwegian Folk Dress in the United States." My observations about the regional preference for the Nasjonaldrakt were corroborated by individuals who live in or have lived in the northeastern United States and by those active in dance groups. Telephone interviews: John Andresen, Aquebogue, New York, April 9, 2018; Barbara Berntsen, Valley Stream, New York, April 9, 2018; Deborah McConaghy, Charlotte, North Carolina, February 26, 2018; Susan Strang, Vancouver, British Columbia, May 16, 2018.

6 Information based on collection objects and records: Costume, Vesterheim 1994.056.001 and 1994.077.001, gift of Gloria Stevenson Giles.

7 "Norwegian Costumes Urged for Nordic Fest," *Decorah Public Opinion*, February 6, 1967. Another prefestival article specifically promised "authentically costumed shopkeepers." See Kinney, "Decorah's July Nordic Fest Will Bring Scandinavia to You."

8 Information based on collection objects and records: Costume, Vesterheim 2017.002.001, gift of Deborah Adams.

9 Mette Bowen, telephone interview, Lake Forest, Illinois, April 6, 2018.

10 Jody Grage, telephone interview, Seattle, Washington, March 19, 2018.

11 Sue Sutherland, telephone interview, Ely, Minnesota, May 30, 2018.

12 Telephone interviews: Carol Colburn, Duluth, Minnesota, May 21, 2018; Jody Grage, Seattle, Washington, March 19, 2018. See also Høidal, *Bunads in America*, 10.

13 Telephone interviews: Lori Ann Reinhall, Seattle, Washington, April 7, 2018; Elaine Helgeson Hasleton, Centerville, Utah, March 30, 2018.

14 Elaine Hasleton, telephone interview, Centerville, Utah, March 30, 2018.

15 Colburn, "Norwegian Folk Dress in America," 168–169.

16 Høidal, *Bunads in America*, 9.

17 Elaine Nordlie, telephone interview, Dassel, Minnesota, April 7, 2018.

18 Amy Boxrud, telephone interview, Northfield, Minnesota, February 20, 2018.

19 Michael Bovre, telephone interview, Madison, Wisconsin, February 23, 2018.

20 Bruening, "Bunad Restoration," 18.

21 Deborah McConaghy, telephone interview, Charlotte, North Carolina, February 26, 2018.

22 Walsten, "I Made My Own Bunad," 19–22.

23 Ellen Levernier, telephone interview, Hopkins, Minnesota, March 21, 2018.

24 In Norway, identifying which bunad is often unnecessary, especially in small and rural communities where many people have the same one (Ingebjørg Monsen, interview, Morvik, Norway, May 26, 2018).

25 Lois Pieper (Stoughton, Wisconsin) and Carolyn Pieper Benforado (Madison, Wisconsin), interview, Decorah, Iowa, May 2, 2018.

26 I count the Petersburg (Alaska, created 1960), Texas (1988), Stoughton (Wisconsin, 1997), Norskedalen (Coon Valley, Wisconsin, 2008), Illinois (2013), and Norwegian American Emigration (1989) bunader because they have motifs and other symbolism specific to the United States, a state, or a community. The Dassel bunad (Minnesota, 1995) is primarily a dance outfit, but wearers perceive it to be a regional US bunad. The Spring Grove (Minnesota, 2008) bunad illustrates the deliberate selection of Norwegian elements to express the identity of the group and to enhance the cultural experience for the wearer and audience. The Peace and Environment bunad, designed by Kathe Nilsen in 1991 for a California organization, warrants further review. Although it has symbolic motifs, I did not count it because its focus appears to be broader than Norwegian cultural heritage. I also did not count the Ballard bunad, which is not a distinct outfit but a term that refers to costumes worn in Seattle, Washington, that combine various Norwegian or Scandinavian elements. For more on the Ballard bunad, see Gradén, "FashioNordic," 357.

27 Glorianne Wollen, telephone interview, Petersburg, Alaska, April 27, 2018.

28 Mary Blaha, telephone interview, Fort Worth, Texas, February 22, 2018.

29 The dancers called the outfit the "Texas-Norwegian bunad." Mary Walter, telephone interview, Kirkwood, Missouri, May 1, 2019; Eudoris Dahl, letter to Odd S. Lovoll, Northfield, Minnesota, September 17, 1996, Texas Norwegians Collection, Norwegian-American Historical Association, Northfield, Minnesota.

30 Inger Langsholt, telephone interview, Rockford, Illinois, April 23, 2018.

31 Barb Johnson, telephone interview, Yorkville, Illinois, March 20, 2018.

32 Traditional foods are among the most consistent and persistent markers of cultural identity. See Henning, "In the Comfort of Home," 66.

33 Darlene Fossum-Martin, interview, Decorah, Iowa, April 21, 2018.

34 Lauffer, "A Bunad All Our Own," 1–2. Interviews: Marg Listug, Stoughton, Wisconsin, February 27 and August 7, 2018; Rose Schroeter, Stoughton, Wisconsin, February 27, 2018. Telephone

interviews: Barbara Keebaugh Poresky, Manhattan, Kansas, July 20, 2018; Laura Poresky, Urbandale, Iowa, July 23, 2018.

35 Lauffer, "A Bunad All Our Own," 1–2.

36 Rose Schroeter, interview, Stoughton, Wisconsin, February 27, 2018. For more on the changing interest in men's bunader, see Hegge, "The Norwegian's New Clothes," 8.

37 Lampe, "The Stoughton Bunad," 9.

38 Helen and Kent Karberg, interview, Cambridge, Wisconsin, August 7, 2018.

39 Susan Strang, email correspondence, May 15, 2018.

40 This description is drawn from archival documents and personal correspondence: K. Jill Vander Brug, letter to Vesterheim Museum, Racine, Wisconsin, January 21, 1990; Vander Brug, interview, Racine, Wisconsin, February 20, 2018, and email correspondence, February 21, 2018.

41 Jerry Paulson, interview, Madison, Wisconsin, August 6, 2018.

42 Helen and Kent Karberg, interview, Cambridge, Wisconsin, August 7, 2018.

43 Schnell, "Creating Narratives of Place and Identity," 23.

44 Lise Skjåk Bræk, telephone interview, Trondheim, Norway, May 1, 2018. See also Skjåk Bræk, *Lystig arv*.

45 Hobsbawm, "Introduction," 9. The Scottish kilt is an example of an invented tradition, and it is easy to see parallels between it and the bunad, especially in how it appeals to wearers who wish to show a regional identity. See Trevor-Roper, "The Invention of Tradition."

46 Linda Brekke Mona, telephone interview, Edina, Minnesota, March 27, 2018.

47 Shirley Lillehaugen Santoro, telephone interview, Maplewood, Minnesota, April 23, 2018.

48 Kim Hakensen, telephone interview, Minnetonka, Minnesota, April 28, 2018.

49 The estimated population in 2019 for the Minneapolis-St. Paul Combined Statistical Area was 4,027,861 (see US Census Bureau, "Estimates of Resident Population").

50 Gradén, "FashioNordic," 382; Gradén, "Folk Costume Fashion in Swedish America," 197.

51 Sollors, *Beyond Ethnicity*, 6. The bunad is an expression of "symbolic ethnicity," a tradition followed occasionally (not in everyday life) by later generations through nostalgic loyalty to the culture of the old country. See Gans, "Symbolic Ethnicity," 201, 204.

Part Three:

Gákti in Sápmi

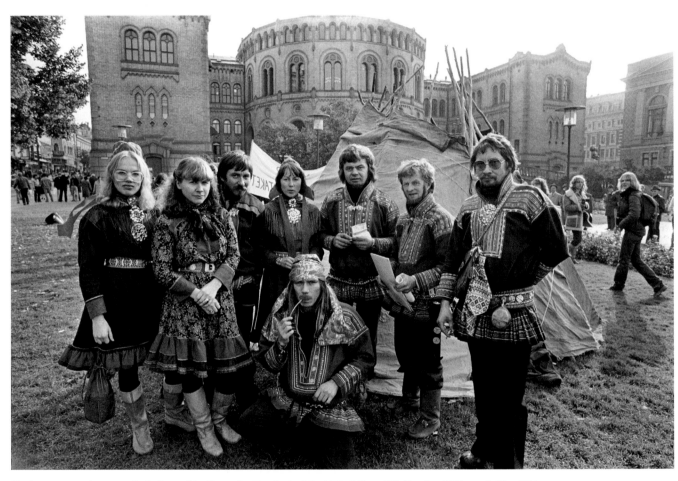

Sámi protesters on hunger strike in front of the Norwegian Storting in Oslo, 1979. © *Bernt Eide/Samfoto, NTB scanpix/Sipa USA.*

6

Sámi Gákti

Carrie Hertz

In 1969, the Norwegian Water Resources and Electricity Board published plans to develop hydroelectric power on the Állá-Guovdageaidnu/Alta-Kautokeino river in Finnmárku/Finnmark county. The project included a proposed dam that would disrupt salmon fisheries and create a reservoir, flooding crucial lands for reindeer husbandry and the Sámi village of Máze/Masi in Guovdageaidnu/Kautokeino municipality. By the 1970s, more than sixty river systems on the Norwegian side of Sápmi, with more still on the Swedish and Finnish sides, had already been dammed for hydroelectricity, with devastating effects on Sámi livelihoods in those areas.[1] Although protests helped save the village of Máze, a revised plan still resulted in a dam on the Állá river. A unified and well-organized campaign against this Állá-Guovdageaidnu development lasted more than a decade. Led by local interest groups and joined by national and international coalitions committed to environmental and Indigenous rights, the protest movement forever changed the relationship between the Sámi people and the colonizing government of Norway.

When measured arguments, petitions, and legal intercessions finally failed, advocates for the movement organized acts of civil disobedience, blocking construction and staging demonstrations. In 1979, a group of Sámi protesters set up *lávvut* and camped on the lawn of the Storting. Lávvut, temporary shelters commonly used while migrating reindeer herds, evoked a way of life threatened by stolen lands and suggested parallels with Native American and other aboriginal groups waging similar civil rights campaigns in North America. At the protest encampment, a few people went on hunger strike. Many dressed purposefully in gávttit, highlighting their indigeneity in relationship to specific territories, especially Guovdageaidnu, and characterizing the conflict as one with far-reaching significance for local, ethnic, and global concerns for human rights.

The ability of clothing to make certain aspects of identity visible also makes it a valuable medium for expressing diverging descent and dissent in contexts of hegemony. As we see throughout this volume, identity entails an awareness and articulation of difference, but between centers and peripheries, majorities and minorities, more powerful groups often command how those differences are parsed and valued. Purposeful dressing can offer individual and collective agency in combatting the characterizations imposed by others, affirming alternative realities and self-esteem, and possibly shifting popular opinion about groups of people and moments in history.

Sámi activists not only dressed strategically in gávttit; they also invoked its imagery in other creative ways, fashioning subaltern perceptions of the historic events unfolding during the Állá Conflict. Sámi clothing traditions, for example, featured prominently in the work of Mázejoavku, the Máze

Artist Group, a collective of international Sámi artists who gathered in Máze to support the Áltá resistance with politically charged artworks.[2] Synnøve Persen, one of the founding members, stitched a flag with a blue ground accented in red and yellow, inspired by the most typical colors for Sámi dress.[3] Waved at Áltá protests, the flag represented Sámi sovereignty and implied a battle between nations. Another member of the collective, Britta Marakatt-Labba, rendered a pivotal moment of the conflict in an exquisite embroidery titled *Garjját* (*The Crows*), infusing it with personal and cultural meaning.[4] In 1981, six hundred policemen were deployed to disband protesters encamped near the construction site for the Áltá dam. Hundreds of demonstrators were arrested and fined. In Marakatt-Labba's scene, the black-clad police reveal themselves to be disguised crows (symbols of greed and destruction in Sámi folklore) as they violently descend on a group of peaceful, colorfully dressed activists huddled around lávvut.

The Áltá case is often presented as a moment of "cultural and legal awakening"—not necessarily for Sámi people, who have been engaged in religious and political struggles with more powerful actors for generations, but perhaps more for national and international publics who finally acknowledged their enduring presence and plight.[5] These events, adding momentum to a growing Sámi grassroots movement (ČSV), tapped

Mittens patterned with Sámi flags by Barbro Rönnqvist, 2018. Museum of International Folk Art, IFAF collection (FA.2019.19.1ab). *Photo by Addison Doty.*

into similar intellectual and progressive movements emerging around the globe, each meant to redress ongoing legacies of colonialism, ethnonationalism, and the forced assimilation of Indigenous peoples and other minorities. Starting in the mid-twentieth century, new tenets of human rights codified in the establishing documents of the United Nations advocated for political structures that recognized and protected the cultural rights of ethnic, religious, and linguistic minorities living within nation-states. The media attention surrounding the Áltá actions raised both national and international awareness of Norwegian-Sámi relations, swaying public opinion against the government and sparking a series of reforms and formal apologies that have continued into the twenty-first century.[6]

One legally binding outcome of these protests included a constitutional amendment (Article 110a) protecting Sámi languages and culture, modeled after the 1966 International Covenant on Civil and Political Rights. The Sámi Act of 1987 established the Sámediggi (Sámi Parliament) as a democratically elected representative body. By the early 1990s, Norway became the first nation (and the only one containing Sámi populations) to ratify the United Nation's Indigenous and Tribal Convention (ILO-169) obligating the protection of Indigenous rights within independent countries. Articles of ILO-169 (specifically 14, 6, and 15) recognize the ownership rights of Indigenous peoples to "the lands they traditionally occupy" or for which "they have traditionally had access for their subsistence and traditional activities" and specify that Indigenous peoples should participate in and benefit from decisions concerning the exploration and exploitation of resources pertaining to their territories.[7] These and other progressive acts, however, have not always been upheld, nor have they undone hundreds of years of paternalism and painful discrimination. Some critics have argued that even model legislation, when interpreted on the ground, is not handled in good faith and so has not resulted in substantive changes in the administration of resources, as recent controversies over fishing rights, deforestation, and the size of reindeer herds demonstrate.[8] Despite shifting cultural and political landscapes, Indigenous Sámi populations still live as permanent ethnic minorities within nation-states that delimit and regulate Sámi legal identity and the customary usage of their territories.

Numerically, the majority of Sámi people live within the borders of Norway, with smaller populations in Sweden, Finland, and Russia.[9] The divergent contexts for these nations have resulted in varied histories, political structures, and experiences. Like Norway, Sweden and Finland established Sámi Parliaments between the 1970s and 1990s following internal and international pressure sparked by the Sámi movement. All of these parliaments, however, primarily serve advisory functions, redistributing finances allocated in budgets first set by overseeing state bodies. According to legal statutes, the Sámi

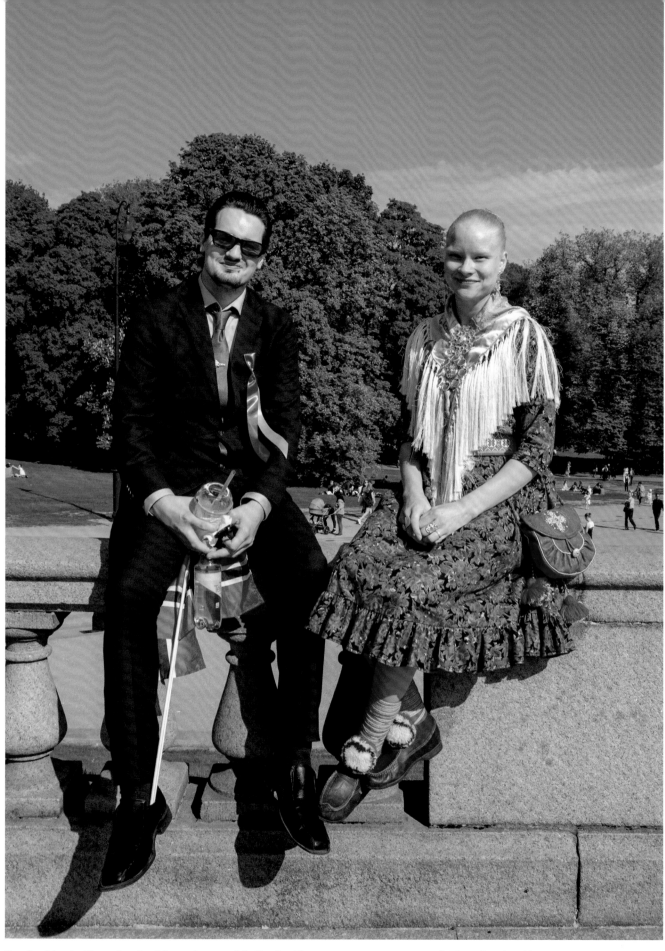

Couple celebrating Norway's national day on the steps of the Storting. The young woman wears summer gákti from Guovdageaidnu.
Photo by Carrie Hertz, 2018.

Parliaments should be consulted on decisions concerning Sámi affairs, but the statutes extend neither concrete jurisdiction nor authority over decision-making.

Sámi political victories, rather than resulting in steps toward decolonization, have often been limited to the same cultural rights promised to any ethnic minorities within contemporary democratic, pluralist states, falling short of securing the territorial control demanded by international conventions concerning the rights of Indigenous groups.[10] Indigenous scholars Tuck and Yang argue that "decolonization is not a metaphor." Its objectives should not be grafted onto similar social justice movements focused on civil or human rights, which do not inherently "unsettle" the sovereignty of settler societies.[11] Similarly, political theorist Nils Oskal has argued, "If the self-government rights of indigenous peoples are meant just as a form of internal autonomy within a pre-existing state, that continues to claim unlimited and outstanding sovereignty, then it could be said to be continuing internal colonization rather than turning away from it."[12] According to Oskal, we cannot claim our era postcolonial without recognizing "*shared* jurisdiction over issues [such] as land and resources on the bases of mutual consent."[13]

Conflicts around land rights in Sápmi are likely to only increase in the context of escalating Arctic development and resource extraction. Extractive industries in the Nordic countries disproportionately impact Sámi individuals, businesses, and communities by damaging or expropriating the renewable natural resources that many have directly depended on for generations, such as fisheries and hunting grounds, fresh water sources, air quality, woods, grazing pastures, and general biodiversity. Such destruction of sustainable industries is routinely dismissed as a necessary and inevitable sacrifice for progress. In industrialized societies organized around an endless growth of profit, "a dependency on natural resources and primary goods has been regarded as an expression of backwardness and peripheral status," contributing to a lack of concern for Indigenous demands that policies promote sustainability and sovereignty.[14] Land, however, is not simply an instrumental resource in a zero-sum game. It locates stories, events, and relationships within the natural and spiritual world through a "geography of significant places."[15] As Coppélie Cocq writes, "For indigenous people, the land is not only a place of longing and belonging, it is also associated with history, culture and legal rights. This is articulated in Sámi identity discourse, where one's place of origin, genealogy and ancestors define one's position within the community."[16] Decolonization, as opposed to other human rights efforts, is explicitly directed at repairing the violent "disruption of Indigenous relationships to land" that have been scorned as "savage" and unfit for modernity. As a movement, "decolonization specifically requires the repatriation of Indigenous land and life."[17] It requires recognizing the value of alternative relationships to land other than enclosure, private ownership, and profit seeking.

The strategic use of Sámi dress enhances the public visibility of Sámi culture and rhetorically connects it to specific histories, perspectives, and territories. These acts potentially support decolonization. Graham Huggan outlines decolonizing processes in the Arctic as taking two forms: "a *politico-economic* form, in which the primary struggle is over appropriate forms for regional governance and the local management of land and resources; and a *cultural* form, in which the powerfully colonizing force of western romantic imaginaries of the Artic is directly challenged if not definitely overcome."[18] The Álta Conflict and the movement it sparked helped frame the gákti in public consciousness as a contemporary symbol of ethnic and Indigenous resistance to domination, assimilation, and forced relocation. As this background predicts, concepts of homeland, cultural vitality, and belonging are central to discourses of gávttit today.

As with folkdräkt and bunad, the gákti has been surveyed, collected, categorized, and in some cases revitalized through a taxonomy that equates geographic divisions with cultural distinction. While all three traditions materialize notions of cultural and spatial continuity, they have been shaped by vastly different histories in the contexts of colonialism and romantic nationalism. Whereas folk and national costumes were widely celebrated, both Sámi dress and identity were more likely disparaged, discouraged, and even demonized by authorities.[19] Regional differences in Sámi dress, furthermore, took on new, potent meanings of discontinuity and displacement after the forced relocations of the late nineteenth and early twentieth centuries when national borders were closed and available grazing pastures became dramatically reduced and overcrowded, resulting in depleted lands and intraethnic tensions.[20] Historical disparities, both between cultural groups and within the Sámi minority, inform contemporary practice.

Traditional Sámi dress is worn for a wider range of occasions than folkdräkt and bunad, comprising styles appropriate for formal, festive, and everyday situations. Individuals enjoy greater flexibility in assembling outfits, regularly blending ethnic styles with cosmopolitan elements for daily wear. For some people, these daily selections may have less to do with ideology than with personal preference or practicality; these individuals may find, say, a pair of reindeer fur pants warmer for spending a winter day outside than its alternatives. For others, the daily, public display of Sámi identity through known sartorial markers is an important political statement of cultural adaptability that defies majority stereotypes of Sámi nonmodernity.[21]

Despite the flexibility of Sámi dress traditions, as with other types of traditional dress, formal occasions warrant greater adherence to mutually recognized and prescribed dress codes,

Dressing with Purpose

typically prioritizing the "traditional" and shared aspects over the fashionable. When scholars depict ethnically marked dress as more "authentic" when worn every day (rather than being reserved only for special occasions), they not only overlook economic necessities and typical patterns for formality within functional wardrobes but also may be imagining a utopian state of nature without social conflict or an awareness of difference—or, perhaps more disturbing, a people without history, a people untouched by modernity. The same binary divisions grounded in scientific racism between tradition and modernity, costume and fashion, reemerge in these declarations of authenticity, implying that those from the ethnic "majority" cannot authentically wear traditional dress and those who have been marginalized cannot authentically modernize. As we have seen, few choices for dressing are made without an awareness of complex social and cultural expectations and differentiations. Notions of authenticity, like tradition, emerge from a dynamic process of negotiation, and some enjoy more authority than others to authenticate objects, people, and practices.[22] When making claims of authenticity, dress scholars can underestimate the potential forces of hegemony and the promises of "soft power" within cultural imperialism to complicate individual choices.[23] As Jason Baird Jackson argues, "choice under pressure is not exactly choice," but it can nonetheless be an authentic response to real circumstances.[24] The desire to actively participate in cultural creativity—to display shared cultural identity through dress—is not unique, yet that desire is influenced asymmetrically when certain identities have been historically, intentionally, and programmatically marginalized and maligned. Täpp Lars Arnesson in Dalarna county, Sweden, faces different consequences and potential rewards when he resists what he considers the mandates of modernity than does someone from a minority group who may be viewed when making similar choices as irredeemably primitive. Centuries of subjugation can leave lasting impressions on how a group of people are seen and how their lives, art, and actions are interpreted, not to mention how they may see themselves.[25] In certain times and spaces, traditional dress may be too dangerous to wear. In others, it may be a tool for forcing change. Traditional clothing, as an evocation of continuity (and thus, survival), not only animates group identification over time but also can demand acknowledgment of that group's resiliency against erasure within shared space.

Despite these potential variables informing practice and perception, Sámi dress traditions—as with other examples of Indigenous and ethnic dress—can convey multiple identities, intentions, and effects. As Jackson has written of Native American dress in the United States, "knowledge of clothing—how it is made, how it is to be worn, and the values it expresses—is acquired cultural knowledge. As culture, it is partially shared and partially individual and idiosyncratic. Clothing, like

language, can be used in a number of styles."[26] It is never limited to one purpose, meaning, or manifestation.

While the significance of gákti is manifold, as with folkdräkt and bunad, the heart of contemporary practice still centers on family tradition. The Aira-Balto family illustrated this idea in the introduction to this book. In this chapter, we take a closer look at the aesthetic and politicized frameworks for understanding Sámi dress today, especially in relation to intraethnic diversity and interethnic contexts of decolonization. In the following chapter, Eeva-Kristiina Harlin and Outi Pieski deepen and personalize these themes with a discussion of their efforts to reconstruct, reclaim, and revive the woman's *ládjogahpir* (horn hat or hat of pride). This headdress, once widely worn in a variety of regional styles, was specifically targeted by Christian authorities as a sign of paganism in need of eradication. As such, it has become a contemporary symbol of Sámi cultural resilience and resistance. At the same time, by recentering Indigenous and gendered interpretations of the ládjogahpir, Harlin and Pieski provide powerful arguments for not simply repatriating objects but also rematriating lost social structures, practices, and ideas obliterated by the imposition of patriarchal Western hierarchies of value.

We begin with a closer look at the legacies of state-directed assimilation policies that were meant to culturally transform Sámi minorities into national majorities. These legacies vary from place to place, resulting in different relationships with and perceptions of local dress. To explore these differences, we then turn to two specific areas in Norway, first Guovdageaidnu in inner Finnmárku and then the coastal region of north Romsa/Troms. While previously recognized as separate counties, they were officially merged in January 2020 as Romsa ja Finnmárku/Troms og Finnmark.

Majority or Minority Dress

In Norway, between the constitutional declaration of 1814 and national independence at the turn of the twentieth century, new policies were implemented to integrate the diverse regions of the North and "re-establish the old Norse Norway" as the country's primary identity.[27] Known as Norwegianization, or *fornorsking*, these policies were meant to formulate and strengthen a singular and distinctive cultural identity for Norway (for example, by purging Danish words from Norwegian language), but eventually, they also targeted Sámi and other ethnic or religious minorities within the nation for cultural assimilation. While multiethnic regions commonly develop hybridized cultures, romantic ethnonational imagination sought to discover, disentangle, and favor a separate Norwegian identity.[28]

Assimilation policies in Norway and elsewhere were designed to weaken divergent cultural identities and justify state expansions. As in many other colonial contexts around

Reindeer hides drying in Guovdageaidnu. *Photo by Chloe Accardi, 2018.*

the world, Sámi children were forcibly removed from their families and isolated in boarding schools where students were prohibited from expressing Sámi culture through language, dress, or religious practices.[29] Sámi languages were also prohibited for legal administration or other official matters, including for place names and signage.[30] Landownership was restricted to those with Norwegian language proficiency and who possessed "Norwegian" names. Barred from owning property, many Sámi lost rights to previously recognized sovereign lands, displaced by influxes of agricultural settlers and industrialists.

Nomadic groups were also discouraged or prevented from following traditional migration routes. In earlier periods, treaties had guaranteed seasonal border crossing for Sámi reindeer herders migrating between the northern Norwegian coast and the Swedish mountains.[31] As Norwegian historian Roald Berg argues, in the age of nationalism and "internal colonialism," the Sámi people were increasingly considered foreigners with questionable loyalty, and their cultural practices were seen as inconvenient to state modernization projects. He writes, "The indigenous Sámi were neither Norwegian nor Swedish by culture or by identity. They communicated in their own language.

They were transnational in the age of the nation-state, when even the northernmost parts of Europe were seen as areas ripe for industrialization. Several traditionally transnational reindeer pasture districts were transformed into mining areas. Thus the Sámi were caught between Swedish and Norwegian cultural and economic penetration into the FennoScandinavian mountain plateaus and the western coast during the nationbuilding process, when state borders became identity markers and where previous common pasture districts became private property."[32] The official period of Norwegianization lasted for more than a hundred years but was incrementally abandoned after World War II and further disrupted by the concerted activism advanced by the Sámi movement. The racist and paternalistic philosophies underpinning its implementation, however, have had lasting consequences, stigmatizing the public expression of Sámi identity.

Guovdageaidnu in Inner Finnmárku

Since its approval in 1987, the heraldic coat of arms for Guovdageaidnu municipality in inner Finnmárku is a gold lávvu against a blue background. The design recognizes the prominence of Sámi cultural identity to the area. Often considered

the Sámi heartland, Guovdageaidnu was the first Norwegian municipality to proclaim North Sámi as an official language for local administration. The area is home to around three thousand residents, the majority of whom (about 90 percent) speak North Sámi and self-identify as ethnically Sámi.

In the winter, rolling hills blanketed in snow look like frosted wedding cake, all tinged in pink during the few hours when the sun rises low in the sky. Semidomesticated reindeer herds roam freely across the plateau; black plastic bags are tied to roadside posts to alert drivers of their movements.[33] In spring, icy lakes and rivers break up under the midnight sun, and herders load up sledges and snowmobiles to lead reindeer to summer pastures near the coast.

Only a small portion of Sámi are or historically were full-time herders of reindeer, though this archetypal image has become ingrained in popular imagination, reinforced by early depictions, collections, and public displays based on inner Finnmárku.[34] This locale remains the largest pastoral region in Norway. Many locals in Guovdageaidnu do engage in reindeer husbandry and practice *duodji* (Sámi art, craft, design, artistically driven activities, and aesthetic worldview) to varying degrees, a fact legible on the landscape. In the municipal town center, for example, rows of single-story homes, painted in cheerful shades of blue, red, and yellow, feature reindeer hides stretched against their exterior walls to dry.[35] Reindeer fur, leather, antler, and bone feature prominently in works of dress and adornment, recognized as important products of duodji practice. Most local families have at least one member, usually a woman, who specializes in making traditional clothes. Many men, however, also knit, weave, work leather, and fashion accessories from wood, bone, and antler.

Guovdageaidnu hosts a number of important Sámi cultural and political institutions, including leading organizations for developing secondary and higher education curriculums that uphold Indigenous languages, skills, and epistemologies as their starting points for instruction. There is a high school and advocacy center specializing in reindeer herding and husbandry (Sámi joatkkaskuvla ja boazodoalloskuvla and the International Centre for Reindeer Husbandry), as well as Sámi allaskuvla (Sámi University College) with an affiliated research unit, the Nordic Sámi Institute. Administrative offices for the Sámi Parliament (the departments of education and language) are also located in Guovdageaidnu. (The main parliamentary building, evoking the conical shape of a lávvu, is located a short distance to the east in another core Sámi area, Kárášjohka/Karasjok.)

Guovdageaidnu is further known as a hub for innovation in Sámi arts and media. The International Sámi Film Institute in the village of Buletjávri supports the development of media produced in Sámi language. Film and TV production crews can often be found having an evening drink in the bar of the Thon hotel, which sits atop a hill overlooking the municipal town center. A major film festival is held every spring. And since 1981, the widely recognized Beaivváš Sámi National Theatre has performed and toured culturally relevant plays in multiple Sámi languages. The theater was founded by a group of activists during the Álttá Conflict with the play *Min Duoddarat* (*Our Tundra*), which imagined a Norwegian woman and a Sámi man as star-crossed lovers who triumph in defeating the planned construction of a mine.[36]

Through concerted effort, the Guovdageaidnu of today has been built on a foundation of institutions that emphasize Indigenous politics, education, vocations, and media, but it is also one node in a far-reaching network across Sápmi. Since the beginning of the Sámi movement, many have contributed to the formation of this contemporary infrastructure, eager to support Sámi art, culture, and scholarship in ways that not only sustain individual desires for positive self-expression but also can collectively pierce the previous silence of Sámi perspectives, aesthetics, and epistemologies in mainstream discourse. Some believe the increased exposure that Sámi artists and intellectuals can now enjoy for their work contributes to a growing sense of "confidence in one's own culture and identity."[37] While this cultural confidence can be felt in many areas across Sápmi and beyond, it seems especially palpable in a place like Guovdageaidnu with a majority Sámi population.

In a recent Norwegian study exploring feelings of identity and belonging among Sámi youth, interviewees stressed that "some places are more Sámi than others," and in those places with a more discernable Sámi presence, their "feeling of belonging increases," especially when such places encompass flexible modes for being Sámi.[38] In places with few Sámi, one young man said, "The romantic image of the Sámi, as living in lavos [*sic*] and wearing traditional clothing every day is difficult." Others, however, embrace urban environments, many with growing Sámi communities, in which they feel freer to expand the ways they express a Sámi cultural identity, especially concerning gender expectations and sexuality.[39]

Some commentators, both Sámi and non-Sámi, have argued that Guovdageaidnu has become increasingly conservative, having "taken on a museum-like quality" as "a site of pilgrimage for Sámi outside the core Sámi areas" who wish to connect with this stronghold of imagined pan-identity.[40] The truth of this is open to debate. Guovdageaidnu can be perceived as conservative in some ways, perhaps in relation to religious piety, but less so in other ways, as the plethora of local creative industries and institutions suggest. Local dress practices, particularly, reveal a flair for fast-moving trends and friendly competition for distinction between ambitious makers.

Guovdageaidnu dress incorporates a large and diverse repertoire of options for clothing and accessories. Choices for patterns, designs, accessories, and other elements can reflect

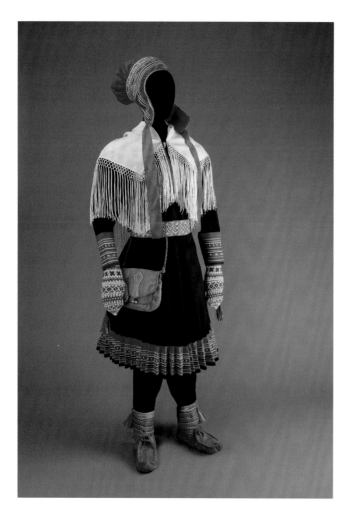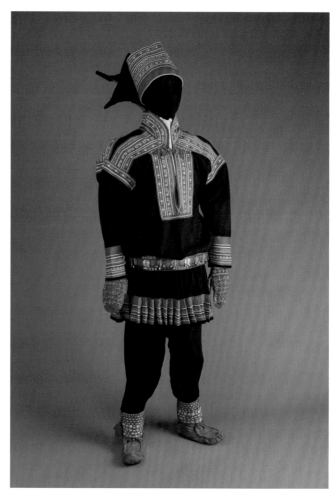

Woman's and man's Guovdageaidnu gávttit, ca. 1966. Museum of International Folk Art, IFAF collection (V.2019.22.1–9 and V.2019.27.1–8). *Photo by Addison Doty.*

gender, marital status, kinship, season, and occasion, as well as personal wealth and style. A typical outfit is built around the local variation for gákti (*kofte* in Norwegian), a tunic or dress with characteristic appliquéd ribbon-work along the cuffs, yoke, shoulders, back, and hem. A man's tunic is shorter and usually boxier and includes a stand-up collar, while a woman's is longer, flared with more gores or pleats, and collarless. Both are cinched at the waist with woven or ornamented leather belts. Either can be made in a variety of colors and fabrics, including woolen or synthetic cloth, leather, and store-bought cotton prints for summer. The most common color combination, especially during formal occasions, is dark blue accented with red and white. The top is usually paired with pants in fur (*gálssohat*) or leather (*sisttehat*), as well as store-bought tights and leggings for women. Handmade leather shoes—with fur for winter (*gápmagat*), without for summer (*čázehat*)—can be worn bound with woolen band-woven ribbons (*vuoddagat*). Women complete basic ensembles with fringed scarves, shawls, and red caps (*nissongahpirahttá*). Men commonly wear scarves, too, and tall, cylindrical hats with star-shaped appendages,

known as the "four winds hat" (*čiehgahpir* or *šávka*). Outfits are further ornamented with brooches, decorative clasps, and other items of silver, antler, or bone. Outer garments, such as fancy fur coats (*beaskkat*) and practical ponchos or capes (*luhkat*), are also popular. Many of these options are specific to Guovdageaidnu, easily identifying the wearer's connection to place (as is typical of headgear, for example), while others share affinities with larger regions or widely shared styles (as with most luhkat, fringed shawls, and jewelry).

As with folkdräkt and bunader, the marketplace for gávttit is varied, spanning private and commercial spheres. In Guovdageaidnu, many women grow up sewing with ample opportunities to learn from relatives, from local experts, and through formal education, including bachelor's and master's programs in duodji offered at Sámi allaskuvla. Boutiques, both online and brick-and-mortar, as well as artist booths at music festivals and seasonal markets, specialize in selling fashionable accessories such as scarves, jewelry, handbags, gloves, shoes, and hats. The more expensive silver jewelry, such as women's saucer-sized brooches (*riskkut*), can be purchased from local

jewelers at Juhls and Kautokeino Sølvsmie. While silver- and goldsmithing has been historically dominated by non-Sámi artisans, new jewelry designers such as Erica Huuva are gaining fame for expanding the repertoire of available designs. For the main garments, customized orders can be placed with professional *duojárat* (practitioners of duodji), but most local people rely on skillful members of their own families.

In Guovdageaidnu, an important resource for those making gávttit is Maritex Gávpi, a local fabric and sewing supply shop. To learn more about local dress, I visited Maritex in February 2017 and in May 2018. During both visits, the shop was bustling with customers, mostly women. The small but densely packed interior is stocked with a curated selection of sewing supplies and notions, tools, materials, finished goods, and pattern books. Near the front, trays of brightly colored spools of thread and cubbies filled with skeins of yarn are displayed alongside an assortment of accessories—hats, silk scarves, plaid shawls, luhkat, pattern-knitted mittens, and curled-toe "beak boots" by Kero (a leather company located in Sattajärvi, Sweden). Time-saving materials can also be found, such as rolls of factory-tanned leather (also produced by Kero), fur pelts, machine-made ribbons mimicking the designs of bandweaving, and precut strips of leather for fashioning belts. The rear

of the store is organized around a large table for cutting fabric. Hundreds of bolts of cloth, especially in shades of red, blue, and teal, surround it. One section features shiny synthetic fabrics with dazzling metallic polka-dot, paisley, and floral patterns in violet, lavender, and aquamarine. Another wall is lined with rows of packaged ribbons, rickrack, and other trimmings in a rainbow of colors used to create the appliquéd ribbon-work common to local styles of gávttit. Additional ribbons and trims can be found in overflowing bins and racks throughout the store.

Maritex has been owned and operated since 1997 by a married couple, a Sámi woman named Inger Marit Bongo and her Norwegian husband, Pål Norvall. They remain the biggest suppliers of gákti-related supplies in Guovdageaidnu. Pål told me their online sales have also been growing. Their thriving business is due in part to fashionable demand. Pål explained by comparing the local gákti to bunader. Most styles of bunader change slowly and may be worn for a lifetime. This conservative pattern is also true for the most formal styles of gávttit—those worn for confirmations, weddings, and church services. During these occasions, trends tend to be limited to ribbon-work design and the accessories used. Unlike bunader, however, gávttit are commonly worn to many events reflecting

Juhls Silver Gallery, overlooking the Guovdageaidnu county seat. *Photo by Carrie Hertz, 2017.*

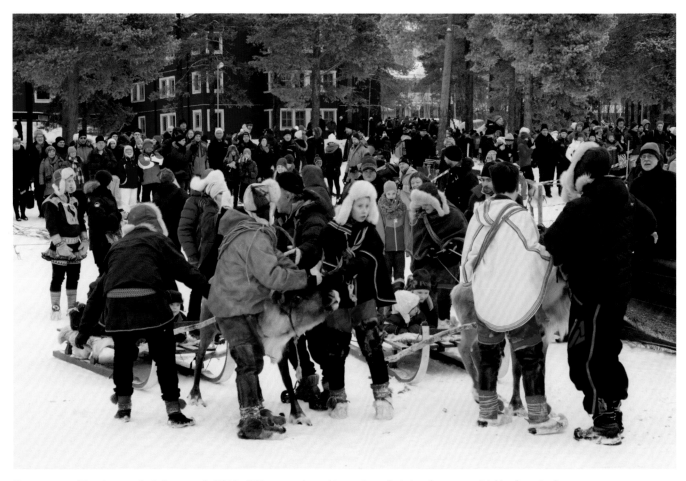

Young men working the annual reindeer races in Jåhkåmåhkke, many dressed in a variety of reindeer fur pants and *luhkat* (ponchos).
Photo by Carrie Hertz, 2017.

a wider range of formality, including concerts, festivals, "parties, meetings, at school or work." As opposed to the one or few outfits of bunader that most Norwegians own, many people in Guovdageaidnu boast closets full of local garments and accessories. According to Pål, "A Sámi gákti changes all the time, and like fashion worldwide, you have the latest fashion, which sometimes can be glitzy and over the top. As others join the trend, the glitz is toned down to [be] more wearable for everybody. The Easter Festival in Kautokeino—the largest winter event for Sámi youths—shows the latest trends for winter, and the many summer festivals show trends for summer gákti. Gákti for men does not change as fast as the gákti for women, and rarely has the colorful fabrics and [as] much glitter."[41] For women of skill, innovative gávttit can be an outlet for creativity and self-expression as well as a medium for asserting one's aesthetic leadership as a local tastemaker.

While I was visiting Maritex in May 2018, Inger Marit introduced me to Marit Helene Sara, a woman she thought was especially talented at introducing new ideas. Marit Helene invited me to visit her at home that evening. Her sister and regular collaborator, Ann Mari, joined us.[42] The timing was

lucky: the sisters had planned to leave with their families earlier that week, driving their reindeer herds to summer grazing in the mountains of north Romsa county, where they usually stay through September. A broken sledge had put them behind schedule.

As we have seen, many materials for making local garments can be purchased from online vendors or craft stores like Maritex, including less expensive, preprepared options for tanned leather and fur. Duojárat like Marit Helene and Ann Mari, who have both direct access to reindeer in number and the requisite knowledge for selecting and preparing skins, have more artistic control over the raw materials and therefore more control over their finished garments. Reindeer leather and fur are primarily fashioned into outerwear, pants, and footwear. Depending on the item of dress as well as the artist's intentions for its function and appearance, different animals are chosen at different times to serve those goals. Reindeer coats vary in color, patterning, and texture; these same attributes change with age, health, and season. Skins generally grow thicker with age and during the summer. Botflies and other parasites can leave holes or imperfections. Different parts of the skin work

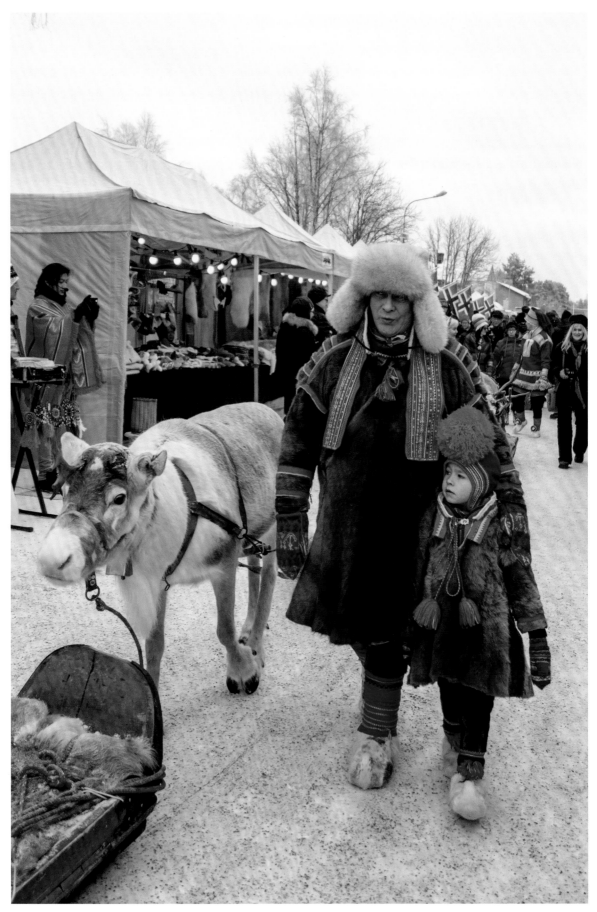

Dressed for the cold in *beaskkat* (reindeer fur coats) during the Winter Market in Jåhkåmåhkke. *Photo by Carrie Hertz, 2017.*

best for different articles of clothing. When choosing, removing, and processing a skin, the best results can be achieved if the intended use is already anticipated.

Marit Helene holds particular preferences for selecting skins. A local style of winter pants for men, known as gálssohat, have leather uppers, fur legs, and cloth hems, usually of red wool. For these, she believes the most beautiful ones are made from dark brown coats taken in the fall when the fur is still smooth and glossy, before it grows shaggy for winter and then molts again in the summer. Since the pant legs are made from the corresponding part of a reindeer's coat, when planning a pair of gálssohat she looks for healthy reindeer with rich brown coats, unblemished around the legs. A suitable animal will also likely be around one or two years old, when the skin is thick enough to withstand wear but still supple.

Some popular preferences reflect shared values for rare (and therefore expensive) features. For example, the most celebrated style of traditional fur coat, the *beaska*, is prized as a status symbol and a special item of beauty. The most coveted version requires similar skins from several young calves with white fur. Since all-white reindeer typically represent less than 2 percent of the population, it may take years to accumulate enough material.[43]

Not all criteria for selecting individual animals are aesthetic, however, and they must be factored into larger considerations of herd management to ensure overall health, profitability, and sustainable numbers.[44] Individual animals are also reserved for reproduction and slaughtered for meat. Pelts, sinew, antlers, and bones are all used or sold.

The Sara sisters regularly select, scrape, tan, and sew skins, but they leave the actual skinning to other family members. Keeping families well-dressed is often shared among relatives who possess varying levels of skill and personal interest. In the large Sara family (including seven siblings and their children and grandchildren), there is no shortage of demand. Little ones, especially, grow quickly and always want the latest fashions. Marit Helene and Ann Mari often work together, but Ann Mari is quick to praise her sister's creative and technical flair. Not everyone in Guovdageaidnu wears gávttit. Among those who do, as with any dress tradition, some people wish to blend in with minimal effort, while others wish to stand out. Marit Helene finds considerable joy in wearing, making, and innovating the local dress.

Marit Helene makes at least one new outfit for herself every year and completes a more elaborate, time-consuming outfit every few years. She is almost always working on various accessories, such as weaving leg bands, making pompoms, or sewing fabric into scarves trimmed with macramé fringe. Many accessories can be made quickly and swapped out frequently. A dress may take two weeks to complete and require expensive materials, but adding fringe to a store-bought scarf can be done in two days. Marit Helene usually prepares at least three new scarves to wear during various festivities held for Easter, when many people show off new clothes.

A few years ago, Marit Helene married Olavi Saijets, a well-known duojár from the Finnish side of Sápmi. For their wedding, she made a gákti in shimmering royal blue. The dress boasted a hem of more than thirty-two meters painstakingly ironed into narrow knife pleats that swung like a bell when she walked. The *holbi*, the hem decoration of ribbon-work, was practically two feet wide, trimmed with row upon row of overlapping glittery ribbons. The cuffs were edged with crystal studs and ruffles of hot pink chiffon. Even before she covered her chest in the customary silver wedding riskkut, her dramatic interpretations of silhouette, color, and material were eye-catching.

Marit Helene's flair for drama is not unique. Throughout Sápmi, Guovdageaidnu has long been thought home to the flashiest dressers. A young Sámi man from the coast told me his grandfather would often jokingly refer to people from Guovdageaidnu as the "Kauto' pimps" for their flamboyant appearance. For non-Sámi, the Guovdageaidnu gákti remains the most recognizable as the one typically chosen to illustrate news stories, travel magazines, and public displays about Sámi cultural identity.

When the Museum of International Folk Art (MOIFA) was planning a traveling exhibition of Sámi duodji in the mid-1960s, it acquired two Guovdageaidnu summer gávttit, a man's and a woman's, to represent Sámi dress traditions.[45] Commissioned for MOIFA by the ethnographer Ørnulf Vorren at Tromsø Museum, the ensembles were typical examples of the fashions at the time with fairly straight tunics of navy wool generously embellished with bright rows of rose-patterned ribbons and rickrack. They appear a bit plain, however, next to any of those made more recently by Marit Helene and Ann Mari. Since the 1960s, Guovdageaidnu makers have expanded the surface areas of decoration, heightened collars, added more volume with gores, widened hems while narrowing pleats, and embraced ever-showier ribbons, braids, ruffles, and notions, like colorful, faceted crystals. The woven leg bands at MOIFA end in little tassels, while the current trend calls for giant, spherical pompoms, sometimes with dazzling gems nestled at their centers.

Multiple factors may account for this general trend toward elaboration. Guovdageainnu gilišillju, the local cultural history museum, tracks local dress changes through a permanent display and implies that they could be read as a response to two historical factors. At the end of World War II, Guovdageaidnu, like much of Finnmárku, was utterly devastated by the war. The reconstruction efforts and the development of the welfare state that followed raised standards of living and flooded the North with affordable new materials and products. This

Dressing with Purpose

pattern has continued through processes of globalization and online commerce. Affordable and diverse materials can spark new ideas.

Elaboration may have also been boosted by the growing sense of cultural pride that accompanied the Sámi rights movement. Rolf Anders Hætta, a young teacher in Guovdageaidnu municipality, told me he believes that locals are especially invested in forging creative futures built on tradition. The fashionable flash of local dress can be seen as evidence of the thriving vitality of Sámi culture, the logical trajectory for a place "where the revolution to reclaim it started," Rolf reasoned.

According to Marit Helene, innovations in Guovdageaidnu dress are further propelled by the presence of a Sámi majority and the high proportion of skilled craftspeople living in close proximity. The concentration of interest and abilities stimulates creative and confident participation, friendly peer competition, and positive feedback for one's efforts. Furthermore, local practice is not considered under threat of disappearing, so the experiments of individual artists can contribute to, shape, expand, and critique shared traditions but rarely upend them. In areas with only a small handful of knowledgeable makers whom others must depend on, far more is riding on an individual's choices. As Marit Helene explains, in some places people may feel they are "not allowed to change" anything, because they are afraid to lose a tenuous grasp on continuity. Marit Helene's assessments about gákti mirror those of Kari-Anne Pedersen about the policing of bunad: low levels of participation and shallow knowledge—historical or technical—tend to result in orthodoxy and less variation.

Despite the local celebration of creative innovation, many duojárat in Guovdageaidnu also express an interest in identifying and supporting a more general and consistent local "sense of style" that could also be interpreted as an investment in notions of continuity and renewal. Pål Norvall characterized fashionable change locally as more cyclical than a single linear progression toward increasing elaboration. Bold ideas flash on the scene and then filter through the community as they are personalized by each participant. One way of achieving a sense of continuity is the intentional recycling and reinventing of stylistically similar designs.

The origins of new patterns and the names of their inventors are well-known in Guovdageaidnu. A beloved pattern book, *Sámisk husflid i Finnmark* (*Sámi Handicraft in Finnmark*), was published in 1987 by Anny Haugen, the founder of a midcentury duodji school in Álta. For more than thirty years, she collected examples of area textiles (many now housed in museum collections) and recorded the names of the individuals or families responsible for originating their designs. Throughout the book, makers' names appear alongside detailed pattern instructions and diagrams, but the designs

themselves are named and known popularly by their locales. One of the patterns featured in Haugen's book, for example, is for a pair of mittens designed by Isak Mikkelsen Hætta and named for where he lived, Ávži.[46]

Ávži, meaning "ravine" or "gorge" in North Sámi, is a village located a short distance from the Guovdageaidnu municipal town center. First introduced by Elen Clemetsdatter (1841–1920), the Ávži mitten, with large fields of white, is less visually busy than most other festive styles associated with the Guovdageaidnu area, which tend to be covered all over in repeating zigzags, crosses, and diamonds in red, blue, and white. The most recognizable feature of Hætta's variation for Ávži is a single, large-scale red-and-blue diamond that fills the back of the hand. For his design, he borrowed the typical colors and pattern shapes of other Guovdageaidnu varieties but reinterpreted them in a way that stands out as unique. The combined elements of the Ávži mitten signal an aesthetic relationship with other local examples but particularize an even finer geographic association. For those who know its history, the design further evokes a particular family and a known inventor.

Knitting expert Erika Nordvall Falck has written that no two pairs of Sámi mittens are exactly alike, but traditional

Mittens in Guovdageaidnu style knit by Laila Keskitalo for Ávži Design, ca. 2018. Museum of International Folk Art, IFAF collection (FA.2019.20.2ab). *Photo by Addison Doty.*

May Toril Hætta wearing an *ulloliidni* (plaid wool shawl) she made in trendy turquoise. *Photo by Carrie Hertz, 2018.*

patterns develop because knitters choose to return to similar designs again and again, often to show affection and connection between different wearers, as when making mittens as gifts of friendship and betrothal.[47] Isak Mikkelsen Hætta's Ávži mitten is now considered part of local tradition, free for anyone to make, wear, and modify. Not surprisingly, however, the pattern holds special significance for his relatives.

May Toril Hætta married Isak Mikkelsen's great-grandson and moved from her childhood home in the Guovdageaidnu town center to Ávži, to live on the land that her husband's family has owned for generations. She was proud of their contribution to local knitting history. Like many people in Guovdageaidnu, both of May Toril's parents had also been knitters and taught her as a child. Once settled with her husband, she started her own knitting business from their home in 2007, naming it Ávži Design. Later, she expanded the business to include another Hætta family traditional art form by weaving the plaid wool shawls known as *ulloliinnit*.

An ulloliidni is a square twill shawl with fringe on all four sides, worn folded into a triangle. Red, blue, and green are the most common grounds, but now they are made in a great variety of colors. Unlike the Ávži mitten, an ulloliidni does not immediately announce a specific territorial association, having become one of the most recognizable sartorial signs of Sámi identity worn by many people on a daily basis. Through knitting and weaving, May Toril offers both highly localized and more broadly used Sámi dress for sale.

In May 2018, I visited May Toril at her weaving studio to learn more about the development of local style.[48] Ávži Design is run from a little red wooden building next to May Toril's farmhouse. When I arrived, she was just finishing a slate-blue shawl by hand-tying the fringe three threads at a time. Two more plaid shawls were in process on two side-by-side looms placed in the cozy two-room workshop. One had a white ground with grey and red stripes. The other was primarily blue and yellow, custom-ordered to match a Nordland bunad. The customer found May Toril, as many do, through her business site online. She also posts via Facebook and Instagram. May Toril has just started receiving orders for shawl styles associated with specific bunader, and she believes her work is attractive to these clients for being handwoven in Norway with high-quality Norwegian wool. Many of the shawls for bunader sold at area craft stores and boutiques can be handwoven, but they are often made abroad using materials with unknown provenance. Considering the history of targeting Sámi for not being "Norwegian" enough, it could be viewed as ironic that bunad shoppers now turn to a Sámi artist for more "authentic" accessories to wear with their "national costume." In May Toril's more positive estimation, however, it is a testament to her fine work and business acumen.

While handwoven shawls tend to be more expensive than outsourced or mass-produced alternatives, May Toril can rarely keep her shawls in stock, sometimes selling one right off her own shoulders. She charges around 2,500 NOK (about US$300) each and weaves nearly two hundred a year. With the higher demand and larger pool of customers for plaid shawls, she now concentrates mainly on weaving, leaving much of the knitting to her mother, Laila Keskitalo.

May Toril specializes in custom orders, providing more personalized options. Clients work with her to select color combinations that suit their needs and preferences. Many people like to carefully coordinate shawls with other elements of their outfits, owning several to choose from when getting dressed. Sometimes individuals bring in old, worn-out family heirlooms, hoping May Toril can copy them. As with patterned mittens, people often return to the same colors and designs to maintain bonds with others who may be separated from each other by time or distance. Other customers wish for unique or hard-to-find color combinations. May Toril has recently noticed a trend for turquoise and teal—bright colors that stand out at crowded music festivals popular with Sámi youth. She has also started introducing thin stripes of metallic or tinsel yarn to her own designs. The yarn is challenging to work with; it can only be added as weft. But she told me, laughing, "You *have* to have a little glitter!" "Glitter" as shorthand for a flashy aesthetic, she explained, is a celebrated characteristic of local style. Glitter is also the element of elaboration most often cited when outlining changes in the Guovdageaidnu gákti over the last hundred years, reaching a level of saturation achievable only with synthetic materials such as shiny fabrics and metallic threads and yarn.

May Toril believes that designs should be specific to a person, reflecting personal taste and creativity, but they will nonetheless display intimate connections with place through a general shared aesthetic. According to her, "People carry a local sensibility about colors and pattern with them." This sensibility may be difficult for individuals to articulate, except in broad terms (as in a popular preference for glitter) or in metaphors. I asked May Toril how she judged the aesthetic success of her own designs. She described the goal as "harmony," a feeling of mutual recognition between wearers and beholders that different variants look good together. They complement each other when placed side by side, not unlike seasonal collections from a fashion design house. They synthesize individual expression and novel combinations with local norms for beauty and craftsmanship. The ability to create new yet harmonious designs and outfits is a demonstration of one's belonging.

People develop expectations for a repertoire of designs, motifs, techniques, and color combinations through extended, careful observation. According to May Toril, people in

A *holbi* (skirt hem) being made by May Toril Hætta with rows of glittery ribbon and rickrack. *Photo by Carrie Hertz, 2018.*

Guovdageaidnu spend a lot of time looking at and evaluating what their neighbors wear. "People have good eyes here," she said. "They know quality. They see everything."

Gunvor Guttorm, a recognized expert of duodji philosophy, explains that aesthetic judgements are learned through extended looking and doing. "When one uses the term 'to have eyes' in the Sami languages," she writes, "it means not only that the individual has the physical ability to see, but also that the person perceives on a deeper level."[49] These intentional observations become the wellspring of visual and technical knowledge from which individuals draw inspiration when getting dressed or making their own clothes. As Marit Helene reasoned, the repertoire of Guovdageaidnu style is healthy and diverse, allowing individuals to find their own harmonious niche within the common idiom.

Recently, one of May Toril's customers had placed an unusual order, requesting an ulloliidni and mittens in black, red, and yellow. May Toril hated the idea at first. "It was so strange," she explained, referring to the unfamiliar combination of colors. When she completed the commission, however, she liked the results. As a practical measure, she always makes multiples of custom orders, since much of the labor of weaving

comes from the time-consuming task of warping a loom. A local resident in Guovdageaidnu town named Gerlinde Thiessen was immediately attracted to these remainders.

Gerlinde, a master goldsmith from Germany, moved to Guovdageaidnu in 1980 to work at Juhls and now lives in a committed partnership with a Sámi man.[50] She wears gákti when singing in the local church choir and for other special occasions. Gerlinde admitted, "I did not grow up with Kautokeino glitter," and she amiably described the local aesthetic as "less is poor." In contrast, she claimed a more minimal, earthy personal style and loved what she called the warm "German colors" of May Toril's black-red-and-yellow accessories. (These colors are indeed the same combination found on the national flag of Germany.) Gerlinde appreciates the way the shawl and mittens, worn with her Guovdageaidnu gákti, reflect the complexities of her layered identity belonging to multiple places and aesthetic traditions.

Localized style, like any purposeful style group, is built from a constellation of commonly used and recognized features—including conventional motifs, designs, patterns, silhouettes, and color combinations—that develop local significance through repetition and a history of intentional

personalization and redesign. Becoming a capable member of any community of practice involves mastering the necessary skills, understanding the history, and learning the common vocabulary. This pattern holds true for joining local communities of sartorial style, offering individuals a pathway toward self-expression that will be legible to and positively received by others. Referring back to Jason Baird Jackson's assessment of Native American dress, acquiring the necessary cultural knowledge to appropriately make, wear, and understand dress can be compared to acquiring a language. The more thoroughly you can understand its rules and patterns, the more you can adeptly, creatively, and compellingly articulate your ideas.

In a place like Guovdageaidnu, there are many conversant interlocuters, nurtured by generations of local artists, activists, and enthusiasts. In an era of globalized communications, however, a growing number of Sámi who do not live in Sámi-majority places can also find a spirit of camaraderie and validation for their sartorial self-expression through online social media platforms, such as Facebook, Twitter, YouTube, and Instagram. In their book *Sámi Media and Indigenous Agency*, Coppélie Cocq and Thomas A. DuBois have demonstrated that forms of social media can facilitate networking and political mobilization, enable the sharing and gathering of information, and intensify existing or compensate for absent face-to-face interactions. Being broadly public facing, these platforms can also insert diverse examples of positive image-making, potentially reducing the dominance of majority media messages about Sámi people.[51]

As one example, the Instagram page @samekofter has more than eleven thousand followers, who lavish positive feedback on the self-portraits of personal style that individuals submit for reposting. The moderator for @samekofter, Eileen Nergård, created the profile in 2016 because she felt isolated from gákti-related fashions as a Sámi woman living in Oslo. She wanted to create a site for finding and sharing inspiring photographs of Sámi dress, inviting others to contribute and comment.[52] The user-generated comments, written in a mix of Norwegian, Swedish, Finnish, Sámi, and English, praise not only the beauty and creativity of the clothes but also the people wearing them. Nergård and the commenters add strings of tags to more comprehensively identify the geographic associations of the garments as well as the various specialized, multilingual terms used for them. Digital sites like this one can visually hint at the multiplicity of Sámi lives, languages, communities, and styles often missed by majorities who may recognize only the ethnic markers of Guovdageaidnu as the archetypical Sámi persona.

Guovdageaidnu dress practices weathered Norwegianization through the self-sustaining presence of a confident Sámi majority. Local style, likewise, was held up as a widely recognized and celebrated model of ongoing Sámi cultural vitality, cemented by the political and artistic activism emerging from

Guovdageaidnu around the time of the Álta Conflict. Not all communities were so well positioned during the fertile period of the early Sámi movement. Their local revitalization projects, especially concerning local dress practices, advanced from very different starting points. To better understand this pattern, we now travel from the Finnmarksvidda plateau to the mountains and fjords of north Romsa.

North Romsa

Assimilation policies such as Norwegianization impacted Sámi communities all across Sápmi, but certain areas were particular targets for aggressive measures.[53] Ethnically and linguistically mixed areas along the northern coast of Norway were often identified as *overgangsdistrkter* (transitional districts) in special need of integration, which resulted in widespread discrimination and disenfranchisement.[54] The compulsory residential school system, especially, sewed rifts in families when children were prevented from using the only language their parents spoke and were indoctrinated with racist theories of Sámi subordination.[55]

Sámi education policies were designed not only to strip children of undesirable ethnic markers such as language and dress but also to transform "their overall view of themselves."[56] Rauna Kuokkanen, writing about Sámi boarding schools, argues that colonial education, regardless of other circumstances, produces remarkably similar results since all forms emerge from "the same ideology of assumed predetermined inferiority of non-European or non-western peoples and cultures." Students experience growing feelings of alienation from and ambivalence toward their own backgrounds that can ripple through generations, but they also develop subversive strategies for coping with, accommodating, minimizing, or challenging domination.

In Norway, Sámi boarding schools forbade ethnic dress in their effort to alienate children from former identifications. In Swedish boarding schools, conversely, Sámi children from herding families were required to wear traditional dress, branding the gákti as a stigmatized sign of their permanent exclusion from and subordination within Swedish society.[57] This history is heartbreakingly fictionalized in the 2016 feature film *Sameblod* (*Sámi Blood*), in which traditional dress plays a critical role in the plot. The young protagonist, Elle-Marja, repeatedly mortified and dehumanized by boarding school officials, racial biologists, and local townspeople, marks her intention to relinquish Sámi identity (as well as the family she has chosen to abandon) by burning her gákti. She then adopts cosmopolitan dress, renames herself Christina, and tries to pass as ethnically Swedish in Uppsala. Notably, however, her descendants eagerly reclaim their Sámi cultural inheritance and rekindle social cohesion, as seen when Christina's granddaughter accepts a gift of gákti from an estranged relative. While

Elle-Marja/Christina has spent a lifetime despising her origins and missing the embrace of community, future generations see potential beauty and pride in being Sámi, but they have also grown up in a new era transformed by the Sámi movement. *Sameblod* particularizes a common historical pattern.

In Norway, many Sámi facing prejudice as minorities in multiethnic coastal areas also chose to disavow a public Sámi identity, whether or not they assimilated in other private ways. This single coping strategy, nonetheless, contains an array of possible motivations. Some scholars have characterized this consequence of Norwegianization as part of a larger "ethnic cleansing" that erased an explicit Sámi presence from public life.[58] In fact, many oft-cited studies of midcentury census data reveal that the ethnic makeup of coastal areas seemingly shifted overnight from Sámi (or ethnically mixed) to Norwegian, though the same families continued to reside there.[59] Others took advantage of the evacuations after World War II to resettle in the south or emigrate to North America, where they could adopt new lives as Norwegian Americans.[60]

According to Brede Várráš, a resident of Romsa/Tromsø in his twenties, being Sámi "was a horrendous shame" when he was growing up.[61] Describing his childhood in a small community located on the Moskavuotna/Ullsfjorden, he said, "You really didn't show that you were Sámi. It was something you knew. It was something everybody else knew. Your neighbor was also Sámi . . . you could hear your neighbor joiking, but you didn't talk about it. It's like a whole village of gay people in the closet, and no one admits to being gay."[62] Brede remembers people gossiping about others being "*komager* Sámi," those who gave away their hidden ethnicity by wearing handmade leather shoes (the summer *gápmagat* known as *komager* in Norwegian). In recent years, wearing a newly reconstructed Ullsfjord gákti has become a way for Brede to publicly embrace Sámi identity as something worthy of acknowledging. Sometimes, strangers threaten or mock him when he is walking the streets of Romsa in gákti. "A lot of people would rather [Sámi culture] die out," he reasoned, "that every little bit of Sámi-ness would go extinct and everyone should buy a bunad. There's still a lot of people who think that way today." He describes his decision to dress in gákti as an act of defiance. As Kuokkanen points out, assertive self-expression is another powerful strategy for surviving and resisting victimization by demonstrating "a willingness to take a stand by drawing upon one's culture and tradition," the very culture and tradition that others have deemed inadequate.[63] This act is not only psychologically motivated but also future-oriented. "I know I carry shame," Brede explained. "I want any [future] children I have to be free of it."

In the wake of the Sámi movement, distinctive Sámi dress has increasingly been worn as a purposeful and in some cases defiant and healing expression of cultural pride. In core areas of inner Finnmárku with unbroken local dress practices, this swell of enthusiasm may have contributed to an elaboration and expansion of existing repertoires. In other places, however, especially along the coast of north Romsa, there was neither a living dress practice nor a living memory of one left. People began looking to the past for information and inspiration, often receiving assistance and encouragement from new institutions in Sámi-majority areas.

In 1982, the Nordic Sámi Institute in Guovdageaidnu (now affiliated with Sámi allaskuvla) organized a group of Coastal Sámi women to research historic dress traditions in the areas of Láhppi, Návuona, and Gáivuotna (Loppa, Kvænangen, and Kåfjord). In these ethnically mixed, mostly fishing and farming municipalities, there was little known about what Sámi residents had worn before Norwegianization, and in the aftermath of Germany's scorched-earth tactics during World War II, there existed scarce material evidence. The project leaders, Gry Fors and Ragnild Enoksen, compiled information from written descriptions, probate records, artist depictions, photographs, and the few extant garments found in museums and archives throughout Scandinavia. The resulting research was published in 1991 as *Vår folkedrakt: Sjøsámisk klestradisjoner* (*Our Folk Dress: Sea Sámi Traditional Clothes*). These efforts were quickly followed by reconstruction projects to develop new clothing designs based on the expanding body of research.

In 1995, a local organization, Gáivuotna Sámesearvi (the Kåfjord Sámi Association), introduced their reconstruction of an Ivgu gákti (commonly referred to in Norwegian as the *Lyngenkofte* and occasionally as the Gáivuotna or Kåfjord gákti) in a pamphlet by Lene Antonsen and Henrik Olsen titled *Sjøsámisk klesbruk i gamle Lyngen* (*Sea Sámi Clothes in Old Lyngen*).[64] Mary Mikalsen Trollvik wrote passionately in a preface for the pamphlet, "All Sámi areas with self-respect have gákti today, so why not us?"[65] In many ways, the pursuit of local dress has served as a statement of purpose to join the larger political and cultural movement.

Association members Eva-Britt Varsi and Berit Sivertsen sewed the first man's and woman's Ivgu gávttit for local representatives to wear to a convening of the Sámi Parliament. They were assisted by many others. Mary Mikalsen Trollvik made the woman's characteristic hat (*gobbagahpir*), and Lene Antonsen wove the ribbon that wraps around the crown of it. Gunvor Guttorm and Ann Ingebjørg Svineng from Sámi allaskuvla added some final touches. In a relatively short time, the clothes have been adapted and personalized into a great variety of forms.

A typical woman's dress is long and straight with two appliquéd stripes along the shoulder seams, the cuffs, and sometimes the hem. The shoulder stripes are most often red-over-yellow

A ferry dock on the Ivgovuotna/Lyngenfjord in north Romsa. *Photo by Carrie Hertz, 2018.*

but can be rendered in many dark-over-light combinations, such as green and silver, blue and grey, or black and white. Currently, it is fashionable to further elaborate the stripes by outlining them with thin rows of multicolored or glittery couched cords. Neck openings may be filled with separate decorative collars called *raddeleahpit*, similar to the *sliehpá* of typical Lule Sámi dress. As with other styles of Coastal Sámi clothing, the Ivgu gákti is decorated with layered and appliquéd geometric shapes. Numerous variations of diamonds, arrows, and crosses are created from small layers of stiff wool punched at the center to reveal a glimmering circle of mica. Mica appliqués are also featured on gorgeous examples of raddeleahpit and wide leather belts. Men's tunics, like those from other North Sámi areas, are shorter with stand-up collars but otherwise follow the same patterns for decoration as women's.

The cultural revitalization efforts of Coastal Sámi are sometimes met with skepticism or scorn, not only by neighbors but also by other Sámi groups, who dismiss their creative search for identity as "new Sámi" or "plastic Sámi."[66] However, in the growing political and cultural awareness that followed the advent of the Sámi movement, many young Coastal Sámi found themselves in ambiguous positions, uncovering family secrets. As one young man told researchers Paul Pedersen and Arvid Viken, "it is very painful when you have to go through such a process (change identity). When you discover that you aren't who you think you are, and that someone (your parents) have lied to you in a way."[67] Conversely, others like Brede grew up knowing, learning about, and appreciating Sámi cultural practices but felt ashamed to express them publicly. Still others realized only later that their private family traditions could be counted as culturally Sámi, since such ethnic origins had been actively forgotten. Many elders still spoke Sámi at home, cooked typical Sámi meals, maybe wore shoes decoded as Sámi, but denied being Sámi. The general sense of confusion that youth felt—being told they were Norwegian but recognizing Sámi ethnic markers in their families—has been described as contributing to a sort of "neither/nor" identity that left individuals feeling destabilized and unrooted.[68] We understand identification as dynamic and situational, a process that is both internal and ascribed by others. As perceptions and comprehension about what it means to be Sámi have shifted, so too have personal and ascribed identifications.[69] Over the past few

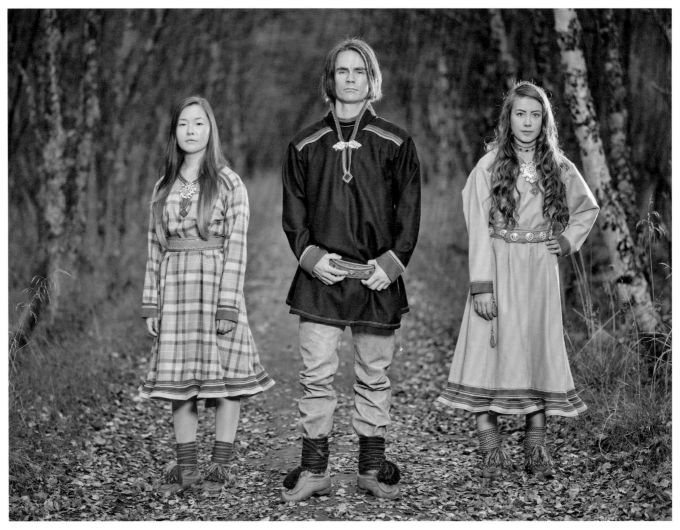

Designs for Ivgu gávttit by Jorunn Løkvold, 2010. *Photo by Ørjan Marakatt Bertelsen, courtesy of Jorunn Løkvold.*

decades, the ethnopolitical hierarchies of coastal areas have been reordered, with some communities counting themselves as Sámi majorities again.[70]

Coastal Sámi dress practices, too, had been largely forgotten, but as with many reconstructed bunader, local garments from the past can be documented and revived. To learn more about the ongoing revitalization of Coastal Sámi dress, I visited duojár Jorunn Løkvold at her studio in Olmmáivággi/ Manndalen, a village of about a thousand residents on the Ivgovuotna/Lyngenfjord in Gáivuotna municipality.[71]

Jorunn was raised on a farm in Olmmáivággi. She grew up speaking North Sámi and now teaches it at a local school. More than half the children in Gáivuotna receive Sámi language instruction as part of their public education today.[72] Jorunn's mother was a talented seamstress and supplemented the family income by making summer gávttit for herders who migrated their reindeer from inland to the coasts of Romsa every year. There is a long history of similar exchanges between

permanent Olmmáivággi residents and migrating mountain Sámi. Many local women prepared skins, knitted, sewed, and wove the characteristic striped blankets (*ránut*) used by mountain Sámi as coverlets or to cover lávvut.[73] When younger generations first began questioning their own origins in the 1980s, they had no local models of Sámi dress, but they had familiarity with inner Finnmárku. A few locals adopted the clothes of Guovdageaidnu, suggesting that it may have served similar functions for them as the *Nasjonaldrakt* based on Hardanger dress did for many Norwegians. Old photographs from the area reveal women dressed in the miniskirted gávttit popular in Guovdageaidnu at the time, paired with tall, store-bought Kero-brand boots.

By 1990, Jorunn and a group of other locals had formed Gáivuotna Sámenuorat (Kåfjord Sámi Youth). Their mission was to provoke questions about Sámi identity through art and to break local silence.[74] "It was like a wave coming," Jorunn said of the enthusiasm for cultural renewal that gained

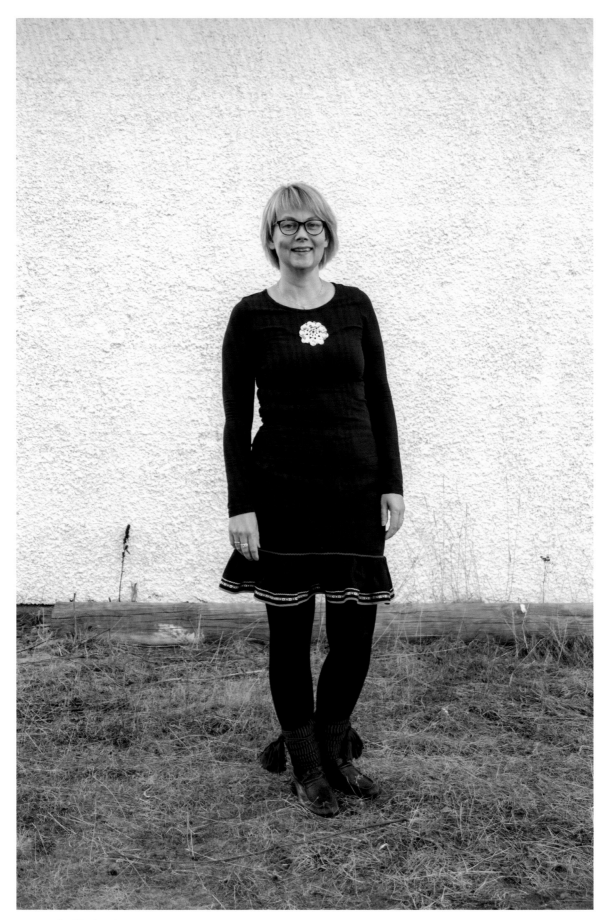

Jorunn Løkvold. *Photo by Carrie Hertz, 2018.*

momentum through the activities of the Sámi movement, then continued to ripple: "We helped start a new wave, I think." They founded the Riddu Riđđu festival, which has become a phenomenal, international success for local Sámi cultural and political mobilization, connecting Sámi communities from all over Sápmi with other Indigenous groups worldwide.[75] First held in 1991, the festival started as a barbecue and rock concert for about twenty young people. It quickly transformed into a major, weeklong event befitting the meaning of its name, "Storm from the Coast." Today, Riddu Riđđu welcomes more than thirty-five hundred participants for a wide variety of educational programs, workshops, seminars, film screenings, and exhibitions, alongside live music and dance performances, including the most popular performing artists in Sápmi, such as Mari Boine, Sofia Jannok, or Maxida Märak.[76]

From the beginning, the organizers promoted Riddu Riđđu as a place for championing Sámi aesthetics and sensibilities about style. The festival is often cited as the public platform needed to boost the new reconstructions of coastal gávttit, leading to widespread adoption among young people.[77] The same year the Ivgu gákti was debuted in 1995, the festival hosted a workshop on how to make it. "Now everyone seems to have one," Jorunn said.

With audiences drawn from all over Sápmi and beyond, Riddu Riđđu has become a public runway for new ideas in Sámi fashions as well as for Indigenous ethnic styles from around the world. For fifteen years, photographer Mari Karlstad and folklorist Marit Anne Hauan from the Tromsø University Museum visually documented the dress of Riddu Riđđu audiences for a traveling exhibition called *Following Arctic Fashion*.[78] Their images attest to the expansive range of Sámi styles, displaying a growing number of recognizable gávttit, creative ensembles fashioned around ethnic markers such as luhkat and ulloliinnit, and clothes made by up-and-coming Sámi fashion designers.

Jorunn wore the Ivgu gákti for the first time when she was twenty-five years old, the same year it was introduced. Since then, she has joined local efforts to deepen historical knowledge of local dress practices as well as introduce new elements to an emerging repertoire of clothes. When we met in the spring of 2018, Jorunn was halfway through a three-year scholarship funded by the Norsk håndverkinstitutt (Norwegian Handicraft Institute) to study and develop new models and methods for producing Coastal Sámi clothes. She understood this work as a continuation of earlier efforts and has collaborated with many of the artists from the original reconstruction groups.

Drawing from her close examinations of Coastal Sámi material culture, Jorunn has begun developing new garments, such as lightweight summer gávttit, luhkat, and a type of pullover sheepskin fur jacket known as a *dorka*, all with characteristic local embellishments of appliquéd mica. In a blog chronicling her progress, Jorunn has written about experiments with raw materials and new designs, including learning to harvest mica in the mountains and adapting nineteenth-century belts from museum collections, such as the beautiful wide varieties with appliquéd wool and mica ornaments trimmed in leather known as *hearvaavvi* or *riebangolleavvi*.[79]

For one belt from nearby Ákšovuotna/Øksfjord discovered in Oslo's Norsk folkemuseum, Jorunn first created a perfect copy using only the tools and techniques she imagined available at the time it was made—measuring with her fingers and cutting with a blade. Then she made additional variations, modifying the motifs, colors, layout, and materials, as well as trying different time-saving methods of construction, such as first gluing down the appliquéd shapes of mica before attaching them with a sewing machine in an attractive zigzag stitch.

Jorunn takes her adaptations and experiments seriously. Reflecting on a sense of accountability, she admitted, "I'm not sure about everything, because we can't know everything." For example, no one knows for sure if the nineteenth-century belts she has been studying were meant for men or women. Unlike with bunader, however, most locals are not looking for a repertoire built from perfected historical accuracy; instead, they are looking for a more generalized feeling of cultural security found in past precedent, a starting point. In a year-end report for her fellowship, Jorunn wrote, "My goal is to be confident in the craft."[80] While she seeks her own personal style, she believes it should emerge from a close awareness of local models from the past as part of a larger restorative healing process. Coastal reconstruction projects not only attempt to uncover and reclaim broken dress traditions; they also endeavor to recreate the conditions for a living practice that will change and grow, that will be responsive to fashions, and that will be transformed as it passes from person to person and generation to generation. In many ways, locals are looking to the creative vitality enjoyed in Guovdageaidnu but searching for their own version of local style for the coastal region.

In this period of revitalization and "recovered continuity," people are still developing a consensual base of knowledge for forms, techniques, aesthetics, and design.[81] This pursuit requires a certain level of speculation, creative adaptation, experimentation, and community negotiation that individuals like Jorunn understand as a social responsibility. "It's a little bit scary," she told me, "to take some of the decisions and to do things. What I make, people will do after me. It will be a model for the rest." These decisions can weigh heavily on some people. "You have heard of the bunad police?" Jorunn asked. "We have that, too," but she believes that people around Olmmáivággi are more encouraging of risk-taking than critical.

As Brede's personal experiences suggest, coastal areas—the overgangsdistrkter—are still transitioning. Beate Hårstad

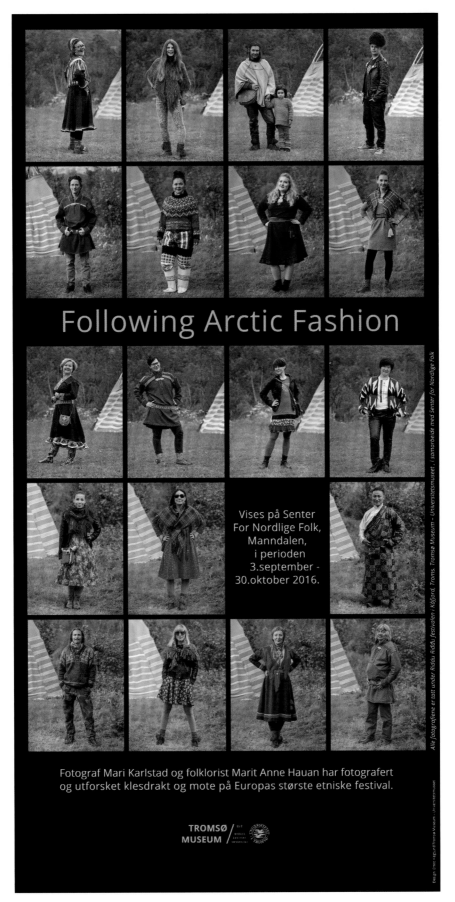

Poster for *Following Arctic Fashion* © *Mari Karlstad and Marit Anne Hauan, UiT the Arctic University Museum of Norway (UMAK).*

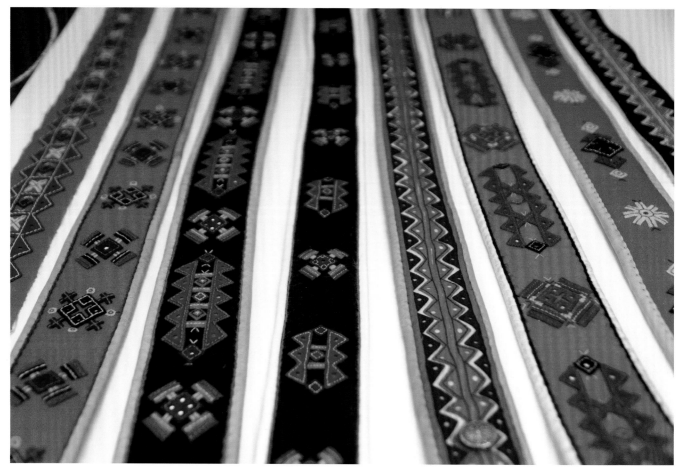

Coastal belt prototypes made by Jorunn Løkvold based on museum collections. *Photo by Carrie Hertz, 2018.*

Jensen, a young woman from Romsa, was quoted in the newspaper *Dagbladet* as saying, "If it has taken 100 years to norwegianise the Coast Sámi, then it will perhaps take another 100 years to make us Sámi again."[82] Areas with supportive majorities, whether because of a shared Sámi identity or an accepting multicultural ethos, tend to have the strongest or fastest-developing local dress practices.

These reconstructions and innovations continue across not only Sápmi but also North America, following an activist wave that continued right across the Atlantic Ocean. In the 1990s, grassroots efforts in the United States and Canada, known as the North American Sámi Reawakening, began raising awareness about Sámi immigration, helping descendants reconnect with lost relatives in Sápmi. Participants even developed new North American gávttit to serve those unable to faithfully pinpoint their families' geographic origins.[83]

Assimilation politics, like Norwegianization policies, have left residual feelings of shame among some minorities and ignorance or arrogance among some majorities, and this ambivalence perpetuates historic inequities that fuel contemporary racism and neocolonial processes. Rather than bringing groups together under a single banner, a single national flag,

they have more often further divided them. Increasingly, people are determining that "the universalist aspirations of Western modernism are no longer tenable."[84] They demand we rethink the old dichotomous hierarchies of majorities and minorities, centers and peripheries, inclusions and exclusions. For Indigenous peoples around the world, resistance is waged on many fronts from the pragmatic to the ontological.

Since Johan Turi published his personal account in 1910, illustrated with his own watercolors of daily life, there has been a long and rich history of Sámi multimedia artworks created explicitly for the purposes of combatting stereotypes and sharing personal perspectives of Sámi culture and collective struggles.[85] Turi wrote that he hoped his book would contradict "those who want to lie about the Sámi and claim that only the Sámi are at fault when disputes arise between settlers and Sámi in Norway and Sweden." As Thomas A. DuBois explains in the afterword to his recent English translation of *An Account of the Sámi*, Turi is artistically adept in considering his diverse audiences, both inside and outside his immediate experience, with the hope of not only persuading remote but powerful policymakers in the south but also creating something with pleasing resonance for other Sámi.[86]

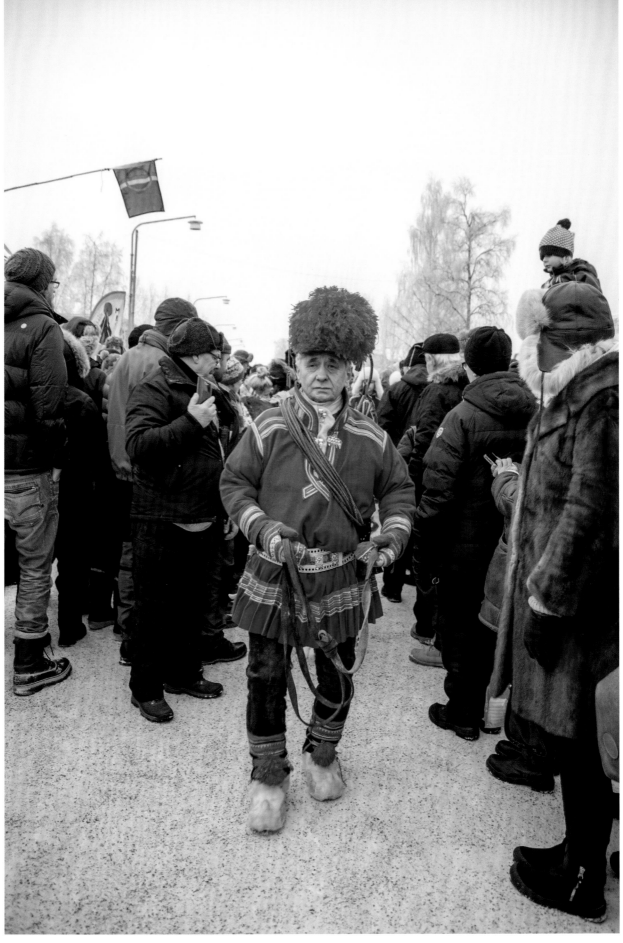

Per Kuhmunen dressed in Gárasavvon gákti and leading the annual reindeer parade during the Winter Market in Jåhkåmåhkke.
Photo by Carrie Hertz, 2017.

Purposeful dressing has simply been one of many creative tools in a long artistic tradition for fashioning belonging and resistance, but it remains one of the most powerful mediums for self-definition. Worn against the skin but facing the world, dress is the "social skin."[87] Even separated from human bodies, it evokes their shape and presence. Clothes impact our daily experiences in the world and our understanding of who we are. These very reasons make them a target for assimilation. Since people's dress has historically been used to identify and categorize them, it can also be harnessed by those individuals for more emancipatory purposes to contest, critique, and comment on the representations imposed by others. "There is a difference," Anne Heith argues, "between the Othering of Sámi people characteristic of colonialism on the one hand, and the use of ethnic symbols in Sámi cultural mobilisation on the other."[88] The difference, of course, is agency. Positive acts of self-representation can further prop up demands for self-determination.

In this final section, we visit four politically engaged artists living and working in Jåhkåmåhkke/Dálvvadis/Jokkmokk, Sweden, who treat Sámi dress as a medium and subject for art, design, and liberation.[89]

The Art and Politics of Appearance

Jåhkåmåhkke, a small town in Norrbotten county, has become a center for Sámi art and activism. Like Guovdageaidnu, it is home to influential cultural institutions, including Sameslöjd-stiftelsen Sámi Duodji (the Sámi Duodji Institute), Samernas utbildningscentrum (the Sámi Education Center), and Ájtte Museum, considered the principal museum of Sámi heritage in Sweden.[90] The downtown supports a variety of Sámi artisanal shops and boutiques, fashion designers, artist studios, and craft cooperatives selling mittens patterned with Sámi flag designs. Every February, tens of thousands of visitors attend the Winter Market in Jåhkåmåhkke, a weeklong festival that includes artist booths, exhibitions, fashion shows, gallery openings, film screenings, concerts, lectures, and reindeer races held on a frozen lake at the edge of town. While the streets are lined with vendors selling everything from fur pelts and screen-printed T-shirts to sour candies and sizzling reindeer burgers, indoor spaces, both public and private, are devoted to displaying exquisite works of duodji, including an array of handmade items of dress and adornment. The festival serves both Sámi and tourist audiences.[91] Like an annual reunion, Sámi from all

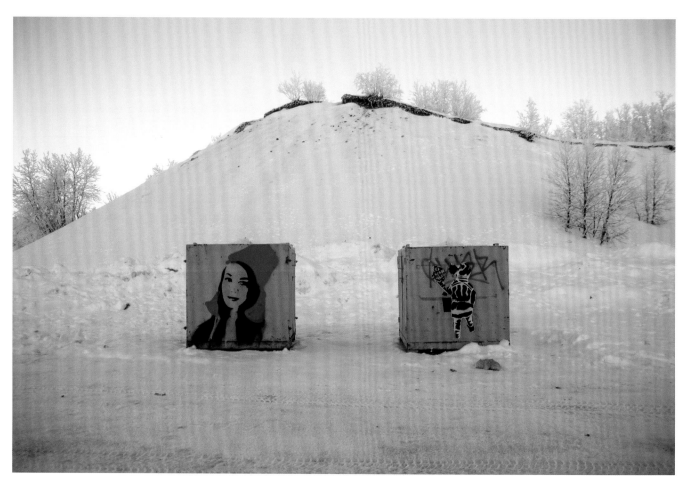

Graffiti at a roadside pull-off on RV92 between Guovdageaidnu and Kárášjohka. *Photo by Carrie Hertz, 2017.*

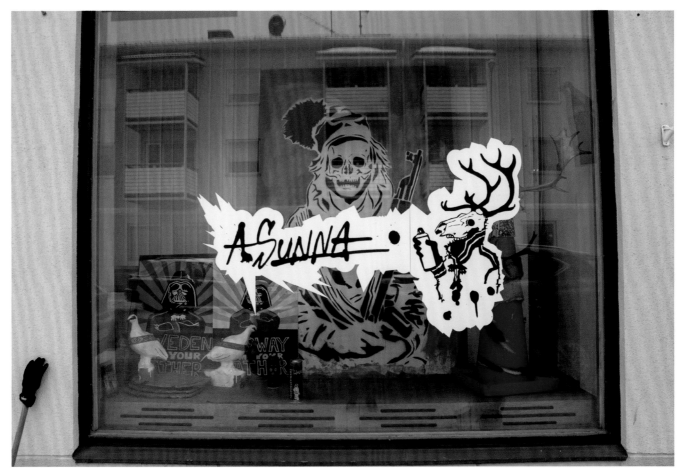

Anders Sunna's studio. *Photo by Carrie Hertz, 2017.*

over Sápmi as well as from southern and foreign cities come dressed in their finest and most fashionable.

Surrounding Jåhkåmåhkke, the landscape is dominated by forests of slim white birch trees laced with lakes and rivers. Two major rivers, Luleälven (the Lule) and Lilla Luleälven (the Lesser Lule), flow through the municipality, meeting at Vuollerim, just south of Jåhkåmåhkke. These water sources are the most heavily tapped for hydroelectricity in all of Sweden, with accompanying dams and power plants. This forested and ore-rich area has also been the site of aggressive timber and mining projects, transforming the landscape, reducing reindeer grazing habitats, and contributing to pollution and climate change in an ecologically fragile region.[92] Just a few hours' drive north, Giron/Kiruna presents a well-known case of Sweden's destructive energy policies, as the entire town is being relocated two miles east to avoid sliding into a gaping sinkhole caused by the world's largest underground iron-ore mine.

For decades, Jåhkåmåhkke has cultivated activist networks, much of it employing creative demonstrations, pop-up displays of protest art, graffiti, and other interventions involving performance and spectacle to garner attention and support for decolonial actions.[93] The town continues to host a significant scene of politically engaged artists. We conclude this chapter by profiling four of them.

Anders Sunna

Anders Sunna works in a wide variety of media. He is perhaps best known for his public wall murals, graffiti performance art, multimedia installations, and collage painting but also for uncredited stenciled graffiti seen throughout Sápmi. In the alleys of Giron or on trash bins at highway pull-offs, one might encounter Anders's stenciled image of a man shown from behind about to lob a bomb labeled "To Colonialism." The widely spaced vertical stripes on the back of his tunic and the oversized pompom on his hat evoke Anders's own Čohkkiras/Jukkasjärvi gákti.

In May 2018, I visited Anders at his studio in downtown Jåhkåmåhkke.[94] Propped up in a window display to the left of the entrance, a stenciled plywood board depicted a skeleton dressed in Čohkkiras gákti holding an AK-47. Anders's signature, splashed across the window glass, appears to have been spray-painted by another skeleton, this one a reindeer with a full rack of antlers, also wearing a man's Čohkkiras gákti.

Anders's artwork is explicitly political, targeting Swedish institutions, politicians, and painful histories of forced relocations, race biology theory, and eugenics. He was born in Čohkkiras and grew up in a reindeer-herding family with ties to Kieksiäisvaara in Tornedalen. Mired in a multigenerational struggle to reclaim lost herding rights that has lasted more than forty years, Anders connects this personal history to larger collective battles against marginalization, stigmatization, and state interventions that he believes have directly led to infighting among Sámi in Sweden. "My family," he explained, "has been fighting against the Swedish government since 1971, and it's still going on." After the passage of the Reindeer Herding Act that year, the Sunna family entered into a protracted dispute with local and state authorities over the new terms, leading to the loss of their earmark (for officially identifying reindeer ownership) and their village membership in the Sattajärvi *sameby* (a herding administrative unit). According to Sunna, the family was forcibly removed from their lands, was physically prevented from accessing pastures, and lost many of their reindeer to poaching. In Sweden, herding rights are tied to sameby membership, so the now-unaffiliated Sunna family continues as "guerilla herders."

"My family has been blacklisted," Anders said. "Nobody has the right to own reindeer. The only right we're really having is [to have] the gákti on. Everything else has been taken away." For Sunna, the loss of herding rights has been experienced as a loss of identity, an identity connected not only to cultural lifeways but also to a sense of community cohesion. He believes the constant carving up of lands, pushing herders into smaller spaces to compete for resources, and the state-directed interventions into herding management and administration have, in his experience, eroded Sámi solidarity.[95] The continued use of his gákti, a palpable sign of Sámi identity and territorial affiliation, forces recognition of his personal loss and family claims. In this way, he said, wearing gákti is "a hidden activism," a silent and subtle protest "without having your fist up." The clothes also help Anders resist his feelings of exclusion from other Sámi. "If you're wearing it together," he explained, "you feel we belong together. It's [about] making your self-esteem better."

Anders's family is only one of hundreds that have become entangled in state interventions and displacements over the last century. In the first half of the twentieth century, for example, herding families and their reindeer were forcibly removed from the Čohkkiras and Gárasavvon/Karesuando areas. Many relocated to the region around Jåhkåmåhkke. In an oral history project with Sámi around Jåhkåmåhkke, one participant, Nils Tomas Partapuoli, described those displaced, once separated from relatives and ancestral lands, as becoming "the living dead," a moniker that resonates with Anders's common iconography of living skeletons dressed in gávttit.[96]

It is not uncommon for newer generations to continue wearing the clothes that proclaim ongoing connections to these homelands as a form of "hidden activism," in Anders's words.[97] Perhaps most famously but still unrecognized by many tourists, Per Kuhmunen annually leads his family members in a reindeer parade (*renrajd*) through the crowds of the Winter Market. Though considered a much-anticipated highlight of the Jåhkåmåhkke event, most of those parading are dressed incongruously in gávttit from Gárasavvon.

The Čohkkiras gákti features prominently in Anders's artwork. A popular poster and T-shirt made from one of his paintings shows a gákti-clad Darth Vader with the caption "Sweden, I'm your father," a playful affirmation of Sámi indigeneity, a criticism of the way Sámi can be portrayed as "bad people," and a warning against pushing Sámi "to the dark side."

In *These Colors Are Not Running Away* (2018), a mixed-media collage on plywood board, three figures—a reindeer skeleton flanked by two human skeletons, all dressed in Čohkkiras gávttit—are shown against a snow-white background. Family photos and images of nature are hidden in the fabric of the clothes, endowing them with notions of continuity and kinship. The bottom edge of the board is hand carved in a traditional duodji pattern that might typically appear scrimshawed on the antler sheath of a knife, a type of art Anders also practices. While the central figure stands square, staring eyeless at the viewer, the others turn inward toward the reindeer, protectively. The reindeer is the center of Sámi life, Anders explained. Everything depends on it: "The reindeer, it's where you get your food, you get your clothes. It's like a multi-animal. You get everything from it." Cultural life and traditional handicraft depend on reindeer: "The people and the reindeer are the same." Their fates are intertwined.

While the protagonists of Anders's paintings commonly wear the gákti associated with his homeland, Swedish authorities are more often shown in outfits with Sam Browne belts reminiscent of Nazi uniforms, but their red armbands bear the coat of arms of Norrbotten county. Norrbotten's heraldry doubles the images of a reindeer and a giant with a club; in Anders's rendering, one of the giants has beaten his neighboring reindeer to death.

Though no antagonists appear in *These Colors Are Not Running Away*, they are implied. The title is a play on the bombastic national slogan "These colors don't run" commonly used in American politics and popular culture. The colors refer to both the integrity of the national flag's symbolism (its colors can't be washed away like running dye) and a patriot's willingness to stand ground and fight. The main figures, as living skeletons, manifest a prediction made by Anders's grandfather, who told him, "If you as a Sámi people are going to get rights against the government, you have to live for two hundred years. And if you live for two hundred years, you'll look like

Anders Sunna. *Photo by Carrie Hertz, 2018.*

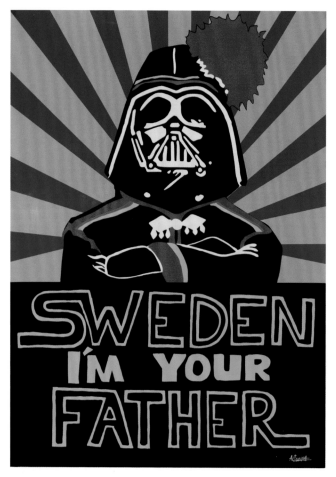

Sweden, I'm Your Father, poster of painting by Anders Sunna, 2015. Museum of International Folk Art (P.2018.2.3). *Photo by Addison Doty.*

appearance—physiological and sartorial.[98] Not all such attention, however, was neutral curiosity.

In the late nineteenth century, propelled by social Darwinist theories of cultural evolution and the development of physical anthropology, museums and universities began anatomical collections for surveying racial "types," theorizing, for example, that humans could be classified by the shape of their skulls or other features.[99] In the 1920s, scientists focused on examining, photographing, and measuring human bodies and remains for the purposes of promoting preconceived racial hierarchies. "Racial hygiene" eugenics programs followed with forced sterilizations across Scandinavia to remove "degenerative" influences from the population.[100] The most well-known center for eugenics in Sweden, the National Institute for Racial Biology at Uppsala University, operated from 1922 to 1958. Despite being widely considered a shameful part of Sweden's past, many of the remains collected during these periods are still housed at Uppsala University and elsewhere. A 1999 documentary, *Oaivveskaldjut* (*Give Us Our Skeletons!*), traces this history and follows Niillas Somby, one of the activists who went on hunger strike during the Álta Conflict, as he tries to reclaim the skull of his ancestor.[101] Since 2007, the Swedish Sámi Parliament has registered claims for the repatriation of human remains from Uppsala and other national collections. With some notable exceptions, few have been returned for reburial.[102]

Anders's use of skeletal imagery, especially the human and reindeer skulls poking out of gávttit collars, is a provocative reminder of this injustice and the dubious racial stereotyping that continues often unwittingly in majority depictions of Sámi people.[103] It further satirizes the notion that an authentic Sámi culture only exists fossilized in the past. He sees his art as a "weapon" and his choice to wear traditional clothes as silent protest against such hegemonic representations. "In media," he said, "you're usually not seeing Sámi with a gákti painting with a spray can. Our culture isn't a museum culture. It's important to show you're still alive, that you're not in a museum." In Anders's work, the past, present, and future all live together, haunting each other into action.

Jenni Laiti

I first contacted Jenni Laiti because, at the time, she was the only named spokesperson for the anonymous artist collective Suohpanterror.[104] The group formed in 2012 to engage in diverse political actions described by some members as "art-shaped politics" meant to expose the ongoing territorial and cultural colonialization of Sámi people across Sápmi.[105] With members from across the region, the collective is best known for their "propaganda posters" that circulate as part of traveling exhibitions, guerilla pop-up displays, and more commonly internet memes shared on Instagram, Facebook, and other

that, probably. Your problems will haunt you forever and even your relatives. It will go on all the time. You'll never get rid of it, so you have to stand up and fight." Resistance is something each generation owes to those who came before and those who will come after.

The number of figures is also significant. Three, influenced by Sámi mythology, is a number of completeness and political power. A person alone can do nothing; a crowd without shared purpose is ineffectual. As with maintaining a healthy herd, either too few or too many is unsustainable. To Anders, three is the number that empowers "standing up for yourself." Though otherwise stripped of distinction, these three skeletons still brandish the symbols of Sámi identity in the form of colorful gávttit. They are dressed for eternal struggle.

Skeletons, a common refrain in Anders's work, are more than symbols of multigenerational resistance; they also conjure up the specters of race biology and eugenics research that was conducted on Sámi individuals and other minorities in the early twentieth century. For centuries, artistic, ethnographic, scientific, and amateur representations of Sámi people demonstrated a fascination with their "exotic"

These Colors Are Not Running Away, mixed-media painting by Anders Sunna, 2018. Museum of International Folk Art (A.2020.13.1). *Photo by Carrie Haley.*

social media sites. Their name, meaning "lasso terror" in North Sámi, references one of the most common instruments of reindeer herding, indicating that they will fight with whatever tools they have at hand (including both traditional knowledge and global pop culture) with a peaceful yet disruptive method often described as "decolonial art" or "culture jamming."[106]

One of Suohpanterror's most famous propaganda posters, for example, shows a woman in Guovdageaidnu dress in a Rosie the Riveter pose and labeled *Suohpangiehta*, or "lasso hand." Jenni told a reporter in 2015, "Everyone recognizes the image and where it comes from. It's American, it's feminism," but she said that to Sámi it also appropriates notions of American soft power, rebel glamour, and military might. It means, "This is who we are and we can do it."[107] And Sámi can do it by co-opting and adapting all the cultural resources at their disposal, including Sámi occupational tools and sartorial symbols combined with American nationalistic war iconography. The point is to Indigenize commonly shared visual media, reinterpreting it "through the lens of Sámi aesthetics" and asserting alternative ways of seeing and understanding the imagery that circulates broadly in majority society.[108]

Suohpanterror's posters regularly use dress to raise questions about contemporary Sámi identity. One poster depicts a young man self-referentially dressed in a Suohpanterror T-shirt and thermal underwear surrounded by a selection of tabbed clothing and accessories in the style of classic paper dolls. His wardrobe includes a slim, tailored suit and briefcase on one side and a man's Guovdageaidnu formal ensemble on the other. He also has the choice of a ski mask, a club wrapped in barbwire, and dynamite—perhaps for the purposes of disrupting a mining project. The man is identified as "Isak-Mahtte / a university professor, Sámi activist, married (notice the square buttons)." The portrayal reinforces the meaningful in-group communication of Sámi dress (square buttons on Guovdageaidnu belts signal marital status), as opposed to the silent hegemony of an anonymizing suit. Yet it also hints at the complexity of balancing multiple identities and allegiances as a minority within a dominant and domineering majority culture. Must a single self be exchanged for another as circumstances demand, like matching clothes to an occasion? Is there a public stage to be traditional, Indigenous, educated, anticolonial, masculine, and cosmopolitan simultaneously? The gákti is personally meaningful within the embrace of the communal, but its visibility is also highly politicized.

Another poster makes the connection between dress and politicized identity explicit. Mimicking the style of public warning signs, the image is divided into two frames. In the left frame, two stick figures stand side by side on equal footing: one the archetypal and unadorned, the other wearing gákti. On the right side, the unadorned figure shouts "whoops" as it knocks

Environmental art installation by Anders Sunna, Sámi Center for Contemporary Art, Kárášjohka. *Photo by Carrie Hertz, 2017.*

the other out of the frame. Underneath, the scene is labeled *Problem . . . Solved*, suggesting the intended results of ethnonationalistic assimilation policies that pictured Sámi people as a problematic Other in need of fixing. As Suohpanterror's work illustrates, the marked difference of Sámi identity, made visible through dress, is both the justification for exclusion and the base of power for collective opposition. The common use of English language in Suohpanterror propaganda posters further hints at the wide audiences they hope to reach with their visual contradictions of globally circulating misinformation about Sámi people. The posters nonetheless reaffirm common Sámi experiences, drawing from insider cultural knowledge to create humorous or damning visual and linguistic juxtapositions between minority and majority realities.

In addition to her work with Suohpanterror, Jenni is an accomplished artist and activist in her own right with a similarly rich body of work centered on Sámi dress. In 2018, Jenni invited me to visit her home in a quiet neighborhood of Jåhkåmåhkke. Throughout the house, stunning, intimate images

of the family engaged in reindeer herding fill the walls, taken by Jenni's partner and well-known photographer Carl-Johan Utsi. One small room just off the kitchen is furnished with nothing but a swing, the kind more commonly encountered hanging from a sturdy tree branch but suspended here from hooks in the ceiling. These features of Jenni's home hint at aspects of her personality: she is interested in notions of traditional continuity and Sámi cultural identity, but she is also eager to question conventions.

Jenni grew up in Anár/Inari, on the Finnish side of Sápmi, and defines herself as an "artivist/craftivist": "I don't do art just for art," she emphasized, "but use it as a tool in my activism." In her estimation, art and art-making should play an active role in improving the lives of others. "My profession," she said, "is traditional craftmaker. I'm coming from a traditional craft family where the whole family is craftmakers. So that's my crown. And at the same time, I got this really political upbringing." For Jenni, wearing gákti and practicing duodji are the media through which she understands herself, her inheritance, and

her intentionality. Insofar as making and wearing gákti intentionally sustains Sámi visibility, subjectivity, and agency, getting dressed becomes a political act. Jenni clarified, "I don't think that everybody [thinks of it as] a political choice when they have their gáktis on, but for me, it's all about politics."

Jenni draws inspiration and strength from global Indigenous rights and environmental justice movements. Like the leaders of the 1970s Sámi movement, she looks to the decolonizing activism of Native Americans and other groups, aligning herself in a worldwide struggle that is potentially empowered by global flows and virtual communities as much as by locally constituted identities. She fuses these influences and interests, local and global, reinforcing both in the process. Many minority groups realize that creating these far-reaching networks will be key to generating enough collective will to meet any large-scale challenges.

In 2015, Jenni participated as the starting runner in a transnational relay, *Run for Your Life*, raising awareness about global climate change. Over twenty days, around nine hundred participants handed off a single rock between each runner, starting with Jenni in Giron and ending in Paris with a Global Climate March, timed to coincide with the 2015 United Nations Climate Change Conference. A promotional video created for the event shows Jenni advancing through a veil of snow, bundled in gákti and patting the large silver riskku pinned at her chest in the rhythm of a heartbeat. In a voice-over, she states, "There is no change without protest. The only way to change things is to resist, protect, react, mobilize, and challenge."[109] Jenni believes that Indigenous peoples must fight against not only the ongoing destruction of their environments and the colonization of their lives but also their minds, so they may see beyond hegemonic patterns of thought that limit one's ability to fashion more just futures. Jenni seeks out diverse insights to pull into her own understanding of Sámi epistemologies and aesthetics, especially the philosophies she finds embedded in the realm of duodji practice.

Raised in a family of duojárat, Jenni has benefitted from the creative and attentive teachings of her large and talented family. Generations have practiced and taught duodji professionally. She described a strong sense of respect for and accountability to the teachings imparted by her kin. She explained, "We had this in our family, a strong philosophy of how you make duodji. And *sharing* is one of our basic values. To share the knowledge. When you're a duojár, a craftsperson, you're not working for yourself. You're working for others. That's really important for my people. We work for others. We dress others for their well-being." In fulfillment of her family's mission, Jenni makes beautiful items of dress for herself and her family to wear, but she also creates clothing as part of artistic and intellectual experiments, thinking creatively with her hands and manifesting ideas in material.

Suohpangiehta, propaganda poster by Suohpanterror. Museum of International Folk Art (P.2018.1.2). *Photo by Addison Doty.*

To help articulate her points about sharing, she pulled out a recently completed gákti, a simple striped cotton garment. She described it as a "working dress," something she imagined her ancestors might have worn on a typical summer day. She made it to contemplate former realities and, she said, "to show that I'm a servant of my community and my people. It was to honor the ancestors." Sewing the "working dress" was an act of remembering who she is and what she knows—a way to practice the techniques she has been taught, to think about those who taught her as well as those who taught them, and to reinforce her vision of a multigenerational duodji philosophy.

One of the lessons of her teachers was a commitment to develop as an individual maker, not simply by absorbing a body of knowledge like a passive witness to the past but by remaking it. Once, her uncle, a silversmith, told her, "Take these materials, develop and create more." Jenni understood this as a challenge. It is not enough to reproduce. Duodji practice requires an artist willing to put herself into the work, shaping and reshaping tradition according to her own mind.

Looking again at the "working dress," she described one of its messages: "A hundred years ago people didn't have so many

Isak-Mahtte, propaganda poster by Suohpanterror, 2014. Museum of International Folk Art (P.2018.1.4). *Photo by Addison Doty.*

materials. [They] just took everything [that was available]." A spirit of survival but also of creative adaptation and renewal has always been a part of duodji tradition. A duojár learns, remembers, and teaches others, but according to Jenni, she also has an obligation to create something new for future generations based on her own experiences and perspectives.[110] New ideas rejuvenate tradition and can be seen as a form of generosity, a giving of oneself in the form of handmade instruments of beauty, for the sake of a better future.[111]

Mindful of this challenge, Jenni has been creating gávttit inspired by specific issues. These thoughtfully designed outfits are meant to challenge beholders with questions about Sámi identity, traditions, art, and power. As with any act of dressing, wearing them can be understood as an artistic, embodied performance of values, though in this case, the act is explicitly framed as "performance art" by Jenni. During my visit, we looked at three examples of these, each tailored to address a different set of issues.

She called the first example *Street Gákti* to conjure up connections with "streetwear," "street fashion," and urban

aesthetics rarely associated with majority representations of Sámi people. While the overall cut and silhouette of the dress follows conventional patterns for Kárášjohka gákti, the territory associated with her father's side of the family, she added a prominent zipper down the center back as an intentional nod to fashionable urban design. The gákti is sewn from a textile she created herself inspired by graffiti art. Using spray paint and fabric pens, she covered a white cotton surface with layers of color, written slogans, and graffiti tags and stencils. This technique rendered the "hidden messages" of political resistance communicated by Sámi dress graphically legible and played on ideas more commonly recognized in public protest art like graffiti. The splash of words references former fights, including the Áltá Conflict, as well as new ones, such as the call to ratify ILO-169 in Sweden and Finland. They also reaffirm Sámi terminology and language by repeating *Sápmi* and *Sápmelaš*, words for Sámi homeland and the "Sámi people" typically overwritten by majority exonyms.

The second gákti expands on the theme of "fashionable" traditional dress and pushes at the limits of conventional

Problem . . . Solved, propaganda poster by Suohpanterror. Museum of International Folk Art (P.2018.1.1). *Photo by Addison Doty.*

design. Again, she altered nothing about the basic construction, leaving it recognizable as a Kárášjohka gákti, but she made the dress in all-over black lace, a trend in streetwear at the time. Worn with a crinoline and bright red lipstick, the look suggests a vintage 1950s prom dress, but Jenni also pins three riskkut in a row down the bodice. When she made it about ten years ago, an all-black gákti was considered too severe.[112] Jenni wanted to challenge such limitations and suggest that it could be as elegant and sophisticated as any celebrated "little black dress." "I just wanted to break the taboo of the color," she said. "We *can* do fashionable things. Whatever we want. We are free to use *every* color, *every* material." For Jenni, these superficial elements do not lessen a garment's traditional authenticity, because tradition is a continual process of adaptation, and like her ancestors, she should be able to survey her material and multicultural environment and find inspiration in whatever is available. She does, however, recognize important limitations on her choices. Her adaptations, for example, should ultimately serve her goals to communicate effectively and connect emotionally with others. They should also remain faithful to her sense of collective responsibility and mutual respect.

Jenni told me that she always strives to honor an "Indigenous worldview" in her work, one grounded specifically in her interpretation of Sámi cultural values. When I asked for further clarification, she replied, "The question is land, the answer is land." She then offered a third gákti to exemplify this position. This one, made of glittery gold sequined fabric, is meant to critique "the way we live right now in this world . . . consuming natural resources, plastic. We just want to wear gold. We just want to decorate ourselves, and everything else dies." The reference to gold is a direct condemnation of ore and mineral extraction in Sápmi. She has been an outspoken thorn in the side of potential mining developers and extraction companies around Jåhkåmåhkke, Giron, North America, and elsewhere, organizing demonstrations and staging protests.[113]

While Jenni wishes to stretch the aesthetic potential of gávttit design, she also cherishes it as a primarily handmade and intimate practice. Gákti as the medium for a message of contemporary greed and materialism is intentionally multilayered. Handmade traditional garments—potentially wearable for a lifetime or more—are often explicitly contrasted with global fashion and its impersonal, wasteful, and destructive supply chains. Jenni is similarly skeptical of the growing commercialization of Sámi culture for profit, not merely by non-Sámi creating counterfeit duodji for tourists but also by Sámi designers who contribute to environmental degradation by mass-producing patterns for personal gain that could be considered collectively owned.[114] Things that, as she says,

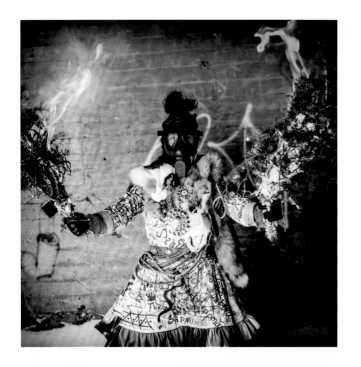

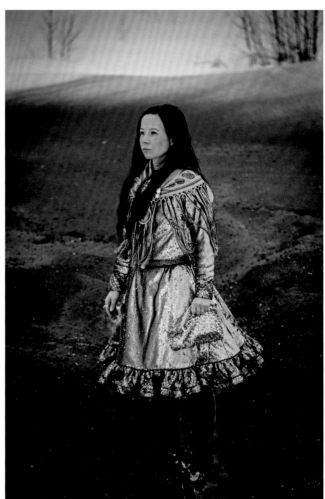

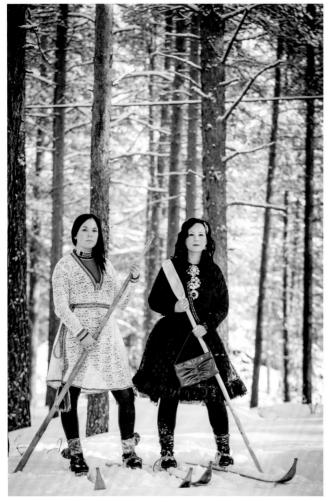

Top left, Jenni Laiti in Street Gákti. © *Carl-Johan Utsi.*

Above, Jenni Laiti in a gold sequined Kárášjohka gákti. © *Carl-Johan Utsi.*

Left, Jenni Laiti in Kárášjohka gákti of black lace. © *Carl-Johan Utsi.*

Giron. *Photo by Carrie Hertz, 2017.*

anyone "can just buy"—these impersonal, ubiquitous possessions do not sustain the people, the tradition, or the planet.

Through her performance of wearing gávttit, Jenni is at once offering an expansive view of Sámi expressive identity and reaffirming more conservative Sámi ethics. Despite her desire to trigger change, she describes herself as a "traditionalist." Change, in her mind, should always be in the service of community vitality. She uses these gávttit, worn at tactical moments, to draw attention and encourage contemplation about issues she considers critical to Sámi futures.

Jenni, working closely with Carl-Johan, staged these outfits in provocative scenes photographed for a publication they coedit, *Nuorat* (*Youth*), a glossy magazine targeted at young, politically engaged Sámi. In one, Jenni wears her *Street Gákti* with a fox fur draped around her shoulders and a lasso wrapped around her waist. Confrontationally, she leans toward the camera, standing square in the snow in front of a cinderblock wall of graffiti. A gas mask obscures her face as she waves burning branches at the viewer, suggesting a dystopian scene of ruin for both nature and humanity. Jenni's stance opposes the processes of hegemony, colonialism, and environmental exploitation. She said of the image, "I like to shock people and provoke people. And that's my role in the society: to give ideas and see things [from] a different perspective. I hate living in a box." She concluded, "Too many are living in these boxes and can't see anything else, so I want to help people see something else. To live this colonized life, there is nothing to do. People feel they don't have power in their lives." One way to decolonize one's mind, Jenni suggests, is to work from the outside in, embodying sartorial visions of liberation.

Stoorstålka: Lotta Stoor and Per Niila Stålka

In 2010, partners Lotta Stoor and Per Niila Stålka launched Stoorstålka, a company with the tagline "Design by Sámis, for Sámi people, and equally cool souls." Today, Stoorstålka is based out of Jåhkåmåhkke with a boutique just around the corner from Anders Sunna's studio and a workshop space in another part of town. The shop specializes in Sámi-inspired readywear dress, adornment, and home furnishings. For garments, there are tongue-in-cheek cotton T-shirts with giant silver riskkut silkscreened on the chest, a much cheaper alternative to the real thing at around 330 SEK (less than US$40). There are also knee-length, polyester "party skirts," advertised with matching red, black, or aquamarine crinolines, for around

Per Niila Stålka and Lotta Stoor in front of their boutique, Stoorstålka. © *Carl-Johan Utsi.*

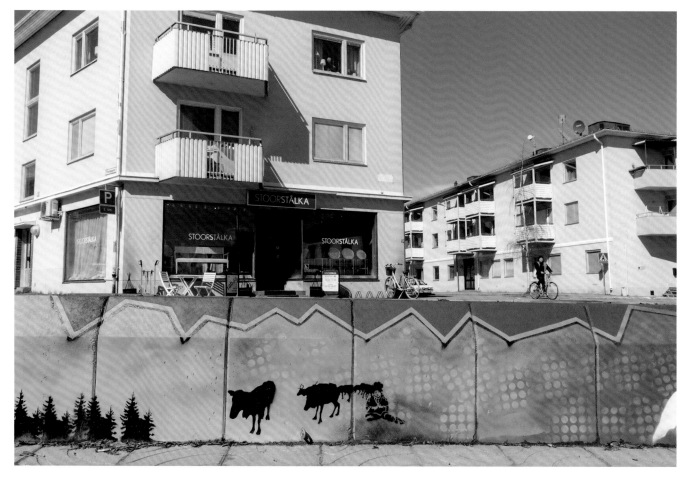

Stoorstålka boutique in downtown Jåhkåmåhkke. *Photo by Chloe Accardi, 2018.*

the same price. These elastic-waist skirts have yellow-over-red striped hems modeled on the gákti from Talma sameby in Čohkkiras, Lotta's home region. Other apparel includes plaid ulloliinnit, reindeer leather pants, bandanas silkscreened with duodji scrimshaw patterns, and shoelaces mimicking the color combinations of typical woven bands. The boutique also sells high-quality wool cloth by the yard for making gávttit, as well as a wide selection of wool yarn and other supplies for bandweaving. Most of the merchandise sold at Stoorstålka can be purchased from their website, especially the bandweaving supplies that ship internationally. Some of the items, like the bandanas and home furnishings, can be found in museum gift shops and stores catering to tourists all over Sápmi. On tags and promotional materials, the language is often trilingual, with text in Sámi, Swedish, and English.

I visited the boutique in Jåhkåmåhkke several times between 2017 and 2018 before sitting down with Lotta and Per Niila at their workshop.[115] The couple started the company initially to further the tradition of Sámi bandweaving. They were living in Stockholm and holding weaving classes, but they struggled to find appropriate teaching tools. Patterned bands are typically woven on rigid heddle looms (*njiškumat*)

hand carved from bone, antler, or wood. As with many items of duodji, rigid heddles are both useful tools and prized objects of craftsmanship and beauty. In the context of hosting introductory workshops, however, they can be heavy, expensive, or fragile. Gathering up large numbers for beginners to use was impractical. So, Lotta and Per Niila designed lightweight versions in acrylic and put them into serial production by contracting with small factories in Sweden. "For me," Lotta explained, "it's not *necessarily* an art object, it's a tool. You don't have to be afraid of dropping or losing it. If I lose it, I can buy a new one." The cost and ease of acrylic heddles served her own weaving practice as well, enabling her to keep multiple looms warped at once.

In addition to substituting the material for manufacturing heddles, Lotta and Per Niila modified the standard design, adding shorter slots to isolate pattern threads for different styles of bands, significantly easing the weaving process for certain patterns. Now they offer a variety of heddle models tailored to specific pattern designs, as well as weaving kits that come prewarped to encourage novices. Produced in a host of fanciful colors, from pale pink to glittery gold and silver, the heddles appeal especially to young beginners. One mother

who was teaching her daughter to weave told me she had mixed feelings about the company. "Stoorstålka is *selling* my culture," she said, but she still appreciated how the factory-made, acrylic heddles made weaving seem fun and promoted the tradition. She enjoyed weaving with them, as did her daughter.

Lotta and Per Niila are well aware of the criticisms related to their commercial approach, but they perceive these ideas as a romanticization of a more "authentic" past. Like Jenni Laiti, they believe Sámi people should feel free to modernize like anyone else, experimenting with new materials, methods, and other ideas found in the world around them, including capitalist entrepreneurship. This last point, however, is where Stoorstålka and Jenni Laiti diverge in opinion.

Lotta and Per Niila shy away from drawing hard lines between Sámi and Swedish histories, aesthetics, and worldviews. "Today, it's more conservative, I think," Lotta explained. As an example, Per Niila offered the essentializing assumption that styles of traditional dress are completely distinctive and separate between groups. "The view on the Sámi dress code," he said, "is they had been living isolated in a corner of the world." The same patterns, materials, motifs, and techniques, however, can be found all over Europe, evidence of previous cultural

exchange. The Jåhkåmåhkke Winter Market, too, stands as another instance of commercial and cultural interaction, existing as a major trade event between Sámi and non-Sámi that has taken place annually since 1605.

Stoorstålka, as the tagline proclaims, is for anyone who approaches Sámi culture with appreciation and respect. Lotta and Per Niila encourage non-Sámi to buy their products and wear their clothes. The divisions between people are not "natural" or inevitable, they contend; they are the consequences of complex historical, ideological, economic, and political factors. Lotta and Per Niila agree that the midcentury Sámi movement against centuries of colonialism and then nationalism was justified, but perhaps the wave of cultural renewal that it set off went too far, cultivating a closed culture in an overzealous attempt to protect and isolate a Sámi ethnic identity. Biological descent, a hallmark of modern Western thought about identity, does not always draw the line between insider and outsider. Sámi marriage customs, after all, have often entailed the gift of a gákti to non-Sámi spouses as a way to signal their new home in the community.[116]

After the Áltá Conflict, Per Niila argued, "things radicalized. It was this *anti*-reaction." He advocates a more "friendly

Three Stoorstålka *njiškumat* (rigid heddle looms) made of acrylic, displayed with an older model made of antler by Nils Huuva, ca. 1964. Museum of International Folk Art, IFAF collection (FA.2019.18.1–3 and FA.1966.21.37). *Photo by Addison Doty.*

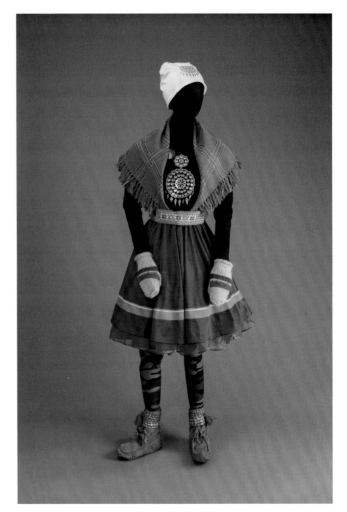

Njiškun of reindeer antler by Johan Thurri with in-process weaving by Viola Thurri, ca. 1966. Museum of International Folk Art, IFAF collection (FA.1966.21.42ab). *Photo by Addison Doty.*

"Party outfit" by Stoorstålka. Museum of International Folk Art, IFAF collection (V.2019.15.1–9). *Photo by Addison Doty.*

revolution." Forced assimilation and marginalization, he suggests, are the source of today's problems, but not necessarily mutual cultural integration and hybridization. "In Sweden," he countered, "the *problem* is you never see Sámi anywhere in media. It's [Sámi culture] invisible. And that's what we wanted to change." Stoorstålka wants to appropriate and adapt the systems of the ruling majority, demanding a more humane and equitable role in the existing power structures of Western society.

Lotta stressed, however, that Stoorstålka products, especially their clothing designs, should not be viewed as a threat to Sámi values or identity. Lotta and Per Niila both own handmade, formal versions of gávttit as part of their wardrobes. Readymade versions do not replace those. Lotta sees the difference as a matter of occasion and economics. "Gákti is haute couture," she explained. "And it costs. It's expensive, which it should be, but it's impossible to use it *every* day." Stoorstålka's clothing designs, in contrast, can function as daily wear, mixed with other store-bought clothes or combined to mimic

the appearance of being dressed in "full gákti." They open up the potential for an expanded vocabulary of creative self-expression. In much the same way that acrylic heddles can support the intangible knowledge and technical mastery of a bandweaving tradition, readywear clothes may multiply the ways one can fashion and communicate a Sámi identity in public. In both cases, the tools themselves can be art, embodying generations of acquired skill, or they can be the building blocks for another type of cultural performance, such as the art of weaving or dressing the body.

Lotta argues that with Stoorstålka clothes, an individual can display a sense of Sámi style while engaged in mundane or recreational activities such as running errands or going skiing. One does not need to rely on either a small repertoire of ethnic markers or a complete ensemble to communicate being Sámi. "You pick and choose. You can put it together," she explained. "We are not going to make a full costume. You don't have to have every part or follow the rules." She wanted to extend the possibilities of Sámi dress beyond the ceremonial and, in the

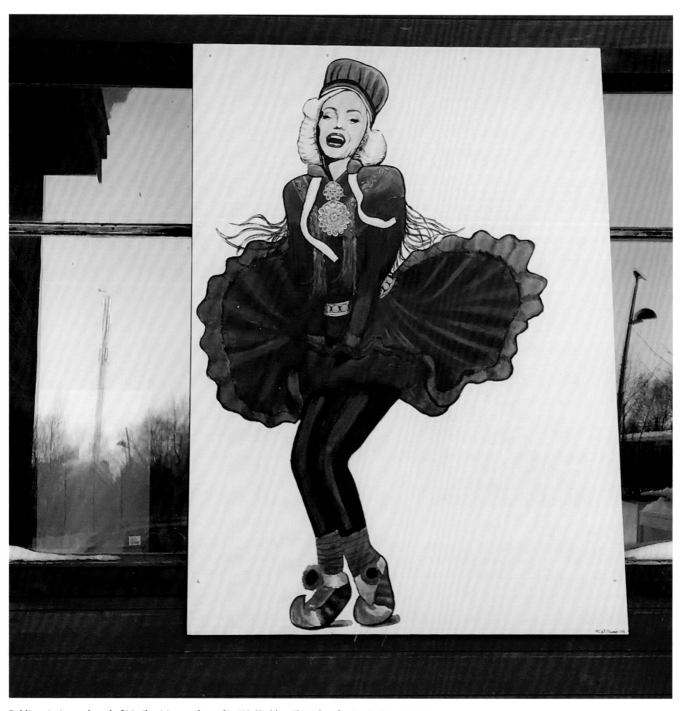

Public painting on board of Marilyn Monroe dressed in Kárášjohka gákti. *Photo by Carrie Hertz, 2017.*

process, promote an everyday, visible, "modern" Sámi style. This approach serves Stoorstålka's mission to make Sámi identity "mainstream" rather than minority. "*I* want to look this way," Lotta said, referring to her own outfit of Stoorstålka clothes. "I want to look this way and not have people stare. They have seen it before, and it's nothing special. It's Monday."

Lotta and Per Niila want to make Sámi aesthetics, products, and a sense of popular style pervasive in Swedish life. "I can see Swedish style in everything in Sweden," Lotta reasoned.

"I want the same things, but the Sámi way. We just want there to be a Sámi alternative." Breaking through the monotony of hegemonic representations and perspectives with subversive and clever recombinations of mainstream pop culture is, in fact, one of Suohpanterror's methods of decolonization.[117] And just as Anders Sunna believes that the juxtaposition of Sámi artists making graffiti can remind people that Sámi culture is found outside of museum displays, acrylic heddles and silk-screened T-shirts prove that Sámi material culture is not

just a collection of precious artifacts filling museum shelves. Sámi "stuff" should be more than beautiful but fragile looms that one is too afraid to use.

A reasonable worry for many like Jenni Laiti, however, is that this methodology only supports "a multicultural neoliberal society where cultural difference is accepted on the surface only, and seen as highly marketable" (as well as extractable and consumable), but does not disrupt the continued colonization of lands and resources.[118] Instead, it simply makes room for Sámi participation in the ongoing reproduction of Western capitalist hegemony and its associated systems of exploitation, alienation, and oppression. Sámi art, after all, has long been admired and collected by individuals who nevertheless despise, dismiss, or dehumanize the people who make it. And too often, Indigenous artists find that to be taken seriously in the world of art and design, they are "expected to follow the Eurocentric norm," another kind of coerced assimilation, a sort of "aesthetic colonization."[119] Jenni and many others do agree, however, that a multiplicity of methods is probably needed, and building a sense of shared community is integral to developing more impactful forms of political mobilization.

Lotta and Per Niila do not just view their mission as a commercial endeavor of market penetration, spreading the love of Sámi aesthetics far and wide. They also see their actions as a means of fostering positive feelings around being Sámi and sharing that identity publicly without fear of shame or misinterpretation. Their first priority is serving other Sámi people, especially those who have felt alienated from Sámi culture, living in the physical or social periphery.

When they first adapted rigid heddles for beginners, they hoped to increase the number of weavers by lowering the barriers for entry. One of their early students, Johan Sandberg McGuinne, a South Sámi man who grew up outside Sápmi, wrote about his gratitude to Stoorstålka in a blog post featured on the company's website: "Band weaving in many ways has become a major part of my personal decolonial process. Weaving roots me, it's a part of my culture, and I feel the presence of my ancestors each time I warp a rigid heddle, or let the shuttle fly back and forth, creating bands meant to decorate dresses, hats and walls or work as straps for backpacks and rifles."[120] Similarly, making affordable ethnic readywear may provide a low-risk entry point for those reclaiming a public Sámi identity in places where taking such a step is fraught. "It's a big step to put on the whole dress," Lotta reasoned. "And maybe it's not even comfortable, if you haven't been born into it. But to wear Sámi accessories is a way, I think, for some Sámi to come closer to the culture and feel some kind of togetherness."[121] In this way, Stoorstålka clothes, despite important material differences, can still serve some of the same functions of belonging and resistance achieved through other more formal styles of dress.

As with any group, the experiences and perspectives of Sámi individuals are diverse, but across Sápmi and beyond, many people are actively and thoughtfully engaged in efforts to "decolonize" Indigenous lives and minds, to undo a collective trauma as minorities within national majorities, and to secure vivacious futures built on a foundation of multigenerational continuity. Even limiting our discussion to the art of purposeful dressing, we can see that the methods and means of waging this fight are both personal and vast.

The histories of folkdräkt, bunad, and gákti help us consider the legacies of colonialism and romantic nationalism in contemporary society. Groups, as well as the diverse individuals contained within them, experience and respond to these legacies differently, and these disparities promote varying priorities for sartorial practice and notions of traditionality for dress. Folkdräkt embraces a certain consensual uniformity. Bunad praises historical precedent and preserved technique. And gákti celebrates adaptability and innovation within a shared philosophy for new creation. These are merely patterns, not prescriptions, sketching some possibilities for interpretation. Is tradition best embodied in a set of mutually acknowledged standards, the materials and techniques, or the overall appearance and sense of style? Perceptions of traditionality, as always, are found in the space between the hands of the maker and the eye of the beholder who meet in the context of sartorial display.

Notes

1 Lehtola, *The Sami People*, 72; Lantto and Össbo, "Colonial Tutelage and Industrial Colonialism."

2 For more on the history and artwork of Mázejoavku, see H. Hansen, "Sámi Artist Group."

3 The gávttit from Buolbmát and Várjjat have been suggested as likely models for Persen's flag. See Office for Contemporary Art, *Let the River Flow*, 28. Persen's flag was later revised by Astrid Båhl in 1986, who added a green stripe and a circle representing the sun and moon.

4 My description here is indebted to profiles of Marakatt-Labba and her artworks in Gullickson, "The Artist as Noaidi," 13–17.

5 Ravna, "The Fulfilment of Norway's International Legal Obligations," 298. Øyvind Ravna mentions important examples of resistance in Norway that predate this period, including the work of Isak Saba, Elsa Laula Renberg, and Daniel Mortenson (298–299).

6 For a discussion of official state apologies made to Sámi people, see Fur, "Dealing with the Wrongs of History?"

7 Ravna, "The Fulfilment of Norway's International Legal Obligations," 300–303.

8 Ibid., especially 300, 308, 312–313. Since 2007, the Norwegian government has placed restrictive caps on the size of reindeer herds, ostensibly to prevent overgrazing, though many herders believe the measures are instead meant to render their way of life untenable so that land can be more freely exploited by industrial projects. See Cohen, "In Norway, Reindeer Are a Way of Life."

9 There are no reliable statistics available for the size of Sámi populations, in part for historical reasons (which will become clear from the body of this text) as well as for contemporary reasons related to government administrative practices. Ethnicity is no longer tracked in census data gathered in Scandinavian countries. Finally, the criteria for identifying one as Sámi are contested. See, for example, Junka-Aikio, "Can the Sámi Speak Now?"

10 Kuokkanen, "Indigenous Peoples on Two Continents," 5–6.

11 Tuck and Yang, "Decolonization Is Not a Metaphor."

12 Oskal, "Political Inclusion of the Saami," 256–257.

13 Ibid., 257 (emphasis in the original).

14 Nilsen, "From Norwegianization to Coastal Sami Uprising," 166–167.

15 E. Helander, "Sustainability in the Sami Area," 1–2.

16 Cocq, "Sámi Storytelling as a Survival Strategy," 41.

17 Tuck and Yang, "Decolonization Is Not a Metaphor," 5, 21.

18 Huggan, "Unscrambling the Arctic," 18.

19 Sámi and their material culture were regularly depicted and treated as connected to witchcraft and demonology. See, for example, Bergesen, "Hybrid Iconoclasm." And their clothes, generally, were considered "unchristian." See Evjen, "Thought I Was Just a Same," 45.

20 The border between Norway and Finland was closed to herders in 1852, pushing many Sámi families into Sweden, including that of author and visual artist Johan Turi, first to Gárasavvon/Karesuando and then to Čohkkiras/ Jukkasjärvi. In Turi's An Account of the Sámi, written in 1910, he describes the resulting devastation of herding lands in northern Sweden (98–99), as well as some of the intraethnic tensions caused by the forced relocations of Guovdageaidnu herders into Swedish pastures (34–35). Thomas A. DuBois, who prepared the English translation of Turi's work, pointed out to me how carefully Turi illustrated the distinctive dress for these different groups that were now occupying shared space, indicating the importance he placed on differentiating groups within a broader Sámi society (personal correspondence).

21 See, for example, Stordahl, "Sami Generations," 145.

22 For useful discussions of the concept of authenticity in relation to people and cultural products in folklore and cultural heritage studies, see Bendix, In Search of Authenticity; Groschwitz, "How Things Produce Authenticity"; Titon, "Authenticity and Authentication."

23 See Cantú, "Wearing Identity," 30.

24 Jackson, "On Cultural Appropriation," 87.

25 For a discussion of "internalized colonization" and post-traumatic stress symptoms now recognized within Indigenous populations, including Sámi, see Bastien et al., "Healing the Impact of Colonization."

26 Jackson, Yuchi Folklore, 137.

27 Berg, "From 'Spitsbergen' to 'Svalbard,'" 155.

28 See, for example, Niemi, "Sami History and the Frontier Myth," for a discussion of the growing restrictions placed on Sámi landownership, resource rights, and cultural expression from Danish-Norwegian rule to the formation of the Norwegian nation-state.

29 Known as the "Wexelsen Decree," these education policies marked an intensification of Norwegianization. For more on this and other phases of Norwegianization, see Minde, "Assimilation of the Sami." For a cross-cultural discussion of educational

institutions serving a central role in colonization, see Kuokkanen, "Survivance."

30 See K. Helander, "Sámi Placenames."

31 Ulfstein, The Svalbard Treaty.

32 Berg, "From 'Spitsbergen' to 'Svalbard,'" 158.

33 Hugh Beach mentions this use of plastic bags in his personal account A Year in Lapland, but he offers a secondary explanation for their presence to the one I regularly heard. He writes that the bags are sometimes referred to as "plastic dogs" for their ability to frighten and thus herd reindeer away from highways (185).

34 See, for instance, Baglo, "Rethinking Sami Agency during Living Exhibitions," 144–148; Silvén, "Constructing a Sami Cultural Heritage." In a recent special issue of Nordisk Museologi, this topic is explored in great detail in relation to the founding of national museums in Scandinavia. See Baglo, Nyyssönen, and Ragazzi, "From Lappology to Sámi Museology."

35 For a more thorough discussion of the duodji concept situated within Sámi systems of knowledge, see Guttorm, "Contemporary Duodji"; Guttorm, "The Power of Natural Materials and Environments in Contemporary Duodji."

36 Brask, "Recovering a Language," 140–141.

37 Dokka, "From Conceptions of Sami Culture," 124.

38 Mathisen, Carlsson, and Sletterød, "Sami Identity and Preferred Futures," 126–132.

39 In recent years, there have been efforts to challenge stereotypes and conservative viewpoints about Sámi identity, including the multiyear project Queering Sápmi, which resulted in a book and traveling exhibit of the same name. See Elfrida Bergman and Lindquist.

40 Conrad, "Mapping Space, Claiming Place," 183.

41 Pål Norvall, personal email correspondence, February 23, 2018.

42 I met with Marit Helene and Ann Mari Sara on May 4 and 5, 2018. I am indebted to Gerlinde Thiessen, who assisted with Norwegian-to-English translation as necessary.

43 Delaporte, Roué, and Cooper, "Lapp Fur Coats," 67.

44 Elina Helander argues that Sámi notions of aesthetics could, in fact, include those economic and practical factors that result in cultivating a herd as a "beautiful unit (čáppa eallu)," and she therefore questions the limitations of relying on Western concepts of "art" that "separate artistic qualities from the rest of culture." See E. Helander and Kailo, No Beginning, No End, 176–177.

45 The exhibition was accompanied by a small booklet. See Robertson and Dickerson, The Reindeer Followers.

46 A. Haugen, Sámisk Husflid i Finnmark, 152–153.

47 Falck, Marknadsvantar/Aejlegsvaanhtsh, 49–55.

48 The audiovisual recording with May Toril took place at her home studio on May 4, 2018. I am indebted to Gerlinde Thiessen, who assisted with Norwegian-to-English translation as necessary.

49 Guttorm, "Stories Created in Stitches," 19.

50 I met with Gerlinde Thiessen at her home on May 4 and 5, 2018, followed by email correspondence and video calls between 2018 and 2020. She graciously accompanied me to visits with the Sara sisters and May Toril Hætta. I am further grateful to textile designer Laura Ricketts for introducing us.

51 See Cocq and DuBois, Sámi Media and Indigenous Agency, particularly chap. 7.

52 Boine Verstad, "Inspireres av sosiale medier til å lage duodji."

53 As an example, Ole Henrik Magga characterizes the assimilation policies in Sweden and Finland as "not quite as intense as in Norway" ("Policy and Sámi Language," 11). Assimilation policies, however, were not limited to the Nordic countries or to targeting Sámi. In his article "Assimilation of the Sami," for example, Minde points out comparable policies driven by nationalist ideologies in Germany, the Russian Baltic, and the United States (7–8).

54 Minde, "Assimilation of the Sami," 9–11.

55 Vuolab, for example, has described these personal experiences in an interview published in E. Helander and Kailo, *No Beginning, No End*, 50.

56 Todal, "Minorities with a Minority," 354.

57 This condition is related to the period of segregationist policies in Sweden known as *Lapp ska vara lapp* in which Sámi were prevented from pursuing most educational and occupational opportunities without completely relinquishing their legal status as Sámi (including rights to own reindeer). For a more thorough examination of the impacts of these policies, especially as they are explored through the film *Sameblod*, see Cocq and DuBois, *Sámi Media and Indigenous Agency*, 175–188.

58 Minde, "Assimilation of the Sami," 9. This erasure was especially true for Sámi that did not fit the nomadic herder stereotype. See Baglo, "The Disappearance of the Sea Sámi." Cathrine Baglo draws a connection between the growing exclusion of Sea Sámi material culture from early museums and expositions and the gradual internalization of shame that led many Sea Sámi to conceal their ethnicity.

59 See, for example, Falkenberg, *Besetningen ved Indre Laksefjord i Finnmark*; Bjørklund, "Local History in a Multi-ethnic Context"; Eidheim, "When Ethnic Identity Is a Social Stigma."

60 Henriksen, "A Gathering Storm," 18.

61 Audio-recorded interviews with Brede took place on February 13, 2017, and April 30, 2018. Email correspondence took place between 2018 and 2020. I am grateful to Ellen Marie Jensen for the introduction.

62 Einar Eythórsson makes this same comparison of hiding one's homosexuality in a society that finds such an identity taboo ("The Coastal Sami," 157).

63 Kuokkanen, "Survivance," 699.

64 Municipal and county boundaries have shifted over time, causing some confusion and overlap in the naming of various local dress practices. "Old Lyngen," for example, included present-day Ivgu/Lyngen, Omasvuotna/Storfjord, and Gáivuotna/Kåfjord. These designations do not necessarily map easily onto Sámi language boundaries or known distinctiveness in dress, so one finds a certain looseness in identifying and defining sartorial zones. Many of the coastal styles are known by multiple or hyphenated territorial names, such as the Loppa-Kvænangen-Alta kofte, and are considered generally appropriate for anyone who claims affiliation with nearby areas.

65 My translation from Norwegian: "Alle Sámiske områder med respect for seg sjøl har kofte idag, så hvorfor ikke vi?"

66 Viken, "Reinventing Ethnic Identity," 195. Other scholars have characterized the criticism coming from majority-area Sámi as contributing to a "second stigma"—for example, by determining that younger generations who cannot speak Sámi (the intended consequence of Norwegianization) are not "Sámi enough." See also Skogholt, "Triple Stigma"; Hernes, "Being Sámi Enough." There are also critics suspicious that people claim Indigenous identity to receive unfair advantages, such as fishing rights. See Eythórsson, "The Coastal Sami," 150.

67 Pedersen and Viken, "Globalized Reinvention of Indigeneity," 196.

68 Viken, "Reinventing Ethnic Identity," 188.

69 Ibid., 185–189.

70 Olmmáivággi, the site of the famous Riddu Riđđu, is an example of such a place.

71 The audio-recorded interview with Jorunn took place on May 1, 2018. Email correspondence continued through 2020. During this time, Jorunn created an Ivgu gákti and luhkka for the Museum of International Folk Art's permanent collection.

72 Viken, "Reinventing Ethnic Identity," 181.

73 Hoffmann, "Manndalen Revisited."

74 L. Hansen, *Storm på kysten*.

75 Hilder, *Sámi Musical Performance and the Politics*, 203.

76 Attendance figures come from Henriksen, "A Gathering Storm," 19.

77 Hilder, *Sámi Musical Performance and the Politics*, 203.

78 *Following Arctic Fashion* was originally on view at the Polar Museum in Tromsø from October 8, 2015, to March 31, 2016.

79 Jorunn's guest posts are hosted by the Norsk håndverkinstitutt and can be accessed online: https://handverksinstituttet.no/stipendiater/Duojarens-blogg/.

80 My translation from Norwegian: "Mitt mål er å bli trygg i håndverket." Løkvold, "Duodji—Samisk Håndverk," 4.

81 Here I borrow the concept of "recovered continuity" from DuBois, who describes it as the conscious attempt to reconnect contemporary artistic practices with the norms of the past, despite the disruptions of colonialism (*Sacred to the Touch*, 26).

82 *Dagbladet*, July 28, 2001, quoted in translation in Minde, "Assimilation of the Sami," 1.

83 Designs for these were regularly discussed in *Báiki*. See, for example, Kitti, "North American Gakti"; Muus and Kitti, "The Ongoing North American Gakti Debate." For more about Sámi emigration/immigration and the Reawakening, see Jensen, *We Stopped Forgetting*.

84 Aamold, "Unstable Categories of Art and People," 18.

85 Cocq and DuBois, *Sámi Media and Indigenous Agency*, 48.

86 Turi, *An Account of the Sámi*, 11, 212.

87 Turner, "The Social Skin."

88 Heith, "Enacting Colonised Space," 72.

89 For this location, I privilege the place name in Lule Sámi, the most widely spoken Sámi language in the area.

90 There are fewer formal institutions dedicated to Sámi culture in Sweden, when compared to the robust system of community museums found in Norway. See Mulk, "Conflicts Over the Repatriation of Sami Cultural Heritage in Sweden."

91 For more on the interactions between Sámi and tourist audiences at the festival, see Müller and Pettersson, "Sámi Heritage at the Winter Festival."

92 Langston, "Mining the Boreal North."

93 See Abram, "Jokkmokk"; Cocq and DuBois, *Sámi Media and Indigenous Agency*, 191–194.

94 The audiovisual-recorded interview with Anders Sunna took place on May 8, 2018. Additional correspondence took place by email between 2018 and 2020.

95　Anders is not alone in this assessment. Others have documented "strong intra-Sámi conflicts" emerging directly from histories of forced relocations and state interventions. See Lantto, "The Consequences of State Intervention." Similarly, Kuokkanen ("Indigenous Women in Traditional Economies") found that government interventions into herding particularly disenfranchised women by engendering patriarchal structures of administration.

96　Mustonen and Syrjämäki, *It Is the Sámi Who Own This Land*, 82.

97　See, for example, Svensson, "Clothing in the Arctic," 71–72.

98　For a discussion of patterns of representation in film, see Dokka, "From Conceptions of Sami Culture," and in photographic archives, see Lehtola, "Our Histories in the Photographs of Others." Lehtola found that the Sámi identity of pictured individuals was often overlooked if the subjects were engaged in "modern" activities or not wearing "traditional clothes."

99　Kyllingstad, "Norwegian Physical Anthropology."

100　Borberg and Roll-Hansen, *Eugenics and the Welfare State*; Spektorowski and Mizrachi, "Eugenics and the Welfare State in Sweden."

101　The ancestor in question was Mons Somby, one of two Sámi who were executed by decapitation after the Kautokeino Rebellion in 1852. I am grateful to Tim Frandy for bringing this documentary to my attention.

102　For an overview of Sámi and other human remains in Swedish institutions and specific cases of their repatriation or reburial, see Ahlström et al., "Sweden." To read about a well-known case of reburial in Norway, see Svestad, "What Happened in Neiden?" As Svestad argues, there are potential ethical dilemmas that may contribute to the slowness in response. See also Aronsson, "Research on Human Remains of Indigenous People."

103　For an example of a recent controversy in which Swedish state lawyers were accused of employing a "rhetoric of race biology" in their legal arguments, see Crouch, "Sweden's Indigenous Sami People Win Rights Battle against State."

104　A few artists in the collective have made their identities public. See Junka-Aikio, "Indigenous Culture Jamming," 3–4. The audio-recorded interview with Jenni took place on May 9, 2018. Additional conversations took place by email and video calls between 2018 and 2020.

105　Finnagora, "Young Sámis and Cultural Activism." For more about Suohpanterror, visit the collective's website at http://suohpanterror.com/.

106　Junka-Aikio, "Indigenous Culture Jamming," 1.

107　Debatty, "Suohpanterror."

108　Cocq and DuBois, *Sámi Media and Indigenous Agency*, 270.

109　See Romero, "Sámi Artists First Out in the World's Largest Climate Performance." The video can be viewed at Runforyourlife, Riksteatern, "Jenni Laiti, Run for Your Life, First Runner" (https://www.youtube.com/watch?v=7ZR6kGNM_L0).

110　In his article "Lars Levi Sunna," DuBois writes that he found a similar sense of "responsibility to adapt the old forms to new uses" among contemporary duojárat (136).

111　Jenni's explanations of duodji practices parallel those outlined by Harald Gaski, who cites "humility," usefulness, and community accountability as key values of Sámi aesthetic traditions ("Indigenous Aesthetics," 189).

112　The appropriateness of various colors changes over time from place to place. See Svensson, "Clothing in the Arctic," 63–64.

113　See, for example, Bladow, "Never Shut Up My Native," 323–324. Jenni has also been involved in the Idle No More movement started by First Nations activists in Canada. She cowrote a manifesto published in 2015 on the movement's website, www.idlenomore.ca. See Holmberg and Laiti, "The Saami Manifesto 15."

114　This, of course, hints at much larger discussions about the differences between culture as property that can be individually owned and culture as a process emerging from a set of relationships. For a discussion of these opposing systems in relation to duodji, see Bydler, "Decolonial or Creolized Commons?"

115　The audio-recorded interview with Lotta Stoor and Per Niila Stålka took place on May 9, 2018. Additional email correspondence took place between 2018 and 2020.

116　Guttorm, "Duodji—árbediehtu ja oapmi," 86–87.

117　Junka-Aikio, "Indigenous Culture Jamming," 8.

118　Ibid, 11.

119　Bydler, "Decolonial or Creolized Commons?," 148–149. "Aesthetic colonization" comes from Kuokkanen, "Towards an 'Indigenous Paradigm,'" 424.

120　McGuinne, *Veasomem suehpedh*."

121　Studies on ethnic identifications among urban Sámi have found that individuals in cities more often prefer to wear ethnically marked accessories rather than full ensembles, not only as an expression of "modern urban design" but also for their subtlety, communicating primarily to those with a deeper awareness of Sámi signs. See Nyseth and Pedersen, "Urban Sámi Identities in Scandinavia," 144–145.

7[1]

The Legacy of Ládjogahpir

Rematriating Sápmi with Foremother's Hat of Pride

Eeva-Kristiina Harlin and Outi Pieski

"Ládjogahpir"

Dat Ládjogahpir vel jo Lei
dolin Sámenissoniin

De dale mearridedje Daid
Ládjogahpiriid Galggai
oaivvis váldit Ja dollii
bálkestit

Dolin girkohearráid mielas Dat
biročoarvvi muittuhii

De jávkkai Ládjogahpir jo Sámenissoniid
oivviin

Ulla Pirttijärvi

"Ládjogahpir" (Hat of Pride)

In the past Sámi women
had Ládjogahpir

Then it was determined
These Ládjogahpirs
need to be taken off
And thrown into the fire

In the past clergymen considered
It resembled the devil's' horn

So Ládjogahpir was lost from Sámi
women

Ulla Pirttijärvi, joik lyrics from the 2002 album Máttaráhku askái / In Our Foremothers' Arms, *our translation*

1 An earlier version of this chapter was published as "Máttaráhku Ládjogahpir—Foremothers' Horn Hat," in *A Greater Miracle of Perception*, edited by Esposito Yussif Giovanna, 79–92 (Berlin: Archive Books, 2019). This version appears with permission.

Aláźis / On the Top, lithograph printed by Tamarind Institute, New Mexico, 2018. © *Outi Pieski.*

Ládjogahpir is a graceful, crown-like headdress that was used by Sámi women until the end of nineteenth century in Sámi areas in what is now northern Norway and Finland. This hat had a prominent appearance with a high wooden protrusion or horn (*fierra*) at the back of the head. There is a common narrative in Sámi society that the Laestadian priests forbid the use of this hat, since the devil lives in its wooden horn. The priests gathered the hats, and like the sacred drums, the hats had to be burned. Nothing was to remain from the old order of the world. As the use and making of the hat came to an end, all the traditional knowledge and symbolism related to it went to oblivion. Today, sixty of these hats remain in museum collections in Europe and the Nordic countries, but only a few in Sápmi.[1]

In this chapter, we discuss our project "Máttaráhku Ládjogahpir—Foremother's Hat of Pride." Our project is both art and research. The results will be presented in different forms, including a scientific article in a peer-reviewed journal, additional publications, and several exhibitions featuring artworks totally or partly inspired by our research. In addition, we have arranged seminars and taken part in many conferences, where we have shared with Sámi people the information we have gathered. In our work, Harlin conducts historical, ethnographic, museum, and archival research, and Pieski creates visual art. Together we demonstrate how communal knowledges are interlaced with the knowledge of the visual arts.

From the beginning of our research, we dived into archives and literature to search for fragments of information, old pictures, written notes, paintings, and articles about the hat. We also consulted studies about the traditional worldview and religion of the Sámi. Our dream and ambition was to dig up the secrets of ládjogahpir that were now hidden within and from the Sámi people. We then traveled from museum to museum, visiting those hats kept in collections. Later on, we spent many hours together designing, discussing, and pondering the aesthetics of the hat. Pieski made a horn hat for herself using contemporary methods. This hat was based on her foremothers' hat, currently held in the collection of the National Museum of Finland. Slowly ládjogahpir started to lead us down paths that we eagerly followed, toward hidden histories of Sámi women and ancestral cosmologies, spiritualities, goddesses, and Mother Earth. Our research takes part in a larger discussion concerning intersectional Indigenous feminism, which studies how colonialism and racism have shaped and still shape gendered positions and social relations affecting Indigenous women today.

We have arranged workshops for Sámi women with the purpose of collectively finding a new way to make and signify ládjogahpir. Our workshops can be defined as craftivism, activism that uses handicrafts as its medium. Craftivism engages often with noncapitalist practices, environmental issues, and feminism. It is essential that participation shift from marginalized "female gatherings" into forms of action that contain cultural, historical, and social values while also empowering the makers. In these workshops, Sámi women came together and had broad discussions that ranged from how to make the hat, its aesthetics and actualization, to its history in relation to colonialism and even its spiritual meanings. During the workshops, Harlin interviewed the participants.[2]

Through the interviews, it became apparent that ládjogahpir, for many women, is not just a headdress.[3] Many women experienced similar feelings and reactions, even though they had never had an opportunity to share, debate, or discuss the hat before. It is apparent that there is something about ládjogahpir that provokes these specific thoughts and feelings for Sámi women. The workshops offered them the possibility to talk about colonialism, gender inequality, religion, traditional knowledge, and the role of women and their foremothers. Many Sámi artisans, *duojárat*, have expressed that Sámi handicrafts, *duodji*, connect individuals with their ancestors. This fact, present also in archival knowledge, is empowering and even helpful in difficult situations. It also became apparent that many of these Sámi women were taking back their foremothers' heritage, and simultaneously the hat was being given a new meaning.

But why was ládjogahpir considered so hideous that it had to be burned, that people felt they must stop using it or speaking about it? This kind of reaction is quite rare in areas where Sámi dress and duodji otherwise prosper. Sámi dress and accessories have contained and still retain a lot of symbolism related to traditional worldview, religion, and an individual's role in society, something that can be visually interpreted inside the community. Many of these symbols have been demonized and forbidden by religious authorities, sometimes successfully, sometimes not.[4]

The pietistic Lutheran revival movement, Laestadianism, brought with it some of the most effective destruction of the old ways. The movement spread among the Sámi from 1840 to 1920. The leader of the movement was the vicar of Gárasavvon/Karesuando, Lars Levi Laestadius, who was Sámi himself and knew the Sámi mythology. Therefore, Laestadius could use the images and symbolisms from Sámi heritage, syncretizing them with Lutheran religion. It has been said that this was a big awakening for Sámi society, but one that also destroyed many elements of the old worldview.[5]

Sámi Laestadianism took different forms in different times and places; therefore, its impacts on material and nonmaterial culture varied. In some areas, the use of particular ornamentations and colors was completely forbidden inside the movement. In general, Sámi dress, including ládjogahpir,

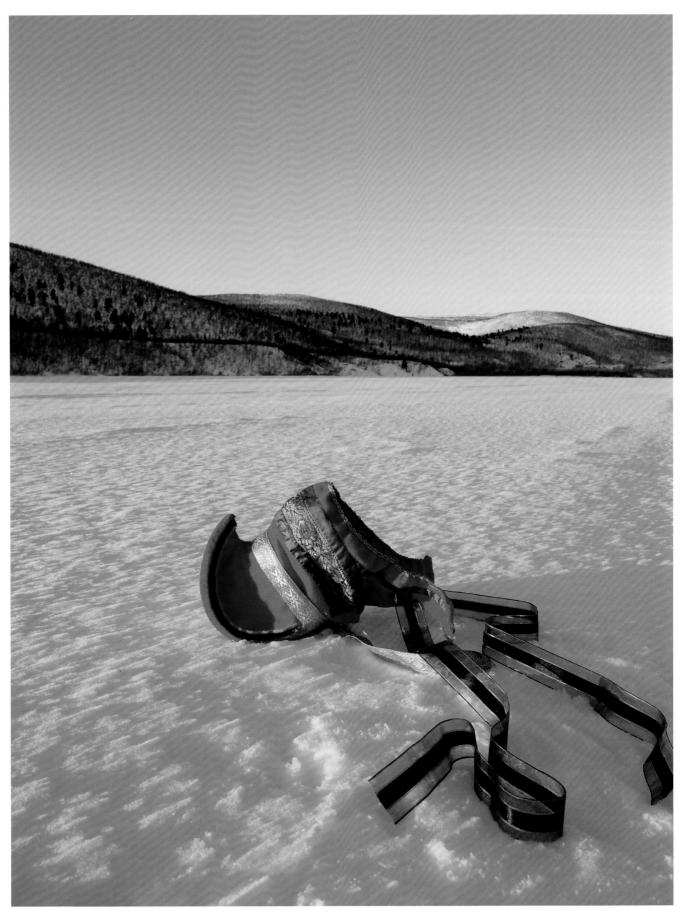

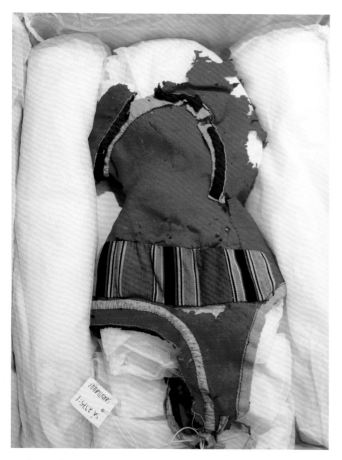
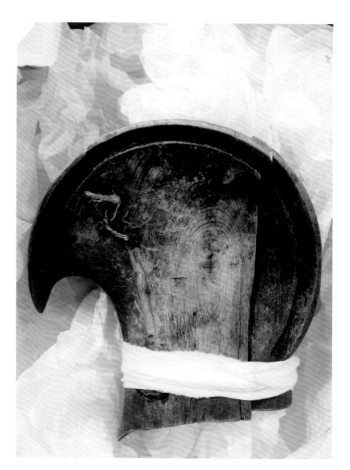

Ruoktut máhccan / Homecoming, two photographs. © Outi Pieski, 2018.

was attacked for being colorful and full of "pagan" symbolism. Many of the important items of adornment, such as silks, silver brooches, and silver belts that were traditionally given in dowry chests (*gihligiisa*) between reindeer-herding Sámi, were strictly prohibited in some Laestadian communities. In some others, functional decorations had to be reduced, and brightly colored woven shoe bands were abandoned and replaced by ones made in dark colors. Regardless of location, anything that signaled female power and worth in the eyes of men or that demonstrated women's skills was considered sinful.[6]

The ládjogahpir was replaced with a tight bonnet called *jollegahpir. Jolle* refers to a reindeer that has shed its antlers. As this name implies, the change in the structure of the hat reflects historical changes in the social position of Sámi women within Christianity. In general, Christianity produced broken relationships between the genders. Colonizers, considering female sexuality licentious, denounced it as something that needed to be controlled and even forbidden.[7]

We suggest that the wooden fierra was a symbol of the social bond between a male and a female, and the making of it was an act of gender equality.[8] A man was expected to

honor a woman by producing fierra and renewing that bond between them through the act. When the fierra was cut off the headdress and rejected, it was a symbolic act of breaking the equality and balance between men and women.

Traditionally, Sámi women were not subordinate to men, but that changed through the processes of colonialism and assimilation. When the Laestadian movement first began, it was radical, serving an important function for Sámi cultural continuity as a counterweight against colonial tactics in the North. Laestadius defended many Sámi ways of life, traditions, and language, and he saw womanhood as a virtue, even divine. However, increased contact with the patriarchal Lutheran church intensified the colonization of Sámi culture and minds, reinforcing the imposition of heteronormative and patriarchal European culture. New values and meanings emerged, especially in relation to women's self-understanding as being socially inferior, changing traditional cultural values and practices in Sápmi.[9]

We think that ládjogahpir carries a message from the foremothers who now live beside us and who will also be with us in the future. Simultaneously, this message comes from the past and the future to commune with current Sámi society.

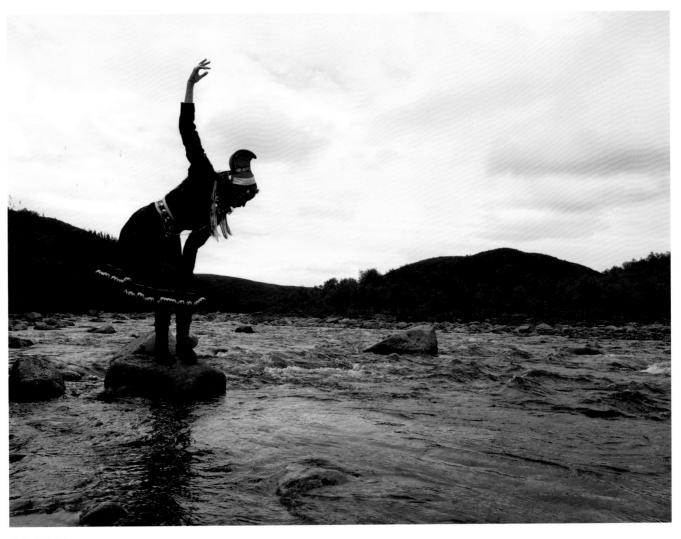

© *Outi Pieski.*

According to our interpretation, ládjogahpir communicates a gender-equal past, a society that prospered before colonial gender violence brought heteropatriarchy and so-called civilization to Sápmi.

Since gender equality in Sámi society was destroyed long ago, it is a miracle to reconstruct it now. Gender discrimination has been one of the epicenters of colonial subjugation of Indigenous communities. When European patriarchy was established in Sápmi, women were displaced from their original positions of respect and subjected to an unbalanced society.[10] This is the message that ládjogahpir has given us. There is something special and powerful when women wear this hat. Revitalizing this tradition is a step toward decolonization. This practice resonates with our relationship to the earth, our mother, and with all the beings to whom we are equal. Even though there is sacredness in all genders, we live in a world where the balance between them has been disturbed, and we must strive to recover its balance.

In North Sámi language, mother is *eadni* and Earth is *eana*, and these words have a common origin. As with other Indigenous peoples, the Sámi consider Earth to be feminine, sacred, and their mother. In the Sámi religion, goddesses dwell in the earth under the terrain of the traditional hut, the *goahti*, and its fireplace, the *árran*. Sámi folklore narrates about ancestors who have hidden treasures in the nature of Sápmi. These narratives tell us that the treasure is the earth itself. According to Sámi cosmology, under our feet, in the earth, there is another world. The inhabitants there look like humans; they are beautiful and dressed up just like the Sámi. They wear Sámi shoes made of reindeer hide or leather and tin or silver belts. They use a walking stick when they walk, just like the Sámi. They speak Sámi, and they practice the same livelihoods as the Sámi people. They teach how the Sámi should live, dress, and act in general.[11] This could be interpreted to mean that all wisdom and knowledge lives in the earth, and there is an obligation to listen to it. This habit has been forgotten, and that is why

Dressing with Purpose

Mother Earth is struggling and suffering. If we listen, she will tell us how to walk our paths like our ancestors have done before us. When we understand and embrace gender equality again, we will also understand that Earth is a female being that must be respected. Violence toward women equals the violence and plundering that we currently do to Earth.

In Sámi traditional cosmology, spirituality was involved in everyday life, not just in certain occasions or places. It was affiliated with everything that surrounded an individual, such as clothing. In the Sámi worldview, the past is always present, but it is also part of the future. One carries responsibility for the generations behind and ahead. This is the Sámi philosophy and way of life. Ancestors are present in time. The people before us are always beside us, and even the people from far away in prehistory are present as whispers. Earlier on, the ancestors were a part of the Sámi household, literally living beside them. During the early days of Christianity, the missionaries wrote in their notes that it was painful and difficult for the Sámi to give up the sacrifices and the connections to their ancestors. But the new faith demanded a change, and the ancestors were forsaken everywhere where Christianity was enforced.[12] The

demonization of sexuality followed and replaced the preexisting gender relations with inequity and hierarchical structures. This happened all around the world as a direct influence of colonialism, and maybe this is why we and our mother, the earth, suffer.

But let us go back to ládjogahpir, the outstanding hat of the Sámi women. Objects, or more accurately, belongings are documents of knowledge and an important part of the histories of oral cultures. Belongings carry the traditional knowledge of the ancestors within, and therefore they are a message that echoes from generation to generation. For those who can read the language, they contain encoded knowledges. In this context, cultural belongings are actors that, among other things, can provide consolation and security. This is why the repatriation of cultural heritage has a profound meaning for the Sámi and other Indigenous societies.[13]

Belongings that have been stored in museums can be rehabilitated and taken into use again for the future. For Indigenous societies like the Sámi, knowledge has traditionally been passed from generation to generation in the family. The history of forced assimilation and boarding schools during

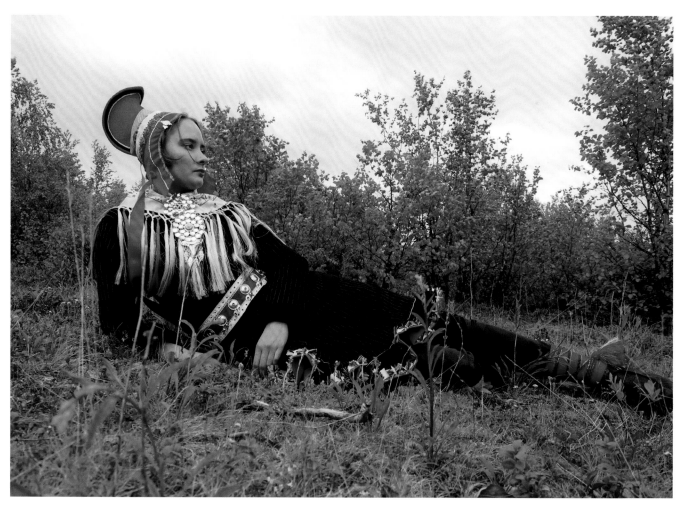

© Outi Pieski.

the twentieth century has disrupted this transmission of knowledge. However, objects can still connect us to our ancestors. Through objects, now stored in museums, we can hear the voices of our foremothers. Emotionally, objects can also transfer to ancestors and repair the cultural emptiness that the centuries of lasting, forced assimilation and living by the standards of the majority have caused. This is how duodji connects us to past generations but also comforts and empowers us in difficult situations. Then and there, it becomes alive again in the present, like ládjogahpir.[14]

We are a coalition of women who share power and wish to take back a worldview that has been lost. Through our work, the power of the hat is revitalized, or rather, it is *rematriated*.[15] In this context, rematriation has the potential to resocialize cultural belongings into the settings of everyday life. Repatriation returns stolen objects, but it does not necessarily restore their meanings and functions within society. The material culture of Indigenous peoples, in this case ládjogahpir, enables the continuance of heritage, despite colonial wounds. Objects can have a healing influence. The spiritual meaning and symbolism carried by ládjogahpir, the rehabilitation and revitalization of it as an object, and everything that follows—the knowledge, the symbolism, and the emotions—signify rematriation, a return to *eana eannážan*, mother our earth. This is why we need to take ládjogahpir back home.

Notes

1 Guttorm, "Ebmos nissonolmmoš dárbbaša hámálaš gahpira"; Fellman, *Anteckningar under min vistelse i Lappmarken*; Stockfleth, *Dagbog over mine Missionsreiser i Finmarken*; Zorgdrager, *De rettferdiges strid Kautokeino 1852*.

2 These interviews took place during workshops held in 2018.

3 Some younger women saw the hat as one more example of duodji and were mainly interested in learning to make it.

4 Demant Hatt, *With the Lapps in the High Mountains*; Dunfjeld, *Tjaalehtjimmie*; Guttorm, "Duoji bálgát"; Jannok-Porsbo, *Samedräkter i Sverige*; S. Magga, *Saamelainen käsityö yhtenäisyyden rakentajana*; Rydving, *The End of Drum-Time*.

5 Dunfjeld, *Tjaalehtjimmie*; Pentikäinen and Pulkkinen, *Saamelaisten mytologia*; Pollan, *For Djevelen er alt mulig*; Pollan, *Slik den ene samen har fortalt til den andre samen*; Rydving, *The End of Drum-Time*; Turi, *An Account of the Sámi*; Valkonen and Wallenius-Korkalo, "Embodying Religious Control."

6 Dunfjeld, *Tjaalehtjimmie*; Pentikäinen and Pulkkine, *Saamelaisten mytologia*; Pollan, *Slik den ene samen har fortalt til den andre samen*; Turi, *An Account of the Sámi*; Rydving, *The End of Drum-Time*; Valkonen and Wallenius-Korkalo, "Embodying Religious Control."

7 Kuokkanen, "The Logic of the Gift"; Pollan, *Slik den ene samen har fortalt til den andre samen*; Valkonen, "Lestadiolaisuuden jäljet saamelaisnaisten elämässä."

8 See, for example, Guttorm, "Duoji bálgát."

9 Kuokkanen, "The Logic of the Gift"; Pentikäinen and Pulkkinen, *Saamelaisten mytologia*; Pollan, *Slik den ene samen har fortalt til den andre samen*; Valkonen, "Lestadiolaisuuden jäljet saamelaisnaisten elämässä."

10 Kuokkanen, "The Logic of the Gift."

11 Pollan, *For Djevelen er alt mulig* and *Slik den ene samen har fortalt til den andre samen*; Rydving, *The End of Drum-Time*; Turi, *An Account of the Sámi*.

12 Pollan, *For Djevelen er alt mulig*; Pollan, *Slik den ene samen har fortalt til den andre samen*; Turi, *An Account of the Sámi*; Rydving, *The End of Drum-Time*.

13 Guttorm, "Sami duodjemetologiijat"; Guttorm, "Contemporary Duodji"; H. Hansen, "Constructing Sami National Heritage"; Rauni Magga Lukkari, personal communication, September 9, 2017.

14 Harlin, "Returning Home"; Rasmus, *Bággu vuolgit—Baggu birget*; White, "Extract from a Presentation at the Symposium, Indigenous Perspectives on Repatriation."

15 See Kuokkanen, "Indigenous Gender Justice."

Conclusion

The Future of Traditional Dress

Carrie Hertz

This book opened with a case of resistance to the cultural mis-appropriation of local dress (and with it, the misrepresentation of marginalized identities), placing it within a larger conversation situated in and repeated throughout networks created by Western colonialism and modernist cultural hegemony. We chose one small node in that vast web for the scope of our subject. Through the words and works of individuals living across Scandinavia today, we have contemplated how people can create and re-create dress traditions to gain personal agency over their own self-image—as well as influence their relationships with others and the meanings they assign to the past. Through the creative and performative medium of dress, many of these individuals are motivated by a desire to express counterhegemonic positions, challenge the assumed irrelevance of particular social and cultural identities within modernity, cultivate aspirations for aesthetic excellence, and transform places into healthy communities of mutual consent.

The early decades of the twenty-first century have been marked by a prolonged struggle to dismantle the disquieting echoes of outmoded social theories and taxonomies, especially those imagining essentialized and hierarchical categories of race, class, and gender. In this book, we join other scholars arguing that "the self and identity are not stable entities; rather they shift in and through performance."[1] Dress can help define, manifest, and manipulate intersectional features of social identity, providing a medium through which aspects of identity can be visually encoded, ranked, policed, and resisted through individual acts of embodiment. At the moment, however, our essentializing vocabularies for describing dress, both academic and vernacular, have not caught up with these ideas, constraining our ability to adequately articulate the nuances of subjectivities created within complex social histories, political conflicts, economic systems, global networks, and personal biographies.

We have also argued for a reconsideration of the importance of tradition in our modern lives and the anticipated disappearance of traditional dress. Styles of dress that have been valorized as traditional remain compelling because they can suggest the authority of consensus, the security of collective responsibility, the intimacy of shared memory, and the possibility for personal distinction and artistic satisfaction within esteemed genres of creativity. They provide the opportunity for claiming social categories of belonging, as well as defining and delineating those categories through embodied representation in living context and therefore extending the potential for positively affecting public perception of the person, the collective identities, and the tradition. In other words, each performance, each act of dressing, is another

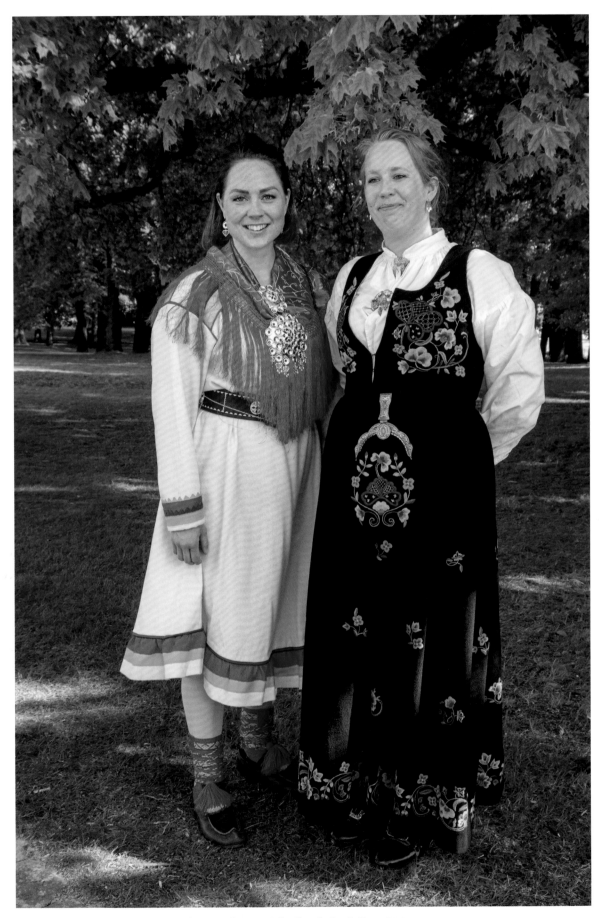

Gákti and embroidered bunad both worn for Søttende mai in Oslo. *Photo by Carrie Hertz, 2018.*

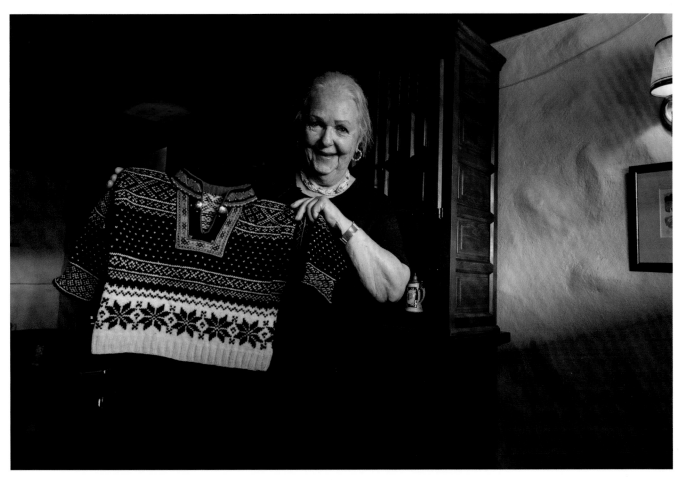

May-Lis Flateland of Valle in Setesdal with a sweater she knitted. *Photo by Chloe Accardi, 2018.*

chance to interpret and renegotiate statements of identity and the construction of categories. Traditional forms of dress can therefore become dense with meanings, accrued and complicated by spatial and temporal shifts; they act as focal points for contemplation and judgment, "performing tasks on a rhetorical level" for their makers, users, and beholders.[2] By dressing with purpose, people everywhere attempt to articulate who they are, reflect critically on the past, and reshape the societies they live in.

As I write this conclusion, I am housebound, isolated in solidarity with millions of others hoping to mitigate the potential ravages of a global pandemic. It feels as if the entire world is in a state of mourning, unstable and poised on the precipice of profound change. The questions we always confront—How do we adapt old forms to our new situation? What aspects from our past are worth saving?—have been heightened to an urgent and explicit mode of public discourse. The disproportionate devastation experienced by those on the social peripheries—the poor, exploited, uninsured, incarcerated, overpoliced, undocumented, disabled, dismissed, disenfranchised, displaced, and discriminated against—has exposed and exacerbated foundational inequalities that have been too easily ignored for too

long. Many are asking what we owe each other. What response can constitute the common good? What good are borders and national isolationism during a global health crisis? What progressive promises do democracy and capitalist economies answer if their functional institutions can be highjacked to serve only the few? As protestors against stay-at-home orders are gathering in the streets, demanding we resume business as usual, and denying that rights may also entail social responsibilities, my social media feeds have been filling up with videos of cooperation and hopeful transformations.

Known variously as the "don't rush," "makeup brush," or "pass the brush" challenge, this meme of self-made videos was started by a group of bored friends, most of African descent, self-isolating in separate dorm rooms at the University of Hull in England. Over WhatsApp, they filmed and edited together a sequence of clips showing each woman, plainly dressed, with no makeup, momentarily blocking the camera with a cosmetic brush passed between them like a "metaphorical baton."[3] When the brush is pulled away, she has magically transformed into a more glamorous version of herself, dressed and styled for a night out with friends. The mundane dress of daily life is disrupted with a breakthrough into the performance of a

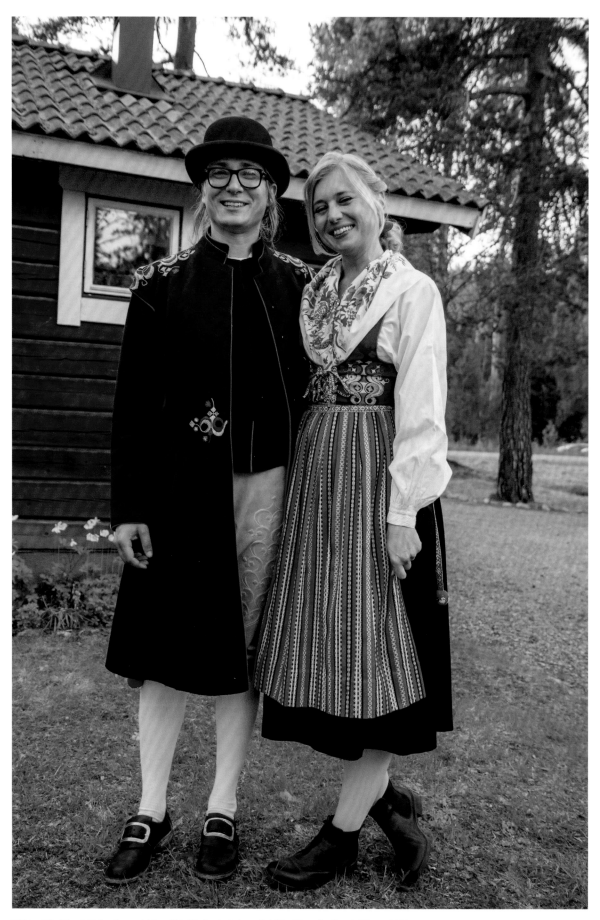

Tobias Gärdsback Rylander and Meredith Marlay in Leksandsdräkt. *Photo by Carrie Hertz, 2015.*

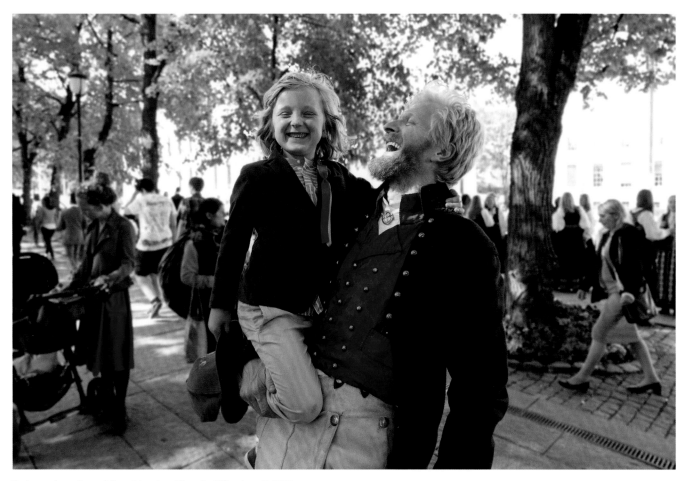

Father and son dressed for celebration. *Photo by Chloe Accardi, 2018.*

heightened, more carefully communicated self-portrait. Toluwalase Asolo, who posted the video for the group on TikTok on March 22, 2020, told *Teen Vogue* that they hoped to "highlight the togetherness in isolation" and to empower "Black women and the immense amount of beauty that is all around the world."[4]

In the weeks that followed, countless iterations emerged across multiple social media platforms, demonstrating diverse networks of belonging, inspiration, and support. When official Søttende mai parades were canceled for public safety, organizations and individuals released videos of Norwegians and Norwegian Americans celebrating at home, changing into bunader with the wave of a Norwegian flag. A subset of the videos appearing specifically celebrate ethnic and Indigenous dress and beauty traditions commonly marginalized, if not historically suppressed, within majority Western cultures. Featuring some men and boys but mostly women and girls, these videos showcase Sámi in gákti, Palestinians in embroidered *thobs*, Maori in *piu piu* with *pari* striking haka poses, Nigerians in Ankara wax prints, and Native Americans from various nations in powwow regalia.

Where I live in New Mexico, a few heavily circulating videos highlight women from local pueblos changing from casual loungewear into highly personalized versions of the off-the-shoulder *manta* dresses worn for dances and feast days. One after the other, from one frame to the next, the women pass not only makeup brushes but also painted clay pots, turquoise jewelry, woven sashes, and blankets—significant objects that further imply the purposeful and selective transmission of shared artistry and cultural knowledge from generation to generation and peer to peer. One of the participants, Mariah Sandoval from San Felipe Pueblo, labeled the video she posted on April 9, 2020, on her Facebook page by writing, "We should be proud of who we are, where we come from, & the simple fact that we still thrive [on] these lands our ancestors fought so hard for us to keep."

Old analytical classifications that artificially or arbitrarily split dress into tradition and fashion can make it difficult to imagine vibrant futures for those whose cultures, perspectives, and personhoods have been devalued and disregarded by modernist, universalist theories and social structures. As so many individuals featured in this book have proclaimed, they do not

recognize themselves in representations that exist only as objectified "museum cultures," collected, preserved, cataloged like specimens using classification systems foreign to their creators, and forgotten like stolen bones on a shelf. These distorted, frozen constructions have worked to legitimize and perpetuate the hierarchical systems of colonialism, nationalism, white supremacy, and class inequality. This museological mode of abstraction makes it possible to sort the world and its people into conceptually bounded and named objects for comparison, but, as Eric R. Wolf argues, it also "creates false models of reality." He explains that "the ability to bestow meanings—to 'name' things, acts, and ideas—is a source of power. Control of communication allows the managers of ideology to lay down the categories through which reality is to be perceived." Wolf concludes that "only by understanding these names as bundles of relationships, and by placing them back into the field from which they were abstracted, can we hope to avoid misleading inferences and increase our share of understanding."[5]

Our goal has been to return commonly accepted conceptual categories of dress (most explicitly folk, national, and ethnic costume) back to the field and to untangle the "bundles of relationships"—the interwoven sociocultural, economic, political, historical, and ideological forces—that create and animate them so we may better understand how dress traditions as cultural forms "work to mediate social relationships among particular populations" in particular times and places.[6]

We end this book by coming full circle from the subjective collecting and classifications wielded by outsiders to the acts of "rematriation" and rehabilitation directed by source communities, reclaiming stolen objects, value systems, and ways of life. Even in the collections amassed for the purposes of nation-building and solidifying colonial power, we find more than subjects of conquest and cataclysmic change; we can find linchpins of hope for cultural survival, empowerment, reclamation, and healing. An appropriate corrective to outdated concepts of dress (as well as museology) requires recognizing the attendant issues of power, privilege, and distance to assign meaning to the self-expressions of others, to claim universalist taxonomies, to write histories and laws, and to take and curate for one's own purposes what others have made.

Though dress helps us fashion personal identity, we cannot act independently from the social regimes that limit access to both material and meaning. Nor can we act outside of time and space, the situated realities we inhabit. In considering the role of clothing during periods of mourning, for example, Peter Stallybrass argues that garments are "about memory, but also about power and possession." As a durable form of material culture, specific articles of dress often outlast their strategic moments of social utility. We cannot possess ideas or fleeting moments, but we can lay our hands on their mnemonic devices. So, we must ask, Who is empowered as their keepers and future interpreters? Who can determine their obsolescence or insignificance? Who can give them new life through revival and reinvention?

Yet garments are more than ideas; they hold meanings beyond a negotiated language of signifiers. Stallybrass writes, "In thinking of clothes as passing fashions, we repeat less than a half-truth," an idealization of modern capitalism in which garments are merely empty containers that can be "endlessly devalued and replaced," consumed and discarded. When our loved ones die, the clothes they leave behind still carry their smell, their shape, their gestural echoes in patterns of wear. They cannot be so easily divested, because "clothes carry the human imprint," surviving transient moments of embodiment.[7] Old clothes (and new clothes made in their image) can supply the implied and tangible presence of those we have lost. As Harlin and Pieski argue, they let our ancestors stand beside us.

While we can imagine even the most mundane garment absorbing its wearer's essence, the styles of dress we call traditional can give similar substance to a greater collective and to longer timelines of continuity. They can help us call on the memory of our ancestors—their struggles and aesthetic achievements, and the better futures they tried to give us. They can promise hope and the comfort of home when we most need it in moments of crisis and rupture. They can help us clarify our true selves, our core values, our greatest aspirations, so we may adapt to meet the challenges of our times.

Notes

1 Graham and Penny, "Performing Indigeneity," 4.

2 See DuBois, *Sacred to the Touch*, 164.

3 Isama, "The Real Reason the #DontRushChallenge Was Created."

4 Ibid.

5 Wolf, *Europe and the People without History*, 6, 388, 3.

6 Ibid., 19.

7 Stallybrass, "Worn Worlds," 28–31.

Bibliography

Aamold, Svein. "Unstable Categories of Art and People." In *Sámi Art and Aesthetics: Contemporary Perspectives*, edited by Svein Aamold, with Elin Haugdal and Ulla Angkjær Jørgensen, 13–30. Aarhus, Denmark: Aarhus University Press, 2017.

Abrahams, Roger D. "Phantoms of Romantic Nationalism in Folkloristics." *Journal of American Folklore* 106, no. 419 (Winter 1993): 3–37.

Abram, Simone. "Jokkmokk: Rapacity and Resistance in Sápmi." In *Postcolonial Perspectives on the European High North: Unscrambling the Arctic*, edited by Graham Huggan and Lars Jensen, 67–92. London: Palgrave Macmillan, 2016.

Ågren, Katarina. "Handicrafts and Folk Art." In *Swedish Folk Art: All Tradition Is Change*, edited by Barbro Klein and Mats Widbom, 195–207. New York: Harry N. Abrams, 1994.

Ahlström, Torbjörn, Elisabeth Iregren, Lena Strid, and Kristina Jennbert. "Sweden." In *The Routledge Handbook of Archaeological Human Remains and Legislation*, edited by Nicholas Márquez-Grant and Linda Fibiger, 441–454. New York: Routledge, 2011.

Aira, Elsa, Karin Tuolja, and Anna-Lisa Pirtsi Sandberg. *Julevsáme Gárvo / LuleSámiska Dräkter*. Jåhkåmåhkke, Sweden: Ájtte, Svenskt Fjäll-och Samemuseum, 1995.

Anawalt, Patricia Rieff. *The Worldwide History of Dress*. London: Thames and Hudson, 2007.

Anderson, Benedict. *Imagined Communities: Reflections on the Origin and Spread of Nationalism*. London: New Left Books, 2016. First published 1983.

Andersson, Eva I. "Foreign Seductions: Sumptuary Laws, Consumption and National Identity in Early Modern Sweden." In *Fashionable Encounters: Perspectives and Trends in Textile and Dress in the Early Modern Nordic World*, edited by Tove Engelhardt Mathiassen, Marie-Louise Nosch, Maj Ringgaard, Kirsten Toftegaard, and Mikkel Venborg Pedersen, 15–30. Oxford: Oxbow Books, 2014.

Anthony, Katharine. *Feminism in Germany and Scandinavia*. New York: Henry Holt and Company, 1915.

Antonsen, Lene, and Henrik Olsen. *Sjøsámisk klesbruk i gamle Lyngen*. Gáivuona, Norway: Gáivuona Sámesearvi / Kåfjord sameforening, 1995.

Anttonen, Pertti J. *Tradition through Modernity: Postmodernism and the Nation-State in Folklore Scholarship*. Helsinki: Finnish Literature Society, 2005.

Arnö-Berg, Inga, and Gunnel Hazelius-Berg. *Folk Costumes of Sweden: A Living Tradition*. Örebo, Sweden: Ljungföretagen, 1975.

Aronsson, Kjell-Åke. "Research on Human Remains of Indigenous People: Reflections from an Archaeological Perspective (with an Example from Rounala)." In *More than Just Bones: Ethics and Research on Human Remains*, edited by Fossheim Hallvard, 65–79. Oslo: Norwegian National Research Ethics Committees, 2013.

Aronsson, Peter, and Lizette Gradén, eds. *Performing Nordic Heritage: Everyday Practices and Institutional Culture*. Surrey, England: Ashgate, 2013.

Asplund, Johan. *Tid, rum, individ, kollektiv*. Stockholm: Kontenta (LiberFörlag), 1983.

Baglo, Cathrine. "The Disappearance of the Sea Sámi as a Cultural Display Category: Assimilation Policies and the Role of Industrial Expositions." In Baglo, Nyyssönen, and Ragazzi, "From Lappology to Sámi Museology," 25–44.

———. "Rethinking Sami Agency during Living Exhibitions: From the Age of Empire to the Postwar World." In *Performing Indigeneity: Global Histories and Contemporary Experiences*, edited by Laura R. Graham and H. Glenn Penny, 136–168. Lincoln: University of Nebraska Press, 2014.

Baglo, Cathrine, Jukka Nyyssönen, and Rossella Ragazzi, eds. "From Lappology to Sámi Museology." Special issue, *Nordisk Museologi: The Journal of Nordic Museology* 27, no. 3 (2019).

Baizerman, Suzanne, Joanne B. Eicher, and Catherine Cerny. "Eurocentrism in the Study of Ethnic Dress." In *The Visible Self: Global Perspectives on Dress, Culture and Society*, edited by Joanne Eicher, Sandra Lee Evenson, and Hazel A. Lutz, 97–106. New York: Fairchild Books, 1996.

Bangstad, Torgeir R. "Industrial Heritage and the Ideal of Presence." In *Ruin Memories: Materialities, Aesthetics and the Archeology of the Recent Past*, edited by Bjørnar Olsen, Þóra Pétursdóttir, 92–106. New York: Routledge, 2014.

Barton, H. Arnold. "The Discovery of Norway Abroad, 1760–1905." *Scandinavian Studies* 79, no. 1 (2007): 25–40.

———. "Skansen and the Swedish Americans." *Swedish-American Historical Society* 48, no. 4 (1997): 164–180.

Bårtvedt, Randi, and Axel Mykleby. "The Tourists, the Landscape and the Fantasy Hotels." *Grind*, Universitetet i Bergen, May 19, 2009. https://www.grind.no/en/animal-life/tourists-landscape-and-fantasy-hotels.

Bastien, Betty, Jürgen W. Kremer, Rauna Kuokkanen, and Patricia Vickers. "Healing the Impact of Colonization, Genocide, and Racism on Indigenous Populations." In *The Psychological Impact of War Trauma on Civilians: An International Perspective*, edited by Stanley Krippner and Teresa M. McIntyre, 25–37. West Port, CT: Praeger, 2003.

Bauman, Richard. "Folklore." In *Folklore, Cultural Performances, and Popular Entertainments: A Communications-Centered Handbook*, edited by Richard Bauman, 29–40. New York: Oxford University Press, 1992.

———. "Performance." In *Folklore, Cultural Performances, and Popular Entertainments: A Communications-Centered Handbook*, edited by Richard Bauman, 41–50. New York: Oxford University Press, 1992.

———. *Story, Performance, and Event: Contextual Studies of Oral Narrative*. Cambridge: Cambridge University Press, 1986.

Beach, Hugh. *A Year in Lapland: Guest of the Reindeer Herders*. Seattle: University of Washington Press, 2001. First published 1993.

Belfanti, Carlo Marco. "The Civilization of Fashion: At the Origins of a Western Social Institution." *Journal of Social History* 43, no. 2 (2009): 261–283.

Belk, Russell W. "Collectors and Collecting." In *Interpreting Objects and Collections*, edited by Susan M. Pearce, 317–326. London: Routledge, 2003.

Ben-Amos, Dan. "Toward a Definition of Folklore in Context." In *Toward New Perspectives in Folklore*, edited by Américo Paredes and Richard Bauman, 3–19. Bloomington: Trickster Press, 2000. First published 1972.

Bendix, Regina. *In Search of Authenticity: The Formation of Folklore Studies.* Madison: University of Wisconsin Press, 1997.

Bendix, Regina F., Aditya Eggert, and Arnika Peselmann, eds. *Heritage Regimes and the State.* Göttingen, Sweden: Universitätsverlag Göttingen, 2012. http://webdoc.sub.gwdg.de/univerlag/2012/GSCP6 _Bendix.pdf.

Bendix, Regina, and Dorothy Noyes, eds. "In Modern Dress: Costuming the European Social Body, 17th–20th Centuries." Special issue, *Journal of American Folklore* 111, no. 440 (1998).

Bennett, Tony. *The Birth of the Museum: History, Theory, Politics.* London: Routledge, 1995.

Berg, Roald. "From 'Spitsbergen' to 'Svalbard': Norwegianization in Norway and in the 'Norwegian Sea,' 1820–1925." *Acta Borealia* 30, no. 2 (2013): 154–173.

Bergesen, Rognald Heiseldal. "Hybrid Iconoclasm: Three Ways of Viewing the Sámi as the Other." In *Sámi Art and Aesthetics: Contemporary Perspectives*, edited by Svein Aamold, with Elin Haugdal and Ulla Angkjær Jørgensen, 31–48. Aarhus, Denmark: Aarhus University Press, 2017.

Berglund, Nina. "Bunads Turn into New Battle Gear." *News in English: Views and News from Norway*, May 2, 2019. https://www.newsin english.no/2019/05/02/bunads-turn-into-new-battle-gear/.

———. "Half Losing Faith in the Welfare State." *News in English: Views and News from Norway*, March 13, 2018. https://www.newsinenglish .no/2018/03/13/half-losing-faith-in-the-welfare-state/.

Bergman, Elfrida, and Sara Lindquist, eds. *Queering Sápmi—Indigenous Stories beyond the Norm.* Umeå: Qub Förlag, 2013.

Bergman, Eva. *Nationella dräkten: En studie kring Gustaf III: Dräktreform, 1778.* Stockholm: Nordiska museet, 1938.

Bergman, Ingrid. *Folk Costumes in Sweden.* Stockholm: Swedish Institute, 2001.

———. "När den första sverigedräkten lanserades i Falun." In *Dalarna 2005: En resa i tid och rum. Dalarnas hembygdsbok*, edited by Jan Raihle and Elizabeth Ståhl, 195–204. Dalarnas Fornminnes och Hembygdsförbund: Dalarnas Museum, 2005.

Bertram, Laurie. "Power Patterns: Discussing the Icelandic Sweater and the Greenlandic Nuilarmiut at the Pitt Rivers Museum." Object Lives and Global Histories in Northern North America: Networks, Localities, and Material Culture c. 1700s–2000s, September 9, 2015. http://objectlives.com/discovery-workshop/2015/9/8/power -patterns.

Billig, Michael. *Banal Nationalism.* London: Sage, 1995.

Bjørgen, Hildegunn, and Brit Marie Hovland. "I takt med nasjonen—den nasjonale 17. Mai paraden gjennom historia." In *Nasjonaldagsfeiring i fleirkulturelle demokrati*, edited by Brit Marie Hovland and Olaf Aagedal, 27–56. Århus, Denmark: Nordisk Ministerråd, 2001.

Björk, Daniel. "Sverigedemokraterna klär sig som eliten." *Expressen*, Debatt, October 6, 2010. https://www.expressen.se/debatt /daniel-bjork-sverigedemokraterna-klar-sig-som-eliten/.

Björklöf, Sune, Ingrid Bergman, Ulla Bergund Brasch, and Elisabeth Thorman. *Leksands Hemslöjd: 100 år av skaparglädje och gott hantverk.* Laholm: Tryck Trydells Tryckeri, 2004.

Bjørklund, Ivar. "Local History in a Multi-ethnic Context—the Case of Kvænangen, Northern Norway." iActa Borealia 1/2 (1985): 47–56.

Björkroth, Maria. "*Hembygd*—a Concept and Its Ambiguities." *Nordisk Museologi* 2 (1995): 33–40.

Bjørnholdt, Margunn. "Hvorfor er folkedrakt så viktig i Norge og marginalt i nabolandene?" *Nordic Journal of Cultural Policy* 8, no. 2 (2005): 34–50.

Bladow, Kyle. "'Never Shut Up My Native': Indigenous Feminist Protest Art in Sápmi." *Feminist Studies* 45, no. 2–3 (2019): 312–332.

Blåhed, Hanna. "Sweden's Indigenous Sami People Held Their First-Ever Pride Event." *Vice News*, October 21, 2014. https://www.vice .com/en_us/article/bn53p3/sapmi-has-its-first-ever-pride-festival -in-kiruna.

Blehr, Barbro. "Sacred Unity, Sacred Similarity: Norwegian Constitution Day Parades." *Ethnology* 38, no. 2 (1999): 175–189.

Blom, Ida. "Gender and Nation in International Comparison." In *Gendered Nations: Nationalisms and Gender Order in the Long Nineteenth Century*, edited by Ida Blom, Karen Hagemann, and Catherine Hall, 3–26. Oxford: Berg, 2000.

Boëthius, Gerda. *Dalarna (Dalecarlia): A Description of Its Scenery, Its People and Its Culture.* Stockholm: Victor Pettersons Bokindustriaktiebolag, 1930.

Bogatyrev, Petr. *The Functions of Folk Costume in Moravian Slovakia.* Paris: Mouton, 1971. First published 1937.

Bohman, Stefan. "Nationalism and Museology: Reflections on Swedish Experience." In *Heritage and Museums: Shaping National Identity*, edited by J. M. Fladmark, 275–286. Dorset, UK: Donhead, 2000.

Boine Verstad, Anders. "Inspireres av sosiale medier til å lage duodji." *NRK Sápmi*, July 21, 2017. https://www.nrk.no/sapmi/inspireres-av -sosiale-medier-til-a-lage-duodji-1.13609114.

Borberg, Gunnar, and Nils Roll-Hansen. *Eugenics and the Welfare State: Norway, Sweden, Denmark, and Finland.* East Lansing: Michigan State University Press, 2005.

Brashers, Kerstin. *Sing the Cows Home: A Folklore Field Study of the Swedish Fäbod.* La Mesa, CA: Associated Creative Writers, 1983.

Brask, Per. "Recovering a Language: An Interview with Knut Walle and Kurt Hermansen of the Beaivváš Theater." In *Aboriginal Voices: Amerindian, Inuit, Sami Theatre*, edited by Per Brask and William Morgan, 139–145. Baltimore: Johns Hopkins University Press, 1992.

Briggs, Charles L. "The Politics of Discursive Authority in Research on the 'Invention of Tradition.'" *Cultural Anthropology* 11, no. 4 (1996): 435–469.

Bronner, Simon. *Explaining Traditions: Folk Behavior in Modern Culture.* Lexington: University Press of Kentucky, 2011.

Brottveit, Ånund, Brit Marie Hovland, and Olaf Aagedal. *Slik blir nordmenn norske bruk av nasjonale symbol i eit fleirkulturelt samfunn.* Oslo: Unipax, 2004.

Brück, Ulla. "Identitet, lokalsamhälle och lokal identitet." *RIG* 67, no. 3 (1984): 65–78.

Bruening, Elizabeth. "Bunad Restoration." *Capital Viking*, April 2014.

Buijs, Cunera, and Mariane Petersen. "Festive Clothing and National Costumes in 20th Century East Greenland." Études/Inuit/Studies 28, no. 1 (2004): 83–107.

Bumpus, Jessica. "A Controversial Fashion." *Vogue UK*, March 19, 2009. https://www.vogue.co.uk/article/protests-against-peter -jensens-autumn-winter-collection.

Bush, Nancy. "The Hair Workers of Sweden." *Piecework* 10, no. 3 (2002): 34–37.

Bydler, Charlotte. "Decolonial or Creolized Commons? Sámi *Duodji* in the Expanded Field." In *Sámi Art and Aesthetics: Contemporary*

Perspectives, edited by Svein Aamold, with Elin Haugdal and Ulla Angkjær Jørgensen, 141–162. Aarhus, Denmark: Aarhus University Press, 2017.

Cantú, Norma E. "Wearing Identity: Chicanas and Huipiles." In *MeXicana Fashions: Politics, Self-Adornment, and Identity Construction*, edited by Aída Hurtado and Norma E. Cantú, 25–50. Austin: University of Texas Press, 2020.

Cashman, Ray. "Critical Nostalgia and Material Culture in Northern Ireland." *Journal of American Folklore* 119, no. 472 (2006): 137–160.

Cashman, Ray, Tom Mould, and Pravina Shukla, eds. *The Individual and Tradition: Folkloristic Perspectives*. Bloomington: Indiana University Press, 2011.

Centergran, Ulla. *Bygdedräkter, bruk och brukare*. Göteborg, Sweden: Idrottens tryckeri, 1996.

Chakrabarty, Dipesh. *Provincializing Europe: Postcolonial Thought and Historical Difference*. Princeton: Princeton University Press, 2007. First published 2000.

Chapman, Malcolm. "'Freezing the Frame': Dress and Ethnicity in Brittany and Gaelic Scotland." In *Dress and Ethnicity: Change across Space and Time*, edited by Joanne Eicher, 7–28. Oxford: Berg, 1995.

Cocq, Coppélie. "Indigenous Voices on the Web: Folksonomies and Endangered Languages." *Journal of American Folklore* 128, no. 509 (2015): 273–285.

———. "Sámi Storytelling as a Survival Strategy." In *Rethinking Cultural Transfer and Transmission: Reflections and New Perspectives*, edited by Petra Broomans, Sandra Van Voorst, and Karina Smits, 33–49. Eelde, Netherlands: Barkhuis, 2012.

———. "Traditionalisation for Revitalisation: Tradition as a Concept and Practice in Contemporary Sámi Contexts." *Folklore: Electronic Journal of Folklore* 57 (2014): 79–100.

Cocq, Coppélie, and Thomas A. DuBois. *Sámi Media and Indigenous Agency in the Arctic North*. Seattle: University of Washington Press, 2020.

Coe, Cati. "The Education of the Folk: Peasant Schools and Folklore Scholarship." *Journal of American Folklore* 113, no. 447 (2000): 20–43.

Cohen, Nadia Shira. "In Norway, Reindeer Are a Way of Life—until It Winds Up in Court." *New York Times*, December 17, 2018.

Colburn, Carol Huset. "Norwegian Folk Dress in America." In *Norwegian Folk Art: Migration of a Tradition*, edited by Marion Nelson, 157–170. New York: Abbeville, 1995.

———. "Norwegian Folk Dress in the United States." In *Berg Encyclopedia of World Dress and Fashion: West Europe*, edited by Lise Skov, 342–344. Oxford: Berg, 2010.

Conrad, Joann. "Mapping Space, Claiming Place: The (Ethno-) Politics of Everyday Geography in Northern Norway." In *Creating Diversities: Folklore, Religion and the Politics of Heritage*, edited by Anna-Leena Siikala, Klein Barbro, and Stein R. Mathisen, 165–189. Helsinki: Finnish Literature Society, 2004.

Crang, Mike. "Nation, Region and Homeland: History and Tradition in Dalarna, Sweden." *Ecumene* 6, no. 4 (1999): 447–470.

Crouch, David. "Sweden's Indigenous Sami People Win Rights Battle against State." *The Guardian*, February 3, 2016. https://www.theguardian.com/world/2016/feb/03/sweden-indigenous-sami-people-win-rights-battle-against-state.

Cruickshank, Jørn, Winfried Ellingsen, and Knut Hidle. "A Crisis of Definition: Culture versus Industry in Odda, Norway." *Geografiska Annaler: Series B* 95, no. 2 (2013): 147–161.

Dahl, Joahn A. *Norwegian and Swedish Poems*. Bergen: Dahl, 1872.

Debatty, Régine. "Suohpanterror: Propaganda Posters from Sápmi." *We Make Money Not Art* (blog), April 7, 2015. http://we-make-money-not-art.com/suohpanterror/.

DeGroff, Daniel Alan. "Artur Hazelius and the Ethnographic Display of the Scandinavian Peasantry: A Study in Context and Appropriation." *European Review of History: Revue Europpeene d'Histoire* 19, no. 2 (2012): 229–248.

Delaporte, Yves, Michèle Roué, and Ann Cooper. "Lapp Fur Coats: Clothing Adaptation in a Pastoral Society." *Arctic Anthropology* 17, no. 2 (1980): 64–67.

Demant Hatt, Emilie. *With the Lapps in the High Mountains. A Woman among the Sami, 1907–1908*. Edited and translated by Barbara Sjoholm. Madison: University of Wisconsin Press, 2013.

Dewar, Veronica. "Our Clothing, Our Culture, Our Identity." In *Arctic Clothing*, edited by J. C. H. King, Birgit Pauksztat, and Robert Storrie, 23–26. London: British Museum Press, 2005.

Dokka, Ingrid. "From Conceptions of Sami Culture in Norwegian Film to an Independent Sami Film Expression." In *Visions of Sápmi*, edited by Anne Lydia Svalastog and Gunlög Fur, 107–127. Røros: Arthub, 2015.

DuBois, Thomas A. "Costuming the European Social Body: A Response." In Bendix and Noyes, "In Modern Dress," 218–224.

———. "Lars Levi Sunna: Crafting a Sámi Presence in the Swedish State Church." *Temenos: The Finnish Society for the Study of Religion* 48, no. 2 (2012): 131–154.

———. *Sacred to the Touch: Nordic and Baltic Religious Wood Carving*. Seattle: University of Washington Press, 2018.

Dunfjeld, Maja. *Tjaalehtjimmie: Form og innhold I sørsamisk ornamentikk*. Snåsa: Saemien Sijte, 2006.

Durán, Laila. *Bunader og Tradisjoner fra Setesdal*. Märsta, Sweden: Duran, 2015.

Edenheim, Ralph. *Skansen: Traditional Swedish Style*. Translated by Neil Smith. London: Scala, 1995.

Eicher, Joanne, Abby Lillethun, and Linda Welters. "(Re)Defining Fashion in Dress." *Dress* 38 (2012): 75–97.

Eicher, Joanne, and Barbara Sumberg. "World Fashion, Ethnic and National Dress." In *Dress and Ethnicity: Change across Space and Time*, edited by Joanne Eicher, 295–306. Oxford: Berg, 1995.

Eicher, Joanne Bubolz, Sandra Lee Evenson, and Hazel A. Lutz, eds. *The Visible Self: Global Perspectives on Dress, Culture, and Society*. 2nd ed. New York: Fairchild, 2000. First published 1973.

Eidheim, Harald. "When Ethnic Identity Is a Social Stigma." In *Aspects of the Lappish Minority Situation*, edited by Harald Eidheim, 50–67. Oslo: Universitetsforlaget, 1971.

Eitrheim, Karsten, Endre Skaar, and Nils George Brekke. "Odda: The Industrial Town." *Grind* (Universitetet i Bergen), June 9, 2015. https://www.grind.no/en/hardanger/odda/odda-industrial-town.

Eklund, Britt. *Dräktalmanacka Boda socken, Dalarna*. Uppsala: Institutet för språk och folkminnen, 2016.

Eklund, Britt, and Katarina Ek-Nilsson. "Folk Costumes during the Ritual Year and Changes in Life, in a Parish in Dalecarlia, Sweden: Continuity, Values, Revitalisation." *Folklore* 66 (2016): 155–164. http://www.folklore.ee/folklore/vol66/eklund_ek.pdf.

Ekman, Ann-Kristin. "The Revival of Cultural Celebrations in Regional Sweden: Aspects of Tradition and Transition." *European Society for Rural Sociology* 39, no. 3 (1999): 280–293.

Eldvik, Berit. "Dräkten som kulturarv." In *Åter till Sollerön: Om kulturarv, folk och landsbygd*, edited by Cecilia Hammarlund-Larsson,

Bo Larsson, and Annette Rosengren, 43–70. Stockholm: Nordiska museet, 2002.

———. *Möte med mode: Folkliga kläder 1750–1900 i Nordiska museet.* Stockholm: Nordiska museets förlag, 2014.

———. *Power of Fashion: 300 Years of Clothing.* Stockholm: Nordiska museet, 2010.

Elgenius, Gabriella. "The Politics of Recognition: Symbols, Nation Building and Rival Nationalisms." *Nations and Nationalism* 17, no. 2 (2011): 396–418.

Engelhardt Mathiassen, Tove, Marie-Louise Nosch, Maj Ringgaard, Kirsten Toftegaard, and Mikkel Venborg Pedersen, eds. *Fashionable Encounters: Perspectives and Trends in Textile and Dress in the Early Modern Nordic World.* Oxford: Oxbow Books, 2014.

Entwistle, Joanne. *The Fashioned Body: Fashion, Dress and Modern Social Theory.* Cambridge: Polity, 2000.

Entwistle, Joanne, and Elizabeth Wilson, eds. *Body Dressing.* Oxford: Berg, 2001.

Eriksen, Thomas Hylland. "Hijaben og 'de norske verdiene.'" In *Hijab i Norge*, edited by Njål Høstmælingen, 97–114. Oslo: Abstrakt forlag, University of Oslo, 2008.

———. "Keeping the Recipe: Norwegian Folk Costumes and Cultural Capital." *Focaal: Journal of Global and Historical Anthropology* 44 (2004): 20–34.

———. "Traditionalism and Neoliberalism: The Norwegian Folk Dress in the 21st Century." In *Culture as Property: Pathways to Reform in Post-Soviet Siberia*, edited by Erich Kasten, 267–286. Berlin: Dietrick Reimer, 2004.

Evjen, Bjørg. "'. . . Thought I Was Just a *Same*': 'Lulesame' and 'Lulesamisk Area' as New Political and Identity-Shaping Expressions." *Acta Borealia* 1 (2004): 41–53.

Export Music Sweden. "Interview: Folk Musicians against Racism." Accessed February 11, 2021. http://exms.org/interview-folk-musicians-against-racism/.

Eythórsson, Einar. "The Coastal Sami: A 'Pariah Caste' of the Norwegian Fisheries? A Reflection on Ethnicity and Power in Norwegian Resource Management." In *Indigenous Peoples: Resource Management and Global Rights*, edited by Svein Jentoft, Henry Minde, and Ragnar Nilsen, 149–162. Delft, Netherlands: Eburon Academic Publishers, 2003.

Facos, Michelle. *Nationalism and the Nordic Imagination: Swedish Art of the 1890s.* Berkeley: University of California Press, 1998.

Fain, E. F. "Nationalist Origins of the Folk High School: The Romantic Visions of N.F.S. Grundtvig." *British Journal of Educational Studies* 19, no. 1 (1971): 70–90.

Falck, Erika Nordvall. *Marknadsvantar/Aejlegsvaanhtsh.* Jokkmokk/Dálvvadis, Sweden: Ájtte Svenskt fjäll- och samemuseum, 2018.

Falkenberg, Johannes. *Besetningen ved Indre Laksefjord i Finnmark.* Oslo: Etnografisk Museum, 1941.

Falnes, Oscar J. *National Romanticism in Norway.* New York: Columbia University Press, 1933.

Fellman, Jakob. *Anteckningar under min vistelse i Lappmarken: 3. delen, Lappmarkerna Land och Folk företrädesvis de finska.* Helsingfors: Finska litteratursällskapet, 1906.

Finnagora. "Young Sámis and Cultural Activism." Accessed February 18, 2021. http://www.finnagora.hu/en/young-s%C3%A1mis-and-cultural-activism.

Fjågesund, Peter, and Ruth A. Symes. *The Northern Utopia: British Perceptions of Norway in the Nineteenth Century.* New York: Rodopi, 2003.

Fors, Gry, and Ragnhild Enoksen. *Vår folkedrakt: Sjøsámisk klestradisjoner.* Nordisk Sámisk Institutt. Kárášjohka: Davvi girji, 1991.

Fossnes, Heidi. *Folk Costumes of Norway.* Translated by Elizabeth S. Seeberg. Oslo: J. W. Cappelens, 1993.

Foucault, Michel. *Discipline and Punish: The Birth of the Prison.* New York: Random House, 1977.

Frost, Gunilla, and Kristina Karlsson. *Mora Dräktbok: Moradräkten vid olika högtider.* Mora: Mora Hemslöjdens Vänner, 1994.

Frykman, Jonas. "Becoming the Perfect Swede: Modernity, Body Politics, and National Processes in Twentieth-Century Sweden." *Ethnos* 58, no. 3/4 (1993): 259–274.

Frykman, Jonas, and Orvar Löfgren. *Culture Builders: A Historical Anthropology of Middle-Class Life.* Translated by Alan Crozier. New Brunswick, NJ: Rutgers University Press, 1990. First published 1979.

Fur, Gunlög. "'But in Itself, the Law Is Only White': Knowledge Claims and Universality in the History of Cultural Encounters." In *Fugitive Knowledge: The Loss and Preservation of Knowledge in Cultural Contact Zones*, edited by Andreas Beer and Gesa Mackenthun, 29–49. Berlin: Waxmann, 2015.

———. "Colonial Fantasies—American Indians, Indigenous Peoples, and a Swedish Discourse of Innocence." *National Identities* 18, no. 1 (2016): 11–33.

———. "Dealing with the Wrongs of History?" In *Visions of Sápmi*, edited by Anne Lydia Svalastog and Gunlög Fur, 129–147. Røros: Arthub, 2015.

Gans, Herbert J. "The American Kaleidoscope, Then and Now." In *Reinventing the Melting Pot: The New Immigrants and What It Means to Be American*, edited by Tamar Jacoby, 33–46. New York: Basic Books, 2004.

———. "Symbolic Ethnicity: The Future of Ethnic Groups and Cultures in America." In *On the Making of Americans: Essays in Honor of David Riesman*, edited by Herbert J. Gans, Nathan Glazer, Joseph R. Gusfield, and Christopher Jencks, 193–220. Philadelphia: University of Pennsylvania Press, 1979.

Garnert, Jan. "Rethinking Visual Representation: Notes on the Folklorist and Photographer Nils Keyland." In *Nordic Frontiers: Recent Issues in the Study of Modern Traditional Culture in the Nordic Countries*, edited by Pertti J. Antonnen and Reimund Dvideland, 63–88. Turku, Estonia: Nordic Institute of Folklore, 1993.

Gaski, Harald. "Indigenous Aesthetics: Add Context to Context." In *Sámi Art and Aesthetics: Contemporary Perspectives*, edited by Svein Aamold, with Elin Haugdal and Ulla Angkjær Jørgensen, 179–193. Aarhus, Denmark: Aarhus University Press, 2017.

———. *Sámi Culture in a New Era: The Norwegian Sámi Experience.* Kárášjohka: Davvi Girji OS, 1997.

Gaughan, Jessie A. "Notes from the Norwegian Fjords." *Irish Monthly* 37, no. 437 (1909): 601–612.

Gjessing, Gutorm. "Hornluen: An Extinct Form of Headgear of the Norwegian Lapps." *Folk-liv* 4 (1940): 52–61.

Gilbertson, Laurann. "To Ward Off Evil: Metal on Norwegian Folk Dress." In *Folk Dress in Europe and Anatolia: Beliefs about Protection and Fertility*, edited by Linda Welters, 199–209. Oxford: Berg, 1999.

Glassie, Henry. *Folk Housing in Middle Virginia: A Structural Analysis of Historic Artifacts.* Knoxville: University of Tennessee Press, 1976.

———. *Material Culture.* Bloomington: Indiana University Press, 1999.

———. *Prince Twins Seven-Seven: His Art, His Life in Nigeria, His Exile in America.* Bloomington: Indiana University Press, 2010.

———. "Tradition." In *Eight Expressive Words for the Study of Expressive Culture*, edited by Burt Feintuch, 176–197. Urbana: University of Illinois Press, 2003.

———. *Turkish Traditional Art Today*. Bloomington: Indiana University Press, 1993.

Goffman, Erving. *The Presentation of Self in Everyday Life*. London: Penguin, 1990. First published 1959.

Goldsmith, David. "Cloth, Community and Culture: Växbo Lin." Paper presented at Current Issues in European Cultural Studies, Advanced Cultural Studies Institute of Sweden, Norrköping, June 15–17, 2011. Conference proceedings published by Linköping University Electronic Press, https://ep.liu.se/ecp/062/013/ecp11062013.pdf.

Gosse, Edmund. "Norway Revisited." *North American Review* 167, no. 504 (1898): 534–542.

Gradén, Lizette. "FashioNordic: Folk Costume as Performance of Genealogy and Place." *Journal of Folklore Research* 51, no. 3 (2014): 337–388.

———. "Folk Costume Fashion in Swedish America: Crafting Cultural Heritage and Diversity through Dress." *Swedish-American Historical Quarterly* 62, no. 3 (2011): 166–203.

———. "Folkdräktsmode i Svenskamerika." In *Modets Metamorfoser: Den klädda kroppens identiteter och förvandlingar*, edited by Lizette Gradén and Magdalena Petersson McIntyre, 177–206. Stockholm: Carlssons, 2009.

———. *On Parade: Making Heritage in Lindsborg, Kansas*. Uppsala: Uppsala University Library, 2003.

———. "Selected Stops along the Norwegian Highway: Norwegian-American Heritage Practice in Seattle after 1945." In *Norwegian-American Essays 2017: Freedom and Migration in a Norwegian-American Context* (Norwegian American Essays 15), edited by Terje Mikael Hasle Joranger, 225–255. Oslo: Novus forlag, 2017.

Graham, Laura R., and H. Glenn Penny. "Performing Indigeneity: Emergent Identity, Self-Determination, and Sovereignty." In *Performing Indigeneity: Global Histories and Contemporary Experiences*, edited by Laura R. Graham and H. Glenn Penny, 1–31. Lincoln: University of Nebraska Press, 2014.

Granlund, Sten. "Sweden." In *Peasant Art in Sweden, Lapland and Iceland*, edited by Charles Holme, 3–34. Washington, DC: Westphalia, 2017. First published 1910.

Grini, Monica. "Sámi (Re)presentation in a Differentiating Museumscape: Revisiting the Art-Culture System." In Baglo, Nyyssönen, and Ragazzi, "From Lappology to Sámi Museology," 169–185.

Groschwitz, Helmut. "How Things Produce Authenticity: Cultural Heritage Networks." Translated by Sarah Swift and Ellen Yutzy Glebe. *Bavarian Studies in History and Culture* (2019). https://www.bavarian-studies.org/2019/groschwitz. First published 2017.

Gullestad, Marianne. "Invisible Fences: Egalitarianism, Nationalism and Racism." *Journal of the Royal Anthropological Institute* 8, no. 1 (2002): 45–63.

Gullickson, Charis. "The Artist as Noaidi." In *Sámi Stories: Art and Identity of an Arctic People*, edited by Charis Gullickson and Sandra Lorentzen, 13–17. Northern Norway Art Museum. Stamsund, Norway: Orkana forlage AS, 2014.

Gustafsson, Anna. "Beauty as a Capacity: A Study of Hands-in-Craft." In *Anthropology and Beauty: From Aesthetics to Creativity*, edited by Stephanie Bunn, 189–203. London: Routledge, 2018.

Guttorm, Gunvor. "Contemporary Duodji: A Personal Experience in Understanding Traditions." In *Related North: Art, Heritage and Identity*, edited by Timo Jokela and Glen Coutts, 60–77. Rovaniemi, Finland: Lapland University Press, 2015.

———. "Duodji: A New Step for Art Education." *International Journal of Art and Design Education* 31, no. 2 (2012): 180–190.

———. *Duodji—árbediehtu ja oapmi / Duodji—hvem eier kunnskapen og verkene / Duodji—Sámi Handicrafts—Who Owns the Knowledge and the Works?* Kárášjohka: Sámikopiija, 2007.

———. "Duoji bálgát—en studie i Duodji: Kunsthandverk som visuell erfaring hos et urfolk." PhD diss., Universitetet i Tromsø, 2001.

———. "Ebmos nissonolmmoš dárbbaša hámálaš gahpira—ládjogahpiriid hámit ja hearvvat 1800-logu álggus." *Sámi dieđalaš áigečála* 1–2 (2007): 205–229.

———. "The Power of Natural Materials and Environments in Contemporary *Duodji*." In *Sámi Art and Aesthetics: Contemporary Perspectives*, edited by Svein Aamold, with Elin Haugdal and Ulla Angkjær Jørgensen, 163–177. Aarhus, Denmark: Aarhus University Press, 2017.

———. "Sami duodjemetologiijat." In *Duodji 2012: International Conference on Duodji and Indigenous Arts, Crafts and Design*, edited by Gunvor Guttorm and Seija Risten Somby, 35–48. Guovdageaidnu, Norway: Sámi University College, 2014.

———. "Stories Created in Stitches." *Afterall: Journal of Art, Content and Enquiry* 45 (2018): 18–23.

Hafstein, Valdimar Tr. *Making Intangible Heritage: El Condor Pasa and Other Stories from UNESCO*. Bloomington: Indiana University Press, 2018.

Hansen, Kjell. "Emerging Ethnification in Marginal Areas of Sweden." *European Society for Rural Sociology* 39, no. 3 (1999): 294–310.

Hansen, Hanna Horsberg. "Constructing Sami National Heritage: Encounters between Tradition and Modernity in Sami Art." *Konsthistorisk Tidskrift* 85, no. 3 (2016): 240–255.

———. "Sámi Artist Group 1978–1983—a Story about Sámi Traditions in Transition." In *Sámi Stories: Art and Identity of an Arctic People*, edited by Charis Gullickson and Sandra Lorentzen, 88–105. Northern Norway Art Museum. Stamsund, Norway: Orkana forlage AS, 2014.

Hansen, Lene. *Storm på kysten*. Tromsø, Norway: Margmedia, 2008.

Harlin, Eeva-Kristiina. "Recording Sami Heritage in European Museums: Creating a Database for the People." In *Provenienzforschung zu ethnografischen Sammlungen der Kolonialzeit*, edited by Larissa Förster, Iris Edenheiser, Sarah Fründt, and Heike Hartmann, 69–84. München, Germany: Museum Fünf Kontinente, 2017. https://edoc.hu-berlin.de/bitstream/handle/18452/19808/06-Harlin.pdf?sequence=1.

———. "Returning Home—the Different Ontologies of the Sámi Collections." In *Knowing from the Indigenous North: Sámi Approaches to History, Politics and Belonging*, edited by Thomas Hylland-Eriksen, Sanna Valkonen, and Jarno Valkonen, 47–66. London: Routledge, 2019.

Hartley, Emma. "Sweden's Folk Musicians against Racism Join Chorus against Far Right." *The Guardian*, August 9, 2015. https://www.theguardian.com/world/2015/aug/09/sweden-folk-musicians-against-racism-fmr.

Haugen, Anny. *Sámisk Husflid i Finnmark* [Sámi handicraft in Finnmark]. Oslo: Norsk Folkemuseum/Landbruksforlaget, 2011. First published 1987.

Haugen, Bjørn Sverre Hol. "The Concept of National Dress in the Nordic Countries." In *Berg Encyclopedia of World Dress and Fashion: West Europe*, edited by Lise Skov, 18–21. Oxford: Berg.

———. "New Look i Norsk bunadkaleidoskop." In *Folkdräkten i kalejdoskop: Nordiskt dräktseminarium. Brages Årsskrift 2012–2013*. Borgå: Nordiskt Dräktseminarium, 2013.

———, ed. *Norsk Bunadleksikon: Alle norske bunader og samiske folkedrakter*. Vol. 1–3. Oslo: N. W. Damm og Søn, 2006.

Haulman, Kate. *The Politics of Fashion in Eighteenth-Century America*. Chapel Hill: University of North Carolina Press, 2011.

Hegard, Tonte. "Collecting, Researching, and Presenting Folk Art in Norway." In *Norwegian Folk Art: Migration of a Tradition*, edited by Marion Nelson, 239–247. New York: Abbeville, 1995.

Hegge, Mary Sanford. "The Norwegian's New Clothes." *Viking*, October 2001, 8–11.

Heith, Anne. "Enacting Colonised Space: Katarina Pirak Sikku and Anders Sunna." *Nordisk Museologi* 2 (2015): 69–83.

Helander, Elina. "Sustainability in the Sami Area: The X-File Factor." *Diedut* 4 (1996): 1–6.

Helander, Elina, and Kaarina Kailo, eds. *No Beginning, No End: The Sami Speak Up*. Edmonton: Canadian Circumpolar Institute Press, 1998.

Helander, Kaisa Rautio. "Sámi Placenames, Power Relations and Representation." In *Indigenous and Minority Placenames: Australian and International Perspectives*, edited by Ian D. Clark, Liuse Hercus, and Laura Kostanski, 325–349. Canberra, Australia: ANU Press, 2014.

Heller, Sarah-Grace. "The Birth of Fashion." In *The Fashion History Reader: Global Perspectives*, edited by Giorgio Riello and Peter McNeil, 25–39. London: Routledge, 2010.

Hellspong, Mats, and Barbro Klein. "Folk Art and Folklife Studies in Sweden." In *Swedish Folk Art: All Tradition Is Change*, edited by Barbro Klein and Mats Widbom, 17–40. New York: Harry N. Abrams, 1994.

Henning, Darrell D. "In the Comfort of Home: The Urban Immigrant Experience." In *Norwegians in New York, 1825 to 2000: Builders of City, Community and Culture*, edited by Liv Irene Myhre, 63–69. Huntington, NY: Norwegian Immigration Association, 2000.

Henriksen, Marianne Vigdis. "A Gathering Storm: As Stigma Dissipates around the Sámi, an Annual Festival Is Helping Young Norwegians Rediscover Their Roots." *Native Voices* 34, no. 4 (2017/2018): 17–19.

Hernes, Maria. "Being Sámi Enough: Increasing the Sámi Stage of Performance." Master's thesis, University of Oslo, 2017.

Hertz, Carrie. "Costuming Potential: Accommodating Unworn Clothes." *Museum Anthropology Review* 5, no. 1–2 (2011): 14–38.

———. "The Uniform: As Material, as Symbol, as Negotiated Object." *Midwestern Folklore* 32, no. 1 (2007): 43–58.

———. "White Wedding Dress in the Midwest." PhD diss., Indiana University, 2013.

Hilder, Thomas. *Sámi Musical Performance and the Politics of Indigeneity in Northern Europe*. Lanham, MD: Rowman and Littlefield, 2015.

Hillström, Magdalena. "Nordiska museet and Skansen: Displays of Floating Nationalities." In *Great Narratives of the Past: Traditions and Revisions in National Museums* (EuNaMus Report 4), edited by Dominique Poulot, Felicity Bodenstein, and José María Lanzarote Guiral, 33–48. Linköping University Electronic Press, 2012. http://www.ep.liu.se/ecp/078/004/ecp12078004.pdf.

Hobsbawm, Eric. "Introduction: Inventing Traditions." In *The Invention of Tradition*, edited by Eric Hobsbawm and Terence Ranger, 1–14. Cambridge: Cambridge University Press, 1983.

Hobsbawm, Eric, and Terence Ranger, eds. *The Invention of Tradition*. Cambridge: Cambridge University Press, 1983.

Hofer, Tamás. "The Perception of Tradition in European Ethnology." *Journal of Folklore Research* 21, no. 2/3 (1984): 133–147.

Hoffmann, Marta. "Manndalen Revisited: Traditional Weaving in an Old Lappish Community in Transition." In *Studies in Textile History: In Memory of Harold B. Burnham*, edited by Veronika Gervers, 149–159. Toronto: Royal Ontario Museum, 1977.

Høidal, Anne Kløvnes. *Bunads in America: A Norwegian Cultural Tradition in Southern California*. San Diego: Ladies of Valhall, 2001.

Holmberg, Niillas, and Jenni Laiti. "The Saami Manifesto 15: Reconnecting through Resistance." Idle No More, March 15, 2013. https://idlenomore.ca/the-saami-manifesto-15-reconnecting-through-resistance-idle-no-more/.

Holmes, Rachel. "Designer Death Threats." *The Guardian*, March 26, 2009. https://www.theguardian.com/lifeandstyle/2009/mar/26/fashion-peter-jensen-death-threats.

Hoppe, Göran, and John Langton. *Peasantry to Capitalism: Western Östergötland in the 19th Century*. Cambridge: Cambridge University Press, 1994.

Horton, Laurel, and Paul Jordan-Smith. "Deciphering Folk Costume: Dress Codes among Contra Dancers." *Journal of American Folklore* 117, no. 466 (2004): 415–440.

Høstmælingen, Njål, ed. *Hijab i Norge*. Oslo: Abstrakt forlag, 2004.

Huggan, Graham. "Unscrambling the Arctic." In *Postcolonial Perspectives on the European High North: Unscrambling the Arctic*, edited by Graham Huggan and Lars Jensen, 1–30. London: Palgrave Macmillan, 2016.

Hurtado, Aída, and Norma E. Cantú, eds. *MeXicana Fashions: Politics, Self-Adornment, and Identity Construction*. Austin: University of Texas Press, 2020.

Hymes, Dell. *Foundations of Sociolinguistics: An Ethnographic Approach*. Philadelphia: University of Pennsylvania Press, 1974.

Idealist Style (blog). "Eco-Express Yourself with a Traditional Costume." May 17, 2018. https://www.idealiststyle.com/blog/eco-express-yourself-traditional-costume.

Ilg, Ulrike. "The Cultural Significance of Costume Books in Sixteenth-Century Europe." In *Clothing Culture, 1350–1650*, edited by Catherine Richardson. Burlington, VT: Ashgate, 2004.

Isama, Antoinette. "The Real Reason the #DontRushChallenge Was Created." *Teen Vogue*, April 7, 2020. https://www.teenvogue.com/story/dont-rush-challenge-creator.

Jackson, Jason Baird. "On Cultural Appropriation." *Journal of Folklore Research* 58, no. 1 (2021): 77–122.

———. *Yuchi Folklore: Cultural Expression in a Southeastern Native American Community*. Norman: University of Oklahoma Press, 2013.

Jacobsson, Bengt. "The Arts of the Swedish Peasant World." In *Swedish Folk Art: All Tradition Is Change*, edited by Barbro Klein and Mats Widbom, 55–81. New York: Harry N. Abrams, 1994.

Jannok-Porsbo, Susanna. *Samedräkter i Sverige*. Bk. 3. Skrifter från Ajtte—Svenskt Fjäll—och Samemuseum. Jåhkåmåhkke: Svenskt fjäll—och Samemuseum, 1999.

Jansen, M. Angela, and Jennifer Craik. *Modern Fashion Traditions: Negotiating Tradition and Modernity through Fashion*. London: Bloomsbury, 2016.

Jansson, Ulf, Peeter Maandi, and Mattias Qviström. "Landscape Research in Sweden: A Comment on Past and Present Tendencies," *Belgeo: Revue Belge de Géographie* 2–3 (2004): 1–8.

Jensen, Ellen Marie. *We Stopped Forgetting: Stories from Sámi Americans*. Kárášjohka: ČálliidLágádus, 2014.

Johansson, Ella. "Nationens pigor: Dalkullor i nationell ikonografi och social praxis." In *Arbete pågår—i tankens mönster och kroppens miljöer*, edited by Anders Houltz, 71–88. Uppsala: Uppsala universitet, 2008.

Jonell-Ericsson, Britta. *Skinnare i Malung: Från hemarbete till fabriksindustri*. Uppsala: Ekonomisk-historiska institutionen, Uppsala universitet, 1975.

Junka-Aikio, Laura. "Can the Sámi Speak Now? Deconstructive Research Ethos and the Debate on Who Is a Sámi in Finland." *Cultural Studies* 30, no. 2 (2016): 205–233.

———. "Indigenous Culture Jamming: *Suohpanterror* and the Articulation of Sámi Political Community." *Journal of Aesthetics and Culture* 10 (2018): 1–14.

Kallin, Stina, and Emma Frost. Åhldräkten. Insjön: Åhls Hembygdsförening, 2016.

Kaminsky, David. "Keeping Sweden Swedish: Folk Music, Right-Wing Nationalism, and the Immigration Debate." *Journal of Folklore Research* 49, no. 1 (2012): 73–96.

———. *Swedish Folk Music in the Twenty-First Century: On the Nature of Tradition in a Folkless Nation*. Lanham, MD: Lexington Books, 2012.

Kapferer, Judith. "City, Community, Nation, State: Participation and Spectacle." *Social Analysis* 48, no. 3 (2004): 108–125.

Karlberg, Magny. "Bunad Etiquette." *Viking*, September 1984, 294–295.

———. *Frå Versailles til Valdres: Ei drakthistorisk reise*. Oslo: Skald, 2015.

———. "Traditional Costumes Yesterday and Today." In Karlberg and Ylvisåker, *Crowns and Roses*.

Karlberg, Magny, and Anne Britt Ylvisåker, eds. *Crowns and Roses: The Living Tradition of Norwegian National Costume*. Translated by Shari Gerber Nilsen and Basil J. Cowlishaw. Oslo: Norwegian Ministry of Foreign Affairs, 1999.

Karlin, Georg Johansson. *Kulturhistorisk förening och museum i Lund 1882–1932: En minnesskrift utgiven till 50-årsjubileet av John Kroon*. Malmö: Malmö ljustryckanstalt, 1932.

Kent, Neil. *The Sámi Peoples of the North: A Social and Cultural History*. London: Hurst, 2014.

Kinney, Dallas. "Decorah's July Nordic Fest Will Bring Scandinavia to You." *Dubuque Telegraph-Herald*, February 26, 1967.

Kirkham, Pat, and Susan Weber. *History of Design: Decorative Arts and Material Culture, 1400–2000*. New Haven, CT: Yale University Press, 2013.

Kirshenblatt-Gimblett, Barbara. *Destination Culture: Tourism, Museums, and Heritage*. Berkeley: University of California Press, 1998.

———. "Intangible Heritage as Metacultural Production." *Museum International* 56, no. 1–2 (2004): 221–222.

———. "World Heritage and Cultural Economics." In *Museum Frictions: Public Cultures/Global Transformations*, edited by Ivan Karp, Corinne A. Kratz, Lynn Szwaja, and Tomás Ybarra-Frausto, 161–202. Durham, NC: Duke University Press, 2006.

Kitti, Anja. "North American Gakti: Labors of Love." *Báiki, the North American Sámi Journal* 13 (1995): 16.

Klein, Barbro. "Cultural Heritage, Human Rights, and Reform Ideologies: The Case of Swedish Folklife Research." In *Cultural Heritage in Transit: Intangible Rights as Human Rights*, edited by Deborah A. Kapchan, 113–124. Philadelphia: University of Pennsylvania Press, 2014.

———. "Cultural Heritage, the Swedish Folklife Sphere, and the Others." *Cultural Analysis* 5 (2006): 57–80.

———. "Folk Art and the Urbanized Landscape." In *Swedish Folk Art: All Tradition Is Change*, edited by Barbro Klein and Mats Widbom, 143–148. New York: Harry N. Abrams, 1994.

———. "Folklore, Heritage Politics and Ethnic Diversity: Thinking about the Past and the Future." In *Folklore, Heritage Politics and Ethnic Diversity: A Festschrift for Barbro Klein*, edited by Anna-Leena Siikala, Barbro Klein, and Pertti J. Anttonen, 23–36. Botkyrka, Sweden: Multicultural Centre, 2000.

———. "Foreigners, Foreignness, and the Swedish Folklife Sphere." *Ethnologia Scandinavica: A Journal for Nordic Ethnology* 30 (2000): 5–23.

———. "The Moral Content of Tradition: Homecraft, Ethnology, and Swedish Life in the Twentieth Century." *Western Folklore* 59, no. 2 (2000): 171–195.

———. "Women and the Formation of Swedish Folklife Research." *Journal of American Folklore* 126, no. 500 (2013): 120–151.

Klein, Barbro, and Mats Widbom, eds. *Swedish Folk Art: All Tradition Is Change*. New York: Harry N. Abrams, 1994.

Kleinschmidt, Gertrud. "Formal Clothing: The Greenlandic National Costume." In *Arctic Clothing*, edited by J. C. H. King, Birgit Pauksztat, and Robert Storrie, 104–107. London: British Museum Press, 2005.

Klepp, Ingun Grimstad, and Tone Skårdal Tobiasson. "Bunadens revansj." *Dagbladet*, May 11, 2016. https://www.dagbladet.no/kultur/bunadens-revansj/60379393.

Knudsen, Anne Merete. *Refugees in Their Own Country*. Alta Museum Pamphlets 2. Alta: Alta Museum, 1995.

Kolltveit, Olav. *Odda, Ullensvang og Kinsarvik: I gamal og ny tid*. Vol. 2. Translated by Hans H. Coucheron-Aamot. Odda, Ullensvang og Kinsarvik Bygdeboknemnd, 2005. First published 1962.

Kramvig, Britt. "Orientalism or Cultural Encounters? Tourism Assemblages in Cultures, Capital and Identities." In *Tourism and Indigeneity in the Arctic*, edited by Arvid Viken and Dieter K. Müller, 50–70. Bristol, UK: Channel View, 2017.

Kramvig, Britt, and Anne Britt Flemmen. "What Alters when the Traditional Sámi Costume Travels? A Study of Affective Investments in the Sápmi." In *Sensitive Objects: Affects and Material Culture*, edited by Jonas Fryktman and Maja Povrzanovic Fryktman, 179–198. Lund, Sweden: Nordic Academic, 2016.

Kuokkanen, Rauna. "Indigenous Gender Justice." Lecture, Faculty of Arts, University of Alberta, November 24, 2016. https://vimeo.com/194058234.

———. "Indigenous Peoples on Two Continents: Self-Determination Processes in Saami and First Nation Societies." *Native American Studies* 20, no. 2 (2006): 1–6.

———. "Indigenous Women in Traditional Economies—the Case of Sami Reindeer Herding." *Signs, Journal of Women in Culture and Society* 34, no. 3 (2009): 499–503.

———. "The Logic of the Gift. Reclaiming Indigenous Peoples' Philosophies." In *Re-ethnicizing the Mind? Cultural Revival in Contemporary Thought*, edited by Thorsten Botz-Bornstein and Jürgen Hengelbrock, 251–274. Amsterdam: Rodopi, 2006.

———. "Myths and Realities of Sami Women: A Post-colonial Feminist Analysis for the Decolonization and Transformation of Sami Society." In *Making Space for Indigenous Feminism*, edited by Joyce Green, 73–92. Winnipeg, Canada: Fernwood, 2007.

———. "'Survivance' in Sami and First Nations Boarding School Narratives: Reading Novels by Kerttu Vuolab and Shirley Sterling." *American Indian Quarterly* 27, no. 3–4 (2003): 697–726.

———. "'To See What State We Are In': First Years of the Greenland Self-Government Act and the Pursuit of Inuit Sovereignty." *Ethnopolitics* 16, no. 2 (2017): 179–195. First published 2015.

———. "Towards an 'Indigenous Paradigm' from a Sami Perspective." *Canadian Journal of Native Studies* 20, no. 2 (2000): 411–436.

Kuutma, Kristin. "Between Arbitration and Engineering: Concepts and Contingencies in the Shaping of Heritage Regimes." In *Heritage Regimes and the State*, edited by Regina F. Bendix, Aditya Eggert, and Arnika Peselmann, 21–38. Göttingen, Sweden: Universitätsverlag Göttingen, 2012. http://webdoc.sub.gwdg.de/univerlag/2012/GSCP6_Bendix.pdf.

Kyllingstad, Jon Røyne. "Norwegian Physical Anthropology and the Idea of a Nordic Master Race." *Current Anthropology* 53, no. S5 (2012): S46–S56.

Lampe, Melissa. "The Stoughton Bunad: Not Just for Women Anymore." *Stoughton Courier Hub*, May 18, 2000.

Landsverk, Halvor. "Tradisjon og nydanning i våre folkedrakter." In *Nordens Husflidsforbund XII*, 44–47. Stavanger: Nordiske Husflidsting, 1965.

Langston, Nancy. "Mining the Boreal North." *American Scientist* 101, no. 2 (2013): 98–102.

Lantto, Patrik. "The Consequences of State Intervention: Forced Relocations and Sámi Rights in Sweden, 1919–2012." *Journal of Ethnology and Folkloristics* 8, no. 2 (2014): 53–73.

Lantto, Patrik, and Åsa Össbo, "Colonial Tutelage and Industrial Colonialism: Reindeer Husbandry and Early 20th-Century Hydroelectric Development in Sweden." *Scandinavian Journal of History* 36, no. 3 (2008): 324–348.

Larsen, Mads. "Seiersmarsjen." *Dagbladet*, May 18, 1999. https://www.dagbladet.no/nyheter/seiersmarsjen/65522395.

Larsson, Jesper. "Boundaries and Property Rights: The Transformation of a Common-Pool Resource." *Agricultural History Review* 62, no. 1 (2014): 40–60.

Larsson, Marianne. "Class and Gender in a Museum Collection: Female Skiwear." In *Fashion and Museums: Theory and Practice*, edited by Marie Riegels Melchoir and Birgitta Svensson, 91–107. London: Bloomsbury, 2014.

Lauffer, Mary E. "A Bunad All Our Own." *Stoughton Courier Hub*, May 15, 1997.

Leerssen, Joep. "Notes towards a Definition of Romantic Nationalism." *Romantik: Journal for the Study of Romanticisms* 2 (2013): 9–35.

Lehtola, Veli-Pekka. "Our Histories in the Photographs of Others." *Journal of Aesthetics and Culture* 10, no. 1 (2018): 1–13.

———. "Sámi Histories, Colonialism, and Finland." *Arctic Anthropology* 52, no. 2 (2015): 22–36.

———. *The Sámi People: Traditions in Transition*. Translated by Linna Weber Müller-Wille. Fairbanks: University of Alaska Press, 2004.

Liby, Håkan. *Kläderna gör upplänningen: Folkligt mode—tradition och trender*. Uppsala: Upplandsmuseet, 1997.

Lien, Marie. *Norwegian National Organization for the Promotion of Home Arts and Crafts (Husflid)*. Oslo: Fabritius og Sønner, 1946.

The Local. "Sweden's Urban-Rural Divide Growing." February 5, 2017. https://www.thelocal.se/20170205/swedens-urban-rural-divide-growing.

Löfgren, Orvar. "A Flag for All Occasions?" In *Flag, Nation and Symbolism in Europe and America*, edited by Thomas Hylland Eriksen and Richard Jenkins, 136–170. New York: Routledge, 2007.

———. "Materializing the Nation in Sweden and America." *Ethnos: Journal of Anthropology* 58, no. 3/4 (1993): 161–196.

———. "The Nature Lovers." In *Culture Builders: A Historical Anthropology of Middle-Class Life*, edited by Jonas Frykman and Orvar Löfgren, translated by Alan Crozier, 42–87. New Brunswick, NJ: Rutgers University Press, 1990. First published 1979.

Lofstad, Ralf. "Sahfana fikk sydd bunad med hijab." *Dagbladet*, June 20, 2016. https://www.dagbladet.no/nyheter/sahfana-37-fikk-sydd-bunad-med-hijab-har-utlost-et-skred-av-hatmeldinger-og-rasisme/60245126.

Løkvold, Jorunn. "Duodji—Samisk Håndverk." Norsk håndverksinstitutt. Accessed February 22, 2021. https://handverksinstituttet.no/stipendiater/Naavaerende-stipendiater/jorunn-loekvold-duodjar.

Long, Carola. "Peter Jensen Has Become the Object of a Surprising and Unusual Protest." *The Independent*, March 23, 2009. https://www.independent.co.uk/life-style/fashion/features/ready-to-wear-peter-jensen-has-become-the-object-of-a-surprising-and-rather-unusual-protest-1651600.html.

Lönnqvist, Bo, Anne Bergman, and Yrsa Lindqvist, eds. *Brage 100 år: Arv, förmedling, förvandling: Brages årsskrift 1991–2006: 100 Brage*. Helsingfors: Brage, Sektionen för folklivsforskning, 2006.

Magelssen, Scott. "Performance Practices of [Living] Open-Air Museums (And a New Look at 'Skansen' in American Living Museum Discourse)." *Theatre History Studies* 24 (June 2004): 125–149.

Magga, Ole Henrik. "Policy and the Sámi Language." In *Sámi Stories: Art and Identity of an Arctic People*, edited by Marit Anne Hauan, 9–22. Tromsø University Museum. Stamsund: Orkana forlage AS, 2014.

Magga, Sigga-Marja. *Saamelainen käsityö yhtenäisyyden rakentajana: Duodjin normit ja brändit*. Acta Universitatis Ouluensis B Humaniora 166. Oulu: Oulun yliopisto, 2018.

Mathisen, Line, Espen Carlsson, and Niels Arvid Sletterød. "Sami Identity and Preferred Futures: Experiences among Youth in Finnmark and Trøndelag, Norway." *Northern Review* 45 (2017): 113–139.

Maxwell, Alexander. *Patriots against Fashion: Clothing and Nationalism in Europe's Age of Revolutions*. New York: Palgrave MacMillan, 2014.

McGuinne, Johan Sandberg. "*Veasomem suehpedh*—to Weave a Life." *Indigeneity, Language and Authenticity*, January 18, 2015. https://johansandbergmcguinne.wordpress.com/2015/01/18/veasomem-suehpedh-to-weave-a-life/.

Michael, Jennifer. "(Ad)Dressing Shibboleths: Costume and Community in the South of France." In Bendix and Noyes, "In Modern Dress," 146–172.

Minde, Henry. "Assimilation of the Sami: Implementation and Consequences." *Gáldu čála: Journal of Indigenous Peoples Rights*, no. 3 (2005). https://ir.lib.uwo.ca/aprci/196. Guovdageaidnu, Norway: Aboriginal Policy Research Consortium International (APRCi).

Misiroglu, Gina. *American Countercultures: An Encyclopedia of Nonconformists, Alternative Lifestyles, and Radical Ideas in US History*. New York: Routledge, 2015.

Moe, Anne Kristin. "Den visuelle dialekta." *Syn og Segn*, no. 4 (2016). https://www.synogsegn.no/artiklar/2016/utg%C3%A5ve-4-16/anne-kristin-moe/.

Moe, Anne Kristin. *Broderte Bunader: Hundre år med norsk bunadhistorie*. With photography by Laila Duran. Flottvik, Sweden: Duran, 2014.

Mojanis, Anders. "Prinsessan i Malungspäls." *Arbetarbladet*, February 26, 2015. https://www.arbetarbladet.se/artikel/malung/prinsessan -i-malungspals.

———. "Skinnskolan återuppstod." *DT*, December 10, 2012. https:// www.dt.se/artikel/skinnskolan-ateruppstod.

Möller, Peter, and Jan Amcoff. "Tourism's Localized Population Effect in the Rural Areas of Sweden." *Scandinavian Journal of Hospitality and Tourism* 18, no. 1 (2018): 39–55.

Moseley-Christian, Michelle. "Confluence of Costume, Cartography and Early Modern European Chorography." *Journal of Art Historiography* 9 (2013): 1–22.

Mulk, Inga-Maria. "Conflicts over the Repatriation of Sami Cultural Heritage in Sweden." *Acta Borealia* 26, no. 2 (2009): 194–215.

Müller, Dieter K., and Robert Pettersson. "Sámi Heritage at the Winter Festival in Jokkmokk, Sweden." *Scandinavian Journal of Hospitality and Tourism* 6, no. 1 (2006): 54–69.

Mustonen, Tero, and Elja Syrjämäki. *It Is the Sámi Who Own This Land: Sacred Landscapes and Oral Histories of the Jokkmokk Sámi*. Vassa, Finland: Snowchange Cooperative, Waasa Graphics, 2013.

Muus, Nathan, and Anja Kitti. "The Ongoing North American *Gákti* Debate." *Báiki*, the North American Sámi Journal 14 (1995): 16.

Näsström, Gustaf. *Dalarna som svenskt ideal*. Stockholm: Wahlström and Widstrand, 1937.

Neumann, Iver B. "State and Nation in the Nineteenth Century: Recent Research on the Norwegian Case." *Scandinavian Journal of History* 25 (2000): 239–260.

Nicklasson, Eva. *Fårskinn för dräkt och mode*. Falun: Dalarnas Hemslöjdsförbund, 2006.

Niemi, Einar. "Sámi History and the Frontier Myth: A Perspective on the Northern Sámi Spatial and Rights History." In *Sámi Culture in a New Era: The Norwegian Sámi Experience*, edited by Harald Gaski, 62–85. Kárásjohka: Davvi Girji OS, 1997.

Niessen, Sandra. "Afterword: Fashion's Fallacy." In *Modern Fashion Traditions: Negotiating Tradition and Modernity through Fashion*, edited by M. Angela Jansen and Jennifer Craik, 209–217. London: Bloomsbury, 2016.

Nilsen, Ragnar. "From Norwegianization to Coastal Sami Uprising." In *Indigenous Peoples: Resource Management and Global Rights*, edited by Svein Jentoft, Henry Minde, and Ragnar Nilsen, 163–184. Delft, Netherlands: Eburon Academic Publishers, 2003.

Nilsson, Bo G. "Att förkroppsliga nationen—om dräkternas betydelse när museimän och folklivsforskare upptäckte folket." In *Påklädd, uppklädd, avklädd: Om kläder, kropp och identitet*, edited by Bo G. Nilsson and Jan Garnert, 20–36. Stockholm: Norstedts akademiska förlag, 2005.

Nilsson, Inge. "Rättviksmössa med norska rötter." *Hemslöjden* 2 (2005): 10–12.

Nilsson, Sven. *The Primitive Inhabitants of Scandinavia: An Essay on Comparative Ethnography, and a Contribution to the History of the Development of Mankind—Containing a Description of the Implements, Dwellings, Tombs, and Mode of Living of the Savages in the North of Europe during the Stone Age*. Translated by Sir John Lubbock. London: Longmans, Green, 1868.

Nordal, Erlingur. "Danish Designer's Boots Causing a Stir in Greenland." *IceNews*, April 2, 2009. https://www.icenews.is/2009/04/02 /danish-designers-boots-causing-a-stir-in-greenland/.

Nordin, Jonas M., and Carl-Gösta Ojala. "Collecting, Connecting, Constructing: Early Modern Commodification and Globalization of Sámi Material Culture." *Journal of Material Culture* 23, no. 1 (2018): 58–82.

Norsk institutt for bunad og folkedrakt. "Bunad på UNESCO-lista." Accessed February 16, 2021. https://bunadogfolkedrakt.no /bunad-pa-unesco-lista.

Noss, Aagot. "Festive Folk Costumes of Norway." *American Scandinavian Review* 53, no. 2 (1965): 154–160.

———. "Frå folkedrakt til bunad." In *Folklig dräkt*, edited by Sigfrid Svensson, 225–276. Lund, Sweden: Liber Läromedel, 1974.

———. "Hovudbunad og norsk drakttradisjon." In *Hijab i Norge*, edited by Njål Høstmælingen, 72–94. Oslo: Abstrakt forlag, University of Oslo, 2004.

———. *Krone og Skaut: Jente-, kone-, og brurehovudbunader i Hordaland*. Oslo: Aschehoug, 1996.

———. *Lad og Krone, frå jente til brur*. Oslo: Universitetsforlaget, 1991.

———. *Nærbilete av ein draktskikk: Frå dåsaklede til bunad*. Oslo: Universitetsforlaget, 1992.

———. "Norwegian Folk-Dress as Seen by the Artists." *Costume: The Journal of the Costume Society* 36 (2002): 75–85.

———. "Rural Norwegian Dress and Its Symbolic Functions." In *Norwegian Folk Art: Migration of a Tradition*, edited by Marion Nelson, 149–156. New York: Abbeville, 1995.

———. *Stakkeklede i Setesdal: Byklaren og valldølen*. Oslo: Instituttet for Sammenlignende Kulturforskning, 2008.

———. "The Transition of Traditional Folk Dress to *Bunad* in West Telemark." In *Crossroads of Costume and Textiles in Poland: Papers from the International Conference of the ICOM Costume Committee at the National Museum in Cracow, September 28–October 4, 2003*, edited by Beata Biedrońska-Słotowa, 113–128. Heidelberg, Germany: Heidelberg University Library, 2005. https://digi.ub.uni -heidelberg.de/diglit/biedronska_slota2005.

Noyes, Dorothy. *Humble Theory: Folklore's Grasp on Social Life*. Bloomington: Indiana University Press, 2016.

Noyes, Dorothy, and Roger D. Abrahams. "From Calendar Custom to National Memory." In *Cultural Memory and the Construction of Identity*, edited by Dan Ben-Amos and Lilane Weissberg, 77–98. Detroit: Wayne State University Press, 1999.

Noyes, Dorothy, and Regina Bendix. Introduction to "In Modern Dress," by Bendix and Noyes, 107–114.

NRK. Podcast, June 25, 2016. https://radio.nrk.no/podcast/ukeslutt /nrkno-poddkast-157-106753-25062016120300.

Nylén, Anna-Maja. *Folkdräkter*. Svenskt liv och arbete 7. Stockholm: Nordiska museet, 1949.

———. *Folkdräkter ur Nordiska museets samlingar*. Stockholm: Nordiska museet, 1976. First published 1971.

———. *Folkligt Dräktskick i Västra Vingåker och Österåker*. Stockholm: Nordiska museet, 1947.

———. *Swedish Handcraft*. Translated by Anne-Charlotte Hanes Harvey. Lund: Håkan Ohlssons, 1976. First published 1968.

———. *Swedish Peasant Costumes*. Translated by William Cameron. Stockholm: Nordiska Museet, Emil Kihlströms Tryckeri, 1949.

Nyseth, Torill, and Paul Pedersen. "Urban Sámi Identities in Scandinavia: Hybridities, Ambivalences and Cultural Innovation." *Acta Borealia* 31, no. 2 (2014): 131–151.

Oakes, Alma, and Margot Hamilton Hill. *Rural Costume: Its Origin and Development in Western Europe and the British Isles*. London: BT Batsford, 1970.

Oakes, Jill, and Rick Riewe. *Our Boots: An Inuit Women's Art*. New York: Thames and Hudson, 1995.

Odell, Amy. "Greenland Deeply Offended by Peter Jensen's Thigh-High Boots." *The Cut, New York* magazine, March 20, 2009. https://www.thecut.com/2009/03/greenland_deeply_offended_by_p.html.

Office for Contemporary Art. *Let the River Flow: The Sovereign Will and the Making of a New Worldiness*. Exhibition booklet, English ed. Oslo-Tromsø: OCA, 2018. https://www.oca.no/publications/project-booklets/let-the-river-flow-the-sovereign-will-and-the-making-of-a-new-worldliness-english/.

Ojala, Carl-Gösta. "East and West, North and South in Sápmi: Networks and Boundaries in Sámi Archaeology in Sweden." In *Sounds Like Theory* (Monographs of the Archaeological Society of Finland 2), edited by Janne Ikäheimo, Anna-Kaisa Salmi, and Tiina Äikäs, 173–185. Oulu: Archaeological Society of Finland, 2014.

Olausson, Magnus, ed. *Konstskatter ur samlingarna*. Stockholm: Nationalmuseum, 2018.

Olian, Jo Anne. "Sixteenth-Century Costume Books." *Dress: The Journal of the Costume Society of America* 3, no. 1 (1977): 20–47.

Olsén, Laura, Leena Heinämäki, and Assi Harkoma. "Human Rights and Multiple Discrimination of Minorities within Minorities: Sámi Persons with Disabilities and Sexual and Gender Minorities." *Juridica Lapponica* 44. Rovaniemi: University of Lapland, 2018. https://lauda.ulapland.fi/bitstream/handle/10024/63142/Ols%c3%a9n.Laura%3b%20Hein%c3%a4m%c3%a4ki.Leena%3b%20Harkoma.Assi.pdf?sequence=4&isAllowed=y.

Ortner, Sherry B. "On Key Symbols." *American Anthropologist* 75, no. 5 (1973): 1338–1346.

Oskal, Nils. "Political Inclusion of the Saami as Indigenous People in Norway." In "Sami Rights in Finland, Norway, Russia and Sweden." Special issue, *International Journal on Minority and Group Rights* 8, no. 2/3 (2001): 235–261.

Östman, Ann-Catrin. "Land and Agrarian Masculinity—Space and Gender in *Finnish Cultural History*, 1933–1936." In *Gendered Rural Spaces*, edited by Pial Olsson and Helena Ruotsala, 33–50. Helsinki: Finnish Literature Society, 2009.

Painter, Nell Irvin. *The History of White People*. New York: W. W. Norton, 2010.

Paredes, Américo, and Richard Bauman, eds. *Toward New Perspectives in Folklore*. Bloomington: Trickster, 2000. First published 1972.

Pearce, Susan M., ed. *Museums and Their Development: The European Tradition, 1700–1900*. London: Routledge, 1999.

Pearson, Stephanie. "Norway's Bold Plan to Tackle Overtourism." *Outside*, September 3, 2019. https://www.outsideonline.com/2401446/norway-adventure-travel-overtourism?utm_source=pocket-newtab.

Pedersen, Paul, and Arvid Viken. "Globalized Reinvention of Indigeneity: The Riddu Riđđu Festival as a Tool for Ethnic Negotiation of Place." In *Place Reinvention: Northern Perspectives*, edited Arvid Viken and Torill Nyseth, 183–202. London: Routledge, 2016.

Pentikäinen, Juha, and Risto Pulkkinen. *Saamelaisten mytologia*. Helsinki: SKS, 2018.

Pettersen, Silje Vatne, and Lars Østby. "Scandinavian Comparative Statistics on Integration: Immigrants in Norway, Sweden and Denmark." *Samfunnsspeilet* 5 (2013): 76–83.

Pierson, Ruth Roach. "Nations: Gendered, Racialized, Crossed with Empire." In *Gendered Nations: Nationalisms and Gender Order in the Long Nineteenth Century*, edited by Ida Blom, Karen Hagemann, and Catherine Hall, 41–62. Oxford: Berg, 2000.

Pollan, Brita. *For Djevelen er alt mulig: Kristne historier om samene*. Kristiansand: Norwegian Academic, 2007.

———. *Slik den ene samen har fortalt til den andre samen, Stemmer fra den gamle kulturen*. Oslo: Emilia, 2017.

Qxaal, Astrid. *Drakt og nasjonal identitet, 1760–1916: Den sivile uniformen, folkedrakten og nasjonen*. Oslo: Doktorgradsavhandling, Universitetet i Oslo, 2001.

Rana, Rubina. "Den norskeste av de norske." In *Nasjonaldagsfeiring i fleirkulturelle demokrati*, edited by Brit Marie Hovland and Olaf Aagedal, 93–96. Copenhagen: Nordisk Ministerråd, 2001.

Rangström, Lena. "Livrustkammarens dräktsamling." In *375 år med Livrustkammaren*, edited by Barbro Bursell and AnneMarie Dahlberg, 67–80. Stockholm: Livtrustkammaren, 2003.

Rasmus, Minna. *Bággu vuolgit—Baggu birget: Sámemánáid ceavzinstrategiijat Suoma álbmotskuvlla ásodagain 1950–1960-logus*. Giellagas Institute 10. Oulu: Gummerrus Kirjapaino Oy Vaajakoski, 2008.

Ravna, Øyvind. "The Fulfilment of Norway's International Legal Obligations to the Sámi—Assessed by the Protection of Rights to Land, Waters and Natural Resources." *International Journal on Minority and Group Rights* 21, no. 3 (2014): 297–329.

Reeploeg, Silke. "Women in the Arctic: Gendering Coloniality in Travel Narratives from the Far North, 1907–1930." *Scandinavian Studies* 91, no. 1–2 (2019): 182–204.

Resare, Ann. "Swedish Shawls and Kerchiefs and Their Relations to Polish Textiles." In *Crossroads of Costume and Textiles in Poland: Papers from the International Conference of the ICOM Costume Committee at the National Museum in Cracow, September 28–October 4, 2003*, edited by Beata Biedrońska-Słotowa, 107–111. Heidelberg, Germany: Heidelberg University Library, 2005. https://digi.ub.uni-heidelberg.de/diglit/biedronska_slota2005.

Ringdal, Siv. *Lapskaus Boulevard: Et gjensyn med det norske Brooklyn* [Lapskaus Boulevard: The Norwegian Brooklyn revisited]. Translated by Floyd Nilsen. N.p.: Golden Slippers, 2007.

Roach-Higgins, Mary Ellen, and Joanne B. Eicher. "Dress and Identity." In *Dress and Identity*, edited by Mary Ellen Roach-Higgins, Joanne B. Eicher, and Kim K. P. Johnson, 7–18. New York: Fairchild, 1995.

Robertson, Edna, and Tom Dickerson. *The Reindeer Followers: Folk Artists of Lapland*. Santa Fe: International Folk Art Foundation and Museum of New Mexico, 1966.

Romero, Gilda. "Sámi Artists First Out in the World's Largest Climate Performance." *Riksteatern*, October 21, 2015. http://news.cision.com/se/riksteatern/r/sami-artists-first-out-in-the-world-s-largest-climate-performance,c9851807.

Ronström, Owe. "The Forms of Diversity: Folk Art in Multicultural Sweden." In *Swedish Folk Art: All Tradition Is Change*, edited by Barbro Klein and Mats Widbom, 175–181. New York: Harry N. Abrams, 1994.

Rosander, Göran. "Herrarbete: Dalfolkets säsongvisa arbetsvandringar i jämförande belysning." PhD diss., Uppsala University, 1967.

———. "The 'Nationalisation' of Dalecarlia: How a Special Province Became a National Symbol for Sweden." *Arv* 42 (1986): 93–142.

Rudling, Per Anders. "Eugenics and Racial Biology in Sweden and the USSR: Contacts across the Baltic Sea." *Canadian Bulletin of Medical History* 31, no. 1 (2014): 41–75.

Runforyourlife, Riksteatern. "Jenni Laiti, Run for Your Life, First Runner." YouTube video, November 10, 2015, 04:40. https://www.youtube.com/watch?v=7ZR6kGNM_L0.

Rydving, Håkan. *The End of Drum-Time: Religious Change among the Lule Saami, 1670–1740s.* Acta Universitatis Upsaliensis: Historia Religionum 12. 2nd ed. Uppsala: Almqvist and Wiksell International, 1995.

Sæbø, Bjørn G. "Norsk nok for bunad?" *Dagsavisen*, June 21, 2016. https://www.dagsavisen.no/rogalandsavis/leder-norsk-nok-for-bunad-1.742767.

Sandström, Birgitta. *Hairwork in the Zorn Collections.* Västervik: AB CO Ekblad, 1995.

Sandvik, Hilde. "Gender and Politics before and after the Norwegian Constitution of 1814." In *Scandinavia in the Age of Revolution: Nordic Political Cultures, 1740–1820*, edited by Pasi Ihalainen, Michael Bregnsbo, Karin Sennefelt, and Patrik Winton, 329–342. Burlington, VT: Ashgate, 2011.

Sarappo, Emma. "The Star of Norwegian Knitwear." *The Atlantic*, November 25, 2018. https://www.theatlantic.com/technology/archive/2018/11/origins-famous-norwegian-knitting-pattern/576502/.

Sennefelt, Karin. "The Shifting Boundaries of Political Participation: Introduction." In *Scandinavia in the Age of Revolution: Nordic Political Cultures, 1740–1820*, edited by Pasi Ihalainen, Michael Bregnsbo, Karin Sennefelt, and Patrik Winton, 269–278. Burlington, VT: Ashgate, 2011.

Schall, Carly Elizabeth. "Multicultural Iteration: Swedish National Day as Multiculturalism-in-Practice." *Nations and Nationalism* 20, no. 2 (2014): 355–375.

Schechner, Richard. *Performance Studies: An Introduction.* 2nd ed. New York: Routledge, 2006.

Scheel, Ellen Wigaard. *Norske drakter, stakker og bunader.* Oslo: NW Damm og Søn, 2001.

Scheffy, Zoë-Hateehc Durrah. "Sámi Religion in Museums and Artistry." In *Creating Diversities: Folklore, Religion and the Politics of Heritage*, edited by Anna-Leena Siikala, Klein Barbro, and Stein R. Mathisen, 225–259. Helsinki: Finnish Literature Society, 2004.

Schmiesing, Ann. "Norway's Embroidered Bunader." *PieceWork*, January/February 2003, 30–33.

Schnell, Steven M. "Creating Narratives of Place and Identity in 'Little Sweden, USA.'" *Geographic Review* 93, no. 1 (2003): 1–29.

Shukla, Pravina. *Costume: Performing Identities through Dress.* Bloomington: Indiana University Press, 2015.

———. *The Grace of Four Moons: Dress, Adornment, and the Art of the Body in Modern India.* Bloomington: Indiana University Press, 2008.

———. "The Maintenance of Heritage: Kersti Jobs-Björklöf and Swedish Folk Costume." In *The Individual and Tradition: Folkloristic Perspectives*, edited by Ray Cashman, Tom Mould, and Pravina Shukla, 145–169. Bloomington: Indiana University Press, 2011.

Silvén, Eva. "Constructing a Sami Cultural Heritage: Essentialism and Emancipation." *Ethnologia Scandinavica* 44 (2014): 59–74.

———. "Staging the Sami: Narrative and Display at the Nordiska Museet in Stockholm." In *Comparing: National Museums, Territories, Nation-Building and Change* (published NaMu conference proceedings), edited by Andreas Nyblom and Peter Aronsson, 311–319. Linköping University Electronic Press, 2008.

Simmel, George. "Fashion." *International Quarterly*, no. 10 (1904): 130–155.

Skavhaug, Kjersti. *Norwegian Bunads.* Translated by Bent Vanberg. Oslo: Hjemmenes Forlag, 1982.

Skjåk Bræk, Lise. *Lystig arv: Eventyrlige jordbær.* Trondheim: Lise Skjåk Bræk Design, KOM forlag, 2002.

Skogholt Jahn-Arill. "Triple Stigma." Translated by Arden Johnson. Retrieved from Árran Archive, *Dagbladet*, March 29, 2000.

Skov, Lise. "The Study of Dress and Fashion in Western Europe." In *Berg Encyclopedia of World Dress and Fashion: West Europe*, edited by Lise Skov, 3–8. Oxford: Berg, 2010.

Slind, Marvin. "Lingering Vestiges of Heritage: The Fate of Washington's Selbu Community." In *Norwegian-American Essays 2014*, edited by Terje Mikael Hasle Joranger, 179–193. Northfield, MN: Norwegian-American Historical Association, 2014.

Smith, Laurajane. *Uses of Heritage.* New York: Routledge, 2006.

Snowden, James. *The Folk Dress of Europe.* New York: Mayflower Books, 1979.

Sollors, Werner. *Beyond Ethnicity: Consent and Descent in American Culture.* Oxford: Oxford University Press, 1986.

———. "What Might Take the Place of Late-Generation European American Ethnicity?" *Ethnic and Racial Studies* 37, no. 5 (2014): 778–790.

Sørensen, Bo Wagner. "Contested Culture: Trifles of Importance." In *Braving the Cold: Continuity and Change in Arctic Clothing*, edited by Cunera Buys and Jarich Oosten, 171–187. Leiden: Research School CNWS, 1997.

Spektorowski, Alberto, and Elisabet Mizrachi. "Eugenics and the Welfare State in Sweden: The Politics of Social Margins and the Idea of a Productive Society." *Journal of Contemporary History* 39, no. 3 (2004): 333–352.

Sporrong, Ulf. "The Province of Dalecarlia (Dalarna): Heartland or Anomaly?" In *Nordic Landscapes: Region and Belonging on the Northern Edge of Europe*, edited by Michael Jones and Kenneth R. Olwig, 192–219. Minneapolis: University of Minnesota Press, 2008.

———. "The Swedish Landscape: The Regional Identity of Historical Sweden." In *Nordic Landscapes: Region and Belonging on the Northern Edge of Europe*, edited by Michael Jones and Kenneth R. Olwig, 141–156. Minneapolis: University of Minnesota Press, 2008.

Stallybrass, Peter. "Worn Worlds: Clothes, Mourning, and the Life of Things." In *Cultural Memory and the Construction of Identity*, edited by Dan Ben-Amos and Lilane Weissberg, 27–44. Detroit: Wayne State University Press, 1999.

Steiner, Sallie Anne. "Woven Identities: Socioeconomic Change, Women's Agency, and the Making of a Heritage Art in Jølster, Norway." *Journal of Ethnology and Folkloristics* 10, no. 2 (2016): 81–101.

Stewart, Janice S. *The Folk Arts of Norway.* Madison: University of Wisconsin Press, 1953.

Stockfleth, Nils Vibe. *Dagbog over mine Missionsreiser i Finmarken.* Christiania: Tønsberg, 1860. http://www.altabibliotek.net/finnmark/Stockfleth/Dagbog.php?kap=4Reise.

Stoller, Eleanor Palo. "Sauna, Sisu and Sibelius: Ethnic Identity among Finnish Americans." *Sociology Quarterly* 37, no. 1 (Winter 1996): 145–175.

Storaas, Randi. *Å velja fortid—å skapa framtid: Bunad som uttrykk for motkulturell verksemd.* Oslo: Masteroppgave, Universitetet i Oslo, 1985.

———. "Clothes as an Expression of Counter-cultural Activity." *Ethnologia Scandinavica: A Journal for Nordic Ethnology* 16 (1986): 145–158.

Stordahl, Vigdis. "Sami Generations." In *Sámi Culture in a New Era: The Norwegian Sámi Experience*, edited by Harald Gaski, 143–154. Kárásjohka/Karasjok: Davvi Girji OS, 1997.

Stuland, Gudrun. *Hardangerbunaden før og no*. Oslo: Fabritius Forlagshus, 1980.

Sunbø, Annemor. *Setesdal Sweaters: The History of the Norwegian Lice Pattern*. Ose: Torridal Tweed, 2001.

Svalastog, Anna Lydia. "Mapping Sami Life and Culture." In *Visions of Sápmi*, edited by Anne Lydia Svalastog and Gunlög Fur, 17–46. Røros: Arthub, 2015.

Svensson, Tom G. "Clothing in the Arctic: A Means of Protection, a Statement of Identity." *Arctic* 45, no. 1 (1992): 62–73.

Sverige Radio. "George Sand—bästsäljande kvinna klädd i herrkläder." March 8, 2019, https://sverigesradio.se/avsnitt/1246148.

Svestad, Asgeir. "What Happened in Neiden? On the Question of Reburial Ethics." *Norwegian Archaeological Review* 46, no. 2 (2013): 194–222.

Tägil, Sven. *Ethnicity and Nation Building in the Nordic World*. London: Hurst, 1995.

Thorbjørnsrud, Berit. "Motstand mot slør, motstand med slør." In *Hijab i Norge*, edited by Njål Høstmælingen, 36–51. Oslo: Abstrakt forlag, University of Oslo, 2008.

Thorkildsen, Dag. "Norwegian National Myths and Nation Building." *Kirchliche Zeitgeschichte* 27, no. 2 (2014): 263–276.

Thuesen, Søren T. "Dressing Up in Greenland: A Discussion of Change and World Fashion in Early-Colonial West Greenlandic Dress." In *Arctic Clothing*, edited by J. C. H. King, Birgit Pauksztat, and Robert Storrie, 100–103. London: British Museum Press, 2005.

Titon, Jeff Todd. "Authenticity and Authentication: Mike Seeger, the New Lost City Ramblers, and the Old-Time Music Revival." *Journal of Folklore Research* 49, no. 2 (2012): 227–245.

Todal, Jon. "Minorities with a Minority: Language and the School in the Sami Areas of Norway." *Language, Culture and Curriculum* 11 (1998): 354–366.

Tønnesson, Johan Laurits, and Kirsten Sivesind. "The Rhetoric of the Norwegian Constitution Day." *Scandinavian Journal of Educational Research* 60, no. 1 (2016): 201–218.

Torpey, Paul. "Industrial Revolution." *The Guardian*, October 3, 2007. https://www.theguardian.com/travel/2007/oct/03/norway.heritage.

Trætteberg, Gunvor Ingstad. *Folk-Costumes of Norway*. Oslo: Dreyers Forlag, 1966.

Trevor-Roper, Hugh. "The Invention of Tradition: The Highland Tradition of Scotland." In *The Invention of Tradition*, edited by Eric Hobsbawm and Terence Ranger, 15–42. Cambridge: Cambridge University Press, 1983.

Trotter, Stephen Richard. "Breaking the Law of Jante." In "Myth and Nation." Special issue, *eSharp* 23 (2015): 1–24.

Tuck, Eve, and K. Wayne Yang. "Decolonization Is Not a Metaphor." *Decolonization: Indigeneity, Education and Society* 1, no. 1 (2012): 1–40.

Turi, Johan. *An Account of the Sámi*. Edited and translated by Thomas A. DuBois. Chicago: Nordic Studies Press, 2012. First published 1911.

Turner, Terrence S. "The Social Skin." *HAU: Journal of Ethnographic Theory* 2, no. 2 (2012): 486–504. First published 1980.

Ugland, Thorbjørg Hjelmen. *A Sampler of Norway's Folk Costumes*. Oslo: Boksenteret Forlag, 1996.

Ulfstein, Geir. *The Svalbard Treaty: From Terra Nullius to Norwegian Sovereignty*. Oslo: Scandinavian University Press, 1995.

US Census Bureau. "Estimates of Resident Population Change and Rankings." Accessed February 17, 2021. https://www.census.gov/data/tables/time-series/demo/popest/2010s-total-metro-and-micro-statistical-areas.html#par_textimage_1139876276.

———. "Selected Population Profile—Norwegian." Accessed February 17, 2021. https://data.census.gov/cedsci/table?q=Norwegian&t=549%20-%20Norwegian%20%28082%29&g=0100000US&tid=ACSSPP1Y2019.S0201&hidePreview=false.

Valkonen, Sanna. "Lestadiolaisuuden jäljet saamelaisnaisten elämässä." In *Poliittinen lestadiolaisuus*, edited by Tapio Nykänen and Mika Luoma-Aho, 206–245. Helsinki: Finnish Literature Society, 2013.

Valkonen, Sanna, and Sandra Wallenius-Korkalo. "Embodying Religious Control: An Intersectional Approach to Sámi Women in Laestadianism." *Culture and Religion* 16, no. 1–2 (2015): 1–16.

van Elswijk, Roald. "Spread the Word: Arne and Hulda Garborg as Cultural Transmitters of Nynorsk." In *In the Vanguard of Cultural Transfer: Cultural Transmitters and Authors in Peripheral Literary Fields*, edited by Petra Broomans and Marta Ronne, 13–32. Groningen, Netherlands: Barkhuis Groningen, 2010.

Velure, Magne. "Folklorisme, Oppatliving av fortida." *RIG*, no. 3 (1977): 76–86.

Viken, Arvid. "Reinventing Ethnic Identity: A Local Festival as a National Institution on a Global Scene." In *Polar Tourism: A Tool for Regional Development*, edited by Alain A. Grenier and Dieter K. Müller, 179–206. Quebec: Presses de l'Université du Québec, 2011.

Vogt, Kari. "Historien om et hodeplagg." In *Hijab i Norge*, edited by Njål Høstmælingen, 23–35. Oslo: Abstrakt forlag, University of Oslo, 2008.

Waldén, Louise. "Women's Creativity and the Swedish Study Circles." In *Swedish Folk Art: All Tradition Is Change*, edited by Barbro Klein and Mats Widbom, 181–188. New York: Harry N. Abrams, 1994.

Walsten, David McCall. "I Made My Own Bunad." *The Norseman*, May 1995.

Welters, Linda, ed. *Folk Dress in Europe and Anatolia: Beliefs about Protection and Fertility*. Oxford: Berg, 1999.

Welters, Linda, and Abby Lillethun. *Fashion History: A Global View*. Oxford: Berg, 2018.

White, Willy. "Extract from a Presentation at the Symposium, Indigenous Perspectives on Repatriation: Moving Forward Together, Kelowna 29–31 March 2017." In "Indigeneities and Museums: Ongoing Conversations," edited by Caitlin Gordon-Walker and Martha Black. Special issue, *British Columbian Quarterly*, no. 199 (2018): 7–10.

Williams, Patricia. "Festival, Folk Dress, Government and Tradition in Twentieth Century Czechoslovakia." *Dress: The Journal of the Costume Society of America* 23, no. 1 (1996): 35–46.

———. "From Folk to Fashion: Dress Adaptations of Norwegian Immigrant Women in the Midwest." In *Dress in American Culture*, edited by Patricia A. Cunningham and Susan Voso Lab, 95–108. Bowling Green, OH: Bowling Green State University Popular Press, 1993.

Wilson, William A. "Herder, Folklore and Romantic Nationalism." In *Folk Groups and Folklore Genres: A Reader*, edited by Elliott Oring, 21–37. Logan: Utah State University Press, 1989.

Winton, Patrik. "Commercial Interests and Politics in Scandinavia, 1730–1815: Introduction." In *Scandinavia in the Age of Revolution: Nordic Political Cultures, 1740–1820*, edited by Pasi Ihalainen,

Michael Bregnsbo, Karin Sennefelt, and Patrik Winton, 207–216. Burlington, VT: Ashgate, 2011.

Wistrand, P. G. *Svenska folkdräkter: Kulturhistoriska studier*. Stockholm: Aktiebolaget Hiertas Bokförlag, 1907.

Wolf, Eric R. *Europe and the People without History*. Berkeley: University of California Press, 2010. First published 1982.

Worth, Rachel. "Developing a Method for the Study of the Clothing of the 'Poor': Some Themes in the Visual Representation of Rural Working-Class Dress, 1850–1900." *Textile History* 40, no. 1 (2009): 70–96.

Ylvisåker, Anne Britt. "Folk Costume as a National Symbol." In Karlberg and Ylvisåker, *Crowns and Roses*.

———. "National Costume: A Symbol of Norwegian Identity." In *Heritage and Museums: Shaping National Identity*, edited by J. M. Fladmark, 299–309. Dorset, UK: Donhead, 2000.

———. "National Costumes as Political Propaganda." In Karlberg and Ylvisåker, *Crowns and Roses*.

Yoder, Don. "Folk Costume." In *Folklore and Folklife: An Introduction*, edited by Richard M. Dorson, 295–323. Chicago: University of Chicago Press, 1972.

Zorgdrager, Nellejet. *De rettferdiges strid Kautokeino 1852: Samisk motstand mot norsk kolonialisme*. Samiske samlinger, Utgitt av Norsk Folkemuseum Bind 18. Oslo: Vett og Viten AS, 1997.

Contributors

Laurann Gilbertson is Chief Curator at Vesterheim Norwegian-American Museum in Decorah, Iowa.

Lizette Gradén is Curator/Research Coordinator at the Royal Armory and Skokloster Castle with the Hallwyl Museum in Stockholm and holds a research position in Ethnology at Lund University.

Eeva-Kristiina Harlin is Project Manager at SIIDA—the National Museum of Finnish Sámi and Researcher at University of Oulu's Giellagas Institute for Sámi Cultural Studies.

Carrie Hertz is Curator of Textiles and Dress at the Museum of International Folk Art.

Outi Pieski is a visual artist with an MFA from the Helsinki Academy of Fine Arts.

Camilla Rossing is Director of the Norwegian Institute for Bunad and Folk Costume.

Khristaan Villela is Executive Director of the Museum of International Folk Art.

Index